RAPHAEL IN FLORENCE

RAPHAEL IN FLORENCE BY JÜRG MEYER ZUR CAPELLEN

Azimuth Editions London

PUBLISHED IN THE UNITED KINGDOM BY
AZIMUTH EDITIONS LIMITED
33 LADBROKE GROVE LONDON W11 3AY

ISBN 1 898592 08 X

BRITISH LIBRARY CATALOGUING IN PUBLICATION DATA
A CATALOGUE RECORD FOR THIS BOOK IS AVAILABLE FROM
THE BRITISH LIBRARY.

TRANSLATED FROM THE GERMAN BY STEFAN B. POLTER
EDITED BY JANE HAVELL
DESIGNED BY ANIKST ASSOCIATES
PICTURE RESEARCH BY CARRIE HAINES
REPRODUCED AND PRINTED IN THE UNITED KINGDOM BY
PJ REPRODUCTIONS, LONDON

THE FRONTISPIECE AND ALL CHAPTER DECORATIONS ARE
DETAILS FROM 'FAITH', 'CHARITY' AND 'HOPE',
PREDELLA PANELS FROM
THE BAGLIONI ALTARPIECE BY RAPHAEL.
OIL ON PANEL. PINACOTECA VATICANA, ROME.

CONTENTS

For Herbert Siebenhüner
1908–1996

Preface

At the beginning of the sixteenth century, the politics of the city of Florence were in a state of transition. The religious reformer Savonarola had expelled the ruling Medici family in 1494, but his reign came to a violent end four years later, and the period between 1498 and 1512 saw the founding of a republican system of government. This was an attempt to revive old Florentine traditions, together with the election of a head of state for life (the *gonfaloniere della giustizia*), in order to safeguard stability and continuity, but the effort – as it turned out – proved unsuccessful.

It is a period of the greatest significance in the history of art. The early years of the sixteenth century saw remarkable developments in the arts, with Leonardo and Michelangelo both working in Florence. In 1504 the young Raphael arrived from his native Urbino to further his studies in what must have been an inspiring and exciting atmosphere of artistic rivalry; within a few years he achieved a reputation second only to these two masters. This period in Florence's history has always been seen as marking the birth of the High Renaissance, a subject upon which there has been been such a mass of publications that today it has reached almost unmanageable proportions.

The discussion in this book is meant only as an introduction to this highly complex topic. Focusing on the activities of the young Raphael, it attempts to present the artistic climate of the times as it might have appeared to him. He is regarded here not as one of the three great masters of the period (as has been done occasionally and rather superficially), but as an artist who was largely an unknown quantity to his contemporaries. My intention is to show how, within a short time, the young man from Urbino developed a language of forms all his own; at first it was imitative of his models, but soon it was in competition with them, enabling him to place himself on a level with both Leonardo and Michelangelo. This 'Raphaelesque perspective' is all the more justified since he lived in Florence almost continuously for four years and

his work during that time is documented by a large number of paintings and drawings, a legacy that provides much fuller documentation than is the case with the two other giants. Raphael's Florentine oeuvre shows in great detail his relationship to the art of Leonardo, Michelangelo and other contemporaries, particularly Fra Bartolommeo, and also to the art of Florence in the previous century. At the same time, the surviving drawings illustrate in exemplary fashion his learning processes and the evolution of his individual compositions; as such, they are an invaluable subject for art historical study.

Since the quincentenary of his birth in 1983, publications about Raphael have appeared in vast numbers; they do not, however, provide us with any clearer view of him. This may partly be due to increasing specialization and to the absence of general surveys that take into account the state of current research. The dichotomy between popular and scholarly approaches is a further hindrance. My aim has been to introduce this complex subject in an accessible manner, and to guide the reader straight to the works themselves rather than bury them under a mound of explanations. Current scholarly opinions are touched upon in the text, but details of the relevant literature are confined to the Notes and the Catalogue. Listed there are the older, classic studies but special emphasis has also been placed on more recent research; the latter has often appeared only in learned journals, edited works or exhibition catalogues and is therefore not always easy to locate. My discussion is deliberately confined to a limited number of paintings and drawings, with the accent on illustrations to provide the core of the argument.

Primary sources are quoted liberally in translation to help establish a broader context (the original language is given in the notes). I have drawn extensively on Giorgio Vasari, whose *Vite* ('Lives of the Artists') is an invaluable source, not only for its factual information but also for its vivid and evocative descriptions and circumstantial details. These biographical essays have often been misunderstood as on-the-spot jottings; although that may have been the case when Vasari was writing about his own age, he presented the 1500s as they appeared to him in the 1550s – a gap of more than a generation, which enabled him to interpret both detail and overall artistic evolution from a much later intellectual position. It should also be borne in mind that Vasari conceived of his biographies as a work of literature, which is how they were understood by his contemporaries. Sometimes Vasari the writer even felt the urge to compete with the artists who were his subjects. While I make use of his writings as a major document for understanding the art of the sixteenth century, therefore, their literary intentions are not my concern.[1]

There is another problem of fundamental importance that scholars tend to neglect: the processes of artistic creation on the one hand, and its analytical reconstruction by later recipients on the other, are based upon completely different principles. While the latter pursues a highly rational course to discover implicit relationships – for instance, in regard to formal iconographic elements – the artist himself, most of the time, follows his intuition and reflects only rarely on the way he manipulates his models. It is worth remembering that all interpretation proceeds from hindsight.

The status of this book is that of a preparatory sketch for a more comprehensive monograph on Raphael which has been long in the making. Material support for my research work, including extensive travel, was supplied by the Raffael-Projekt established in 1990 at the uni-

versities of Münster and Würzburg. I am very grateful for the help I received from numerous colleagues during the preparation and writing of this study, especially from those working at European and American museums. I am also deeply indebted to my fellow students on the Raffael-Projekt.

Jürg Meyer zur Capellen
1996

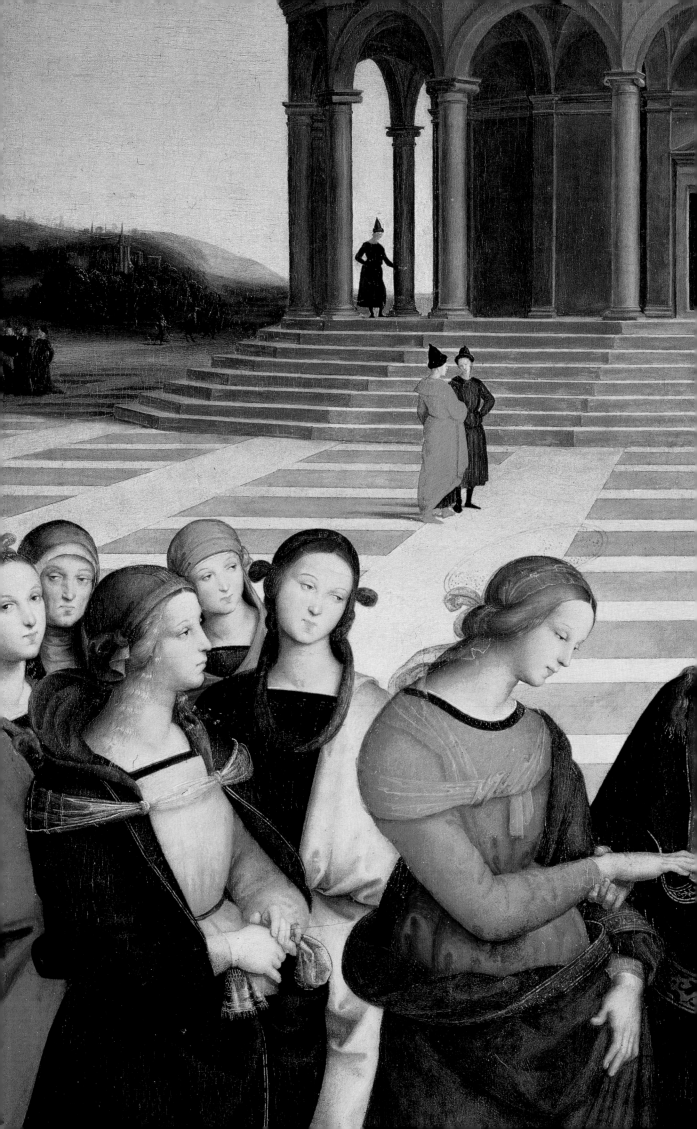

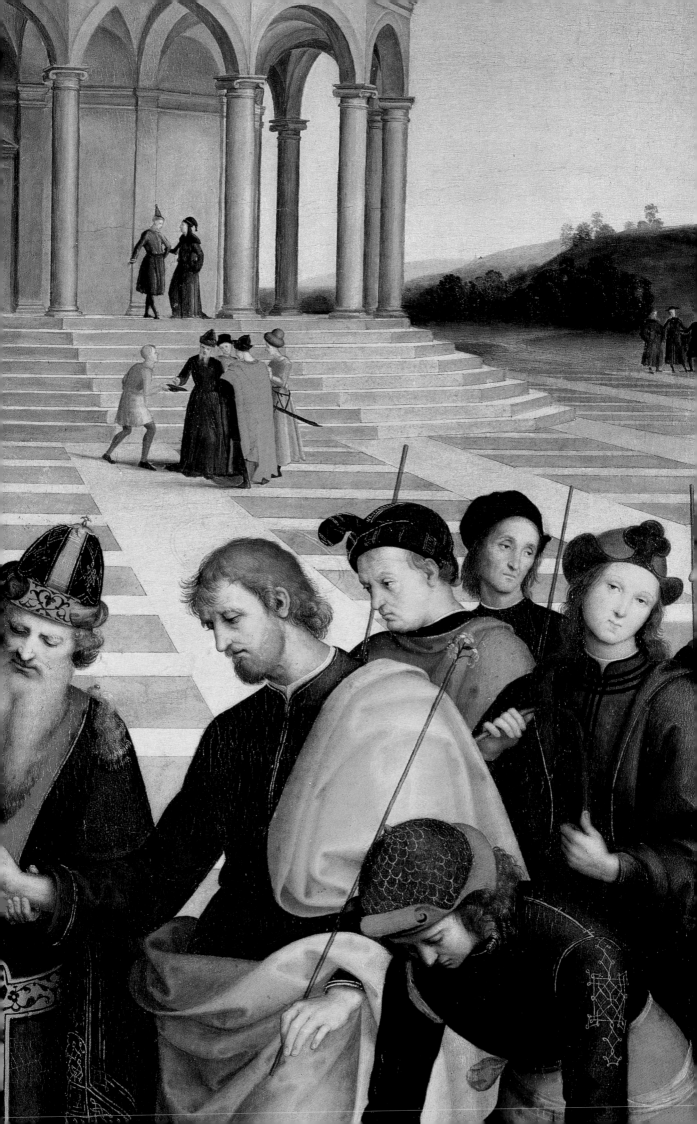

I. EARLY WORKS, CLIENTS AND THE HISTORICAL SETTING

The court at Urbino, Raphael's Umbrian commissions and his relationship with Perugino

There survives at the Palazzo Ducale in Urbino a rectangular panel painting of an ideal cityscape which in some respects encapsulates the Renaissance spirit of the late fifteenth century. The painting shows a two-storeyed, circular building of classical appearance, which dominates a broad piazza surrounded by Renaissance structures (1). The composition's strict adherence to perspective and the central building (2, reminiscent of the Baptistery in Florence) both symbolize the humanistic ideals of a well-ordered and harmonious civil polity. The panel, part of a group of similar works, still awaits a secure attribution to either an artist or a workshop, as well as a definition of its original function. Since it has long been associated with Urbino and is vaguely similar to *intarsias* (decorative inlaid work on wood) surviving in the Palazzo Ducale, the panel is usually linked with the court of Guidobaldo da Montefeltro.

The founder of the Renaissance palace at Urbino was the *condottiere* Federigo II da Montefeltro (r. 1444–82), father of Guidobaldo, well known for his military exploits and his deep interest in humanism. For the construction and decoration of his building projects, mainly his residence in Urbino, he secured the services of architects who included Luciano Laurana, Francesco di Giorgio and others. The Palazzo, although never completed, became a model for other palaces of the time. According to his biographer Vespasiano da Bisticci, Federigo was the first *signore* with a love for philosophy and the ancient authors, interests that were shared by his son Guidobaldo (r. 1482–1508). At his father's death in 1482 during a military campaign, Guidobaldo was still under age, so his uncle Ottaviano Ubaldini acted as regent. At the age of fourteen Guidobaldo won distinction as a *condottiere*, and served Pope Innocent VIII as *gonfaloniere* and *generale della chiesa*; not much later, he took over the reins of power at Urbino. Marriage to Elisabetta Gonzaga of Mantua in 1488 strengthened his political position in central Italy, yet his rule remained threatened. In 1502 Urbino was captured by

the troops of Cesare Borgia, son of Pope Alexander vi, but Alexander died in August the following year, and Guidobaldo regained his ducal powers. The peaceful period that followed was overshadowed by the fact that Guidobaldo remained without an heir. In 1504 he designated his nephew Francesco Maria della Rovere, a close relative of the future Pope Julius ii (1503–13), as his successor. On Guidobaldo's death in 1508 Francesco succeeded to the ducal seat at Urbino unopposed.[2]

The Montefeltro court – with its lively interest in cultural matters, especially intellectual and literary affairs – constituted a model for the Italian nobility. However, it never became a centre for the fine arts in the manner of Mantua under the Gonzaga, who engaged Andrea Mantegna (*circa* 1431–1506) as their court painter and valued painting highly for its ability to represent their power and that of their city-state. It is therefore not surprising that early depictions of the Palazzo Ducale are rare, even though it presents an unforgettable sight in its picturesque setting, the characteristic twin towers of its main façade and two superimposed loggias overlooking the landscape. The panel painting of an ideal city (1) provides something of a substitute; it has in turn become an emblem of that humanist ideal of an Italian Renaissance community, which the court at Urbino fostered and in some ways exemplified.[3]

Federigo da Montefeltro's main involvement in artistic matters was embodied by his collection of manuscripts, one of the best of his time (today it forms an important part of the Vatican library). Occasionally, he employed well-known painters like Melozzo da Forlì (1438–94)and Piero della Francesca (*circa* 1416–92) for substantial projects. The latter painted the famous double portrait of the ducal couple (now in the Uffizi, Florence) and also the *Montefeltro Altarpiece* (3; now in the Brera, Milan). The altarpiece was first displayed in the church of S. Donato outside Urbino, but was almost certainly intended for the church of S. Bernardino, built to designs by Francesco di Giorgio after Federigo's death in 1482, and where he was eventually laid to rest and the altarpiece installed.[4] The composition dates from the mid-1470s and was still unfinished when the duke died; Piero was probably responsible for the major part. Its symbolism is closely connected with its function as a tomb painting. Mary is shown seated on a throne surrounded by angels and saints, the figures and classical architecture possibly alluding to the heavenly government, the *Curia Coeli*. The Infant asleep on his mother's knees (a reflection of the Pietà motif) and the egg above Mary are symbols of death and resurrection; it is in this context that Duke Federigo is depicted, kneeling in the pose of eternal adoration. Federigo's status as a noble knight is indicated by his dress, and his helmet placed on the ground is a sign of humility. This ambitious concept vaguely recalls elements from French court painting. The *Montefeltro Altarpiece* can be regarded as the most important painting produced in Urbino during the Renaissance, and it was a particular subject of study by artists who stayed in the city. It exercized a powerful influence on the type of composition known as a *sacra conversazione* far into the sixteenth century.

While Piero della Francesca received occasional patronage at Urbino's court, the three artists who found most regular employment there were all of mediocre talent. Justus of Ghent (Joos van Wassenhove, documented between 1460 and 1470) was active during Federigo's rule. Between 1472 and 1475 he was working at the palace on the famous cycle of the *Uomini Illustri* and *Arti Liberali*, probably together with Pedro Berruguete (*circa* 1450–1504).[5] Greater interest must necessarily be accorded to the third artist, Giovanni Santi, Raphael's father.

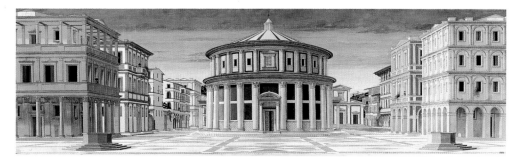

1 Anonymous, *Ideal Cityscape*. Oil on panel. Palazzo Ducale, Urbino.

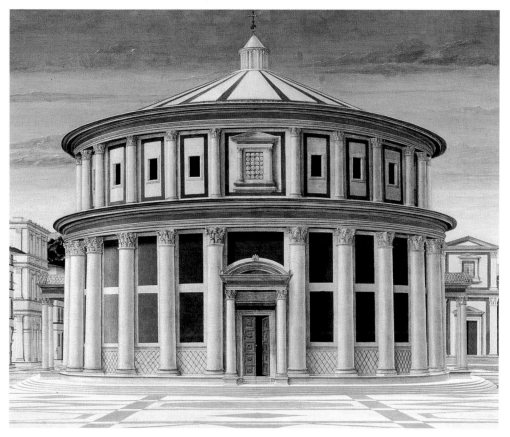

2 Anonymous, *Ideal Cityscape* (detail of central building).

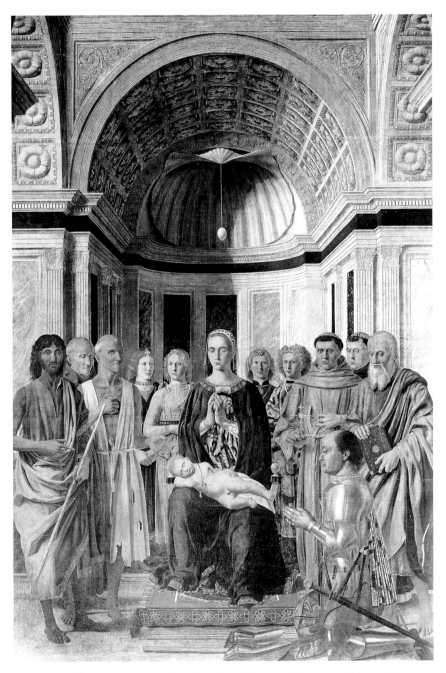

3 Piero della Francesca, *Montefeltro Altarpiece.* Oil on panel. Pinacoteca di Brera, Milan.

Born in Colbordolo *circa* 1440, Giovanni Santi and his family moved to the relative safety of Urbino in 1446 after their home town had been partly destroyed by Sigismondo Malatesta; they owned property in both places. At the age of forty, Giovanni married Magia di Battista Ciarla, who gave birth to Raphael in 1483 (Giovanni remarried in 1492 after Magia's death). From the 1480s onwards he worked for the Montefeltro court under the reign of Guidobaldo and Elisabetta, and several of his altarpieces survive from this period. In 1493 he was in Mantua to paint portraits for Isabella d'Este; he died on 1 August 1494 at the age of about fifty-four. Giovanni Santi has been treated rather harshly by art historians, despite (or perhaps because of) being the father of Raphael. One of his most important altarpieces, the *Oliva Altarpiece* (4), shows clearly how his style incorporated elements of Netherlandish and northern Italian painting. He did not follow his models very closely; the influence on him of Melozzo da Forlì and Piero della Francesca remained marginal, although the latter perhaps provided the inspiration for the kneeling figure of the patron.

Of greater significance are Giovanni's literary productions, among which pride of place goes to a rhymed chronicle glorifying Federigo da Montefeltro. From this *Cronaca* we learn that Giovanni took up painting quite late in life, but there is no information on whom he studied with, or where. Giovanni also provides sketches of various contemporary artists, showing that he had knowledge of the artistic developments around him, which was the fruit of much travelling. He emphasizes his closeness to Melozzo da Forlì, perhaps surprisingly in view of the visual character of the *Oliva Altarpiece*, and praises Andrea Mantegna. It is indicative of his position as a 'provincial' that he thinks very highly of Perugino as an artist, equal to Leonardo.[6]

General opinion regards Giovanni Santi's literary output and especially his rhymed chronicle as just another example of conventional panegyrics to a ruler. It does, however, show Giovanni as a man of learning and indicates that he not only acted as an artist at the Montefeltro court but also as a courtier (*cortegiano*).[7] The ideal of the *cortegiano* was given precise expression almost one generation later in Baldassare Castiglione's book of the same title, its first version completed in 1508 but printed only in 1528, in which Castiglione explicitly refers to Urbino's court under Guidobaldo da Montefeltro.[8] From his description of the ideal courtier, couched in the classical form of an imaginary debate, we receive a precise impression of the intellectual climate in Urbino under Guidobaldo. Among the participants are some illustrious names: besides Duke Federigo and Castiglione himself, Pietro Bembo, Barnardo Dovizi (Cardinal Bibbiena), Cesare and Elisabetta Gonzaga, Giuliano de' Medici and Francesco Maria della Rovere all appear. In the *paragone* (the competition between the various branches of the arts), the sculptor and musician Giovan Cristoforo Romano presents the case for sculpture. All aspects of courtly life are discussed in *Il Cortegiano*, one of the most crucial being the learning and manners characterizing the courtier. We can assume that, like the others, Giovanni Santi conformed to this ideal; as an artist and one of the ducal *familiari*, he would have played a general role in the entertainment at court besides receiving particular commissions. He was given additional commissions by other patrons, which he executed by order or with the approval of his ducal master – for example, the portraits he painted for Isabella d'Este. Court life at Urbino must have offered many opportunities for Giovanni to further his career and improve his art. Although he never managed to gain more

4 Giovanni Santi, *Oliva Altarpiece*. Oil on panel. Convento di Montefiorentino, Frontino.

than local recognition for himself, his position must have been of central importance for the career of his son. Raphael began his studies in Florence with the support of Giovanna della Rovere, and some of the people who frequented the court at Urbino – for example, Baldassare Castiglione and Cardinal Bibbiena – eventually became his patrons or friends.

When Giovanni died in 1494, however, Raphael was only eleven, far too young to assume the position his father had held at court. Thus several of Guidobaldo's commissions went to Luca Signorelli (in 1494) and to Pietro Perugino (in 1497), while the court engaged the painters Timoteo Viti (1469–1523) and Girolamo Genga (1476–1551) on a permanent basis.[9]

It may well be that after the death of his father Raphael continued as a member of his workshop, and received further training from its older members. He would have been able to use the paintings and drawings from Giovanni's estate, and may also have studied works of art to be found in the vicinity, such as Piero della Francesca's *Montefeltro Altarpiece* (3). It seems quite likely that at a relatively early date the Urbino court commissioned certain portraits from Raphael, giving the young artist a chance to prove himself. These portraits, whose authorship is under dispute, cannot be discussed within the compass of the present work, nor have they ever been researched in context.[10]

How long Raphael remained in Urbino after his father's death is uncertain, but he is next reported by Vasari as working in Umbria, in the workshop of the leading artist of the region, Pietro Perugino (*circa* 1445/50–1523). As well as being the most famous artist in Umbria, by the 1490s Perugino had also become one of the Florentines' favourites and had set up a workshop in their city. His great reputation is attested to, not only by the many commissions he received but also by the fact that, as we have seen, in his *Cronaca* Giovanni Santi considered him the equal of Leonardo. With hindsight such praise seems exaggerated, but it does show that Perugino was greatly admired far beyond Florence and his home city, Perugia. In 1494, for example, he was summoned to execute a fresco in the Sala del Gran Consiglio in the Doge's Palace, Venice; in fact, the work was never started, but the agreed fee, if the commission had been realized, was 400 gold ducats – a very considerable sum.[11] Taking into consideration the influence of his father's recommendation and Perugino's evident popularity in a number of artistic centres, it is not unlikely that the young Raphael sought him out. The date and circumstances of Raphael's move to Perugia are unknown, and the paucity of contemporary sources makes it unlikely that these problems will ever be completely resolved; political instability in Urbino may have been a contributing factor. Traditional devotional paintings of the Madonna and Child type, the principal subject of Raphael's later Florentine period, are not treated in the following survey of Raphael's Umbrian period, partly because none of his clients for such works has been identified;[12] the main focus here is his large commissioned altarpieces, made during the time of his greatest involvement with the art of Perugino.

By the age of seventeen, however, Raphael appears also to have resumed his association with the Santi workshop, for in 1500 he received a commission to paint the *S. Nicola da Tolentino Altarpiece*, made for the Cappella Baronci in the church of S. Agostino, Città di Castello. This work, the first documented painting by Raphael, was badly damaged during an earthquake in 1789, and only fragments of the painting remain today (6–9, kept in museums in Naples, Brescia and Paris). Documents have survived for both the order on 10 December 1500 and the delivery on 13 September 1501. The commission was not given to Raphael

5 Raphael, *Compositional Study for the S. Nicola da Tolentino Altarpiece*. Chalk over stylus.
Musée des Beaux-Arts, Lille.

6 Raphael, *Madonna*. Oil on panel.
Museo Nazionale, Capodimonte, Naples.

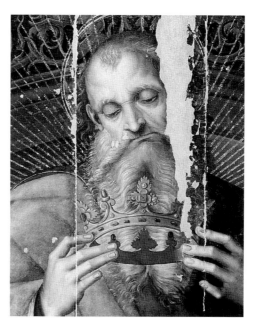

7 Raphael, *God the Father Holding a Diadem*.
Oil on panel. Museo Nazionale, Capodimonte, Naples.

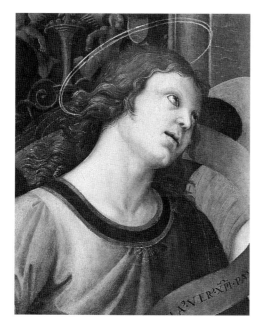

8 Raphael, *Angel with a Scroll*. Oil on panel.
Musée du Louvre, Paris.

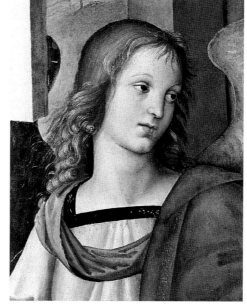

9 Raphael, *Head of an Angel*. Oil on panel transferred
to canvas. Pinacoteca Tosio Martinengo, Brescia.

6–9 Fragments from the *S. Nicola da Tolentino Altarpiece*

directly, but made out jointly in his name and that of Evangelista di Pian di Meleto, an artist about whom nothing else is known. It has been convincingly argued that the latter served as a collaborator in the Santi workshop, directing it as the more experienced colleague while Raphael did the overseeing as the legitimate heir. A reputable workshop, it could be expected to give satisfaction, and seems to have been chosen for reasons of economy: the payment of 33 gold ducats for a painting of this size (it originally measured approximately 390 × 230 centimetres) was quite low.[13]

The saint by whose name the painting is known, Nicholas of Tolentino, was a thirteenth-century Augustinian monk of great popularity in Umbria and the Marches, who was canonized in 1446. The reconstruction of the complete painting is based on a later copy as well as on preparatory drawings (5) and the surviving fragments; the recently discovered section now in the Louvre showing an angel (8) has allowed earlier hypothetical reconstructions to be corrected.[14] Raphael chose a relatively conventional composition, severely symmetrical and arranged in two registers: the victorious saint stands on a devil and is accompanied by four angels in an architectural setting opening into the landscape. Above him God the Father appears within the traditional mandorla (from the Italian for 'almond'), with Mary and another saint. The preparatory drawings show that Raphael studied the poses from models, and built up the whole composition with care – common practice in Perugino's studio as elsewhere. The delicate facture shows elements of Perugino's style, although Raphael has not yet adopted it as consistently as he was to do in his later Umbrian works. Overall, the treatment differs so much from Perugino's that, despite the views of some scholars, it seems unlikely that Raphael had been studying with him for very long.[15]

Raphael must have made a favourable impression with this first work for Città di Castello, for Domenico Tommaso de' Gavari, a citizen of that town, soon afterwards placed a commission with him. This was the *Crucifixion*, executed for the Cappella Gavari in the church of S. Domenico (10; in the collection of Cardinal Fesch in Paris in 1818, it is now in the National Gallery, London; the surviving predellas are in Raleigh, N.C., and Lisbon). The signature in roman capital letters appears on the lower part of the upright of the Cross: RAPHAEL/URBIN/AS/P. The original stone substructure of the altar at S. Domenico preserves the inscription: HOC.OPUS.FIERI.FECIT.DNICUS./THOME.DEGAVARIS.MDIII. Except for this explicit statement identifying Domenico Tommaso de' Gavari as the donor, no documents survive that shed further light on the circumstances of the commission for this painting or its execution. The date 1503 most likely refers to the year it was finished. There is no indication that Domenico Tommaso de' Gavari was a patron of the arts, and we therefore have to conclude once again that Raphael's client was interested mainly in obtaining some modestly priced furnishings for the family chapel.

The panel painting, with a semi-circular top, shows Christ on the Cross flanked by two angels in front of a wide, hilly landscape. In the foreground St Jerome and St Mary Magdalene are kneeling on either side of the Cross with the Virgin and St John standing behind them. Penitence as a concept is symbolized by the two kneeling saints, and as a sacrament by the two angels catching drops of Christ's blood. The perfectly symmetrical composition is finely balanced, the figures emphasizing the main constuctional lines and turning towards the compositional and emotional centre. Vasari correctly pointed out the painting's character:

22

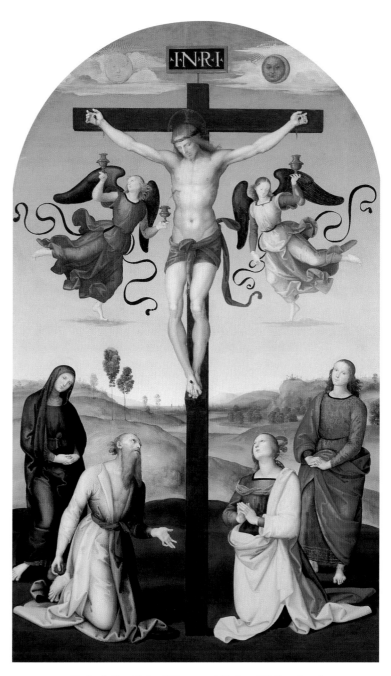

10 Raphael, *Crucifixion*. Oil on panel. National Gallery, London.

'Raffaello departed from Perugia and went off with some friends to Città di Castello, where he painted a panel for S. Agostino in the same manner, and likewise one of a Crucifixion for S. Domenico, which, if his name were not written upon it, no one would believe to be a work by Raffaello, but rather by Pietro.'[16] Today, we, too, tend to focus on its Peruginesque elements – the contrived movements of the figures and their insecure stance, the rich folds of the draperies, and the stereotyped idealized faces which by their gaze and expression provide a sense of unity. The thin, delicate layers of colour of the flesh tones, which contrast with the more emphatic delineation of the drapery, are just what one would expect from Perugino. But then there are features in this *Crucifixion* which already mark a development beyond his style. The modelling of Christ's body is more insistent, and the texture and volume of the cross rather recall Luca Signorelli. Even more significant is the pronounced directedness of the secondary figures, each playing a clearly defined part in the whole composition, with their gestures and gazes all well coordinated – unlike the vagueness of Peruginesque figure compositions. Compared with the earlier *S. Nicola da Tolentino*, here Raphael is fully in command of Perugino's vocabulary of forms, while his artistic intentions already aim further. He deeply understood Perugino's art, but also recognized its limitations, and his adoption of its idioms was surely deliberate and well considered. Raphael's later works show how this understanding provided a basis for his dialogue with the art of Leonardo and Michelangelo.

Neither documents nor inscriptions survive to help us date the altarpiece with the *Coronation of the Virgin* painted for the Cappella Oddi in S. Francesco, Perugia (11; removed by Napoleon in 1797 and in the Vatican museum since 1815). It is most likely that the commission came from Leandra (Alessandra), wife of Simone degli Oddi. The Oddi, one of the most powerful families in Perugia, were leaders of the opposition to the Baglioni: the rivalry between the two for the dominant position came to a head in the late fifteenth and early sixteenth centuries. Leandra Oddi is linked with Perugino in a contract of 1512, which indirectly mentions the *Coronation of the Virgin* as a model. Two events have repeatedly been connected with the commission for the *Coronation*: the death in exile of the patriarch Simone degli Oddi in 1498, and the temporary return of the family to Perugia in 1503 under the protection of Cesare Borgia. But there is no historical evidence to link these events to the painting for the purpose of dating it; in any case, the women of the family presumably never left the town, and could well have commissioned the painting themselves and kept an eye on its progress. It is perhaps significant that the Oddi and Baglioni families, although deadly enemies, were related to each other: Leandra was the sister of Grifone Baglioni, who was the husband of Atalanta (see page 215). Simone unsuccessfully tried to effect a reconciliation between the two dynasties. Leandra may have kept in touch with her sister-in-law, Atalanta Baglioni, a possibility all the more plausible since some years later Atalanta commissioned Raphael for *The Entombment*, also destined for the church of S. Francesco (139). On 20 September 1506 Pope Julius II celebrated morning Mass at S. Francesco in connection with a concerted effort to reconcile the families. On this occasion the Pope may have seen Raphael's *Coronation*, and perhaps the seed was sown for his later summons to Rome. The historical interconnections are complex, and do not present any conclusive evidence as far as dating is concerned.[17]

The complete altarpiece (now dispersed) consisted of the main panel with the *Coronation of the Virgin* and three predellas, an *Annunciation*, an *Adoration* and a *Circumcision*. The

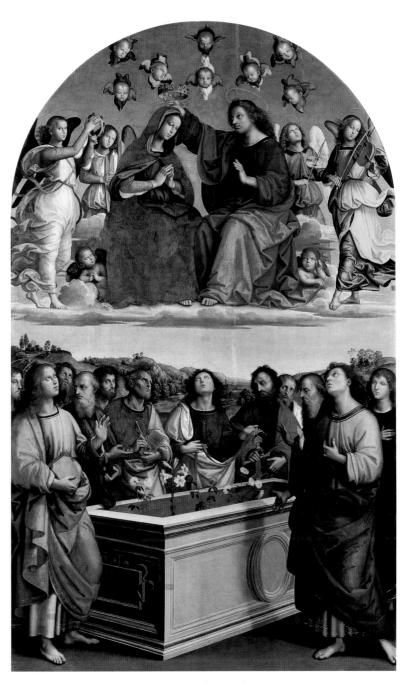

11 Raphael, *Coronation of the Virgin*. Oil on panel. Pinacoteca Vaticana, Rome.

main painting is divided into a heavenly and a terrestrial sphere. The lower part shows the twelve apostles, heads level, grouped around an open sarcophagus which, sprouting flowers, is placed diagonally to the picture plane and projects deep into the foreground; the background affords occasional glimpses of a landscape. In the immediate foreground two young apostles flank the sarcophagus, while St Peter and St Paul stand behind it, together with St Thomas, who draws attention to Mary's gift of the girdle. Strict symmetry, broken up in the lower part by the sarcophagus, dominates the composition of the heavenly scene above. Seated on cloud-banks, Christ is crowning Mary, surrounded by angels playing instruments and the heads of cherubim. (The painting and its brilliant colours have emerged after thorough restoration in good overall condition, except that the blue colours of Mary's and Peter's robes have faded.)

Style and composition as well as problems of documentation have given rise to widely differing opinions about the date of this painting. One main point of debate is the perceived incongruity between the two sections, the lower part frequently being regarded as from a later and more sophisticated period. The disposition of figures in the heavenly sphere is certainly much more severe and the execution of the drapery occasionally somewhat arid: the angel on the right playing a tambourine has been borrowed from Giovanni Santi and does indeed seem to connect with the pre-Peruginesque phase of Raphael's development. However, if one looks at the painting as a whole, the compositional and stylistic differences do not appear so very dramatic. The highly regular arrangement of the upper part is fully justified by its subject-matter and its allusion to the heavenly order. Neither should it be a matter of concern if Raphael, who was still very young, borrowed a figure from his father: faced with his most exacting commission so far, the artist would surely not have hesitated to make good use of any designs he had inherited. And the lower section is not without its weak and confused passages. The unhappy overlap between the figures surrounding St Thomas, caused by the oblique placing of the sarcophagus, has often been remarked, and the stance of the apostle to the left of St Paul is completely unclear. While there are awkward areas everywhere typical of a beginner, the painting as a whole presents a new conception which is still further removed from Perugino than the *Crucifixion* (**10**). Among Perugino's major paintings from the beginning of the century, none shows a comparable dynamic approach – depicting figures in the round, together with a palpable sense of space, as produced by the young apostles flanking the projecting sarcophagus. The variety among the apostles' heads, modelled in the round, also surpasses Perugino, even while Raphael retains the master's vocabulary of forms. Chronologically, the *Coronation of the Virgin* must be dated later than the *Crucifixion*, to about 1503–4.

The next step in Raphael's artistic development is expressed in *The Betrothal*, painted for the Cappella Albizzini dedicated to St Joseph in the church of S. Francesco, Città di Castello (**13**; kept in the chapel until 1798, when it passed through the collection of Conte Giuseppe Lechi and entered the Brera, Milan). The influential Albizzini family, its putative donors, may have taken their decision on the strength of the *S. Nicola da Tolentino Altarpiece* and the *Crucifixion*. No documents pertaining to the commission have survived, but the building depicted in the picture gives both signature and date: RAPHAEL URBINAS MDIIII. The signature, like that on the *Crucifixion*, means the commission was given to Raphael personally, and

26

indicates that his name and reputation were becoming better known in Umbria. The date 1504, the year of completion, serves as a chronological marker for the evaluation of his early works. One obvious parallel to Raphael's *Betrothal* is an altarpiece on the same subject by Perugino (**12**; now in Caen). Perugino produced his painting for the Cappella dell' Agnello in the cathedral at Perugia, where a reliquary contained what was believed to be the Virgin Mary's betrothal ring. Although Perugino received the commission in 1499, the painting was still unfinished in 1503, and was presumably completed only some time in 1504. The close resemblance of the two compositions suggests that Raphael at least knew of Perugino's compositional designs, and used them as the basis for his own work.[18]

The story of Mary's betrothal to Joseph in the Temple in Jerusalem is derived from the late thirteenth-century *Legenda Aurea* of Jacobus de Voragine. The ritual takes place in the presence of Mary's unsuccessful suitors: all the candidates for Mary's hand carry staffs, but Joseph's bursts into bloom as an indication of heavenly providence. Raphael's painting, with its harmonious composition, is certainly the finest he produced during his Umbrian period. Again he bases it on the formal language of Perugino, but chooses a different emphasis. In the centre, the high priest performs the betrothal ceremony for Mary and Joseph, on the left are the attendant women, and on the right the unsuccessful suitors. Rejecting Perugino's frieze-like arrangement, Raphael loosens up the composition by providing the protagonists with greater flexibility and more space, while carefully accentuating each group. Thus the five figures in the foreground form a semi-circle that leads the eye of the beholder into the picture space. Raphael again follows Perugino in achieving cohesion by means of poses, gestures and expressions, but produces a new and dramatic accent by linking Joseph with his flowering staff to the unsuccessful suitor who breaks his barren one over his knee. The careful construction of the middle distance according to a central perspective has been especially admired since the time of Vasari. The figures are placed on a pavement continuing right down to the lower edge of the panel and are thereby solidly secured within the picture space. There is a more forceful use of perspective in the foreshortening of the pavement pattern across the stepped approach to the arcaded polygonal temple, which both crowns the protagonists and at the same time directs attention back to them. The depiction of a centrally planned religious building, similar to the severely classical one in the *Ideal Cityscape* (**1** and **2**), is ultimately based on the perspective theories of Leon Battista Alberti (1404–72) and is to be understood as a reference to the Dome of the Rock in Jerusalem, referred to in the Latin West as the *Templum Domini*. The freer movement of the figures, the wide pictorial space and the backlit architecture together produce an almost palpable sense of space. But, although the picture may be read like a wholly new conception, Raphael is in fact still adhering to the precepts of Perugino's art and simply filling them with greater intensity.

We know that in the autumn of 1504, Raphael went to Florence, though he returned to Perugia the following year for a certain period. The documented commissions he received from Umbria in 1505 indicate his growing reputation, especially in Perugia. A visit to Umbria in December 1505 is recorded, but presumably he had already worked in Perugia earlier that year,[19] for two altarpieces produced for the city can be dated to 1505. The *Ansidei Madonna* continues the development sketched above, while the *Trinity* fresco in the church of S. Severo shows a completely new approach inspired by the visit to Florence.

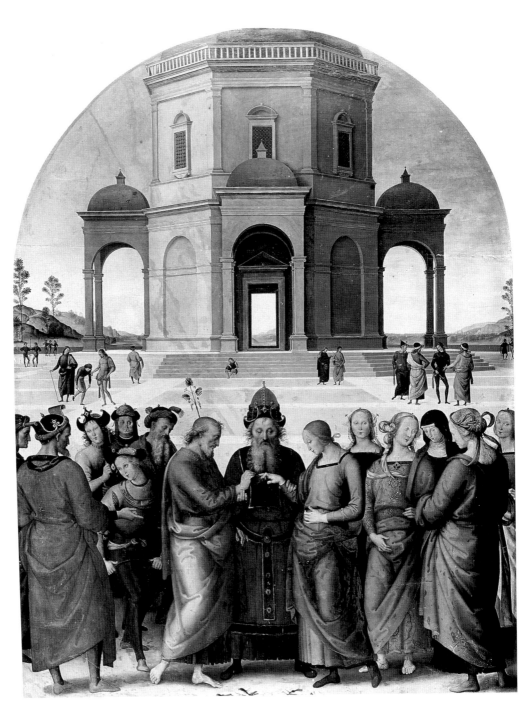

12 Pietro Perugino, *The Betrothal*. Oil on panel. Musée de Caen.

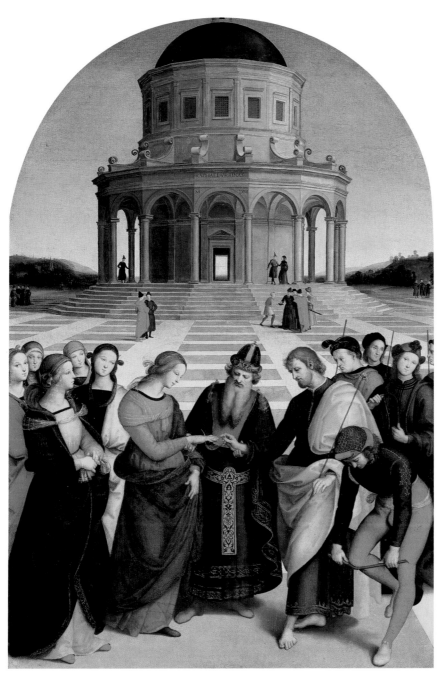

13 Raphael, *The Betrothal*, signed and dated 1504. Oil on panel. Pinacoteca di Brera, Milan.

14 Raphael, *Ansidei Madonna*, signed and dated 1505. Oil on panel. National Gallery, London.

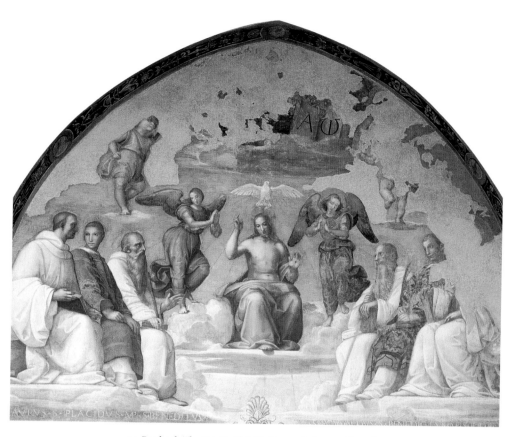

15 Raphael, *The Trinity* (detail). Fresco. S. Severo, Perugia.

The *Ansidei Madonna* (**14**) was produced for the Cappella di S. Nicola di Bari in the church of S. Fiorenzo, Perugia. The Ansidei were wealthy merchants, and the client may have been one Bernardino. The family began to decorate the chapel after 1490, presumably to celebrate a new family branch in a style befitting their position, but no documents about the precise circumstances of the commission have survived. The altarpiece incorporates a date on the hemline of Mary's cloak which can fairly accurately be read as MDV, indicating that the painting was completed in 1505.[20] Belonging to the well-known type of the 'Madonna enthroned', the painting shows a central wooden throne on a stepped platform, inside a chapel-like building with a coffered ceiling and a background landscape; Mary is accompanied by St John the Baptist and St Nicholas of Bari. The language of forms is still directly derived from Perugino, and Raphael's compositional sketch recalls the former's *Decemviri Altarpiece* (**24**, discussed in more detail below).[21] More clearly than in any of the works discussed so far, one notices an energetic revision of Peruginesque principles. First, the composition is conceived in narrative terms with an introduction, a main motif and a conclusion: St John's gesture leads the eye of the beholder towards the main 'event' – the self-contained mother-and-child group, here represented reading a devotional text. This motif is taken up and paraphrased by the figure of St Nicholas on the right. Secondly, Raphael changes the conventional symmetri-

31

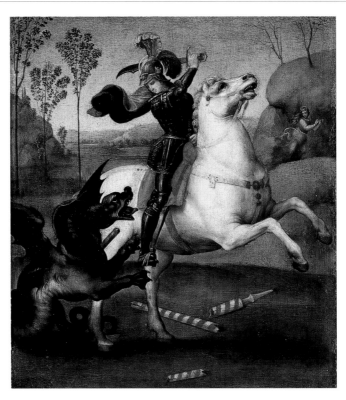

16 Raphael, *St George*. Oil on panel. Musée du Louvre, Paris.

cal arrangement into a calculated asymmetrical one: while John, almost in walking posture, is placed in the foreground, the corresponding figure of Nicholas is positioned slightly further back. In this way, the two figures given in the round define the dimensions of the building and assist the observer to experience the throne as a three-dimensional object. Such features show Raphael's interest in modelling space and volume – something almost completely absent in Perugino's art. As yet some of the spatial relationships are awkwardly handled: Mary, for instance, seems to be seated in front of the throne rather than upon it, and the throne itself looks impossible to mount. On the whole, however, the sensitive, Peruginesque *Ansidei Madonna* has been enriched by important new elements. There is some indication that Raphael began work on the altarpiece before leaving for Florence, and that he completed it during an unrecorded stay at Perugia some time in 1505.

Looking again at the altarpieces for Umbrian clients produced or at least begun at this time, their evident conservatism is due to a heavy reliance on Perugino's manner of figure painting. Responsibility for the long survival of Peruginesque characteristics in Raphael's paintings has recently been attributed partly to the conservative taste of his clients.[22] As yet this argument fails to convince, since we know very little about these Umbrian patrons. Only the Oddi and Baglioni can be said to have played a substantial role, but it is doubtful whether even they can be regarded as serious patrons. We have yet to discover what they thought of Raphael's work, whether they were conscious of his artistic innovations, or whether they admired him only for his skilfully handled 'Peruginism'. Some scholars take the opposite line, arguing that

32

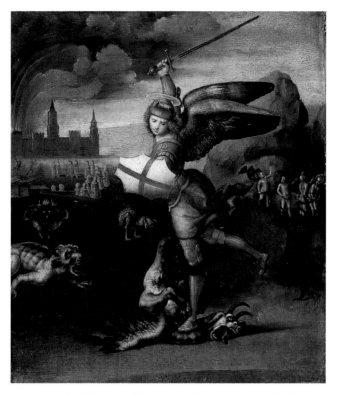

17 Raphael, *St Michael*. Oil on panel. Musée du Louvre, Paris.

Raphael was confident enough at this stage to decide on his own style, and that his creations served to raise the status of his clients.

It is clear that Raphael was already picking up inspirations from other directions (for instance, from Florentine art), but that he did not yet question the essentials of Perugino's style. We can trace his aesthetic development clearly through his series of altarpieces. If we compare the securely dated *S. Nicola da Tolentino Altarpiece* of 1501 (**5–9**) with the London *Crucifixion* of 1503 (**10**), we notice both a growing facility in the handling of Peruginesque elements and the first inklings of greater aspirations. In *The Betrothal* of 1504 (**13**), there are suggestions that Raphael is moving beyond the principles he learnt from Perugino, although he does not yet abandon the master's formal vocabulary; the *Ansidei Madonna* illustrates a further step in this direction. These works document years of intense involvement with Perugino, and Raphael's deep understanding of his art and realization of its limitations.

Compared with these works, *The Trinity* (**15**) strikes a completely new note, one that seems to owe next to nothing to Perugino. It can only have been conceived after Raphael's first few months in Florence, a period of new and clearly overwhelming personal impressions. The fresco, dated without any doubt to 1505, shows on the left the saints Maurus, Placidus and Benedict, in the centre Christ enthroned with angels, and on the right the saints Romuald, Benedict the Martyr and John the Martyr. The upper part is decorated with the Dove of the Holy Spirit and the Heavenly Father, the latter image heavily damaged. The lower register, by Perugino, was not completed until 1521, with depictions of saints associated with the earthly

realm. The new artistic development is the result of Raphael's first direct confrontation with the art of Fra Bartolommeo (1472–1517). He took for his model Bartolommeo's *Last Judgement* (**26**), painted in 1501 in collaboration with Mariotto Albertinelli (1474–1515) for a chapel in the Hospital of S. Maria Nuova (see below, page 55). Raphael's *Trinity* closely follows the characteristic features of that fresco, both in the composition of the heavenly realm and the modelling of the figures in the round. His reaction to this new inspiration is as yet superficial – something of an 'irritation' aroused by a first intense contact with the art scene in Florence. The monumentally conceived figures, although impressive as a whole, are neither sufficiently solid nor convincing, the scale of the heads is not proportionate, and the individual figures do not come together as groups. Side by side with such 'modern' features as the seated saints and the figure of Christ, derived from Bartolommeo, are quintessential Peruginesque elements such as the angels that flank the Saviour. Raphael's appropriations remain skin-deep and decorative, and this defines *The Trinity* as the product of a transitional period; it has little in common with the works he later produced during his first years in Rome with which it has sometimes been connected.[23]

Of the two inscriptions below the fresco, the one on the left identifies Raphael as the author and includes the date 1505: RAPHAEL DE URBINO.DOMINO.OCTAVI/ANO.STEPHANI.VOLATE (…) ANO.PRIO/RE.SANCTAM TRINITATEM.ANGE/LOS.ASTANTES/SANCTOSQ (…) /PINXIT/A.D. (…) D.V. The inscription, mentioned by Vasari, was later restored, but nobody today doubts its authenticity. It has been suggested that the painting was commissioned by Ottaviano di Stefano da Volterra, prior of the small Camaldolese monastery of S. Severo in Perugia; the founder of this independent Benedictine order, Romualdo of Camaldoli in Tuscany, is depicted by Raphael in the heavenly sphere. We must assume that this was a minor commission, although it indicates Raphael's growing reputation in Perugia. Recently, a connection has been suggested between the commission and the learned and influential prelate Gabriello Gabrielli, who in 1505 became head of the much larger abbey of S. Salvatore di Monte Acuto which ruled S. Severo, but any proof is lacking.[24]

During his time in Perugia, Raphael presumably visited Urbino repeatedly, as he did later during his years in Florence, and kept in touch with the court. Increasing political stability in Urbino meant that the court there may have provided some support during his move to Rome in 1508. There are reasons to assume that in about 1504 he painted two small panels of St George and St Michael for Guidobaldo da Montefeltro, perhaps on commission (**16, 17**; in the collection of Cardinal Mazarin by 1661; now in the Louvre, Paris). Their history suggests that they were always regarded as a pair. Guidobaldo Montefeltro and his adopted heir Francesco Maria della Rovere have been put forward as both clients and recipients, with the order probably dating from 1504. Francesco had been made a member of the Order of St Michael by the French king Louis XII in 1503; the following year, on 12 May, he was officially adopted as the Montefeltro heir. Just nine days later on 21 May, in a brilliant ceremony in Rome, Guidobaldo was invested with the Order of the Garter conferred by the English king Henry VII, whose patron saint was St George; at the same time he was accorded the title of *capitano della chiesa*. Soon afterwards, Guidobaldo and Francesco returned to Urbino where the adoption ceremony was performed a second time. The argument that the pictures were produced for these occasions makes much sense, but final proof is missing. It is slightly puzzling that not even

Vasari seems to have known about them; they were first mentioned in a note by the artist Giovanni Lomazzo (1538–1600) which probably dates from before 1571 when he went blind. Perhaps at the time neither commission nor artist was important enough to deserve a mention; the two paintings may have been given away by Guidobaldo as gifts before they surfaced in Milan in the mid-sixteenth century and were bought by Count Ascanio Sforza of Piacenza.

Raphael's work during this formative period, from 1494 to 1505, allows us to trace his progress from a reliance on the methods and manner of Perugino to his first recognition of the influence of Florence. By the age of 22 he had already received several substantial commissions, first jointly, then in his own name, which, while only from local patrons, confirmed both his rising confidence and his growing reputation. Travel opened up new possibilities – Raphael is also reported as working in Siena with the artist Bernardino Pinturicchio (*circa* 1454–1513) at this time – and no destination was more appealing than Florence.

Florence and the Florentine patrons of the early Cinquecento

The travels Raphael undertook, especially those before 1508, are not documented in any detail, but modern commentators tend to assume a greater number than are mentioned in the primary sources. It seems likely, however, that he had made visits to Florence before moving there in the autumn of 1504. Only after this move did he begin to engage in a serious and continuous dialogue with the art on view in that city. He arrived with a letter of introduction dated 1 October 1504 written by Giovanna della Rovere, Duchessa di Sora and wife of Giovanni della Rovere, prefect of Rome and *signore* of Sinigallia. It was addressed to the ruler of Florence, the *gonfaloniere della giustizia* Pier Soderini (1452–1522), and was a generous introduction for a twenty-one-year-old: 'The bearer of this letter is the painter Raphael from Urbino, whose early work shows him to be well talented and who has decided to spend some time in Florence in order to study. And like his father who was a very virtuous man and was very close to me, so likewise is his son a considerate and charming youth; with due respect he is close to my heart and I pray that he achieves perfection. Therefore I sincerely recommend him to your Honour . . .'[25]

The duchess found these kind words for someone who was presumably close to her as a member of her household, but she does not mention any major accomplishments – rather, she writes very broadly about his artistic *ingegno*. Raphael must have appeared to her not as an artist who was already successful, but rather as someone whose further studies she wanted to encourage. The choice of addressee also suggests that the writer and perhaps the artist were not only thinking of a continuation of studies but were indirectly hoping for some substantial commissions. If that was so, they were disappointed; and we may assume that the letter did not greatly impress Soderini, who had other projects more ambitious than the sponsoring of a young and almost totally unknown painter. This first visit must have been rather short, for Raphael's documented activities in 1505 suggest that he spent some time in Perugia.

The world that Raphael encountered in Florence must have struck him as a great change after his first, successful, experiences in Umbria. In Florence, the rivalry between artists was fiercer than in any other Italian city. Art was a subject discussed with discrimination not only by specialists but also by members of the public, who went to see every new work and gave their verdicts, not always favourable.

The political and social centre of the Florentine community was and still is the Piazza della Signoria, a space that has repeatedly played a part in the history of art. This is where festivals and public meetings were held, and its significance was further emphasized when the republican government built the Grand Council Chamber. The *Portrait of a Man* of about 1505, formerly attributed to Piero di Cosimo (*circa* 1462–1521) and more recently to Francesco Granacci (*circa* 1469–1543), shows in the background the façade of the Palazzo della Signoria and one arcade of the Loggia dei Lanzi (**18**). In front of the Palazzo we recognize the Marzocco, emblem of Florence, and next to its entrance Michelangelo's *David* (**35**), erected under spectacular circumstances the year before Raphael arrived, on 15 May 1504.

The greatest flowering of Medici rule under Lorenzo, *il Magnifico* (1449–92) was already regarded as a bygone golden age, although it had come to an end fewer than twenty years earlier. Lorenzo's court, with its international contacts and grand patronage, had been second to none in Italy. That had been the time of the humanist philosophers Marsilio Ficino and Pico della Mirandola and the artists Filippo Lippi, Botticelli and Verrocchio, although Lorenzo – himself a poet and bibliophile – tended to show his munificence more towards scholars than artists, a factor that may have been instrumental in the decision of the young Leonardo to move to Milan in the early 1480s. The situation in Florence changed greatly after Lorenzo's death, because his successor, Piero, was unable to consolidate his position as first among equals in the state. The main threat to Medici authority was the religious reformer Girolamo Savonarola (1452–98). He became very influential after 1491 as prior of S. Marco, and lent his support to factions in favour of a republican government; in 1494 he succeeded in having Piero exiled and the Medici expelled. While Florence became increasingly isolated – with setbacks in its foreign policy and its opposition to the Borgia Pope Alexander vi – within the city Savonarola created a repressive regime strongly supported by the people (and by artists like Botticelli and Fra Bartolommeo), but which also encountered massive resistance. After Savonarola's capture and execution in 1498 – he was burnt at the stake in the Piazza della Signoria – a republican government was set up modelled on that of Venice. From 1502 it was headed by a patrician elected for life, the *gonfaloniere della giustizia*, Pier Soderini. In cultural matters, Florence under Soderini went through a transitional phase, while domestic affairs were dominated by internal political problems and rivalries. Except for the traditional clientele of churches and monasteries, there was no focus for artistic patronage, although Soderini made efforts to add lustre to republican rule by supporting the arts. His role in the building and decoration of the Grand Council Chamber is discussed below (page 87).[26]

Knowledge about the economic and social background of Raphael's clients can help to define his position as an artist, and to explain why during this period he mainly produced – or, rather, was restricted to producing – relatively small devotional pictures. The subject of his clients is also interesting in connection with the patrons of the other two great masters, Leonardo and Michelangelo. The fact that Florence offered little promise of important com-

missions was probably a primary reason why all three of them decided to leave the city during the second half of the decade.

Among Raphael's Florentine patrons, a special role was played by Taddei Taddeo (1470–1528), to whom Vasari paid tribute, describing his domicile in somewhat courtly style: 'and [Raphael] became much honoured in that city, particularly by Taddeo Taddei, who, being one who always loved any man inclined to excellence, would have him ever in his house and at his table. And Raffaello, who was gentleness itself, in order not to be beaten in courtesy, made him two pictures, which incline to his first manner, derived from Pietro, but also to the other much better manner that he afterwards acquired by study, as will be related; which pictures are still in the house of the heirs of the said Taddeo.'[27]

Taddeo Taddei came from a family whose economic and social fortune was closely tied to that of the Medici, since one of their forebears, Taddeo di Filippo, had established a wool-weaving factory with money supplied by the Medici. His successor, Antonio Taddei, became a partner and confidant of Lorenzo the Magnificent in 1480 and held various public offices. Family policy was directed by his son Francesco Taddei, Taddeo's father; thanks to his great diplomatic skill, the family remained unscathed during the enforced exile of their patrons. Taddeo was entered as a member of the Arte della Lana (the wool-weavers' guild) on 17 November 1472; in 1499 he married Costanza di Andrea Capponi, and practised as a lawyer. He was a friend of Pietro Bembo, and possibly through him was in contact with the court at Urbino and with the Medici who had found refuge there. Raphael's close relations with Taddeo are confirmed by a letter of 21 April 1508 to his uncle Simone Ciarla, in which he announces Taddeo's imminent arrival at Urbino in connection with the solemn funeral of Duke Guidobaldo, who had died on 11 April.[28]

Giovanna della Rovere's letter of introduction must have paved the way for Raphael's acquaintance with Taddeo Taddei, who in turn may have looked upon the young artist as in some way a member of his own household, as *familiare*. Even though it is no longer possible to identify conclusively any of the paintings that, according to Vasari, Raphael produced for Taddeo (one may have been the *Madonna del Prato*, **117**), there are some indications that Taddeo helped Raphael to find more clients. His family had become related to the Nasi when his brother Gherardo Taddei married Ippolita Nasi in 1500; it was Lorenzo Nasi who was to commission the *Madonna del Cardellino* (**126**). At the Taddei mansion in the via de' Ginori, Raphael would have seen Michelangelo's *Taddei Tondo* (**36**), a work of direct inspiration to him. The little documentation we have suggests that Taddeo Taddei was among Raphael's most influential patrons during his years in Florence.

We are on slightly safer ground with Agnolo Doni, who commissioned the well-known marriage portraits (**19, 20**; for *quadri da spose*, see pages 145–6). No records of the transaction have survived, but the two paintings are generally dated to 1506 on grounds of style. As will be shown below, Raphael used Leonardo's *Mona Lisa* (**33**) as a model for the female portrait and composed the two pictures as a complementary set. These paintings, which include elements of Netherlandish and central Italian art, are among the most important contributions to the portraiture of the High Renaissance in Italy.[29]

The merchant Agnolo Doni (1474–1539) was born into a family of dyers, joined the Arte della Lana in 1488 and probably lived on the Corso de' Tintori in the S. Croce district. The

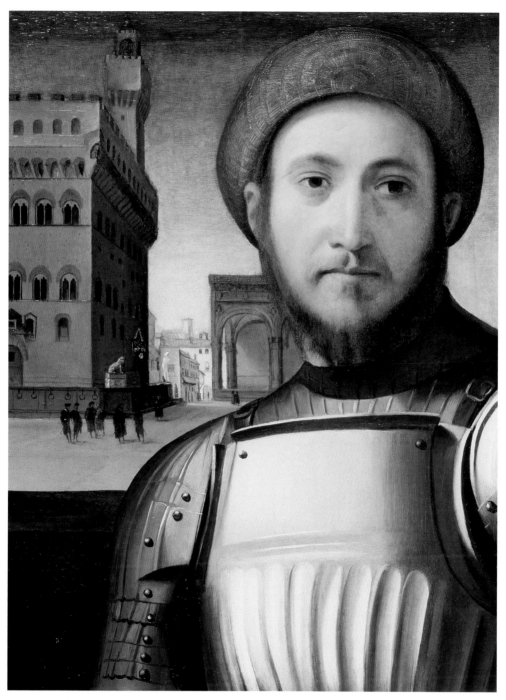

18 Attributed to Francesco Granacci, *Portrait of a Man* (detail). Oil on panel. National Gallery, London.

19 Raphael, *Portrait of Agnolo Doni*. Oil on panel. Palazzo Pitti, Florence.

20 Raphael, *Portrait of Maddalena Strozzi Doni*. Oil on panel. Palazzo Pitti, Florence.

owner of several shops and properties, Agnolo's financial situation was secure; socially, he bettered himself in 1504 by marrying Maddalena di Giovanni Strozzi, a member of a junior branch of the famous Florentine dynasty. Agnolo Doni was a supporter of the republican government and held public office in the S. Giovanni district; even after the return of the Medici he managed to stay in business by investing in property. Member of a group of rich cloth merchants, he distinguished himself as a patron of the arts; during the republican period he commissioned a remarkable number of substantial works from artists including Michelangelo – who produced the *Doni Tondo* (**38**) – Raphael and later Fra Bartolommeo. He was a collector of engraved gems and antiquities, and it was at his house that Vasari saw Donatello's *Amor–Atys* some time before 1568. In general, however, the size and character of his collection remains strangely vague. Vasari seemed quite critical of him as a patron: 'While he [Raphael] was thus staying in Florence, Agnolo Doni – who was very careful of his money in other things, but willing to spend it, although with the greatest possible economy, on works of painting and sculpture, in which he much delighted – caused him to make portraits of himself and of his wife; and these may be seen, painted in his new manner, in the possession of Giovan Battista, his son, in the beautiful and most commodious house that the same Agnolo built on the Corso de' Tintori, near the Canto degli Alberti, in Florence.'[30]

Thus Raphael started to make his name among the cloth merchants and it was this group that gave him his first important commissions. One of them was Lorenzo Nasi who, as we saw, was related to the Taddei family by marriage, a connection that could well have been responsible for Raphael's access to the Nasi. According to recent research, Lorenzo Nasi was entered in 1485 into the Arte dei Mercanti di Calimala (drapers' guild). He took over his father's trade and lived in the via de' Bardi. He married Sandra di Matteo Canigiani some time before 23 February 1506, and it has been suggested that it was this occasion that led to the commissioning of the *Madonna del Cardellino* (**126**). Lorenzo was certainly wealthy, but there is no evidence for any further acts of patronage. Vasari wrote of Lorenzo Nasi directly in connection with Taddeo Taddei, mentioned that Raphael's painting was kept at the Nasis' house, and that it was damaged during an earthquake in 1548: 'Raffaello formed a very great friendship with Lorenzo Nasi; and for this Lorenzo, who had taken a wife about that time, he painted a picture in which he made a Madonna, and between her legs her Son, to whom a little S. John, full of joy, is offering a bird, with great delight and pleasure for both of them … This picture was held by Lorenzo Nasi, as long as he lived, in very great veneration, both in memory of Raffaello, who had been so much his friend, and on account of the dignity and excellence of the work; but afterwards, on August 9, in the year 1548, it met an evil fate, when, on account of the collapse of the hill of S. Giorgio, the house of Lorenzo fell down … However, the pieces of the picture being found among the fragments of the ruins, the son of Lorenzo, Batista, who was a great lover of art, had them put together again as well as was possible.'[31]

Vasari also tells us that Domenico Canigiani, related to the Nasi by marriage and living across the street in the via de' Bardi, commissioned from Raphael *The Holy Family (Canigiani)* (**121**). Recently it has been claimed that the execution of this picture was directly connected with the marriage of Domenico to Lucrezia Frescobaldi in 1507, but such an event provides at best only an approximate date. Domenico Canigiani also entered the Arte di Calimala at an early age, and in 1501 was in Spain on behalf of the Signoria; during the repub-

lican period his career stalled, perhaps partly on account of his Medici sympathies. Only after the Medicis' return in 1512 was he given various public assignments, on the strength of his close friendship with the Duke of Urbino and the Cardinals Giulio and Ippolito de' Medici; he remained close to the Medici until his death on 31 August 1548. With no information about any further patronage, we can assume that his commission remained an isolated decision, taken perhaps to mark his betrothal.[32]

Raphael received his first major commission in Florence in connection with the execution of the will of Renieri di Bernardo Dei (1454–1506), who died on 20 September 1506. The Dei family had originally been goldsmiths but were later active in the silk and wool trades, mainly through their branch in Lyons, where Renieri had his permanent residence (he therefore never held public office in Florence). He returned to his native city only at the beginning of the sixteenth century, where he built a large palace, presumed to have been designed by Cronaca, on the Piazza di S. Spirito.[33] His will provided for an altarpiece to decorate the family chapel in the church of S. Spirito. Raphael received the order in 1507 and a letter to his uncle Simone Ciarla indicates that the preparatory cartoon for the *Madonna of the Baldacchino* (**142**) was probably finished in 1508. This work was crucial in winning Raphael increasing acclaim. Earlier commissions had belonged to the rather modest genre of devotional painting, even if some were for quite large works. An order for an altarpiece was not only a mark of success; it showed undoubted confidence in the artist's organizational abilities. Raphael had already achieved this level of acceptance in Umbria, particularly in Perugia, but when he moved to Florence it took him several years to acquire a comparable reputation in that demanding city. His growing circle of clients, however, were Medici sympathizers, so Florence on the whole offered Raphael only limited opportunities and prospects; except for Agnolo Doni – the only one who could be called a patron of the arts – they were not prominent in republican Florence. This would explain why the artist left the *Madonna of the Baldacchino*, his most prestigious commission to date, unfinished. In 1508 he accepted the more promising summons of Pope Julius II to Rome.[34]

II. THE ARTISTIC CONTEXT

Art in Florence around 1500

Around the turn of the century, the arts in Florence went through a transitional phase during which traditional concepts were being challenged by radically new ones. The new modes appeared first in Florence, and reached their full maturity in Rome. They were expressed most clearly in frescoes, beginning with Fra Bartolommeo's *Last Judgement* (**26**) and continuing with murals by Leonardo and Michelangelo for the Grand Council Chamber (**40, 44**). Even though the latter two works never went beyond a preparatory stage, they made an enormous impact on the art of their time. The altarpiece, too, received fresh impulses. Traditionally, altarpieces were among the more substantial commissions: orders usually came from the heads of important families who wanted to build family chapels, and from the heads of churches and monasteries. Most altarpieces were 'public' works of art, and we can gather from surviving examples and contemporary records that Florentines followed the new developments with the greatest interest. Devotional pictures, on the other hand, belonged primarily to the private sphere, and were usually easel paintings of varying sizes. They served both devotional and decorative needs, and by the early sixteenth century had come to be regarded as works of art in their own right. By moving to Florence Raphael was able to confront this artistic revolution directly, and he took an increasingly active part in it, even if, despite continuing support from Urbino, commissions for the most highly regarded type of mural, the *historia* (any figurative painting that told a story), never came his way. It was popular demand for devotional pictures that caused Raphael to dedicate himself at first to this genre.[35]

Many altarpieces of the time continued to employ well-established compositional schemes. A type that was still widely popular was Filippino Lippi's *Nerli Altarpiece* (**21**; the complete retable and frame are still in their original positions in the former Cappella Nerli in the church of S. Spirito). Paintings of almost identical dimensions are typical of the Quattrocento decoration of S. Spirito. Tradition has it that the altarpiece, most likely painted

21 Filippino Lippi, *Nerli Altarpiece.* Oil on panel. S. Spirito, Florence.

22 Raffaellino del Garbo, *Madonna and Child with Saints*. Oil on panel. S. Spirito, Florence.

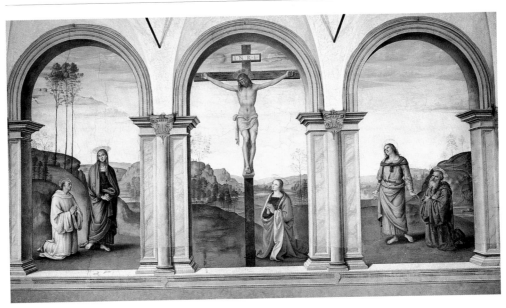

23 Pietro Perugino, *The Pazzi Crucifixion.* Fresco. S. Maria Maddalena dei Pazzi, Florence.

circa 1488, was produced for Tanai de' Nerli, a rich Florentine merchant who was occasionally employed by the government. One of Filippino's best-known works, it illustrates his style before he went to Rome. The Madonna is shown seated on a marble throne with the Christ Child on her lap, turning towards the infant St John. The latter kneels as if in adoration and presents the Child with a cross-staff, a symbol of the future Passion. On either side, St Martin and St Catherine of Alexandria commend the donors Tanai de' Nerli and his wife Nanna Capponi. The lively rhythmic disposition of the figures is developed in front of an arcade of segmental arches affording a view of a cityscape reminiscent of Florence. The background architecture on the right may show a Florentine city gate with the Palazzo Nerli in front of it. At the entrance of the palace the donor is seen once again, this time receiving members of the family or parting from them. The very carefully arranged composition and triangular structure of the image of the Virgin may reflect early inspiration from Leonardo, while the portraits of the donors and the topographical view show influences of Netherlandish art.[36]

Of particular interest is the way the two infants are linked. Lippi was using a motif that is found in many paintings of the period, especially devotional pictures; it was something of a Florentine speciality, since St John the Baptist is the city's patron saint. In the early fourteenth century, the Dominican Domenico Cavalca's *Vite de SS Padri* enriched the story of John the Baptist's early years with numerous narrative elements, creating the type of a young hermit which was directly adopted in the visual arts.[37] During the later fifteenth century, depictions of John and Christ as infants reached their greatest elaboration. The intimate relationship between the two children alludes both to the sacrament of baptism and to Christ's Passion. Filippino expresses the central idea with exemplary clarity: the young hermit, clad in an animal hide and with a baptismal chalice, refers to Christ's future baptism; the holy Infant, almost playfully taking the offered cross-staff, indicates his acceptance of the Passion. Some of the paintings discussed later provide further variations on this central motif.

24 Pietro Perugino, *Decemviri Altarpiece*. Oil on panel. Pinacoteca Vaticana, Rome.

Filippino Lippi based his altar painting on a conventional pattern, but added topical interest by incorporating the fruits of his intense dialogue with current artistic developments. The result is a remarkable production, perfectly attuned to contemporary expectations. A completely different tenor characterizes the retable by Raffaellino del Garbo (*circa* 1466–1524) dated 1505, the *Madonna and Child with Saints* (**22**; the altarpiece, designed to stand in a tabernacle or niche, remains undamaged and in its original location in the former Cappella Segni dedicated to St Laurentius, also in the church of S. Spirito, Florence). The painting was presumably commissioned by the Segni and Benci families, who were probably related, since the latter's crest appears both on the frame and the altar front (*paliotto*). The artist has arranged the four saints in a semi-circle on two levels, grouped around the central figures of the Virgin and Child set off by the curtain motif, and has also provided a view into the landscape. It is a work very much in the tradition of Filippino's *Nerli Altarpiece*, with a simpler overall composition and an arrangement of the figures that appears severe and somewhat stylized. That Raffaellino followed the formal language and compositional scheme of his master Filippino Lippi is less remarkable than the fact that such a style, in an era of rapidly changing artistic fashions, was still deemed acceptable at the same church after some twenty years; by this time, it was definitely conservative, even backward-looking. A number of large altarpieces by Raffaellino dating from the early years of the sixteenth century are recorded, and they seem to indicate that many clients still favoured such conventional productions.

In this connection, Perugino also deserves attention. Art historians have praised very highly his fresco of the *Crucifixion* at S. Maria Maddalena dei Pazzi, the former Cistercian monastery of Cestello in Florence (**23**). The artist has translated the triptych format into a fresco, providing a tripartite *trompe l'œil* arcade which extends the view into a wide stretch of hilly landscape. The Cross, and the praying Mary Magdalene and saints on either side, are harmoniously placed within the three arches. Only rarely did Perugino so successfully combine the quiet devotion of the main figures with the typical mood and topography of the Umbrian countryside. The sensitive interplay between figure and landscape had not been a particular feature of Florentine art, but may well have caught the imagination of artists following the period of deep, pious introspection in the city under Savonarola in the 1490s.

We have already noted that Perugino's *Decemviri Altarpiece* (**24**) was something of a model for Raphael's *Ansidei Madonna* (**14**). The altarpiece dates from the mid-1490s and was produced for the chapel of the Priors' Palace in Perugia. It is a well-known composition, partly because there are several versions, and interesting in the present context as a typical example of Perugino's manner at the height of his career. The Madonna is seated on a stepped throne within an airy architectural setting, and flanked by the four patron saints of the city of Perugia and of the Priors' Palace. The delicately detailed architectural elements balance the solid, slightly severe figure composition. The arrangement of this *sacra conversazione* captures the quintessence of Perugino's mature style. Although it was produced in and for Perugia, it is certain that its compositional pattern was known and taken up in Florence.

In the face of the new artistic developments at the very beginning of the sixteenth century, however, Perugino's fame in Florence seems quickly to have waned. In his biography, Vasari recounts an event perfectly illustrating the new situation: 'Now Pietro had done so much work, and he always had so many works in hand, that he would very often use the same sub-

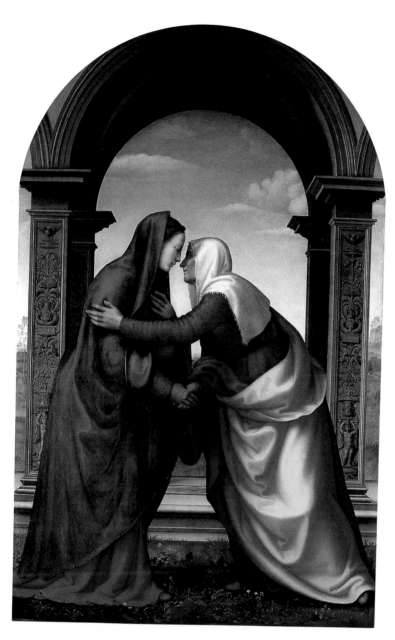

25 Mariotto Albertinelli, *The Visitation*, with predella panels.
Oil on panel. Galleria degli Uffizi, Florence.

jects; and he had reduced the theory of his art to a manner so fixed, that he made all his figures with the same expression. By that time Michelagnolo Buonarroti had already come to the front, and Pietro greatly desired to see his figures, by reason of the praise bestowed on him by craftsmen; and seeing the greatness of his own name, which he had acquired in every place through so grand a beginning, being obscured, he was ever seeking to wound his fellow-workers with biting words. For this reason, besides certain insults aimed at him by the craftsmen, he had only himself to blame when Michelagnolo told him in public that he was a clumsy fool at his art. But Pietro being unable to swallow such an affront, they both appeared before the Tribunal of Eight, where Pietro came off with little honour.'[38] Vasari picked up many such anecdotes, sometimes slighting, and used them to set off the brilliant innovator Michelangelo against the traditionalist Perugino. Still, there is probably some truth in the story, which reflects Perugino's waning star. There are other indications of changing fashion – for instance, Antonio Billi's early criticism of Perugino's *Assumption* in SS Annunziata – which was possibly why Perugino received fewer commissions in Florence, and slowly began to withdraw from the city.[39] If this was the mood in 1504, it seems exceedingly doubtful that Raphael's close cooperation with Perugino would have been any recommendation in Florence. Once he moved to the city, however, and plunged into the current art scene, Raphael was probably quick to grasp this fundamental change of direction.

This shift is illustrated particularly well by Mariotto Albertinelli's *Visitation* of 1503 (**25**). Albertinelli had been a colleague of Fra Bartolommeo in the workshop of Cosimo Rosselli (1439–1507), and the two artists subsequently worked closely together. Their first major joint production was *The Last Judgement* (**26**), completed in 1501. Fra Bartolommeo, generally regarded as the more forceful and artistically consistent of the two, developed a formal language based on solid volume, thereby taking the decisive step towards the High Renaissance style. The design of Mariotto's *Visitation* has usually been assigned to Fra Bartolommeo: although the latter gave up painting for a time after joining the Dominican order at the beginning of the century, he had apparently already produced preparatory studies. The architecture of *The Visitation* recalls features from Perugino's *Decemviri Altarpiece* (**24**), and scholars have repeatedly observed how Fra Bartolommeo and Albertinelli used Perugino as a model. But this architecture is treated in a completely new manner: the pillars, with sculptural decoration, are more massive and form tightly linked pairs, while the arch – to be read as part of a longer arcade – performs such a wide curve as almost to repeat the picture frame. The main function of the arch, however, is to bracket and accentuate the two protagonists, whose own modelling has an architectural quality. The robed figures of Mary and Elizabeth help to define the space: they echo the motif of the arch and are intimately linked by just a few expressive gestures. The carefully constructed picture planes not only create a convincing sense of volume for the corporealism of the figures, but also mediate between the landscape elements, linking the meadow in the foreground with the distant views on either side. The strong play of light and the sombre, rich colours round off the overall impression of unity and harmony. The revolutionary coloration (visible again after recent restoration) was probably a strong influence on Michelangelo and others. Comparing it with Perugino's *Decemviri Altarpiece*, produced only some ten years earlier, the wholly new pictorial language of Albertinelli becomes immediately apparent.

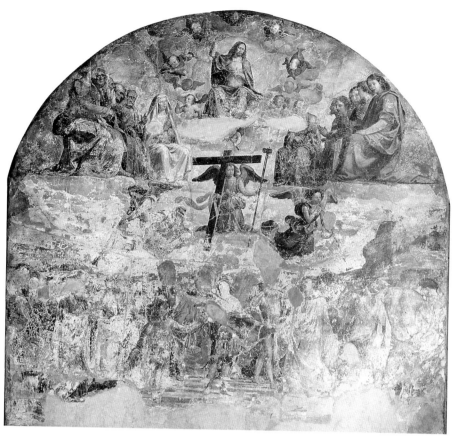

26 Fra Bartolommeo, *The Last Judgement*. Fresco. Museo di San Marco, Florence.

It is even more visible in *The Last Judgement* fresco, heavily damaged though it is, which was produced for the Chiostro delle Osse (the charnel house) of the hospital of S. Maria Nuova (**26**). Vasari's notes, as well as the surviving drawings, document that Fra Bartolommeo prepared the whole composition but executed only part of it. It is generally agreed that he painted the better-preserved upper section, but it seems impossible to define precisely the extent of his contribution. The iconographic and formal innovations, even if they can barely be made out in the lower part, are indeed impressive. The artist has completely dispensed with the figures from Hell traditionally associated with the subject – those fantastical creatures mauling the damned with relish – and has instead concentrated on the clear disposition of the standing and moving figures. They define the pictorial space in the lower part, and it is remarkable that clothed figures are more numerous than nudes. This may be due to Fra Bartolommeo's sympathy for Savonarola's brand of piety: Vasari wrote that under the influence of the latter's preaching he burned all his nude sketches. This feature is in marked contrast to the series of frescoes painted during the same period by Luca Signorelli for the Cappella di S. Brizio in the cathedral at Orvieto, in which particular care has been bestowed on the nudes in the approved manner of the time.[40] Fra Bartolommeo was more interested in the depiction of expressive, clothed figures like those that dominate the upper section of *The*

55

27 Luca Signorelli, *Madonna and Child*. Oil on panel. Galleria degli Uffizi, Florence.

Last Judgement. The saints, modelled in the round and seated on cloud-banks in a semi-circle, are successful both in defining the pictorial space and in establishing a link between the events of the Resurrection and the figure of Christ sitting in judgement. Fra Bartolommeo still based his composition on a traditional, multi-tiered scheme, but at the same time enriched it by adding a most persuasive sense of depth. This feature must have made a very strong impression on the young Raphael, and presumably on other painters as well: we can see immediate reflections of it in his fresco for S. Severo (**15**), and later echoes in the more mature *Disputà* in the Vatican. The monumentally conceived clothed figures of Fra Bartolommeo and Albertinelli reappear more than once in Raphael's early Florentine works, such as the *Madonna del Granduca* (**98**) and the figures of saints in the *Colonna Altarpiece* (**136**). Vasari was apparently not just repeating some vague rumour when he mentioned the special relationship between Raphael and Fra Bartolommeo: 'While he was living in Florence, Raffaello, besides other friendships, became very intimate with Fra Bartolommeo di San Marco, being much pleased with his colouring, and taking no little pains to imitate it: and in return he taught that good father the principles of perspective, to which up to that time the monk had not given any attention.'[41]

These few examples of altarpieces and frescoes must suffice to give a first impression of the state of public art projects in Florence at the turn of the century. On the one hand, traditional types of composition were still being produced and found favour with a broad spectrum of clients. On the other hand, new approaches began to emerge aiming for a pictorial language that was monumental and, at the same time, able to convey deeper shades of religious meaning. In painting, Fra Bartolommeo was the most important local innovator in Florence, and his achievements must be put in relation to those of Leonardo and Michelangelo.

Devotional paintings constituted a genre that played an outstanding role in Raphael's development while in Florence. One important type within the genre was the tondo, a type of figurative art with a long tradition going back to antiquity. Tondi featuring the Madonna were first developed in sculpture; they were treated as decorative architectural features, especially on Florentine sarcophagi for which the most distinguished sculptors were engaged to produce and elaborate on the motif. In painting, the fashion for Madonna tondi began only in the 1470s, initiated probably by Botticelli. During the following decades, the most important Florentine painters produced tondi and developed a multitude of compositional solutions.[42]

Two tondi from this time are of particular interest. The first was executed by Luca Signorelli (1445/50–1523), born in Cortona and active at various places in central Italy, who was in close touch with Florence and the Florentine court. His well-known *Madonna and Child* (**27**; now in the Uffizi, with a provenance going back to the Medici villa at Cestello) was, according to Vasari, produced for Lorenzo the Magnificent, although no further proof is available.[43] The painting is exceptional in that the tondo itself seems almost a quotation within the overall picture, which has a traditional vertical format with painterly and sculptural *trompe l'œil* elements added. The tondo section shows Mary seated on the ground in the pose known as *umiltà* (humility, the opposite of the image of the Madonna enthroned), gently assisting the Child who is attempting his first steps. Both are placed on a meadow of allegorical plants, while in the background young men in loincloths (*ignudi*) who stand amid

ancient ruins represent the pagan age which ended at the birth of Christ. At the time, this combination of the Virgin and Child with classical *ignudi* was a new and daring idea. The decorative programme also includes a *trompe l'œil* sculptural frame into which are set, again within roundels, two prophets and a bust of John the Baptist as references to the birth of Christ. The painting thus presents the *ante legem* world of paganism (*ignudi* and ruins), the *sub lege* world of the Old Testament (prophets and John the Baptist), and the *sub gratia* world which begins with the birth of Christ. The plants on the meadow in the foreground allude to the *hortus conclusus*, itself a symbol of virginity (*Song of Songs*, 4:12), and symbolize both the Passion of Christ the Redeemer and the Virgin's *umiltà*. For a devotional picture, such a complex programme is rather exceptional; it may have been meant to fulfil a special function, or have been produced for a specific customer such as Lorenzo de' Medici. Signorelli arranges the figures very skilfully within the circular central field. The mother-and-child group, together with a seated figure in the background, follow the left-hand outline of the roundel, while on the right the view leads deeper into the background where the figure of a standing youth again echoes the curvature of the frame. These classical youths also appear in other paintings by Signorelli, and were an inspiration for the *ignudi* Michelangelo included in the *Doni Tondo* (**38**).

A second important tondo is by Piero di Cosimo (1461/2–1521), whose oeuvre includes numerous paintings in this format. His *Madonna and Child with the Infant John the Baptist* from the late fifteenth century is a compact composition, which arranges its main theme in strict triangular order (**28**). We have already mentioned the popularity in Florence of depictions of the infant St John as a hermit (see page 50). Piero di Cosimo's painting presents this motif, which appears several times in Raphael's own Florentine works, in exemplary fashion. The image of the two children tenderly embracing is related directly to the future Passion by the cross-staff on the parapet. The compact figure composition is set off against a landscape in the Northern style in which St Jerome and St Dominic provide incipient narrative elements; Jerome is shown with his lion, while Dominic by his gestures links himself to the group in the foreground. Piero also distinguishes clearly the types of landscape associated with the two saints, the wilderness surrounding Jerome contrasting markedly with Dominic's more refined setting, in which a Cistercian monastery rises above antique ruins. As with Signorelli, Piero di Cosimo's tondo is a work typical of the art of the late Quattrocento, which eloquently testifies to the skill with which Florentine artists handled this particular format. Only a few years later, Michelangelo was to provide completely new accents.

28 Piero di Cosimo, *Madonna and Child with the Infant John the Baptist.* Oil on panel.
Musée des Beaux-Arts, Strasbourg.

Leonardo in Florence 1499–1506

Significant among works Raphael studied in Florence are those executed by the two great innovators, Leonardo and Michelangelo, during the first few years of the new century. What follows is a summary only, a brief discussion of the works themselves and their particular significance. The whole subject, of almost infinite complexity, has produced a deluge of scholarly publications, which still have not cleared away all contradictions and uncertainties.

After working for a time in Florence, Leonardo left for the Milan court in about 1482, at the age of 30. When Ludovico Sforza, *il Moro*, was overthrown in 1499 and Milan occupied by the French king Louis xii, he returned to Florence by way of Mantua and Venice, arriving sometime in 1500. Here he painted the *Madonna with the Yarnwinder* (**29**) for Louis xii's secretary Florimond Robertet and, presumably during a stay with the Servite Brethren, designed the first cartoon for the painting *St Anne with the Madonna and Child* (**32**). During 1502 he spent about a year with Cesare Borgia on his campaign in Emilia-Romagna as leading architect and engineer. By March 1503 he was back in Florence and in April received the commission for *The Battle of Anghiari*, one of two monumental wall-paintings intended to decorate the new council chamber attached to the Palazzo Vecchio. The driving force behind this commission was the *gonfaloniere* Pier Soderini, and part of the commission famously went to Michelangelo (see pages 87, 93). On 18 October, Leonardo rejoined the Florentine Compagnia dei Pittori (painters' guild) and on the 24th of the same month was given the keys to the Sala del Papa in S. Maria Novella to start work on the cartoon for *The Battle of Anghiari*, for which he received several payments during 1504. On 25 January 1504 he was one of the members of the commission which had to decide on the best position for Michelangelo's sculpture, the *David*. In 1505 he paid a visit to Rome, and in May 1506 was granted three months' leave; he went to Milan in June, but did not return to Florence until September of the following year. The resulting dispute between Maréchal d'Amboise, the French governor of

Milan, and Pier Soderini over Leonardo's unduly long absence from Florence was finally settled when Soderini yielded, implicitly abandoning all hope of seeing *The Battle of Anghiari* completed. In 1508 Leonardo returned to Florence for a short while, and then turned his back on the city for good. The crucial periods of Leonardo's various documented projects in Florence are his two prolonged spells in the city, which were only briefly interrupted: from mid-1500 to the summer of 1502, and from March 1503 to May 1506 – respectively, his first and second Florentine periods. Even this brief summary of Leonardo's activities shows that the artist, almost 50 years old in 1500, enjoyed an extraordinary reputation and was in contact with the outstanding personalities of his time. Soderini clearly considered him the right person to add artistic lustre to the new republic by decorating the Grand Council Chamber. During this period, however, the artist was receiving urgent requests from various quarters which made it difficult to pursue his commissions with due diligence. Nevertheless, his designs for paintings, most of which were never finished, made a lasting impression on the artistic life of the whole epoch.[44]

As a documented work from about 1501, the *Madonna with the Yarnwinder* is of major importance (**29**). The painting, which survives in several versions, was commissioned by Florimond Robertet, who held various important offices under three French kings (Charles VIII, Louis XII and Francis I) up to his death in 1527 and who was a patron with an international outlook. He acquired, for example, the bronze *David* Michelangelo had made for Pierre de Rohan.[45] It is important to note the characteristic indifference of Renaissance artists to the political leanings of their patrons. Despite his longstanding relationship with the Sforza, Leonardo was ready immediately after their fall to accept orders from their French enemies, and soon afterwards even to commit himself completely to their service.

Remarks by a contemporary, Fra Pietro da Novellara, about Leonardo's *Madonna with the Yarnwinder* are of the greatest interest. In a letter of 14 April 1501 he mentions that Leonardo is working on the painting for Robertet, and gives quite a detailed description: 'The little picture which he is doing is of a Madonna seated as if she were about to spin yarn. The Child has placed his foot on the basket of yarns and has grasped the yarnwinder and gazes attentively at the four spokes that are in the form of a cross. As if desirous of the cross he smiles and holds it firm, and is unwilling to yield it to his mother who seems to want to take it away from him.'[46] This letter helps to date the painting, and also tells us something about the way contemporary observers looked at a work of this type. It shows that Pietro da Novellara is primarily interested in its narrative aspects, in the way the various motifs can be easily read together, and in the fact that the picture expresses the mother-and-child relationship as vividly as the readiness of the Child to be sacrificed.

For a long time it was thought that the original *Madonna with the Yarnwinder* was lost and that, of the surviving versions, the two outstanding ones were early copies. Recent research, however, has determined their superior quality and suggests Leonardo's direct involvement in their execution. In the version in the collection of the Duke of Buccleuch (**29**), the landscape is a later overpainting, but the mother-and-child group is of such impressive quality that Leonardo's participation seems likely. This does not necessarily mean, however, that it is *the* original painting, the one that was produced for Robertet. It may well be that Leonardo himself painted one or more versions, with assistants doing part of the work. To speculate

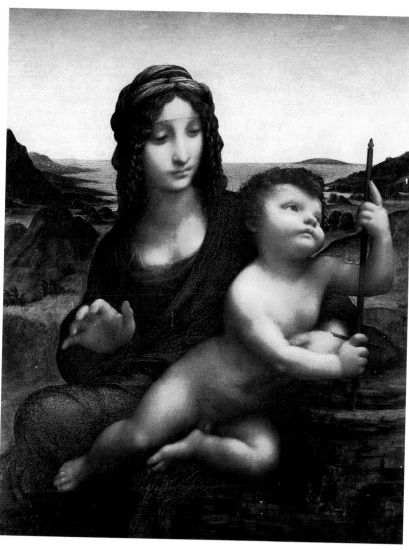

29 Leonardo da Vinci, *Madonna with the Yarnwinder*. Oil on panel.
Collection of the Duke of Buccleuch.

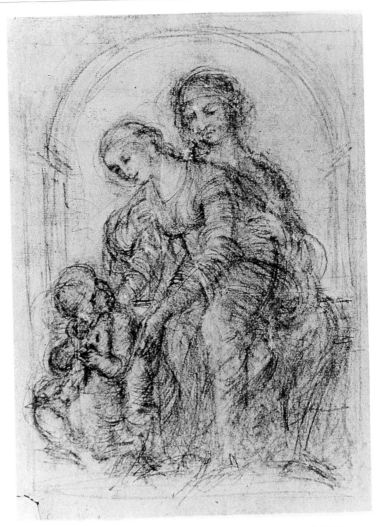

30 After [?] Leonardo da Vinci, *St Anne with the Madonna and Child.*
Black chalk over leadpoint. Private collection.

further, we would need to know more than we do about the details of Leonardo's working methods, a problem that particularly affects the evaluation of his late works. He seems to have usually supplied a completed cartoon, and then relied heavily on his assistants for the actual execution, but nevertheless intervened constantly while work was in progress. In a letter of 3 April 1501, Pietro da Novellara made some pertinent remarks, for example: 'apart from this he has produced nothing, except when his two pupils make copies [*retrati*] and he himself takes up the brush intermittently. He spends all his energies on geometry, and painting makes him impatient [*Impaciēti simo al panello*].'[47] Furthermore, Leonardo's interest in scientific studies and outside claims on him as mathematician and engineer occupied him more insistently than painting did. His organization of his work was quite customary for the time; we have only to think how Giovanni Bellini and Raphael in his later years made use of assistants in their workshops. When a painting was successful, it was fairly common to produce several

versions, and sometimes presumably the master himself took part in this work, although his precise contribution would be hard to pinpoint.

We do not know whether Pietro da Novellara was describing a nearly finished painting of the *Madonna with the Yarnwinder* or only a preparatory cartoon; the basket of yarns he mentions does not appear in any of the surviving versions. It is also unclear whether Robertet ever received the painting he commissioned; it does not appear in the inventory of his estate made in 1532. If the picture Pietro da Novellara saw was ever completed, we are still in the dark about when this happened. However, we do know that the composition must have been accessible to other artists quite early, soon after Novellara's note of 1501, because both Michelangelo and Raphael reacted to it. Furthermore, a large number of early copies have come down to us, which testify to the popularity of the composition.

Having decided on a diagonal placement of the figures, Leonardo came up with an unusual and dynamic arrangement to show the Child completely absorbed, physically and spiritually, with the yarnwinder. This object can be understood partly as a reference to Mary's housewifely chores as well as being a symbol of the Cross and thus of Christ's later martyrdom. With her left arm, Mary embraces the Child and opens her right hand as if in sudden fright; here, too, Pietro da Novellara's interpretation – that Mary's gesture and her prophetic and apprehensive expression refer to her child's eventual fate – is convincing. Although it was common practice to include some symbol of Christ's Passion into such scenes – for instance, a goldfinch (see **126**) – Leonardo's symbolic use of a yarnwinder is unprecedented. With its psychologically charged narrative and formal resolution, the painting was a sensational pictorial invention which strongly affected Florentine artists.

Together with the *Madonna with the Yarnwinder*, the group of Leonardo's works dealing with the subject of St Anne with the Madonna and Child played a crucial role in Raphael's studies in Florence. This is not surprising given the reaction Leonardo's work provoked among the Florentine public at large. In his *Vita* of Leonardo, Vasari wrote about a cartoon for a *St Anne with the Madonna and Child* executed while Leonardo was staying with the Servite Brethren: 'and the friars, to the end that Leonardo might paint it [the altarpiece], took him into their house, meeting the expenses both of himself and all of his household; and thus he kept them in expectation for a long time, but never began anything. In the end, he made a cartoon containing a Madonna and a St Anne, with a Christ, which not only caused all the craftsmen to marvel, but, when it was finished, men and women, young and old, continued for two days to flock for a sight of it to the room where it was, as if to a solemn festival, in order to gaze at the marvels of Leonardo, which caused all those people to be amazed; for in the face of that Madonna was seen whatever of the simple and the beautiful can by simplicity and beauty confer grace on a picture of the Mother of Christ, since he wished to show that modesty and that humility which are looked for in an image of the Virgin, supremely content with gladness at seeing the beauty of her Son, whom she was holding with tenderness in her lap, while with the most chastened gaze she was looking down at St John, as a little boy, who was playing with a lamb; not without a smile from St Anne, who, overflowing with joy, was beholding her earthly progeny become divine – ideas truly worthy of the brain and genius of Leonardo. This cartoon, as will be told below, afterwards went to France.'[48]

This passage is interesting for various reasons. First, we learn that Leonardo did not take

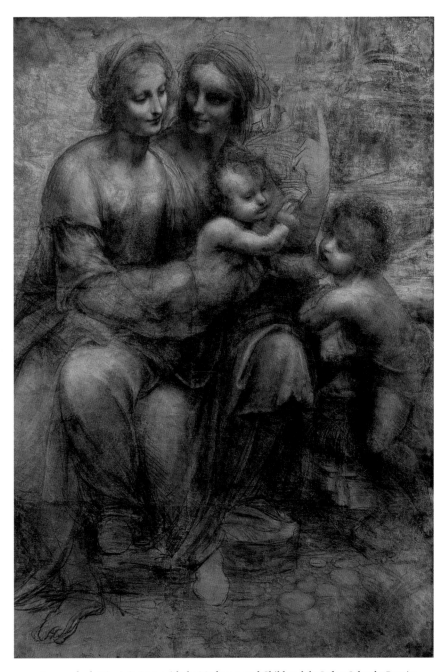

31 Leonardo da Vinci, *St Anne with the Madonna and Child and the Infant John the Baptist.*
Chalk and white lead. National Gallery, London.

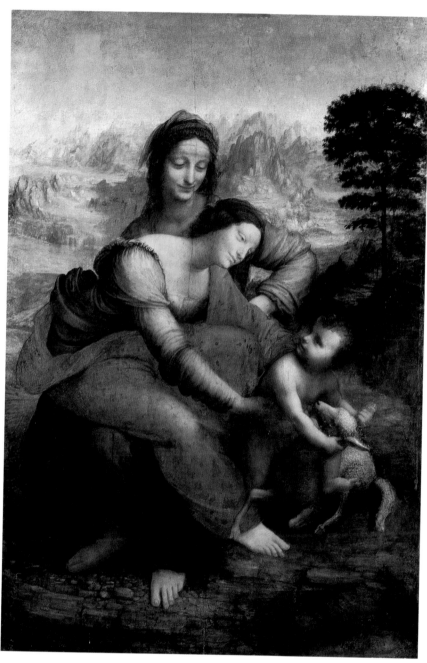

32 Leonardo da Vinci, *St Anne with the Madonna and Child.*
Oil on panel. Musée du Louvre, Paris.

the altarpiece in hand, but instead produced a cartoon with a St Anne. For Vasari, the cartoon and the altarpiece are two separate projects, and he obviously does not connect them. Scholars are sometimes confused on this point, and also wrongly assume a connection between Vasari's description and a cartoon mentioned by Pietro da Novellara. The latter, as we shall see, belongs to a completely different context; more generally, there is the question of whether Vasari's graphic account refers to any of Leonardo's surviving works, since none of the extant versions includes both the Child and a St John who plays with a lamb. It has rightly been pointed out that Vasari never saw any of the works that have come down to us, and that he presumably assembled items of oral and pictorial tradition about various conceptions, and from these elements composed a complete, if apocryphal, picture. He does not, after all, indicate where he saw the cartoon, but mentions only its removal to France. This last point is presumably a reference to the painting now in the Louvre (32), which was recorded at Cloux as early as 1517. Essentially, therefore, the passage is not a description of a specific painting, but Vasari's literary homage to Leonardo's genius. His encomium is occasioned by his mention, at the beginning, of the sensation caused by the cartoon when it was seen by the artists and population of Florence. This statement has always been considered a true and poignant comment on cultural life in Florence at the time; the choice of the best location for Michelangelo's *David* was, as has already been mentioned, a matter of great public interest.

Questions remain about the chronology of the various works associated with the eventual painting, which may have had a prolonged period of evolution. Pietro da Novellara described a cartoon of the subject in Leonardo's workshop in his letter of 3 April 1501 to Isabella d'Este: 'The life Leonardo leads is haphazard and extremely unpredictable, so that he only seems to live from day to day. Since he has come to Florence he has done the drawing of a cartoon. He is portraying a Christ Child of about one year old who is almost slipping out of his Mother's arms to take hold of a lamb (a sacrificial animal) signifying the Passion. St Anne, rising slightly from her sitting position, appears to want to restrain her daughter from separating the Child from the lamb. She is perhaps intended to represent the Church which would not have the Passion of Christ impeded. The figures are shown life-size but are depicted on a small cartoon, since they are seated or bowed and on the left side crane one above the other. And this study has not yet been completed.'[49]

For a long time, the composition to which this passage refers was thought to have been lost, because the two known versions – one in the National Gallery, London (31), the other in the Louvre (32) – do not fit the description. A small drawing recently discovered in a private collection, however, fits very closely – in fact, its composition exactly resembles that of the Leonardo cartoon that Pietro saw (30). The corresponding features are the Child sliding down as he embraces the lamb, Mary rising from Anne's lap to separate the Child and the lamb and, finally, Anne straightening up to restrain Mary. The drawing has the narrative complexity described by Pietro, but at the same time is much simpler in its paratactic composition (each figure occupies a definably separate space) than Leonardo's later versions of the same subject. The note on the back of the drawing, '*Leonardo alla Nunziata*', although of a later date, also establishes a link to the cartoon. Vasari tells us that, after his return to Florence, Leonardo first stayed with the Servite Brethren in the monastery of SS Annunziata, and promised them that he would paint the altarpiece originally commissioned from

Filippino Lippi. If Vasari is correct, this newly discovered drawing would date from this time, or at least from Leonardo's first Florentine period between 1500 and 1502. For our purpose, the main interest of the drawing lies in the fact that Raphael explicitly refers to the composition (115). A painting by Andrea del Brescianino (documented 1506–25), very close in composition, suggests furthermore that it was known to at least some other members of the Florentine art world.[50] This design is one example of Leonardo's characteristic pyramidal composition, which became a leitmotif of Raphael's Florentine period.

The well-known cartoon of *St Anne with the Madonna and Child and the Infant John the Baptist* (31; National Gallery, London) is another design exploring the same subject. While the only partially finished cartoon is unanimously regarded as autograph, scholarly opinion is very much divided about its evolution and date.[51] A date of about 1505 recently put forward by various scholars on good evidence seems most persuasive, particularly because of various echoes of the composition in contemporary works such as Michelangelo's drawing *St Anne with the Madonna and Child* (39; in the Ashmolean Museum, Oxford). The London cartoon is thematically related to the 'lost' cartoon, but corresponds neither to Pietro da Novellara's description nor to 30, the most obvious difference being the substitution of the infant St John for the lamb. Here, Mary is shown seated on Anne's bent right knee, holding the prone figure of the Child out to the approaching St John. The figure of St Anne does not form the apex of the pyramidal composition but, in relation to Mary, has receded slightly into the background. All the more important is the pointing gesture of her right hand, emphasizing the significance of the meeting of the two children. It seems likely that St Anne, with her pointed reference to Christ's Passion, is here too meant to symbolize the Church.[52] The Child himself, held out by his mother to the infant St John, has now become the true focus of the composition, and holds centre stage in a most remarkable way: directly or indirectly, all the figures' gestures and gazes converge on the Child.

A cursory sketch in the British Museum, London, difficult to make out clearly, is certainly a preparatory study for the National Gallery cartoon, while on the verso – which includes the study of a head – Leonardo defines the crucial configuration more precisely (50). The Child, the approaching infant St John and St Anne's poignant gesture are already well articulated, but the pyramidal scheme is largely abandoned in the later cartoon. Seen within a wider framework, the cartoon appears to represent an independent conception. The substitution of the infant St John for the lamb, a symbol of the Passion, carries wider implications. The meeting of the two holy infants in a wild, mountainous landscape presumably echoes imagery from the *Vite de SS Padri* by Domenico Cavalca, a major influence on Florentine painting of the time (see above, page 50). The gesture of the Child blessing the young hermit, the patron saint of Florence, emphatically invests St John with a significance of his own. Finally, the increasing structural links between the figures suggest their narrative companionship more strongly than the relatively loose, paratactic relationship of the 'lost' cartoon. The London image, however, represents a strangely imbalanced evolutionary stage, in that the spatial relationship between the two female figures remains unresolved. This problem has been repeatedly noted, and it is significant that the cartoon shows no traces of transfer, although later copies and variants do exist.[53] It seems best to regard it as an alternative conception, based on the first St Anne composition but with a major change in narrative content.

This would give it an independent standing, even while its formal aspects are closely related to the other designs. It also provides a valuable insight into Leonardo's explorations of painterly values during the middle of the decade: by means of *chiaroscuro* (working only with light and shade, and not with colour) and a delicately nuanced *sfumato* (a softening of outlines and a shading of tonal values so that they fade into one another), the figures are placed in a dynamic relationship; equal weight is given to the 'acting' bodies and the emotions of the protagonists. It seems something of a paradox that our best indication of Leonardo's painterly intentions at this time should derive from an unfinished cartoon.

St Anne with the Madonna and Child (32) represents a further development of the earlier drawing (30) after a long period of elaboration; as far as the participants are concerned, it accords with the description given by Pietro da Novellara. The disposition of the figures and their gestures, however, are fundamentally different, which rules out any direct connection between the painting and Pietro's cartoon, and rather suggests a related but much more advanced composition. A comparison of cartoon and painting is not meant to imply a straightforward, evolutionary progression; a drawing at Chatsworth, for instance, represents an intermediate stage, and hints at the complex path towards a pictorial solution.[54] The figures are now rationally linked together, their compact structural and narrative interplay successfully visualized. All the protagonists play their parts with easy, natural grace. Metaphorically speaking, St Anne symbolizing the Church provides the basis and backbone of the group, while the Virgin to whom she gave birth is seated on her lap and lovingly turns towards the Child. The latter turns his head towards his mother and is playfully attempting to climb on to the lamb, a posture clearly indicating that he has accepted the Passion. The figures are now convincingly fused together, both through spatial relations and animated interaction, the whole group defined by movement and counter-movement. Finally, the delicately painted atmospheric 'world landscape' is intimately connected with the event and the sentiment of the two women.

The dating of this picture is still under debate, but scholars have recently proposed a rather late date, during Leonardo's second Milan period, predicated on the assumption that there was a period of work extending over several years. A closer look at the Florentine paintings of Raphael, however, especially the *Madonna del Prato* (117) of 1505/6, would suggest an earlier date – certainly one prior to Leonardo's move to Milan in May 1506. At this point, some kind of visual formulation must have existed – a first sketch perhaps, a design of the composition, or a cartoon – while work on the painting itself would have gone on over a prolonged period. The overall conception may therefore be dated to Leonardo's Florentine period, while the painterly elaboration of the composition and the evocative landscape belong presumably to a later date. Leonardo must have taken the painting with him to France, for Antonio de Beatis mentions seeing it when he was visiting the artist's studio at the Castle of Cloux in October 1517.[55] A chronological sequence of Leonardo's compositions for the *St Anne* project would have to cover both of his Florentine periods. The early version mentioned by Pietro da Novellara and presumably recorded in the small drawing (30) must certainly be dated to his first Florentine period, of about 1501. With its revised interpretation of the subject, the London cartoon would then have to be assigned to his second Florentine period. At the end of this time and probably in close conjunction with the cartoon, the final conception for the

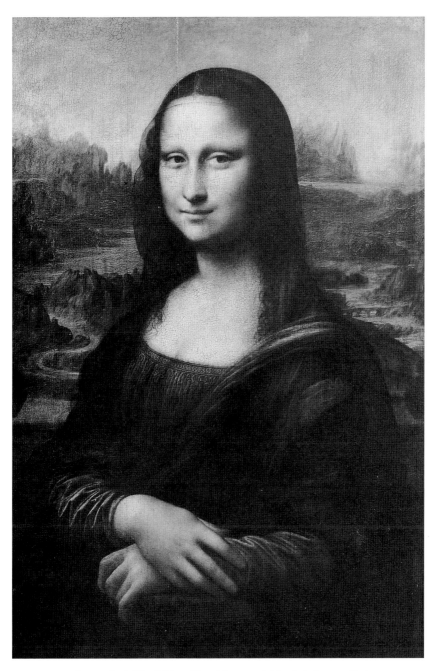

33 Leonardo da Vinci, *Mona Lisa*. Oil on panel. Musée du Louvre, Paris.

Louvre painting must have taken shape; based upon the early design, it has achieved greater intensity and concentration after what must have been a long process of creative revision.

The last example of a picture by Leonardo which had a major influence on Raphael is the *Mona Lisa* (33). Vasari's vivid description of this portrait deserves to be quoted at length: 'Leonardo undertook to execute, for Francesco del Giocondo, the portrait of Monna Lisa, his wife; and after toiling over it for four years, he left it unfinished; and the work is now in the collection of King Francis of France, at Fontainebleau. In this head, whoever wished to see how closely art could imitate nature, was able to comprehend it with ease; for in it were counterfeited all the minutenesses that with subtlety are able to be painted, seeing that the eyes had that lustre and watery sheen which are always seen in life, and around them were all those rosy and pearly tints, as well as the lashes, which cannot be represented without the greatest subtlety. The eyebrows, through his having shown the manner in which the hairs spring from the flesh, here more close and here more scanty, and curve according to the pores of the skin, could not be more natural. The nose, with its beautiful nostrils, rosy and tender, appeared to be alive. The mouth, with its opening, and with its ends united by the red of the lips to the flesh-tints of the face, seemed, in truth, to be not colours but flesh. In the pit of the throat, if one gazed upon it intently, could be seen the beating of the pulse. And, indeed, it may be said that it was painted in such a manner as to make every valiant craftsman, be he who he may, tremble and lose heart. He made use, also, of this device: Monna Lisa being very beautiful, he always employed, while he was painting her portrait, persons to play or sing, and jesters, who might make her remain merry, in order to take away that melancholy which painters are often wont to give to the portraits that they paint. And in this work of Leonardo's there was a smile so pleasing, that it was a thing more divine than human to behold; and it was held to be something marvellous, since the reality was not more alive.'[56]

Vasari's crucial remarks in this wonderfully evocative description of the portrait are, however, contradictory. The identification of the sitter as the wife of Francesco del Giocondo is doubtful. On his visit to Leonardo at Cloux in 1517, Antonio de Beatis mentioned three paintings, among them one of 'a certain Florentine lady after nature and at the time belonging to the late *magnifico* Giuliano de' Medici.'[57] Antonio pronounced all three paintings '*perfettissimi*': are the two chroniclers talking about the same painting, only identifying it differently, or are they referring to different portraits? Vasari's remark about the unfinished condition of the *Mona Lisa* not only contradicts Antonio's evaluation, but also his own description, which sounds very much like that of a finished painting. Furthermore, Vasari was never at Fontainebleau and therefore could not have seen the original. His animated description of the *Mona Lisa*, like that of the *St Anne*, is better understood as a literary celebration of Leonardo's art by which he aimed to impress on the reader both the special qualities and the general principles of the great Florentine. We may suppose that Vasari saw copies of the portrait, from which he extrapolated the appearance of the original work, assisted in this effort by his general familiarity with Leonardo's style. The dating of the painting is still a matter of controversy. Recent scholarship has suggested dates between 1503/5 and 1513/15, the uncertainty resulting partly from the assumption of long gestation periods for Leonardo's later works. Discussion of Raphael's Florentine works, however, will show that he knew the overall conception of the *Mona Lisa* by the middle of the first decade of the new century: he made use of

this new type of portraiture not only in a drawing (**61**), but also in the Doni double portrait mentioned earlier (**19, 20**).

The innovative aspects of the *Mona Lisa* for the development of portrait painting are very well known. The painting originally showed the sitter in front of a balustrade between two columns, but was later cut along the sides so that the effect of the framing device can today be studied only in copies and in the drawing by Raphael. Leonardo's treatment of the sitter shows him going far beyond his Netherlandish models. The half-length figure sits comfortably within its space, while the architecture provides a dignified setting. Vasari praised the sophistication of its painterly qualities, and one can assume that all contemporary lovers of the arts appreciated them in a similar way. Today, we would add that Leonardo's great achievement, the feature with which he surpassed all earlier masters, was the psychological penetration of the portrait. He relates the sitter's spiritual complexity closely to the background landscape which, as it were, frames the head as the compositional and spiritual centre.

Although few, if any, of Leonardo's works were completed during the period with which we are primarily concerned, his designs – or rather, perhaps, his 'conceptions' – greatly influenced contemporary art. Leonardo seems to have been eager that his artistic ideas became known quickly, but how much importance he attached to finishing a painting is difficult to say. We may certainly assume that he was willing to make his work accessible to interested parties, even while it was still in progress – and, presumably, to artists in particular. Young Raphael provides us with a prime example.

Michelangelo in Florence 1501–1506

A completely different role, but one scarcely less important at the time of Raphael's arrival in Florence, was played by the still relatively young Michelangelo. Born in 1475, he had joined Ghirlandaio's workshop for only a short period and, according to Vasari, managed to become a protégé of Lorenzo the Magnificent just before the latter's death in 1492. During the mid-1490s he spent some time in Venice, and later produced some sculpture for the Arca di S. Domenico in Bologna. He achieved his first real success in Rome, where he lived as a guest of Cardinal Riario from 1496 onwards. During the following years he produced the *Bacchus* (now in the Bargello, Florence) and the famous *Pietà* at St Peter's in Rome. By 1501 Michelangelo was back in Florence by invitation of the republican government. On 16 August 1501 he received the commission for the *David*, followed on 24 April 1503 by one from the Arte della Lana for figures of the twelve apostles for the cathedral in Florence. In 1504 Pier Soderini ordered him to paint *The Battle of Cascina* as part of the decoration of the new council chamber, and on 8 September of that year the *David* was unveiled. In 1505 Pope Julius II commissioned from Michelangelo the decoration of his tomb, including numerous pieces of sculpture; at the same time, the contract for the group of apostles was terminated, since the artist had only just begun work on *St Matthew*. Michelangelo started on the Julius tomb in Rome in 1505, but returned to Florence in 1506 when he was hampered in the execution of the work, due – he felt – to the jealousy of other artists. In Florence he completed the cartoon for *The Battle of Cascina*, and in November he went to Bologna, where the Pope ordered him to produce the monument to Julius for the church of S. Petronio. This was completed on 21 February 1508 (and later destroyed, in 1511); afterwards, he passed through Florence on his way to Rome, where he began work on the Sistine Chapel.

Clearly, therefore, at the time with which we are concerned – the years between 1501 and 1506 – Michelangelo was already one of the most sought-after of artists. Between the two

Roman commissions for the *Pietà* and the decoration of the Sistine Chapel, he accepted a further eighteen orders in various media, many of them very substantial – no fewer than forty statues were planned for the tomb of Julius II. Of these commissions, only a few were completed, others were begun and abandoned, and most remained simply proposals. While still a young man, Michelangelo had acquired a great international reputation: monarchs, including the French kings Francis I and Henry II and the Ottoman sultan Selim I, were competing to employ him. He was in contact with influential Florentine patrons and, although the greatest part of his long artistic career was spent away from Florence, Michelangelo never severed his ties to the city. Unlike Leonardo and Raphael, he saw himself first and foremost as a citizen of Florence.[58]

When considering Michelangelo's influence on Raphael, it is useful to keep in mind that the former was in Florence continuously only from spring 1501 until early 1506; thereafter, his influence on events in the city was only indirect. It should also be noted that he produced his early sculptures while simultaneously working in various other media. Such artistic cross-fertilization was a Florentine tradition, but in Michelangelo's case the revolutionary innovations of his sculptural works from the early years of the century were an inspiration mainly to painters. Even so, they were never quite as important for the development of Florentine painting as the works of Leonardo, Fra Bartolommeo and, later, Raphael.

The Bruges *Madonna and Child* (**34**) is particularly interesting for the way in which Michelangelo redefined a conventional pattern. The posture of the Virgin, looking at us with slightly bent head, is in keeping with tradition. The surprise lies in the role Michelangelo assigned to the big, strong Infant. The Child, his physical development that of a three-year-old, is placed slightly off the main axis and introduces narrative elements which structure the whole conception and emphasize the physical immediacy of the figures. The boy, half-standing and half-sliding, grasps his mother's hand and thigh while, with his right foot, he tries to lift himself from the base of the rock on which his mother is seated. The effect of these movements is to break down the strict frontal orientation of the group and, together with the accentuated drapery, invest it with real physical presence.

Like most of Michelangelo's works of this period, the Bruges *Madonna and Child* is not securely dated but is generally assigned to about 1501, possibly before the artist began work on the *David*. In 1506 the sculpture was sold to the heirs of Alexander Mouscron (in Italian, Moscheroni) and sent to Bruges, where it was later placed in the cathedral on an altar donated by Mouscron. Something of Michelangelo's character is captured in a letter the artist wrote to his father on 31 January 1506, in which he mentions the sculpture: 'the other thing concerns Our Lady in marble: here again I would like you to have her brought to our house and not to show her to anybody.'[59] So we know that in 1506 the sculpture was still in Florence, and that Michelangelo was highly secretive about it. Nevertheless, other artists seem to have seen it; Raphael, as we shall later show, was one of them.

On 16 August 1501, the consuls of the Arte della Lana and the heads of the Opera del Duomo (the cathedral's office of works) commissioned Michelangelo to complete the carving of a huge block of marble owned by the cathedral and called 'the Giant'. This block, supplied to Agostino di Duccio in 1464, was regarded as badly hewn; it was passed on to Michelangelo only after several unsuccessful attempts by other sculptors. He was ordered to

complete work within two years, and was paid 400 ducats. On 25 January 1504, with the *David* nearly finished, a commission of thirty men was set up to decide on an appropriate site. Made up of 'masters, citizens and architects', it included the most famous Florentine artists: Andrea della Robbia, Cosimo Rosselli, Filippino Lippi, Sandro Botticelli, Piero di Cosimo, Leonardo da Vinci, Lorenzo di Credi and Perugino. The choice was between three locations: one of the cathedral's buttresses, as originally intended; the Loggia dei Lanzi; or a site near the entrance of the Palazzo della Signoria. The final decision followed a suggestion by *messer* Francesco, First Herald of the city, who was in favour of the position at the Palazzo's entrance, arguing that the sculpture should replace Donatello's *Judith*, which he regarded as responsible for the city's misfortunes.[60]

Transporting the *David* took several days and required much ingenuity. The event is recorded in Luca Landucci's diary: 'And on 14 May 1504 the Giant of marble was removed from the cathedral's site office; he left at midnight and above the door so much was broken off the wall as was necessary to let him pass through. And during this night stones were thrown at the Giant with evil intention; guards had to keep watch at night; and his progress was very slow, tied in an upright position so that he floated and his feet did not touch [the ground] … he arrived at the Piazza on the 18th, at noon; and had more than forty persons to move him; … and they toiled till 8 June 1504 to put him up on the parapet just where the *Judith* was which had to be removed and set down in the Palace. The said Giant was the work of Michelangelo Buonarotti.'[61] This entry by Landucci, who was mainly interested in political events, shows clearly that the erection of the *David* was a matter of great public interest. The location was not only of symbolic significance, but was well chosen in aesthetic terms: the sculpture was aligned with the tower, and stood so close to the Palazzo della Signoria as to be linked with it, the massive bosses of the Palazzo providing a regular and animated background. At the same time, it stood far enough away from the palace walls to be inspected from all sides (**35**).

Michelangelo's *David* was recognized as something entirely new, a public statue with all the main characteristics of the new style. David is portrayed in the nude, holding only a sling and a stone. Both posture and body presage the combat with Goliath but do not focus on any particular moment, Michelangelo being more concerned to convey David's character. The youth is shown in a calm, almost languid *contrapposto* (a pose in which the different parts of the body are shown on different planes around a vertical axis), the gaze and turn of his head expressing decisiveness and concentration, yet without the slightest hint of inner tension. His muscular body has the slightly oversized head and hands of a young man. The statue is conceived to be seen in the round, although a principal viewpoint has been carefully elaborated – the full frontal view, which remains fascinating even in the copy we see today outside the Palazzo della Signoria.

Vasari enthusiastically commented on the *David*: 'When it was built up, and all was finished, he uncovered it, and it cannot be denied that this work has carried off the palm from all other statues, modern or ancient, Greek or Latin; and it may be said that neither the Marforio at Rome, nor the Tiber and the Nile of the Belvedere, nor the Giants of Monte Cavallo, are equal to it in any respect, with such just proportion, beauty and excellence did Michelagnolo finish it. For in it may be seen most beautiful contours of legs, with attachments of limbs and slender outlines of flanks that are divine … And, of a truth, whoever has seen

34 Michelangelo, *Madonna and Child*. Marble. Notre Dame, Bruges.

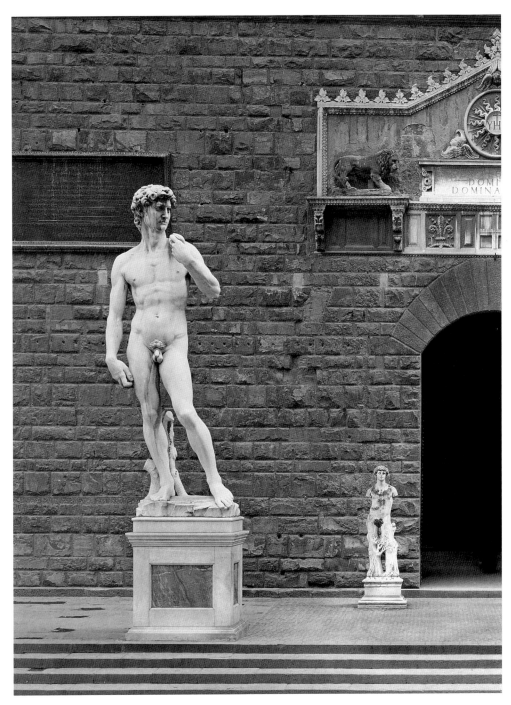

35 Michelangelo. *David.* Marble copy outside the Piazza della Signoria, Florence.

this work need not trouble to see any other work executed in sculpture, either in our own or in other times, by no matter what craftsman.'[62] Such fulsome praise shows how much the *David* contributed to young Michelangelo's reputation: almost overnight, he was acclaimed the greatest sculptor of the time. It is all the more surprising, then, that the *David*, even if it inspired artists such as Leonardo and Raphael, never established a distinctive figure type. The statue, which became a symbol of an independent republican Florence, was perceived at the same time as an *exemplum*, the crowning achievement of all sculpture – unique and absolutely inimitable.

The circumstances of the commission that led to the *St Matthew* discussed later (**79**) offer an insight into Michelangelo's position in Florence at this time. As early as 24 April 1503, more than a year before the completion and erection of the *David*, Michelangelo signed a contract with the consuls of the Arte della Lana for statues of the twelve apostles destined for Florence Cathedral. Each statue was to be about 4 $^1/_4$ *bracce* high (about 2.7 metres), and carved from Carrara marble. The contract committed Michelangelo to complete one statue per year in return for a monthly payment of two gold florins. It was further agreed that a house would be built for the artist, jointly designed by him and Simone del Pollaiuoli, in the via dei Pinti. The house seems to have been nearly completed early in 1504; in the same year, work started on quarrying the marble and transporting it to Florence. Michelangelo, however, was unable to carry out the commission; late in 1505 he was already trying to extricate himself from the agreement. There is mention that in 1506 he again worked on the apostles, but at the end of that year Pope Julius sent him to Bologna. The sculptures were later entrusted to other artists; Michelangelo's unfinished *St Matthew* remained at the cathedral's site office until the nineteenth century, when it was removed to the Accademia. It is generally agreed that he began work on the statue in the summer of 1505 and that it was accessible to Florentine artists from 1506, as documented in a drawing by Raphael (**78**).

The three tondi produced by Michelangelo during his Florentine years are also of particular interest because of their direct influence on Raphael. The first was the *Taddei Tondo* (**36**), probably dating from 1502–5, and made, according to Varchi and Vasari, for Taddeo Taddei.[63] Taddeo was one of Raphael's more important clients (see page 38), and it seems likely that he was allowed to see and study Michelangelo's tondo at his patron's house. The subtly dramatic composition both explicitly refers to the current idiom and is itself a remarkable innovation. The image can be read as a narrative: the infant St John on the left holds out a small goldfinch, from which the Christ Child recoils in fright and seeks protection from his mother who, seated on the ground, touches John as if to calm him. The motif of the goldfinch as a symbol of Christ's Passion had been used since the fourteenth century: while the Child fearfully turns away from the symbol of his suffering, his mother – fully aware of the inevitable – tries to provide a calming presence. Michelangelo's *Taddei Tondo* characteristically mediates between painting and sculpture. Starting with the image of a *madonna dell' umiltà* (a traditional subject for painting) and a disposition of figures within a roundel, he then turns to Leonardo's *Madonna with the Yarnwinder* (**29**), to which he owes the dramatic arrangement of the main motif. This imagery made a deep impression on the young Raphael, who was to use the narrative elements, especially Mary with the agitated Child, several times in his own compositions.

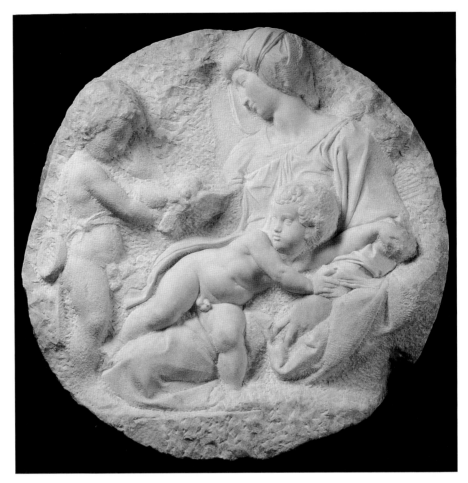

36 Michelangelo, *Taddei Tondo*. Marble. Royal Academy of Arts, London.

Michelangelo's second sculpted roundel, the *Pitti Tondo* (**37**), was produced for one Bartolommeo Pitti between 1503 and 1505 and later presented by Fra Miniato Pitti as a gift to Luigi Guicciardini. The tondo presents the Madonna seated on a stone bench, looking sideways away from her open book. With her left arm she embraces the standing Child whose right arm rests on the book. Behind the Madonna's right shoulder appears the head and upper body of the infant John. Michelangelo invests this image with greater calm and solidity than in the *Taddei Tondo*. Here, the Madonna is the focal centre of the group and is of Sibylline appearance, with the cherub crown perhaps hinting at her gift of prophecy. As in a vision, she realizes what the future holds in store for her son and holds him protectively. The Child nestles lovingly to her, his head supported as if in thought, no doubt signifying his contemplation of the Passion. Some of the elements Michelangelo uses in this new interpretation go back to Tuscan art of the Quattrocento, in which the motifs of both the cherub and the open book were known.

Michelangelo's *Doni Tondo* (**38**) is the most interesting and the most extensively discussed example of its type. Among the artist's surviving paintings it is without precedent, and does

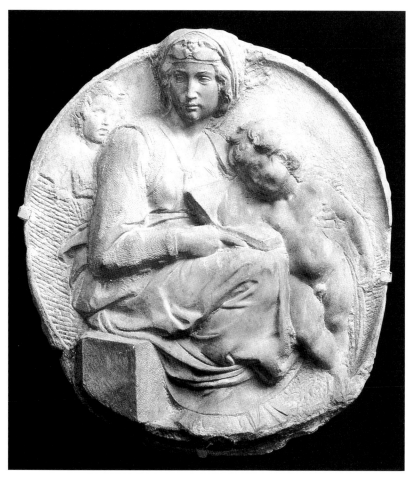

37 Michelangelo, *Pitti Tondo*. Marble. Museo Nazionale del Bargello, Florence.

not relate to any other work he produced during the early years of the century. His client Agnolo Doni (see pages 38–42) was mentioned by both Condivi and Vasari, the latter giving a detailed description of this painting: 'There came to Agnolo Doni, a Florentine citizen and a friend of Michelagnolo, who much delighted to have beautiful things both by ancient and by modern craftsmen, a desire to possess some works by Michelagnolo; wherefore that master began for him a round picture containing a Madonna, who, kneeling on both knees, has an Infant in her arms and presents Him to Joseph, who receives Him. Here Michelagnolo expresses in the turn of the head of the Mother of Christ and the gaze of her eyes, which she keeps fixed on the supreme beauty of her Son, her marvellous contentment and her loving-ness in sharing it with that saintly old man, who receives Him with equal affection, tender-ness, and reverence, as may be seen very readily in his countenance, without considering it long. Nor was this enough for Michelagnolo, who, the better to show how great was his art, made in the background of his work a number of nudes, some leaning, some standing, and some seated; and with such diligence and finish he executed this work, that without a doubt, of his pictures on panel, which indeed are but few, it is held to be the most finished and the

most beautiful work that there is to be found.'[64] He then recounts an anecdote of how Agnolo Doni foolishly tried to argue with Michelangelo about the price, to indicate that the highly self-confident artist knew the value of his work and was not willing to bow to the unreasonable demands of any client. This was probably one of Vasari's literary inventions (*bugia*), designed to set the young creative genius off against his patron, whom Vasari more than once portrayed as a miser.

The *Doni Tondo* and its matching frame today constitute a unified whole in shape and in content. The painting shows various inspirations and borrowings, but also offers innovations in both composition and subject. In the near foreground, Mary kneels with a closed book in her lap. With a slight turn of the body and a more emphatic one of the head, she faces back to receive the Child whom Joseph holds out to her. Joseph himself is shown crouched behind Mary, uniting the group as if in protection. The Child seems about to climb on to Mary's upper arm and with both hands uses his mother's head for support. The three figures focus on the central action, Joseph calm and solid, the Child lively and energetic, Mary happily expectant. They are placed on a patch of grass, set off by a low wall from the middle distance. On the slightly sloping ground beyond, several nude young men of classical appearance (*ignudi*) disport themselves in a landscape of hills and lakes. They pose in different attitudes against a wall-like semi-circular construction, with a sharply defined profile suggesting a piece of architecture. On the right side, the infant St John appears immediately behind the low wall, his eyes raised to the main group. Through the complex interplay of posture and movement of the three protagonists, the motifs of giving and receiving form an inseparable unity. The group as a whole is compactly constructed; the Christ Child, the object and origin of every movement, provides the painting's focus, both in form and in sentiment. Line and colour give solidity and unity to the figures, and clear-cut outlines define the bodies and clothes, providing very distinct modelling for the group, which is suffused by a bright light. The modelling becomes softer only in the rendering of the background figures, where the shadows show a trace of *sfumato*. Michelangelo's coloration deliberately runs counter to the prevailing fashion for soft, warm colours and for *sfumato* to enhance the painterly values, a technique introduced by Leonardo. He develops his own new colour aesthetics, in which clear, cool hues are made to change their value in bright light. The blues and pinks of Mary's robes turn into pure white, and the orange tint of Joseph's cape becomes a light yellow.

The formal unity of the *Doni Tondo* is paralleled by a narrative one. The composition can be read as an allegory of the Christian view of the world: the *sub gratia* world of Christ corresponds to the *sub lege* world of his parents, which in turn corresponds to the *ante legem* world personified by the classical youths in the middle ground (whom, as we have seen, Michelangelo borrowed from Luca Signorelli; **27**). In this relationship, the infant St John acts as a mediator. This basic theme is repeated in the frame. Within a pattern of scrolling floral and zoomorphic motifs, five small tondi are set between the ledges of the frame and decorated with three-dimensional heads: Christ is shown on the main axis, flanked by two prophets and two sibyls.

The *Doni Tondo* was probably executed between 1504 and 1506. The frame, with the coat of arms of Maddalena Strozzi, refers to her marriage to Agnolo Doni in 1504. Since one of the figures in the background relates to a classical sculpture, the *Laocoon*, which was discovered

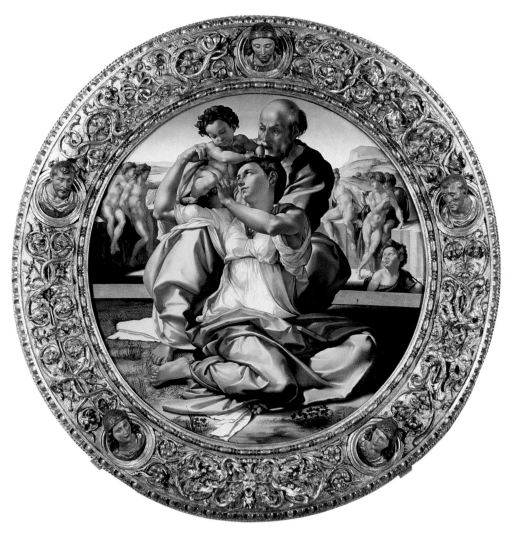

38 Michelangelo, *Doni Tondo*. Oil on panel. Galleria degli Uffizi, Florence.

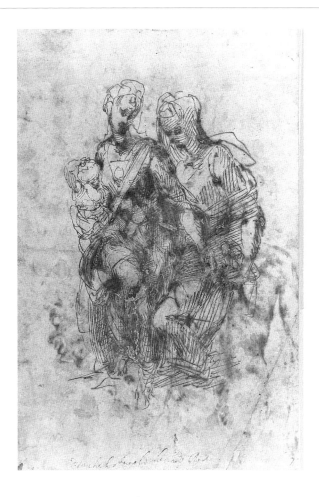

39 Michelangelo, *St Anne with the Madonna and Child*. Pen.
Ashmolean Museum, Oxford.

only in 1506, the painting was presumably still in progress at that date. In 1507 Raphael, after extensive explorations, finally borrowed Mary's posture for a figure in *The Entombment* (**139**). By that time Michelangelo had probably finished his painting.

The new conception of the *Doni Tondo*, through which Michelangelo staked his claim in the field of painting, was presumably at least partly a result of his rivalry with Leonardo. The older master was a dominating influence on Florentine painting, and each regarded the other as something of a competitor. In his *Vita* of Leonardo, Vasari speaks of deep mutual dislike: 'There was a great disdain [*sdegno grandissimo*] between Michelagnolo Buonarroti and him, on account of which Michelagnolo departed from Florence, with the excuse of Duke Giuliano, having been summoned by the Pope to the competition for the façade of S. Lorenzo. Leonardo, understanding this, departed and went into France, where the King, having his works by his hand, bore him a great affection; and he desired that he should colour the cartoon of St Anne.' The *Anonimo Magliabechiano* makes further mention of an encounter when Michelangelo bitterly reproached Leonardo: 'One day Leonardo passed the benches at the Palazzo Spini where a number of people of respect were discussing a passage in Dante. They

turned to Leonardo and asked him for an explanation. At this moment Michelangelo passed by and when one of them called him, Leonardo said: "Michelangelo will explain it to you." Michelangelo got angry because he thought Leonardo was making fun of him: "Try explaining it yourself, you who have designed a horse to be cast in bronze and then were unable to cast it in bronze and ignominiously deserted the project." With these words he turned and walked away; Leonardo remained and blushed because of these words.' Whatever truth there may be in the details of these stories, it seems obvious that even outsiders were aware of the rivalry between the two.[65]

Against this background it seems entirely reasonable to see the *Doni Tondo* as a production made to rival the cartoon of St Anne that Leonardo exhibited in the summer of 1501 at the Convent of SS Annunziata and that realized designs that had occupied the older artist at this period. Comparing it with other works by Leonardo, it seems to represent an intermediary stage, but is remarkably close to the London cartoon (**31**, and see pages 65–70). In this context, a compositional sketch by Michelangelo is of particular interest, because it clearly refers to one of Leonardo's concepts for the *St Anne* (**39**). The back of the sheet bears the inscription '*lenardo*' (Leonardo) in Michelangelo's hand; it is generally accepted that Michelangelo made the drawing in direct response to the cartoon exhibited at SS Annunziata. Here again, substantial rephrasing would indicate Michelangelo's freedom of approach. On the right, perhaps one needs to visualize the figure of the infant St John, or the lamb with its symbolic connotations, to account for Mary's emphatic movement. The important feature is the alteration of the balance, so that with Mary now seated on Anne's right thigh and between her legs, the whole group acquires greater structural stability and comes together in an almost semicircular arrangement. This poignant rephrasing of the figure composition must be regarded as a decisive revision of Leonardo's concept, even though Michelangelo remains indebted to the older artist's manner in the way that the figures interlock.

Michelangelo's *Doni Tondo*, incorporating as it does elements from the two earlier tondi, may justifiably be regarded as the sum of his previous achievements. At the same time, it can be seen as a self-confident statement of challenge to Leonardo. Instead of tightly linking the physical and spiritual aspects of the protagonists, Michelangelo provides a clear and spacious disposition where all movements centre on the Christ Child. Like Leonardo, he aims to emphasize the links between the individual participants, but wants to make these links immediately intelligible. The unmodified, almost harsh, light thrown upon the figures invests the flesh and the clothes with a cool, ethereal quality – a manner perhaps deliberately formulated in opposition to Leonardo's characteristic use of *sfumato*, of finely nuanced modelling to heighten the expressiveness and emotional modes (what Alberti called the '*moti dell' anima*') of his figures. That the *Doni Tondo* proposes an alternative aesthetic seems all the more pertinent an interpretation in view of the fact that precisely at this time the two artists were commissioned to decorate the Grand Council Chamber in the Palazzo della Signoria. Their rivalry thus became public knowledge.

The rivalry between Leonardo and Michelangelo

After the expulsion of the Medici in 1494, the popular government under Savonarola built a council chamber in the Palazzo della Signoria on the model of the Consiglio Maggiore of the Doges' Palace in Venice. The great hall had been designed and built by Antonio da Sangallo the Elder with the assistance of Cronaca, Baccio d'Agnolo being responsible for the interior design including the panelling and a coffered ceiling. Around the walls there was probably a gallery, with two rows of seats above a balustrade reached by a flight of steps. On the east wall was the elevated seat of the *gonfaloniere* and the eight priors, while at the opposite wall stood the altar. It was intended to decorate the hall with paintings and sculpture of a sumptuousness appropriate to its lofty character. Above the priors' balcony a statue of Christ the Redeemer was to be erected, and it was decided that the altarpiece should depict St Anne. Along the walls adjacent to the balcony and starting at a height of approximately 4–4.5 metres, two monumental paintings were planned, depicting scenes from the history of Florence. Neither the exact position of these paintings nor their measurements – sometimes said to have been 7 × 17.5 metres – can be conclusively established.

All the decorative elements were part of a well-defined programme meant to celebrate republican (i.e. anti-Medici) Florence: Christ is shown as King of Florence in accordance with Savonarola's doctrines, and the figure of St Anne refers to the city's liberation from the Duke of Athens in 1343 (an event still recent enough to form part of the communal memory of the Florentines). The battle pieces, traditional subject-matter for the decoration of Italian town halls, were as much a reminder of a glorious past as a comment on the current political situation and Florence's endeavour to remain the dominant power in Tuscany. There was no question that for such a prestigious undertaking only the greatest artists would be considered. The sculpture of Christ was assigned to Andrea Sansovino, the altarpiece to Filippino Lippi (and, after his death, to Fra Bartolommeo), and the two huge murals were commis-

sioned from Leonardo and Michelangelo. Leonardo received his order for *The Battle of Anghiari* in autumn 1503, and the next year Michelangelo was commissioned to paint *The Battle of Cascina*. Our reconstruction of the original layout remains tentative (**47**); it relies mainly on contemporary documents and descriptions, because the chamber was rebuilt from 1563 under Vasari's supervision. Details concerning the location of the doors and the shape and height of the windows remain obscure.[66]

The commissions for the decoration of the council chamber were initiated by Pier Soderini. He and the Signoria were following tradition in having prominent artists decorate the hall, but perhaps in this case they also hoped to keep the two greatest artists in Tuscany, Leonardo and Michelangelo, in Florence. For Leonardo the painting of the Grand Council Chamber must have been one of his major projects: the mural was double the length of *The Last Supper* in Milan; the subject was to be a narrative painting (*historia*), the most important genre; and it was to be displayed at the most prestigious location in Florence. The same considerations probably applied to Michelangelo, and in his case there was the added spur of competing with Leonardo who had already started work. There is some indication that in autumn 1503 it was intended to commission Leonardo for both murals,[67] but it seems that the clients soon became impatient with his slow progress. Perhaps this was the reason for deciding in autumn 1504 to assign 'the other wall' to Michelangelo.[68]

Several payments to Leonardo are recorded during 1504 and in March 1505 for scaffolding (*ponte*), so the artist must have started to transfer the cartoon on to the wall. These payments were discontinued in October 1505, meaning that Leonardo had finished this part of the work. By that time, the central part of the mural had been transferred on to the wall, for which a protective lattice framework was put up in 1513. Several sources record that Leonardo did not employ the conventional method of fresco painting, but used one he had invented himself and had previously employed for *The Last Supper* (information about this is contradictory, and scholars' interpretations vary). What is not in doubt is that Leonardo thought the conventional fresco technique unsuitable for his artistic intentions and also for his impulsive methods of working.[69] It is sometimes suggested that he tried to rediscover ancient techniques of wall painting in order to utilize fully all possibilities of modulated colour and light. There are indications that this involved him in scientific studies and experiments that not only prolonged the work, but finally sabotaged the whole project.[70] We know that his clients in general, and Pier Soderini in particular, were unsympathetic to such an approach. In a letter of October 1506 to Geffroy Carle, the French vice-chancellor in Milan, Soderini did not disguise his anger: 'As for granting Leonardo leave of absence, we ask your Excellency's indulgence: he has not behaved towards this Republic as in duty he should; for he has taken a considerable sum of money and yet has made little headway on the great work he was asked to do.'[71] Soderini was a businessman and a politician, and without a patron's familiarity with the way of artists and the trouble they sometimes cause; his prime consideration was the speedy execution of his new political headquarters.

Leonardo went to Milan in May 1506 and was never to return to work on *The Battle of Anghiari*. By then an important part of the mural must have been completed, showing surely more than a 'little headway'. Vasari must have been familiar with the painting (and probably with some copies as well), for in 1563, by order of Cosimo I, he started rebuilding the cham-

ber and in the process either removed or covered up what remained of Leonardo's work. In his *Vite*, he details the commissioning process, and then launches into an extremely lively account of the battle itself. Leonardo's subject concerned an event of 29 June 1440, when Florentine troops, allies of the papal army, had repelled the attack of a Milanese force under Piccinino at Anghiari. During the long battle and its constantly shifting fortunes, a bridge over a river in the Apennines changed hands several times. One of the decisive moments of the engagement was the struggle for the battle standard. Vasari's description captures the novelty of Leonardo's painterly conception: the tremendous intensity and energy of the scene and the tight interlocking of the figures. The only finished part Vasari mentions, the scene showing the struggle for the standard, was certainly just one section of the whole composition. Vasari assigned to Leonardo's work the character of an *exemplum*, on which he himself sought to model the decoration of the reconstructed council chamber, today known as the Salone dei Cinquecento. 'It was ordained by public decree that Leonardo should be given some beautiful work to paint ... Whereupon Leonardo, determining to execute this work, began a cartoon in the Sala del Papa ... representing the story of Niccolò Piccinino, Captain of Duke Filippo of Milan; wherein he designed a group of horsemen who were fighting for a standard, a work that was held to be very excellent and of great mastery, by reason of the marvellous ideas that he had in composing that battle.' Vasari continues with a long and vivid description of the struggle for the standard: 'two are defending it, each with one hand, and, raising their swords in the other, are trying to sever the staff; while an old soldier in a red cap, crying out, grips the staff with one hand, and, raising a scimitar with the other, furiously aims a blow in order to cut off both the hands of those who, gnashing their teeth in the struggle, are striving in attitudes of the most fierceness to defend their banner.' Finally, Vasari mentions the reason why work on the painting was discontinued; he would have known this only from hearsay, but it was probably correct: 'It is said that, in order to draw that cartoon, he made a most ingenious stage, which was raised by contracting it and lowered by expanding. And conceiving the wish to colour on the walls in oils, he made a composition of so gross an admixture, to act as a binder on the wall, that, going on to paint in the said hall, it began to peel off in such a manner that in a short time he abandoned it, seeing it spoiling.'[72]

Several sixteenth-century copies of 'The Struggle for the Standard' composition survive, along with preparatory sketches by Leonardo. These help to give a general idea of the whole composition, and are also important for an evaluation of Raphael's reaction to *The Battle of Anghiari*. The battle scene is dominated by four figures; it seems reasonable to assume that they are meant to portray the main participants in the event. These were: the Milanese *condottiere* Niccolò Piccinino, his son Francesco, the Florentine Piergiampaolo Orsini, and the papal legate, the cardinal–patriarch Lodovico Scarampo. The figures were not meant as portraits, but as personifications of the fury of battle and as representatives of the warring parties. The early copy in the Rucellai collection, although of little artistic merit, shows the disposition of the participants very well (**40**); the missing passages reflect either the unfinished state of the original, or the degraded condition of the painting by the time the copy was made. On the left, a horseman on a rearing horse looks backwards, grasping the disputed standard and holding its pole end in his right hand; the shaft snaps behind his back just as he is wresting it from his enemies. On the right, a horseman from the enemy camp joins the fight with drawn

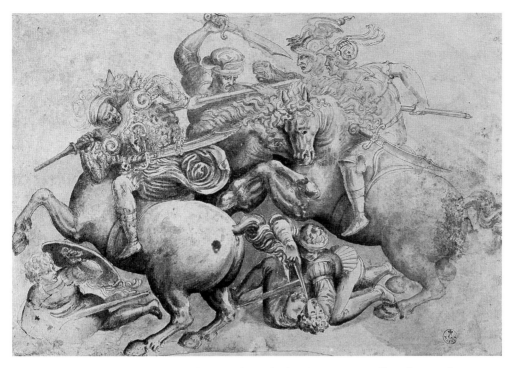

40 Anonymous copy after Leonardo da Vinci, *The Battle of Anghiari*. Pen. Ruccellai Collection, Florence.

lance, his left hand also clutching the standard. He is assisted by the rider behind him, whose activities remain somewhat obscure. At the centre, a rider obviously belonging to the camp of the first horseman brandishes his sword in a decisive attempt to end the struggle. His horse has dug its teeth into the neck of the enemy horse, and the front legs of the two horses are entangled. Underneath these two horsemen, who create a pictorial bridge, are two foot soldiers wrestling fiercely on the ground, the stronger one about to knife his enemy. On the left, a soldier covers himself with his shield, seeking protection from the mêlée and in particular from the horses' hooves.

It has often been noted that, even before receiving this commission, Leonardo had worked on battle scenes both in drawings and in his writings. A well-known passage from his notebooks sheds light on his conception of a multi-figured battle-piece: 'And if you introduce horses galloping outside the crowd, make the little clouds of dust distant from each other in proportion to the strides made by the horses …. Make also a horse dragging the dead body of his master, and leaving behind him, in the dust and mud, the track where the body was dragged along. You must make the conquered and beaten pale, their brows raised and knit, and the skin above their brows furrowed with pain, the sides of the nose with wrinkles going in an arch from the nostrils to the eyes, and make the nostrils drawn up – which is the cause of the lines of which I speak –, and the lips arched upwards and discovering the upper teeth; and the teeth apart as with crying out and lamentation …. Others represent shouting with their mouths open, and running away. You must scatter arms of all sorts among the feet of the combatants, as broken shields, lances, broken swords and other such objects. And you must

89

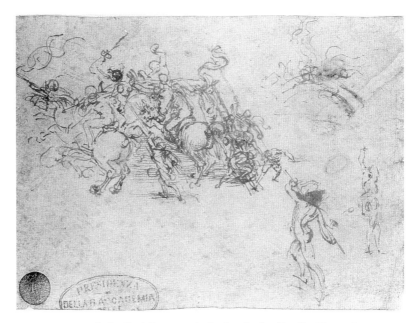

41 Leonardo da Vinci, *Horsemen in Combat, Study of Battling Figures.* Pen.
Galleria dell' Accademia, Venice.

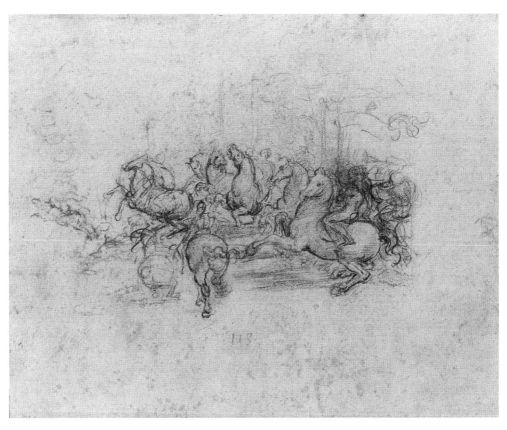

42 Leonardo da Vinci, *Cavalcade.* Chalk. Windsor Castle.

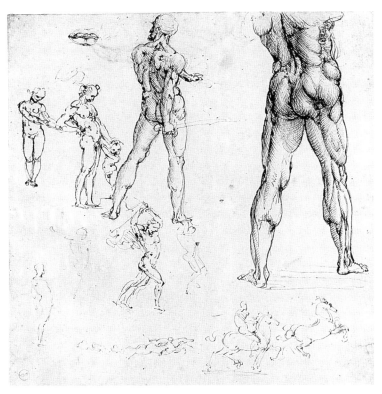

43 Leonardo da Vinci, *Battling Figures*. Pen. Biblioteca Reale, Turin.

make the dead partly or entirely covered with dust.'[73] Leonardo here provides a panorama of a battle and is especially concerned with a realistic rendition of the fury of the action. *The Battle of Anghiari* gave him the opportunity to realize his ideas in a prominent location and thereby to enrich the genre of the *historia* with a new pictorial concept. At the same time, he retained the traditional practice of presenting the members of one's own camp in a heroic light, by emphasizing the physical inferiority of the enemy. The most important figure must be the horseman in the centre, whom Vasari singles out as the fighter with the red cap. Together with his companion on the left, he presumably represents the Florentine camp which grimly and with great effort is trying to defend its standard against the Milanese attackers. The two enemy horsemen on the right are relatively less important.

Among the group of surviving preparatory sketches, three are particularly helpful in giving an impression of the intended painting in its entirety.[74] A sheet in the Accademia in Venice shows horsemen fighting near a bridge, an action which had been an important feature of the battle (**41**). The drawing includes certain elements that reappear in copies of 'The Struggle for the Standard' composition, such as the central figure brandishing his sword and the horses tearing at each other. The final arrangement, however, in which the narrative elements are subdued and the number of actors reduced in order to concentrate better on their activities and present a quintessential image of the furies of war, has not yet been arrived at. Here, the bridge indicates the setting and also suggests that Leonardo envisaged the battle continuing on the right.

91

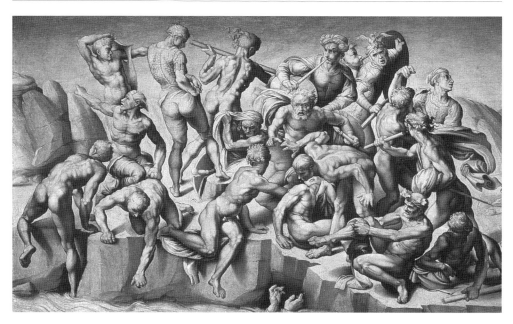

44 Aristotele da Sangallo after Michelangelo, *The Battle of Cascina*. Grisaille on panel. Holkham Hall, Norfolk.

A drawing at Windsor shows a cavalcade, a group of approaching horsemen not yet engaged in battle (**42**). It looks as if they are approaching from the right, which would relate them directly to the warriors fighting for the standard. Given the proximity of the 'struggle' to the bridge, the horsemen would have to be placed on the far side of the bridge. This reading is a key factor for the reconstruction of the entire *Battle of Anghiari* and it is confirmed by a Raphael sketch which links this drawing to 'The Struggle for the Standard' (**53,** discussed below).

Finally, a sheet now in Turin has long been regarded as a further preparatory study for *The Battle of Anghiari* (**43**). It is covered with sketches of battles and horsemen, as well as two images of a warrior with a pronounced twist to the body. The latter would have had a prominent role in the overall composition; since he directs his movements to the right while looking in the opposite direction, he must have acted as a link between the warring parties. His position was probably to the left of the central group. The reconstruction (**47**), by now standard, offers the most uncontrived combination of the various elements in the preparatory drawings; one may still argue about details, for all such attempts at reconstruction must remain conjectural by their very nature.[75] The reconstruction allows us to follow the sequence of events in natural succession, as a narrative painting is supposed to do, and arranges the various documented features into a largely consistent, unified whole. If we take into account Leonardo's artistic intentions and usual practice, and the thorough studies of the effects of light and colour he attempted to reproduce with *chiaroscuro* and *sfumato*, we can probably say that he intended to place *The Battle of Anghiari* in a landscape setting. Within such a setting, the group in 'The Struggle for the Standard' would have provided the centrepiece of the whole composition as well as the key to its programmatic message: to unite for the defence of Florence's independence.

It may seem surprising that the commission for the second painting in the council cham-

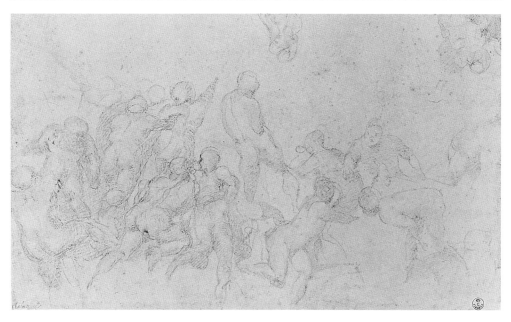

45 Michelangelo, *Sketch for the Battle of Cascina*. Silverpoint. Galleria degli Uffizi, Florence.

ber, a depiction of the battle of Cascina, went to an artist as young as Michelangelo, who was not yet thirty. In the field of painting he had produced nothing spectacular, and it must have been admiration for the *David* as well as confidence in his general talents that proved decisive.[76] For Michelangelo the project must have held great significance: it meant entering Leonardo's very own territory, and the opportunity to prove himself in direct competition.

We do not know the precise date of Michelangelo's contract, but in October 1504 payments had already been made in connection with the cartoon. After the artist's prolonged absence in Rome in 1505, Soderini wrote in a letter of 27 November 1506 that 'he has undertaken a *storia* for the town hall which will be much admired.'[77] This remark, however, presumably refers only to Michelangelo's short period of work before he left for Rome; the time he was able to give to *The Battle of Cascina* cannot have been very long. It is now generally agreed that he produced only the cartoon and, unlike Leonardo, never began to transfer it on to the wall. The cartoon was kept for some time in the Sala del Consiglio and then in the Sala del Papa at S. Maria Novella before entering the Palazzo Medici, where it was cut into sections in 1515–16 and distributed to various collections. Nothing remains of it. We have, however, a *grisaille* copy by Aristotele da Sangallo – based on a lost, seemingly very exact, drawing – which is generally regarded as highly reliable (**44**). In addition, various copies of details, as well as related figure studies by Michelangelo himself, have survived.

The subject of Michelangelo's painting was an event of 1364. According to Filippo Villani's chronicle, to make sure the Florentine army was ready for battle, Manno Donati staged a mock alarm which found some soldiers, bathing because of the great heat, completely unprepared. As a result of this ruse, the camp was better secured and the soldiery roused so much that when, in fact, the Pisan troops attacked the very next day they were successfully repelled. Although he would not have known the original cartoon, Vasari offers a highly detailed

description, presumably based on Sangallo's copy and other visual and oral evidence: 'It happened that while Leonardo da Vinci, that rare painter, was painting in the Great Council Hall … Piero Soderini, who was then Gonfalonier, moved by the great ability that he saw in Michelagnolo, caused a part of that Hall to be allotted to him; which was the reason that he executed the other façade in competition with Leonardo, taking as his subject the War of Pisa … and there he began a vast cartoon, but would never consent that anyone should see it. And this he filled with naked men that were bathing in the River Arno on account of the heat, when suddenly the alarm sounded in the camp, announcing that the enemy was attacking; … there could be seen … some hastening to arm themselves in order to give assistance to their companions, others buckling on their cuirasses, many fastening other armour on their bodies, and a vast number beginning the fray and fighting on horseback. There was, among other figures, an old man who had a garland of ivy on his head to shade it, and he, having sat down in order to put on his hose, into which his legs would not go because they were wet with water … was struggling to draw on one stocking by force … There were also many figures in groups, all sketched in various manners, some outlined with charcoal, some drawn with strokes, others stumped in and heightened with lead-white, Michelagnolo desiring to show how much he knew in his profession …. since the time when it was finished and carried to the Sala del Papa … all those who studied from that cartoon and drew those figures … became persons eminent in art, as we have since seen.'[78]

Vasari goes on to describe the cartoon and calls it an *exemplum* every aspiring artist should study. In fact, both Michelangelo's and Leonardo's cartoons were for a time recognized as perfect examples of how to depict the human body; Benvenuto Cellini mentions in his autobiography that he made drawings after both, ending: 'Of these cartoons one hung in the Medici palace and the other in the Pope's Hall, and as long as they were exhibited they served as a school for all the world.'[79] Vasari's account is also of interest for its mention of men on horseback; these do not appear in Sangallo's copy but left a trace in Michelangelo's preparatory drawings (see, for example, **46**). Presumably, therefore, the complete composition included more than just the group of men we find in Sangallo's drawing. Vasari's remark about the different drawing techniques may point in the same direction. All this would suggest that some sections of *The Battle of Cascina* were only sketched, whereas, on the evidence of Sangallo's copy, 'The Bathers' group had been fully laid down.

Like Leonardo, Michelangelo made a very free interpretation of the historic event that formed his given subject-matter; at best, the figure right of centre, turning round and shouting, may be supposed to stand for Manno Donati. The artist's principal aim was to provide a model of how to portray human figures within a tightly constructed space, very carefully combined with the greatest possible range of movements (following here the rules of *varietà*, artistic variation) in keeping with an overarching logic. Reading the composition from left to right, one notices an increasing concentration of human bodies which finally seems to settle around a compositional centre consisting of a group of three figures. The principal accents within this group are supplied by one man on the bank who turns round, another one in frontal view who emphatically leans forward, and a third man whose whole upper body performs a tautly stretched, forward-slanting movement. The whole composition is much more artificial than Leonardo's, especially since there is no general point of reference to provide a

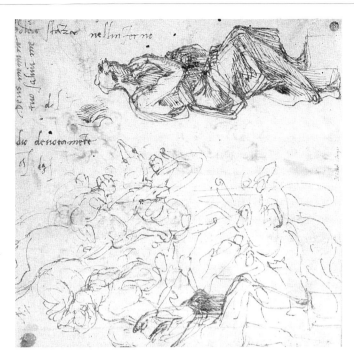

46 Michelangelo, *Horsemen in Combat, Sketch for St Matthew*. Pen.
British Museum, London.

focus. Rather, Michelangelo illustrates the effects of the call to arms: all the individual reactions are cued to a common spiritual goal, and it is to this that all activities are finally directed.

A highly significant feature of the broadly spaced disposition is that it becomes more compact towards the right, thus shifting the focus off-centre and at the same time directing the movements towards a notional point beyond the group. This concept is even more apparent in a preparatory drawing (**45**; in the Uffizi). Here, several figures are shown detaching themselves from the group to rush away, presumably to the point of the attack. In the cartoon, this emphatic movement has become somewhat diluted yet is not completely obliterated. Some movements are obviously still directed towards a point to the right of the group, again suggesting that it was from there the attack was threatening. The same applies to a group on the left, where two figures are deliberately moving in the opposite direction.

Finally, on a sheet with a design for the *St Matthew* commissioned for the cathedral in Florence, we also find a sketch of a battle of horsemen (**46**). Considering the outward-directed movements of *The Bathers*, together with Vasari's remark about warriors on horseback, it seems reasonable to assume that this sketch refers to Michelangelo's overall concept for the fresco. The composition would almost certainly have included more than just the scene with the bathers; the sheer size of the painting surface alone would suggest this. Michelangelo would also have had to consider the scale of Leonardo's *Battle of Anghiari*, of which 'The Struggle for the Standard' group formed only a part. Since *The Bathers* includes movements in two directions, at least two further groups, possibly of horsemen, must have been intended for the complete painting. These not implausible assumptions result in a reconstruction that places *The Bathers* in the middle distance and the flanking groups further

95

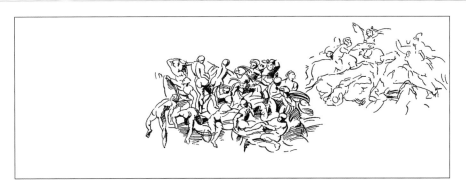

Michelangelo, *The Battle of Cascina* (A)

Scale — 1 *braccio* = approx. 60 cm

0 5 10 15 20 BRACCIA

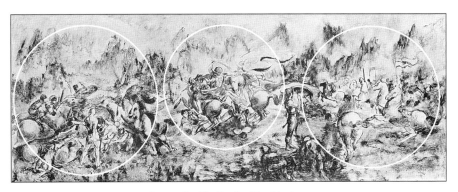

Leonardo, *The Battle of Anghiari* (B)

47 Reconstruction of the decorative scheme for the new council chambers in the Palazzo della Signoria
(after Wilde, Pedretti and Kemp).

back (**47**).[80] More generally speaking, contemporary observers would probably not have felt a scene like *The Bathers* sufficient to fulfil the requirements of a *historia*: further explanatory features would have been needed.

When we place the attempts to reconstruct the two decorative frescos side by side, their overall unity of both form and content becomes evident. Whereas the key concept of Leonardo's *Battle of Anghiari*, the fight for the standard, is an allusion to the political situation of his own time, the underlying theme of Michelangelo's *Battle of Cascina* is that of constant vigilance in times of external threat. In conjunction with the other sculptural furnishings for the Grand Council Chamber, the two wall paintings would have been a clear expression of the ideals of the Florentine republic. While the reasons for the abandonment of this decorative programme were many, in Leonardo's and Michelangelo's cases the main cause was probably the pressure of numerous other commissions, which they felt unable to refuse. In autumn 1504, however, at the time of Raphael's arrival in Florence, the two masters' painting projects were the talk of the town, and other artists in particular followed their progress with the greatest attention.

III. FLORENTINE STUDIES

Florentine studies

One of the most important reasons for Raphael's move to Florence was undoubtedly his determination to study by himself. The letter written by the Duchessa Giovanna della Rovere said so clearly enough (see page 36), and what we know about Raphael's work during his Florentine years reveals his constant endeavour to perfect his personal style and technical proficiency. Vasari's remarks on the subject in his *Vita* are both a late confirmation and a description of the self-study method typical of the time: 'This most excellent of painters studied in the city of Florence the old works of Masaccio; and what he saw in those of Leonardo and Michelagnolo made him give even greater attention to his studies, in consequence of which he effected an extraordinary improvement in his art and manner.' To Vasari, the results were obvious: 'I will not refrain from saying that it was recognized, after he had been in Florence, that he changed and improved his manner so much, from having seen many works by the hands of excellent masters, that it had nothing to do with his earlier manner; indeed, the two might have belonged to different masters, one much more excellent than the other in painting.'[81] The form these studies took is better documented by his surviving drawings than by textual evidence. Raphael, having already received professional training, had no need to join the workshop of an established artist; instead, he followed the Florentine tradition of studying the great masters – Masaccio as an example of the illustrious past, and Leonardo and Michelangelo as the outstanding contemporaries. Studying meant making careful copies of one's models, for in Florence the drawing (*disegno*) was regarded as the first step towards the final painting. In his *Commentarii* of the 1440s, Lorenzo Ghiberti had stated: 'For the sculptor and the painter the drawing forms the basis and theory of both these arts.'[82] And Leonardo detailed the steps for learning to draw properly: 'First draw from drawings by good masters done from works of art and from nature, and not from memory; then from plastic work, with the guidance of drawing done from it; and then from good natural models and

48 Raphael, *Studies of Heads and Hands*. Silverpoint with white highlights. Ashmolean Museum, Oxford.

this you must put into practice.'[83] Such redrawings varied greatly and could be anything from a rough mental note to a highly accurate copy, or to an almost finished rephrasing already moving towards a new and independent formulation.

Raphael's copies from his Florentine years are immensely instructive: they provide information about his interests, his favourite artists and his contacts, and help us to follow his progress during a formative period of his career. A small selection of such drawings has been chosen here to illustrate Raphael's pointed dialogue with the works of his great models. Compared to the drawings from living models he continually produced, they are commonly treated as mere copies and have seldom received serious scholarly attention. However, they reveal in exemplary fashion the artistic and mental processes of a young artist still in search of his own language of forms. Such creative copies, which Leonardo and Michelangelo also produced, correspond to the principle of *imitatio* (imitation) as propounded during the Renaissance, and document aspects of study and recollection, of interpretation and, last but not least, of criticism.[84] Of necessity, their emphasis is on figure drawing; drawing from the model was the most important prerequisite for narrative painting, which was the most exalted of all genres. Examples of this type, therefore, are particularly numerous from Raphael's early years in Florence. The chronology of the drawings is still a highly contentious issue; where necessary, problems of chronology will be noted, but they cannot be discussed in great detail in the present publication. Here, our main aim is to provide an overview of the artistic development and orientation of the young Raphael.[85]

A link between these drawings and Leonardo's *Battle of Anghiari* material is provided by a sheet dating from Raphael's early Florentine days, which is instructive in several respects (**48**; Ashmolean Museum, Oxford). It shows two heads – one of a young man and largely finished, the other of an old man in profile and only roughly sketched – together with two studies of hands and a cursory sketch of a battle scene. There is apparently nothing to connect the individual drawings, but detailed research has shown that the two heads and the hands are probably preliminary studies for Raphael's fresco for S. Severo in Perugia (**15**).

Of greatest immediate interest is the largely finished drawing of the youth's head. Drawn with strong outlines, the physical features are nevertheless delicately modelled, while the hair or tonsure (or perhaps headgear) is indicated only by light shading. The beginning of the torso is lightly indicated, as is a barely visible halo. A direct relationship to the partly damaged figure of St John Gualbert in the fresco at S. Severo can be established through the turn of the head. Confirmation comes from the two studies of hands – one spread out, the other holding a book. They turn up again with reasonable likeness in the surviving parts of the fresco. This establishes the connection between the studies of the head and the hands and furthermore proves that all three, although not organically linked, all refer to a single figure.

This reading is confirmed by the profile of the old man which, if one turns the sheet by ninety degrees, appears above the sketch of the youth's head (**49**). This head also reappears in the S. Severo fresco, where it belongs to St Maurus, seated on the left-hand cloud-bank. Again, the correspondence between the drawing and the painting is quite loose, the painted profile being much less articulated. The suggested relationship between the studies of heads and hands on the sheet and the S. Severo mural rests on the premise that the studies represent designs of a relatively early date, which the artist elaborated later. This conjectural relation-

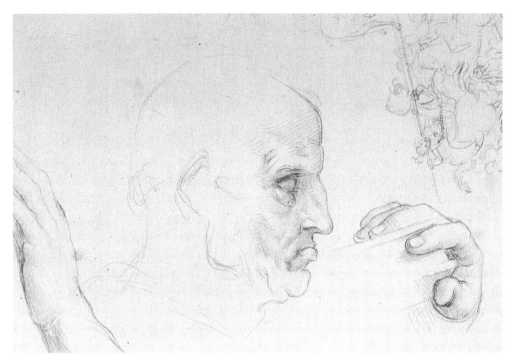

49 Raphael, *Head* (detail of **48**)

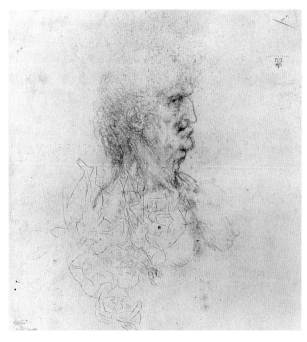

50 Leonardo da Vinci, *Head, Compositional Sketch for a St Anne.*
Chalk and pen. British Museum, London.

ship is instructive as it shows how seemingly unconnected sketches can relate to one figure.

There is another interesting aspect to the old man's profile. Compared to the head of the youth, it is not only differently angled and more strongly marked, but also completely different in spirit. The facial details are delineated forcefully and the whole head expresses tremendous energy. The artist has lavished special care on the profile, given with strong outlines and modelled around the eye, nose and mouth with nuanced shading, and has indicated the rest only with a few strokes. The manner of the profile is something new in Raphael's oeuvre of drawings; the reason is that the artist was using a Leonardo drawing as a model. Several surviving character heads by Leonardo may have inspired Raphael, among them a sheet showing the profile of an old man (**50**; British Museum, London), although this cannot have been the direct inspiration. Here, Leonardo is simply highlighting characteristic features, while elsewhere he raises characterization to the level of grotesque distortion. Leonardo's interest in bizarre physiognomies is a marked feature of his corpus of drawings, one that early on caught the attention of his contemporaries.[86] A detailed comparison of the two drawings shows that Raphael, working presumably from a more restrained study by Leonardo, concentrated on the main elements of the profile and arrived at a clearly constructed, expressive physiognomy he could use for his own purposes. On the basis of the suggested relationship between the two heads on the Ashmolean sheet and the S. Severo fresco, one would have to acknowledge that in the case of the old man's profile Raphael considerably toned down the facial peculiarities in his painting. Further discussion of his drawings will show that the reduction of exaggerated features was indeed characteristic of Raphael's general approach.

The dating of **48** presents certain difficulties, but the two heads, in particular, are likely to date from Raphael's early Florentine years. The medium is metalpoint, a favourite instrument during Raphael's Umbrian period; while in Florence he increasingly worked with a pen.[87] More importantly, the head of the youth is still imbued with idealism and with that psychological vagueness typical of Raphael's studies of heads produced during his Umbrian period, while the profile, with its energy and sense of purpose, reflects a new orientation. The differences between the two heads on this sheet present a stylistic disparity which, by the end of the Florentine period, would be unthinkable.

Turning the same sheet a further ninety degrees, we notice on the lower right a brief sketch (**53**) which obviously relates to 'The Struggle for the Standard' composition from Leonardo's *Battle of Anghiari* (**51**). It is of special interest because it is not modelled on the wall-painting in progress in 1505. Although it broadly corresponds to early surviving copies of that painting, some details show a marked difference: the two warriors underneath the horses are more tightly arranged, and the horseman on the left holds the flagstaff by its lower rather than its upper end. Furthermore, to the right of the group we can make out some indication of the flying banner, which did not appear in the finished section of Leonardo's mural but must have been part of the overall composition. Since none of Leonardo's surviving drawings corresponds with Raphael's sketch, it is unanimously agreed that the sketch is a copy after a drawing now lost. The argument is strengthened by the fact that the galloping horse shown from behind, although it appears to be an independent drawing, is in fact a direct quotation from the cavalcade motif, which formed a part of *The Battle of Anghiari* corpus (**52**). Finally, beneath the head of the youth there is a very brief and almost indecipherable sketch of the

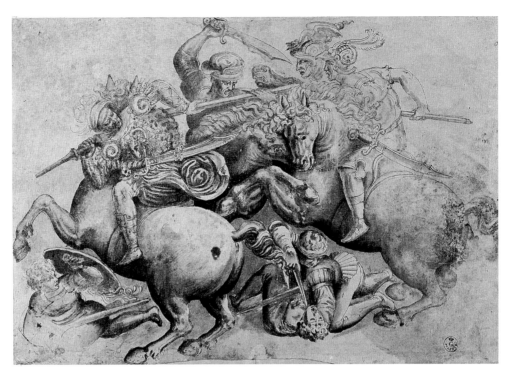

51 Anonymous copy after Leonardo da Vinci, *The Battle of Anghiari* (see **40**)

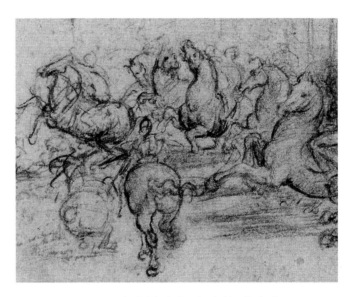

52 Leonardo da Vinci, *Cavalcade* (detail of **42**)

53 Raphael, *Sketch of a Battle Scene* (detail of **48**)

heads of two horses sinking their teeth into each other. This again is one of the main motifs from 'The Struggle for the Standard' composition.

The juxtaposition of the various sketches in **48** also, incidentally, proves significant for Leonardo studies, because it documents the connection between the *Cavalcade* and the *Anghiari* corpus. The rather inconsistent use made of this study sheet is typical of the thriftiness of the times as regards drawing paper. It is covered with sketches for different projects and of various degrees of formality: here, the largely finished head of a youth; there, the only partly developed profile of an old man, together with a rushed *aide-mémoire* of an early version of *The Battle of Anghiari*. In this way, the sheet affords us a glimpse of the way Raphael pursued his studies during the early Florentine years. The different, even fundamentally opposed, expressive values of the heads indicate how far he was still continuing with his Umbrian manner, yet at the same time reacting to a first direct influence from Leonardo. Altogether it seems plausible to assume that the studies of the heads, as well as the three *Anghiari* studies, refer directly to Leonardo drawings.

Raphael's sheet with a standing Leda (**54**) also draws on a design by Leonardo. Again, no direct model has survived, but scholars have generally followed Vasari in dating Leonardo's work on the *Leda* to his Florentine period.[88] It is certain that Leonardo had three conceptions: one of a kneeling Leda, and two versions of a standing Leda, the earlier of which formed the basis for Raphael's drawing. The standing figure rests on the right leg, the free leg is slightly drawn back and the hip shows a marked swerve to the right. Leda has to perform a slight turn backwards with the upper torso to be able to embrace with both arms the neck of the swan that stands on a rock next to her. Her slightly inclined head is turned again to look at the observer. The group is extended to include a *putto* on the lower left picture border. Raphael has emphasized Leda's body and head with strong outlines and modelling, whereas her arms, the swan and the *putto* are only lightly sketched, and has dispensed with any additional setting. Furthermore, the torsion and counter-torsion in the drawing he was working from are only briefly indicated and thus appear unresolved – with the result that the body develops rhythmically in a relief-like way. Because of this, the base of the arms is not quite correctly located, and the movement of the left arm not logically related to the swan. This may be regarded as a weakness in the drawing, and so may the knees: they are slightly parted for greater depth, but have consequently become slightly too slender. These features raise several questions. What did the Leonardo drawing from which Raphael was working look like? Are there any indications of how far Raphael modified the hypothetical model? And if so, how can such modifications be interpreted?

As we have said, no direct model has survived, and Leonardo's larger drawings for the *Leda* consist only of studies of details. However, several of his small-sized sketched notes offer further insight. These jottings are found on two sheets, one of which shows connections with sketches for *The Battle of Anghiari*. They can plainly be read as a sequence, and provide some hints about the process of artistic creation. The first study (**56**) – a detail from a sheet already discussed in connection with *The Battle of Anghiari* – shows a standing female nude, which already includes the basic conception of the *Leda*. Leonardo clearly differentiates between the standing and the free leg, and outlines both the gesture of the arms and the inclination of the head. The rhythm of the composition is still fairly basic and depends solely on shifts along the

main axis. Since the head and arms point in the same direction, attention immediately shifts to the swan, which as yet is missing. It is also significant that the shoulders are almost horizontal. Scholars generally agree that the drawing connects with the *Leda* studies, but it can represent only a very early and relatively simple conception. Leonardo himself gives advice on how to draw a figure: 'Never make the head turn the same way as the torso, nor the arm and leg move together on the same side. And if the face is turned to the right shoulder, make all the parts lower on the left side than on the right; and when you turn the body with the breast outwards, if the head turns to the left side make the parts on the right side higher than those on the left.'[89] These basic rules have not been applied to the present sketch, permitting us to assume that it represents a first, tentative formulation.

A very small sketch helps to illustrate a further stage of evolution (**57**). The drawing, pasted on a sheet with diagrams and anatomical studies, shows the upper part of the body still parallel to the picture plane, especially noticeable in the area of the shoulders, placed almost horizontally; the lower part, however, has a distinct torsion, indicated by the legs placed one behind the other. The head now performs a counter-movement to the arms. Finally, we find on the verso of the same sheet a third sketch, difficult to decipher because of later erasure (**58**). The main features, however, are clear enough: the standing and the free leg, the swinging hip, the posture of the arms and the inclination of the head. Already all these particulars largely correspond to Raphael's drawing. Leonardo, in his brief sketch, seems to have aimed at a more emphatic torsion of the figure, hinted at by the noticeable drawing back of the left shoulder. A new idea is suggested by the sharply inclined head in near profile: while the arms reach out in one direction, the head turns the other way. Here, the aspects of attraction to and aversion from the swan are already formulated, though not yet completely resolved. The next step is recorded in Raphael's drawing, where the conflicting movements are harmoniously fused by the posture, and by the head's inclination and barely noticeable return movement.[90]

Leonardo's sketches illustrate his evolution towards that version of the *Leda* which Raphael copied. Although we have no further full-length drawings by Leonardo which would allow a closer comparison with Raphael's drawings, later versions of Leonardo's *Leda* prove useful. The first is documented by several copies, one of which is particularly helpful (**55**; Louvre, Paris). The sheet, by an unknown hand, has been dated to the sixteenth century; after comparison with the other surviving copies, it can be regarded as reliable. It shows Leda much as she appears in Raphael's drawing, omits the children sprung from egg-shells, but includes the swan standing on a rock covered with a broad-leaved plant.[91] A detailed comparison of the two full-length figure drawings reveals major differences. While the outlines of the legs are almost identical, the modelling of the free leg in **55** is more convincing. It begins with a slight forward movement, cuts across the inner outline of the standing leg, and only with its lower part makes a distinct backward move. The spatial disposition is more convincing and the rounded female forms more pronounced than in Raphael's drawing. The upper part of the body shows even more fundamental differences. While the outlines more or less correspond, the complex posture of the body has been successfully handled only in the anonymous copy. Here, Leda's left arm has been turned so far backwards as almost completely to disappear behind the upper part of the body, and is then taken downwards so that the hand is

54 Raphael, *Leda and the Swan*. Pen over leadpoint and black chalk. Windsor Castle.

55 Anonymous copy after Leonardo da Vinci, *Leda and the Swan.*
Chalk. Musée du Louvre, Paris.

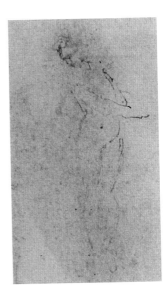

56 Leonardo da Vinci,
Figure Study (detail of **43**)

57,58 Leonardo da Vinci, *Two Figure Studies on a Sheet with Diagrams...*
Pen and ink. Windsor Castle: details, recto and verso.

able to rest on the base of the swan's neck. The upper right arm, its fleshy shape consonant with Leda's well-rounded figure, slightly presses the breast sideways. In this way, the whole body is invested with emphatic movement that accords well with its message of simultaneous attraction and aversion.

Several discrepancies in these areas have already been noted in Raphael's drawing. He avoids the overlap of the strong upper arm with the breast, but now the right arm is too slender, and the left arm is attached in a way that does not continue the backward swing initiated by the body, but redirects it to the picture plane. Furthermore, the inclination of the head is so restrained that Leda seems to glance at the observer. The depiction of the swan, indicated only roughly by Raphael, likewise shows substantial differences. Its neck does not perform the snake-like contortions shown in the Leonardo copy; it is only slightly curved, and therefore much shorter. One may doubt whether in this case Raphael followed his model – this neck rather belongs to a goose, while Leonardo, with his profound interest in natural history, depicts a characteristically long swan's neck and uses it as a visually successful counterpart to Leda's sinuous posture.

Scholars have so far failed to account convincingly for the obvious disparities between Raphael's drawing and other copies of the first *Leda* version exemplified by **55**. The differences have been explained on the implicit assumption that Raphael was working from a lost model. Indeed, the draughtsmanship of his *Leda*, with its clear and energetic outlines and the internal modelling with cross- and parallel hatching, connects it with Leonardo's own drawing style of his Florentine years. But this does not necessarily mean that his model was also a drawing. Raphael carefully studied Leonardo's drawing techniques, especially at the beginning of his years in Florence, and perfected his own style based on these observations. The anonymous artist of **55**, on the other hand, lays particular emphasis on *chiaroscuro* – the soft,

painterly, nuanced passage of light and shadow. Such modelling would be most appropriate to a cartoon immediately preceding a final painting (for example, **31**). The numerous similarities between the sheets suggest only one possible explanation: that the two drawings reflect the same model, presumably the cartoon for the first version of the standing *Leda*. Raphael's drawing includes various inconsistencies of a kind one hesitates to blame on Leonardo. These are weaknesses, however, only in a limited sense: they all follow the same principle, in that Raphael always substitutes a more simplified structure for Leonardo's logically constructed, increasingly complicated torsion. He places the body almost parallel to the picture plane, and restricts the movements to axial shifts. In this way he eliminates the complexity of Leonardo's figure, which portrays Leda's inner tension, her vacillation between her conflicting emotions. As a result, Raphael not only simplifies Leonardo's language of forms, but also empties his drawing of its spiritual complexity and depth of meaning.

This analysis can be confirmed by a final comparison. A number of Leonardo's studies of details concerning Leda's head and elaborate coiffure have survived. One of the sheets with different coiffures includes a head with a position and hairstyle closely related both to Raphael's drawing and to that of the anonymous copyist (**59**). The hairstyle is particularly elaborate; it has often been pointed out that Leonardo drew upon contemporary Florentine fashion and pictorial representations, similar to those seen in female portraits by Verrocchio and Botticelli. For Leonardo, the depiction of elaborate hairstyles was not an end in itself, but part of a larger context: 'Observe the motion of the surface of the water which resembles that of hair, and has two motions, of which one goes on with the flow of the surface, the other forms the lines of the eddies; thus the water forms eddying whirlpools one part of which are due to the impetus of the principal current and the other to the incidental motion and return flow.'[92] In the *Leda*, Leonardo emphasizes the close relationship between a woman's elaborately interlaced hair and her emotions; his repeated drawings of coiffures are placed within the broad field of depictions of elementary creative forces. His studies of plants are another aspect of this larger theme; painted copies of the *Leda* show a rich scattering of plants. The studies of heads with downcast eyes refer unmistakably to Leda and her inward-directed psyche. Raphael greatly simplifies the hairstyle, however, and it is hard to imagine that while doing so he was also pondering Leonardo's philosophical elaborations. He omits from his Leda all the ambiguities of a complex inner life, and presents us instead with a young and pretty woman who faces the observer with a slightly flirtatious look (**60**).

Such rephrasing may well be explained by a hesitancy on Raphael's part to engage in Leonardo's multi-level imagery, and is certainly also due to a sense of insecurity during these first explorations of Leonardo's work. Being intent on learning from the great master and model, Raphael at the same time is determined to perfect a formal language all his own; he is therefore careful not to take over too much of the other's personal manner. With his intention of creating clear and easily legible compositions, he is intuitively on his guard and, by keeping a distance, avoids following Leonardo too closely.

A completely different kind of draughtsmanship characterizes the *Portrait of a Woman*, which also dates from the early Florentine period (**61**; Louvre, Paris).[93] Here, Raphael uses strong outlines only for the silhouette of the head and shoulders and to emphasize the facial features, and not for the whole figure. Hair and dress are given with light strokes, and the

113

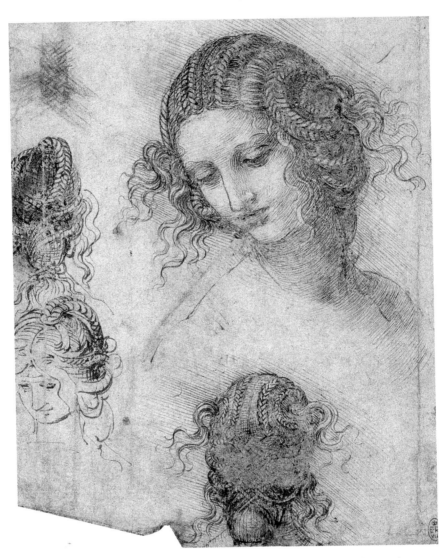

59 Leonardo da Vinci, *Studies for the Head of Leda*. Pen over chalk. Windsor Castle.

60 Raphael, *Head of Leda* (detail of 54)

shading built up with areas of loose cross-hatching. Compared to the *Leda*, where the aim was an accurate copy of a distinct posture, the *Portrait* has the lightness of touch typical of a sketch. Again the model is by Leonardo, but Raphael has intensified his discourse with the master. A crucial difference concerns the task he set himself. The *Leda* could still be called a copy, even if Raphael rephrased certain important aspects. The *Portrait*, however, is undoubtedly based only very freely on Leonardo's *Mona Lisa* (33), with no intention of making an exact copy. There is no dispute that the *Mona Lisa* was the model, but scholars argue about whether Raphael was working from a cartoon or a partly finished painting.[94] Whatever the answer, Leonardo had already decided on the composition and the spatial disposition. The woman is seated in an armchair, with the immediate foreground defined by the balustrade of a terrace or balcony, from which two columns rise as a framing device, features of the painting that have been lost. A view into the landscape must have been included in Leonardo's original conception, but the background we have today is presumably of a much later date. Raphael immediately changes the balance of this overall idea. His figure is more slender, and her arms do not lie on an arm-rest but on a narrow balustrade, a common prop in portraits of the time. The balustrade and columns behind her have been placed higher, thereby reducing the view.

The intention and significance of the *Portrait of a Woman* are immediately clarified if we compare it to an earlier Raphael drawing of a similar subject, the *Portrait of a Young Woman* (62; British Museum, London). This has generally and with good reason been dated to the artist's period in Perugia – the type itself is obviously still indebted to Perugino. The handling of the figure shows precise contours that capture the essentials of the posture, while for the internal modelling the accents produced by parallel hatching are almost evenly distributed. Altogether the modelling is still somewhat hesitant; Raphael has not yet acquired that space-defining technique we find in the later *Portrait*. The posture of the two half-length figures is quite similar, but the earlier drawing is still somewhat timid, for instance in the almost parallel disposition of the arms. The later *Portrait* illustrates the lessons Raphael learned from the *Mona Lisa*: how to stabilize the composition, invest the body with a sense of volume and arrange it within the picture space. Yet the *Portrait of a Woman* represents only a beginning, and not yet the results of Raphael's long discourse with Leonardo. Compared to his great model, there are still areas of uncertainty. The position of the arms is too little defined and constricts the figure's freedom of movement, and that of the hands remains tentative and timid. Furthermore, the balustrade is placed at an awkward height where it divides the sheet in half, so framing only the head and encumbering the corporeality of the torso; the gimp of the bodice at the same level as the balustrade acts as an additional divide.

Only if we understand the *Portrait of a Woman* as an early record of Raphael's study of Leonardo can we appreciate the great progress underlying his *Portrait of Maddalena Strozzi Doni* (63). On the one hand, Raphael uses a figure composition closer to the *Mona Lisa*, borrows the feature of the arm-rest and arranges the hands in a similar way. Yet the overall conception is now freer and more self-assured. The spatial qualities of the half-figure are convincingly displayed: the voluminous puffed sleeves together with a slight turn of the upper part of the body define the figure within the picture space, while the head and shoulders rise above the low horizon and produce an almost palpable presence against the blue, slightly

61 Raphael, *Portrait of a Woman*. Pen over chalk and wash. Musée du Louvre, Paris.

62 Raphael, *Portrait of a Young Woman*. Chalk.
British Museum, London.

clouded sky. The emotional message of this painting owes nothing to Leonardo's *Mona Lisa*, with its direct link to the inscrutable idealized portrait and the fantastic landscape of jagged rocks in the background. Raphael's Maddalena Doni, presented as a sober Florentine housewife, is entirely of the here-and-now. The fact that she is no great beauty should not distract us from the beauty of the painting and its sophisticated execution. Here Raphael, basing himself on the *Mona Lisa*, succeeded in creating a type of portrait that made it possible to depict everyday, even nondescript faces in a dignified and representative manner. The development of Italian portraiture immediately afterwards reflects the extraordinary influence of Raphael's contribution to Florentine as well as Roman and Venetian art.

Compared to the *Portrait of Maddalena Strozzi Doni*, Raphael's portrait drawings of this period are characterized by a rather high level of idealization and seem to be only vaguely interested in producing realistic likenesses. A closer look at the physiognomy of the *Portrait of a Woman* will explain this impression, which could be given further elaboration on the evidence of several other sheets of drawing.[95] If we look at the woman's head (**65**) and compare it to that of the *Mona Lisa* (**64**), we notice again how little Raphael enters into Leonardo's manner of depiction; indeed, his style of representation is completely at odds with Leonardo's. As regards plasticity and clear, solid composition the head in Raphael's drawing owes a great deal

118

63 Raphael, *Portrait of Maddalena Strozzi Doni* (see **20**)

to its model, but any trace of *sfumato* has been avoided, as has that suspicion of a smile which invests the sitter with her famously mysterious beatific expression. Raphael renders the head clearly and solidly, indicates its plasticity and makes the sitter face the observer with a straightforward look. We are in the company of a woman who is simply young and charming, but has nothing of that haunting quality that confounds all interpretation. Raphael's independence is all the more astonishing in that he not only worked from a specific model, but also employed pen-drawing techniques he had learned from Leonardo.

The few drawings we have discussed on these pages make it seem likely that Raphael was in personal contact with Leonardo during his early Florentine period; the older master must have given him access to drawings for various projects. But from the very start of this relationship, the young artist had his own definite aims and was not tempted to adopt the master's complexity. He did not succumb to Leonardo's fascinating personality – a fusion of creativity, aesthetic theories and the artistic lifestyle. In a well-known passage Leonardo, discussing the hard labour of the sculptor and aiming indirectly at Michelangelo, mentions the superficial attractions of a painter's life: 'The painter sits with greatest comfort and well-dressed in front of his work, handles the featherweight brush with beautiful colours and has put on exactly the clothes he likes, and his house is full of beautiful pictures and clean and

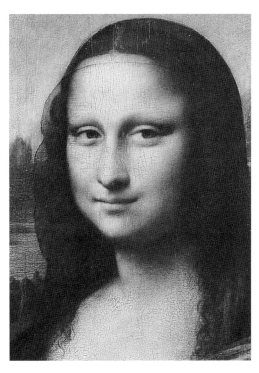

64 Leonardo da Vinci, *Mona Lisa* (detail of **33**)

often you hear music there or various beautiful books are read aloud, a most pleasant sound unaccompanied by hammer-blows or other noises.'[96] Against this, Raphael seems to have had a rather sober and craftsmanlike approach, formed during his years of apprenticeship and early successes in Umbria. The dialogue with Leonardo was useful in that it enabled him to free himself of his Umbrian beginnings and Peruginesque style, and to develop his own *maniera* in response to the highest standards in the arts.

Raphael's relationship with Michelangelo was of a different kind. The greater distance between them may partly be explained by Michelangelo's occasionally documented tendency to keep his own artistic productions secret for as long as possible. The only known drawings by Raphael after Michelangelo are of sculptures – that is, of works accessible to the public. Primarily – and almost inevitably – they deal with Michelangelo's *David*, placed on public view in May 1504 and a matter of widespread interest (**35**, **67**). Leonardo also seems to have studied the *David* very carefully, and a sketch survives to record his interest (**68**). He gives the figure from the principal viewpoint and generally retains its features, only making the body stronger and more Herculean. The position of the arms is slightly changed, and the head turned so that it is seen in profile. The lightly sketched sea-horses at the feet of the figure perhaps suggest that Leonardo thought of changing the figure into a Neptune, although he does include David's identifying sling in the right hand. The main elements of Michelangelo's sculpture are retained, so that the sketch illustrates an interpretative understanding of the sculpture's central concept.

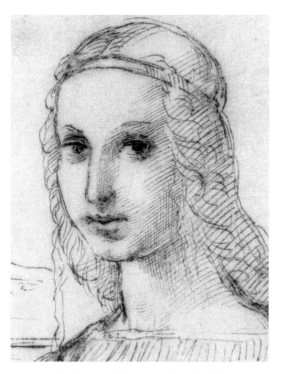

65 Raphael, *Portrait of a Woman* (detail of **61**)

Raphael shared his contemporaries' interest in all that was new about the *David*. Several drawings record his analysis of various motifs of the sculpture,[97] and at least one gives a modified impression of the whole figure (**66**). It is interesting to note that Raphael did not reproduce the well-known main viewpoint from in front of the Palazzo della Signoria, but decided on a more unusual rear view.[98] Scholars trying to determine the exact line of sight of the drawing have pointed out various incongruities, because they were working from the assumption of a consistent angle – natural enough in the age of photography, but not necessarily applicable to the sixteenth century. The explanations offered – for example, that Raphael was working not from the statue itself but from a *modello* – are unsatisfactory. The distinctive view from below is proof enough that Raphael's sketch refers to the actual, overlifesize statue. The artist was looking for an incisive way of representing central motifs given in *contrapposto*. He carefully takes in the posture of the body resting on its right standing foot, as well as the ensuing movements and counter-movements – in particular, the relaxed right arm hanging down and on the left side the free leg and raised shoulder. David's firm gaze, the focal point of the sculpture, would of course not be visible from the artist's position, but the turn of the head is suggestive of the figure's inner concentration, an attitude that defines its whole posture. The main angle of Raphael's rear view is oriented roughly on the diagonal of the whole block, which shows all the parts already mentioned and their interplay.

The 'incongruities' of this view become apparent when it is compared with a photograph (**67**). The 'truth' of a photograph is naturally of a limited nature, one of the basic reasons being the discrepancy between a fixed viewpoint and the optical distortions inherent in the

121

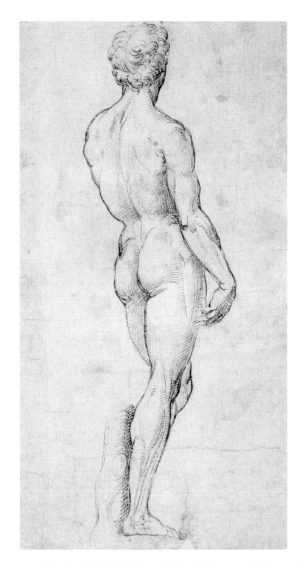

66 Raphael after Michelangelo, *David.* Pen over chalk.
British Museum, London.

67 Michelangelo (copy), *David*. Marble. Piazza della Signoria, Florence.

68 Leonardo da Vinci, *Standing Figure*. Pen and wash.
Windsor Castle.

photographic process. But at least a photograph helps to show that from Raphael's chosen viewpoint the left part of the back and shoulder almost disappear, making this area of the sculpture look strangely flat. To counter this weakness, Raphael changed his position until he was able to incorporate the left side of the body in a satisfactory way. His exact procedure is difficult to reconstruct, and it is possible that the drawing was made not on the spot but composed from several preliminary studies. Only the fusion of two adjacent viewpoints produces a rear view with persuasive power, but this is exactly the weak point in Raphael's drawing: the left part of the back and especially the shoulder are too big, and refuse harmonious integration with the rest of the body. As it is, the drawing would suggest a turn of the upper part of the body to the left, a torsion that neither the statue nor the drawing can otherwise account for. Except for this weakness, the sheet expresses Raphael's newly found confidence in his technical abilities. These are particularly noticeable in his handling of the pen – for instance, in the construction of the clear, dynamic and at the same time rhythmic outlines, and the different tonal values of the modelling.

This drawing has often been discussed together with another of nearly identical size (**69**; also in the British Museum, London). They both deal with the subject of a figure turning away, or rather with the analysis of defining postures and movements in figures seen obliquely. Both drawings concern a fundamental aspect of figure composition – one giving a rear view, the other a side view. On the second sheet the modelling is obviously more insecure. In many areas, the outlines are halting and devoid of the rhythmic harmony of the *David* sketch. The same must be said of the internal modelling, built up with irregular

69 Raphael, *Figure of a Youth*. Pen. British Museum, London.

70 Leonardo da Vinci, *Standing Figure* (detail of **43**) 71 Michelangelo, *Male Nude* (detail). Pen over chalk.
Albertina, Vienna.

strokes. The obvious awkwardness of the modelling has led some scholars to propose a significant interval between the two drawings, the *David* sketch being generally regarded as the later and more mature production. Such a conclusion is by no means self-evident, and the differences may not be due solely to improved technical skills. One of the chief distinctions lies in the fact that on the second sheet Raphael paraphrases Michelangelo's *David* very freely, using the pose as a starting-point for an independent pictorial invention. For this, he chose a similar heroic and monumental figure but without deciding on its final posture. The rendering of the attachment of the right arm is as weak as the adjacent part of the back, and *pentimenti* make the contours of the chest unclear. Finally, the movement and counter-movement of the upper part of the body are abrupt and contrived; they do not come together in one continuous motion. The fact that Raphael obviously had difficulties reaching a solution is reflected in the way he handles the pen. For the *David* sketch, on the other hand, the only slightly modified model supplied a firm structure for analytical purposes. So one may put the two drawings closer together chronologically without necessarily deciding on their sequence.

Raphael's sketch of the *David* is, in any case, probably rather early, because the draughtsmanship is still influenced by Leonardo. For a comparable drawing on the sheet already mentioned in connection with the *Anghiari* corpus (**70**), Leonardo uses strokes of almost equal strength for both the contours and the interior modelling, and carefully renders the bundles of bulging muscles of a man standing with spread legs. Raphael likewise draws heavy outlines

126

72 Raphael after Michelangelo, *David* (detail of **66**)

and articulates the muscles through modelling. He does not simply copy Leonardo's drawing technique, however, but adapts it by reducing its expressive qualities. At the same time, he retains something of Leonardo's idiom by articulating the body's flow of energy. These aspects can best be seen in the modelling of the leg (72). The pronounced cross-hatching in the upper part shows him departing from Leonardo's calligraphy, but it does not yet reflect Michelangelo's own drawing manner at the time of *The Battle of Cascina* project (71). Michelangelo uses outline to frame the body and models the sculptural elements with a network of cross-hatching as if in relief, doing completely without any interior contour lines. Only later did Raphael use this technique – for example, in connection with the *Baglioni Altarpiece* (see 140).

In conclusion, we can say that both in intention and execution similarities exist between Raphael's *David* sketch and his copy of the *Leda*. Both drawings are executed in an almost pictorial manner, and with their obvious attempts at rephrasing both are much more than simply copies. These two examples show that Raphael was aiming mainly for a harmonious depiction of the human body – in the *Leda* sheet he reduces the emphatic torsions of the standing figure, and in the *David* sketch harmonizes the proportions of the body. His analysis of the works of the great masters is also a way for him to solve his own artistic problems. This makes the drawings creative copies in the best sense of the word, produced not in order to appropriate the solutions of others and possibly recirculate them, but to find a new artistic idiom equal to their own.

❧

Besides the great contemporary masters, a young artist would naturally look to the works of the Florentine Quattrocento to train himself and to provide solutions to his own artistic queries. Vasari's mention of Masaccio as one of the artists studied by the young Raphael should be understood as a general *pars pro toto* remark; it need not imply that Vasari had ever seen studies by Raphael after Masaccio.[99] No such studies have survived, but there are at least two drawings that testify to a dialogue between Raphael and the artists of this period. One of these (73), in which the draughtsmanship is close to that of the *David* drawing, shows Raphael directly taking up the challenge of Donatello's *St George* (74). That statue, placed in a niche of Or S. Michele in the centre of Florence and therefore well known to the public, was considered by Renaissance writers on art as Donatello's greatest achievement; during the Quattrocentro it frequently served as a model for heroic standing figures. It appears, for example, in Perugino's full-length study of a man-at-arms (75). The changes in Perugino's figure are the result of its transposition into a different medium, and also of a change in taste, expressing a concept of art that is far removed from the austerity of Donatello's statue. Perugino breaks up the characteristic, block-like compactness of the *St George* by choosing a more open stance and by emphasizing the space between the right arm and the rest of the body. He is especially attentive to the richly decorated armour, with its reflected highlights. Perugino uses the model simply as a point of departure for his own standing figure, which he then interprets according to his own aims. For this reinterpretation he contributed the facial features of an old man, so precisely observed as to suggest that a workshop assistant (*garzone*), clad in armour, posed for the drawing. The sheet is generally regarded as a preparatory study for a *St Michael*, which in its final realization shows the youthful sweetness

typical of Perugino's vocabulary. The *St Michael* in the National Gallery, London, was originally painted as part of the polyptych in the Certosa at Pavia, but **75**, which can be dated to the late 1490s, was the basis for a number of paintings. We can assume that the design was known in Perugino's workshop at the time that Raphael was working there.[100] The younger artist may therefore have seen Perugino's paraphrase of Donatello and become interested in the Florentine *St George* as early as his time in Perugia.

This makes it all the more interesting that, in his interpretation of Donatello's sculpture, Raphael chooses not to follow Perugino's lead. For the standing figure in the centre (**77**), he uses the statue as a starting-point, just as Perugino did, but immediately aims for a personal, direct approach. Although the broader conception of the stance and the turned head links the drawing to Perugino's version, with the position of the arms, the cloak and the shield motif Raphael preserves the integrity of the statue's pose, even emphasizing it by bringing the arms closer together. Donatello's *St George* is basically frontally conceived, but the slender figure comes alive through differentiated movements and counter-movements, combining solidity with grace. Raphael, however, makes his figure look austere and solid, simply by giving it a squatter form; he retains the frontal view and, by turning its head, supplies it with a forceful thrust. One suspects that his rephrasing of Donatello reflects insights gained from studying Michelangelo's *David*: the sense of energy and purpose of the central figure owes a debt to the latter's artistic propositions.[101]

The drawing of which the figure derived from *St George* forms the centre is not a variation in the usual sense, but rather, like Perugino's version, a refashioning of Donatello's concept to suit a new context. Here, armour is indicated by shields and lances but otherwise the figures are left in the nude, a treatment not unusual for composition studies.[102] The warriors form a compact group of three, with the head of a fourth enlarging the arrangement, suggesting greater depth and relieving the symmetrical rigidity of the overall disposition. The central focus is countered by a movement towards the right, whereby the warrior on the left turns to the right with a swinging movement of the body and an inclination of his head. The viewer's eye, following this direction, focuses on the right side of the central figure, and then the position and stance of the next figure on the right direct it back towards the middle. In this way the disposition of the figures achieves coherence and also makes a connection with the observer. A close reading supports the assumption put forward by some scholars that the drawing belongs to a group of narrative compositions, although no convincing candidates have emerged from among the surviving drawings.[103] The precise subject and its final utilization likewise remain to be identified.

A further drawing of a male nude in frontal view (**76**) has tentatively been identified as the Apostle Paul on account of the sketched attributes of a sword and a book, and it has been suggested that the drawing belongs to a series of designs for apostles. Here again, a comparison with Donatello's *St George* is helpful; his stance and posture provide the starting-point. In this new approach to Donatello's statue, Raphael is interested in the rhythmic build-up of the body and the depiction of movement in the hip, shoulders and head. The statue's very light indications of movement are here worked up to a noticeable degree. Torsion is emphasized, creating a dynamic relationship with the solid stability of the figure as a whole. This in turn changes the character of the figure by adding to its firm bodily posture a mood of critical

73 Raphael, *Four Soldiers*. Pen. Ashmolean Museum, Oxford.

74 Donatello, *St George.* Marble. Museo del Bargello, Florence.

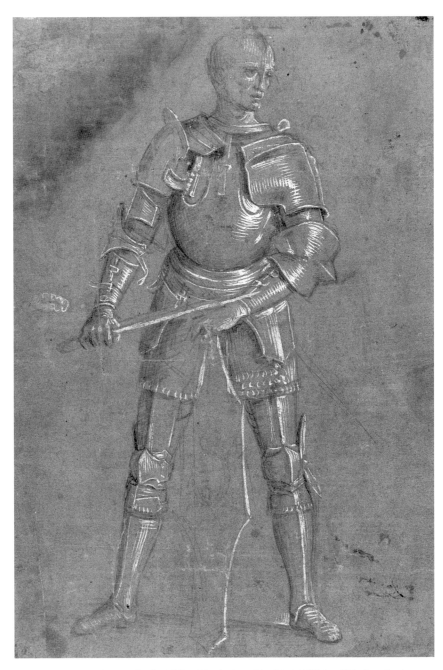

75 Pietro Perugino, *Study of a Soldier*. Metalpoint with white highlights. Windsor Castle.

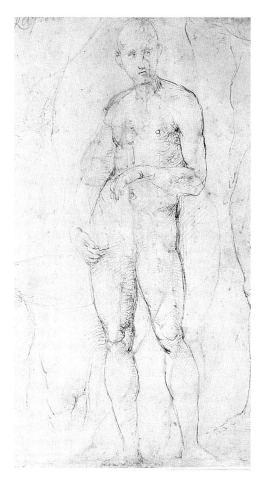

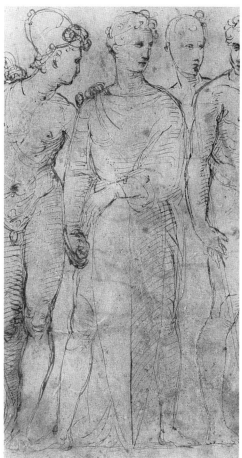

76 Raphael, *Study for a St Paul*. Pen. Ashmolean Museum, Oxford.

77 Raphael, *Four Soldiers* (detail of 73)

reflection, which is most clearly expressed through the slight inclination of the apostle's head. In this second refashioning by Raphael, Donatello's *St George* has acquired a new interpretation, providing the inspiration for a new, autonomous artistic creation. How thoroughly it partakes of the spirit of the approaching High Renaissance becomes apparent if one compares it to Perugino's paraphrase, executed only a few years earlier and still imbued with Quattrocento rigidity.

This process of fundamental transformation can also be studied in a sheet referring to Michelangelo's *St Matthew*. The unfinished sculpture (**79**) was probably accessible to other artists once Michelangelo had left for Bologna at the end of 1506. Raphael's sketch (**78**), dating from about 1506/7, is found on the verso of a compositional design for the *Baglioni Altarpiece* (**141**), on which he was working at the time. At first sight, the drawing has all the characteristics of a copy: it records the main motifs of the sculpture, and only slightly indicates the unfinished condition of the lower legs. But then one begins to notice major differences between model and copy. Raphael has moved the right arm further away from the body, the area of head and shoulders has greater spatial depth and the torsion of the left leg is reduced. The drapery is more conventionally arranged, emphasizing the movements of the body, and avoiding the complexity of the model. Typically, those parts of the drapery where Raphael moves away from the model still employ folds in a traditional 'eye-of-the-needle' form. This may be because the artist had not yet fully managed to adapt traditional styles of representation to the new Florentine manner. Above all, it is the head – turned out of profile and upwards – that invests the figure with a new sentiment. Michelangelo gave Matthew a backward turn and a look of recognition after being called by Christ; Raphael interprets this as a look to heaven. The posture suggests a man carrying something, all the more so because Raphael does not show Matthew's right arm and the book he holds. One gets the impression that Raphael was primarily interested in modifications to the statue's posture and expression for some specific purpose of his own.[104] Such an approach is repeatedly suggested in these drawings, testifying to the determined and self-assured way Raphael treated his models.

The drawing technique has changed noticeably, compared to the earlier examples. Raphael's study of Michelangelo now begins to show results, especially in the cross-hatching of the muscular parts and the shadows. This is not, as some consider, a reflection of the chiselled surface of Michelangelo's sculpture, for we also find it in the designs for the *Baglioni Altarpiece*. A more likely explanation is that Raphael by now had had the opportunity to examine Michelangelo's own drawings.

A final look at two more drawings clearly shows how deeply Raphael was inspired by Michelangelo's *St Matthew*. One, dating from his early days in Rome, shows the upper part of a man in chains (**80**; Albertina, Vienna). The posture and turn of the head derive from the *St Matthew*, though the head is turned in the opposite direction and its position and expression indicate another rephrasing, this time to represent the anguish of the tortured body. The pathos of Michelangelo's model is here channelled into the expression of a quite different emotion; only by knowledge of Raphael's sketch of the *St Matthew* can this drawing be traced to its ultimate source. The same can be said about a slightly later sketch on a sheet with three studies of heads for the *Parnassus* painting in the Vatican (**81**; Windsor Castle). The type of bearded figure is retained, but the dramatic upward gaze of the *St Matthew* sketch has been

transformed into the serious, energetic turn of the head of a dignified philosopher. Both drawings are only distantly related to their models, and thus should be regarded not as copies but as paraphrases. They illustrate how, after a period of time, the artist was able to adapt his copy of the *St Matthew* to express new meanings.

One drawing that shows Raphael no longer directly reflecting specific works by his masters, but being intimately involved with the most progressive currents in Florentine art, is the sheet showing a *Battle Scene with Captives* (**83**; Ashmolean Museum, Oxford). The composition belongs to a group of three drawings illustrating Raphael's experiments with the *historia* genre.[105] The specific subject remains unidentified, and we can only speculate that Raphael took his inspiration from the narrative paintings by Leonardo and Michelangelo for the Grand Council Chamber. It has rightly been pointed out that this and other sheets also show influences of other models – of Antonio Pollaiuolo (*circa* 1432–98) and Signorelli, for example. Raphael's relationship to both Leonardo and Michelangelo finds remarkable expression in this drawing.

The free, sketchy handling would suggest that the artist developed the visual concept swiftly and spontaneously, without detailed preparatory studies from the model. The composition nearly fills the whole space and shows the fighting men centred on a group including a bearded man who bends down to tie up a kneeling figure. Three figures come rushing from the left, their gestures connected to an event taking place outside the picture area. A fourth figure, only lightly sketched, lies on the ground. On the right side we see a bent figure walking and shouting, and the back of another man holding a lifeless body. These two figures also look in the direction of the invisible event. The combination of emphatic movements with excited attention focused on some unspecified action had already been used successfully by Michelangelo for his *Battle of Cascina* cartoon, and it could well be that the basic idea provided the inspiration for the present drawing (**84**). Dependence on the *Cascina* cartoon becomes more obvious once we look at the central group, where the positions and spatial relation of the two figures are similar to those in the cartoon. The nude figure viewed from the rear likewise paraphrases one of the *Cascina* figures. Side by side with such obvious borrowings from Michelangelo, we find references to Leonardo, most clearly in the figure of the shouting man. The head vividly expresses the fury of battle, a motif specifically mentioned by Leonardo in his advice on the depiction of battle pieces (see page 89). He himself used the motif in his drawings, of which a well-known sketch in Budapest is a good example (**85**).

Battle Scene with Captives and the related group of works are often regarded as mature productions, examples of the artist's independent conception of narrative painting. This view is usually coupled with a tendency to assign them to the end of Raphael's Florentine period. Reflecting Raphael's long dialogue with his Florentine masters, the drawing is indeed characterized by a more relaxed and detached relationship to them, in that, for instance, he now combines elements borrowed from both Leonardo and Michelangelo. Nevertheless, an earlier date of about 1506 is more plausible, because the drawing's shortcomings are too obvious and its borrowings too much like quotations instead of being fused to form part of a new independent idiom. Some areas are distinctly weak – for instance, the somewhat skewed proportions and foreshortening of the figure rushing up from the left, and on the right side the

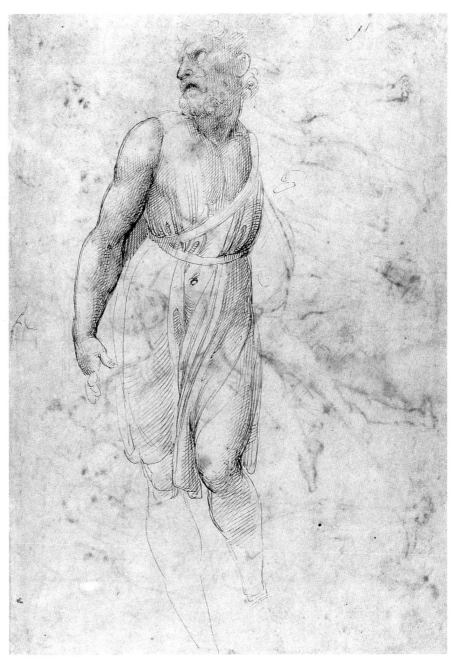

78 Raphael after Michelangelo, *St Matthew*. Pen. British Museum, London.

79 Michelangelo, *St Matthew*. Marble. Galleria dell' Accademia, Florence.

80 Raphael, *Figure Study* (detail). Pen over leadpoint. Albertina, Vienna.

81 Raphael, *Study of a Head* (detail).
Pen. Windsor Castle.

82 Raphael after Michelangelo, *St Matthew* (detail of **78**)

83 Raphael, *Battle Scene with Captives*. Pen over chalk. Ashmolean Museum, Oxford.

slightly stiff and incorrectly drawn body supported by the figure seen from the back. Finally, the composition fails to unite the individual figures into a compact group. Yet one can clearly recognize Raphael's intention, his attempt to carve out his own position midway between his two great forerunners. By deciding not to fill the whole picture space with sculptural plasticity, he follows Michelangelo's idea for *The Battle of Cascina* only in part, and also shies away from Leonardo's powerful display of complex interpenetration of the figures in the design for *The Battle of Anghiari*. Instead, Raphael concentrates on the narrative sequence, arranging his figures into an almost frieze-like disposition, with only moderate use of pictorial depth. His figures project a sense of continuous motion across the breadth of the picture, which in the present drawing is focused on the group of captor and captive, the centre both of the composition and the narrative. For us, the significance of the drawing is that Raphael, although still dependent on his models, shows a clear determination to create a style all his own.

He was not looking for ready-made solutions, but rather approached the models he chose in a highly creative way. He consistently avoided complexity and simplified complicated compositions, his rephrasing of the *Leda* being a particularly striking example. He was always concerned with readability, with the development of a vocabulary of forms that was easy to grasp. *Battle Scene with Captives* represents an early foray into the *historia*, illustrating the astonishing progress in Raphael's expressive skills within a short time. The weaknesses and insecurities in these drawings only underline Raphael's considerable problems in shedding the traditional elements of his Umbrian training in order to develop a pictorial language equal to the high standards of Florentine painting then being created.

84 Aristotele da Sangallo, after Michelangelo, *The Battle of Cascina* (detail of **44**)

85 Leonardo da Vinci, *Head of a Warrior*. Chalk.
Szépmüveszéti Múzeum, Budapest.

IV. THE FLORENTINE PAINTINGS

The half-length Madonna paintings

Raphael's intense study in the art of drawing was a way to prepare himself for greater painting projects, for sophisticated and preferably large-sized narrative paintings. Although the young artist never received such commissions during his Florentine years, the city at least gave him the opportunity to make his mark as a painter. An important genre in this respect was the small devotional picture, which had become very popular in Italian centres of art during the later part of the fifteenth century. This type had first appeared during the Trecento and was designed for private devotion, not for church service. It was produced in various media – painting, sculpture and printing – and brought about close links between the different branches of the arts. During the fifteenth century, the devotional picture experienced a rich flowering and a great many individual subjects evolved: the Pietà, the Holy Family, the Virgin and Child with St Anne, the Mystic Marriage of St Catherine, and, most popular of all, the Madonna and Child. Many households possessed devotional images, choosing a cheap print or a relatively expensive painting according to their means.

The great popularity of these pictures was closely linked to the piety characteristic of the time, and was further enhanced by the custom of presenting them, especially those depicting the Madonna and Child, as gifts to newly-weds. Although documentary evidence dates only from the late sixteenth century, it seems safe to assume that the custom was widespread during the Quattrocento. Vasari repeatedly mentions *quadri da spose* (betrothal pictures), and Armenini has this to say in connection with old devotional pictures in private hands: 'In this respect, therefore, the custom of Tuscany and Rome is certainly excellent. They do not marry women unless with their gift, besides the dowry, there is a beautiful picture, and it must be well painted, since the Tuscans are most knowledgeable about the power and excellence of this art.'[106] Furthermore, connoisseurship had been evolving since the second half of the fifteenth century together with an interest in collecting, which also included devotional pic-

tures. By the early sixteenth century, therefore, such images could serve more than one pur-pose. Their principal function was to fulfil a religious need, and artists catered for this aspect partly by supplementing the mother-and-child group with a host of motifs and attributes alluding to the martyrdom of Christ. But such paintings also came to be valued as works of art, and were acquired as such.

This widespread demand caused established artists to produce devotional works in large numbers or, rather, to have them produced by their assistants – as was the practice of Perugino and Giovanni Bellini (*circa* 1430–1516), to name but two. In their workshops, the production of devotional pictures followed an organized pattern: a successful composition would be copied repeatedly with only minor changes, or the central image of a larger compo-sition would be reproduced in the appropriate format. However, the devotional picture also presented an opportunity for experiment of which all the well-known masters availed them-selves. Given the extremely limited repertoire of figure types, there was a constant search for new motifs and manners of representation; from the fifteenth century onwards, this invari-ably meant a greater degree of realism, showing religious events in a more life-like and per-suasive setting. The most eminent practitioner in Florence during the later fifteenth century was Leonardo; he had produced his first pictorial innovations in the 1470s and was now devising completely new and exciting imagery – for example, in the *Madonna with the Yarnwinder* (**29**). Michelangelo's *Doni Tondo* (**38**), itself perhaps a betrothal picture, can partly be understood within a framework of artistic rivalry and was, in certain respects, an answer to Leonardo's distinctive manner in this genre (see page 85).

Small devotional pictures cost little to make and were easy to sell, which must have made them particularly attractive to younger artists. The relatively large number of surviving paintings from this time also suggests that they were often produced not for specific cus-tomers but for the open market. As yet, little is known about the organization of such a mar-ket in Florence around 1500, when it was presumably still in an embryonic stage, or about transactions involving works of art. It seems unlikely to have been as highly structured as the Antwerp art market of the early sixteenth century. But we know of at least one art dealer, Giovanni Battista della Palla, who was active during the first quarter of the sixteenth century. Perhaps workshops kept copies of successful designs in stock, and customers could choose what they liked from the selection at hand. We cannot assume that every small-sized painting was produced on commission, a caveat that should be borne in mind in connection with some of Raphael's paintings.[107]

To the newly arrived Raphael it would therefore have seemed advisable that he concentrate initially on the production of small devotional pictures. Only his financial circumstances can explain this choice: with neither a substantial commission nor a supportive patron nor any funds to speak of, he would be guaranteed a certain income and at the same time have an opportunity to attract the attention of collectors by offering paintings of superior quality.[108] He approached the new genre as he had previously studied drawing, training himself system-atically and entering into a dialogue with the great masters in order to develop his own lan-guage of forms. The mother-and-child motif was a most suitable subject, because of its restricted repertoire; typical examples from his Florentine period demonstrate Raphael's consistent approach and progress. We will begin with some half-length paintings of the

Madonna – not a very demanding type of composition and, on account of its limited range of features, one well-suited to comparative studies. Full-length paintings presented a greater challenge to the artist, partly because of the increased number of figures to be handled, partly because of the larger format.

86 Raphael, *Christ Child* (detail of 126)

87 Raphael, *Madonna and Child with a Book*. Oil on panel.
Norton Simon Foundation, Pasadena, California.

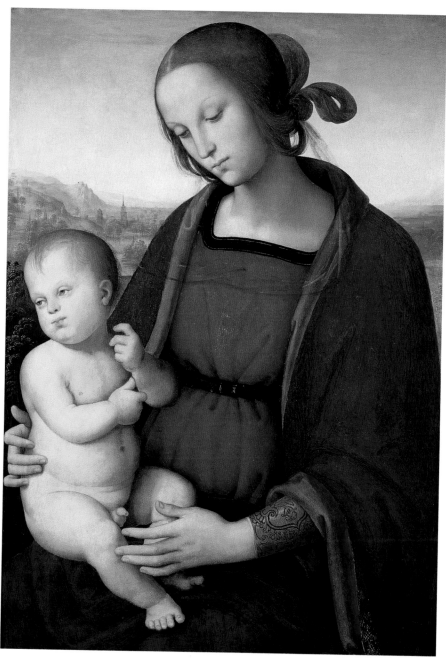

88 Perugino, *Madonna and Child*. Oil on panel.
National Gallery, Washington.

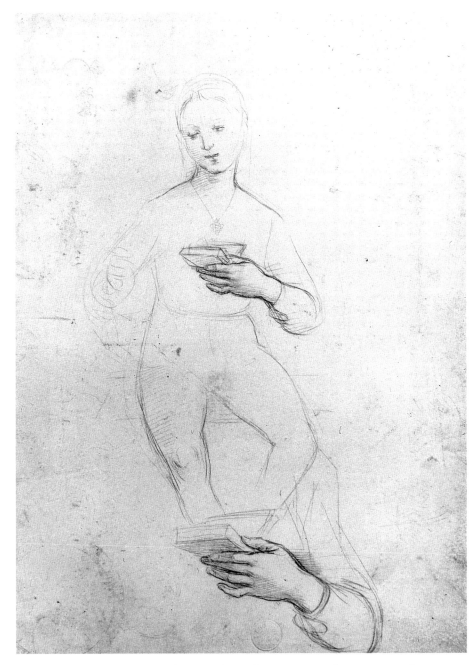

89 Raphael, *Figure Study for the Madonna*. Silverpoint. Musée des Beaux-Arts, Lille.

Raphael's *Madonna and Child with a Book* (**87**; Norton Simon Foundation, Pasadena) is a classic example of its type. Certainly produced before the artist moved to Florence, it illustrates clearly his artistic accomplishments and intentions at the start of his Florentine career. It is thus particularly well suited as a starting-point for our observations. At first sight, the painting appears to conform with the standard pictorial representations of the mother-and-child group. The Virgin is shown in the near foreground with the Child seated on her right knee. Looking up to his mother, the Infant touches her hand and the breviary she holds for him. The background consists of a hilly landscape with a lake and a castle, apparently surrounded by water, on the left. The sweetness of the Madonna, the types of the heads and the intimacy established between mother and child make one think immediately of Perugino.

Perugino's own *Madonna and Child* of about 1500 (**88**; National Gallery, Washington), being almost contemporaneous, offers a good case for comparison. The two paintings share motif and sentiment through the lively gestures of the Child, the meditative gaze of the Virgin and the atmospheric landscape. In terms of quality and delicately nuanced colour application, the works also have much in common, but Perugino's depiction is more evenly balanced and his landscape richer in atmospheric detail. On closer examination, however, one begins to notice various incongruities in Perugino's figure composition. The seated position of the Child is only partly defined, the Virgin's hands do not actually hold him, and neither the turn of his head nor his gestures are clearly motivated. These features receive new, clarifying accents in Raphael's painting, because he explains the relationship between mother and child through a logical sequence of narrative details. He places the Child on a pillow and thus justifies the posture of the body and the position of the legs. With her right arm Mary gently embraces the Child, and with her left hand offers the open breviary. The Child in turn touches both her hand and the book, and his upward glance at his mother suggests an exchange of thoughts about the sacred text. The tight interlacing of the two figures is elaborated by the direction of their gazes, the similarity of outlines on the right, and in the area where the hands meet to hold the precious book. These formal innovations, or rather intensifications, combine to suggest a deeper sense of meaning.

The breviary is opened at a page showing the letters *Ad m/De/in* in Gothic minuscule script. Despite the slip of the brush in the first line, Raphael was obviously quoting from nones, a short prayer said in the afternoon at the ninth hour, which begins with the words 'Ad *nonam. Deus in adiutorium meum intende ...*' Nones is usually associated with thoughts about the hour of Christ's death. This defines the situation very precisely: the Child – according to Church doctrine having 'understanding' of his destiny from the very beginning – is reading nones with his mother and thus reflecting on his own Passion. Raphael illustrates this aspect with an expressive language of gesture and gaze, and the open breviary at the centre of the painting is accorded special significance (**92**). Among Raphael's paintings of Madonnas, the legible characters in the open book are an exceptional feature and need to be explained by non-artistic factors.[109] He may have received a very specific commission, but we are completely in the dark about the circumstances; perhaps it was for a member of a religious order, who stipulated exactly its iconographical features.

Raphael does not merely insert this uncommon motif, but goes on to place it right at the centre of a clearly expressed narrative. It is here that he becomes more specific than Perugino,

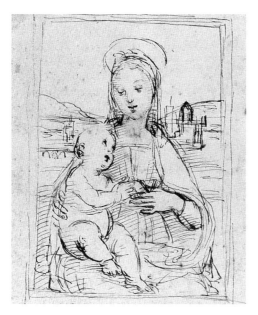
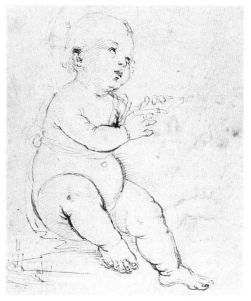

90 Raphael, *Madonna and Child.* Pen over stylus. Ashmolean Museum, Oxford.

91 Raphael, *Study for the Christ Child.* Pen over stylus. Ashmolean Museum, Oxford.

and decidedly parts company with the latter's artistic manner. The preparatory drawings support this impression, and provide us with a clear insight into the thought processes of the artist at work. The first of three relevant figure studies is concerned with the disposition of the Madonna and is a classic example of a *garzone* drawing (**89**).[110] This term refers to the practice whereby one of the workshop assistants (*garzoni*), either nude or dressed in the typical tight-fitting shirt and narrow hose of the time, adopted the pose required and was drawn by the artist, irrespective of whether the final figure was to be male or female. The practice was especially common in the workshops of Florence, and was also used by Perugino. Raphael accustomed himself to it at an early stage and made increasing use of it. The present drawing concentrates exclusively on the Virgin's seated position, adopted by the *garzone* sitting on a plank. The right hand, which is eventually to hold the Child, is indicated only roughly and is not yet defined in detail. The position of the legs, however, already reflects the weight of the body in that, for instance, the thighs are spread asymmetrically. Raphael pays particular attention to the head, which already shows the slight inclination and downcast gaze, and to the hand holding the book, to which he devotes a second, slightly larger study. In this way the main elements of the Virgin's posture were already clarified in the drawing.

The second sheet (**90**) bears a sketch of the complete composition and a separate design for the castle in the background, which has been much modified in the painting itself. The compositional sketch roughly outlines the disposition of the Virgin and Child, but some details obviously still needed to be worked on before a final resolution. The Madonna is rendered more slender, her dress is more loosely arranged and does not yet partly cover the Child. The position of the hands, in particular, needed clarification: her right hand is placed lower down and the central motif of offering and receiving is not yet formulated. In a third drawing (**91**) Raphael concentrates on the position of the Child, investing the figure with a greater sense of

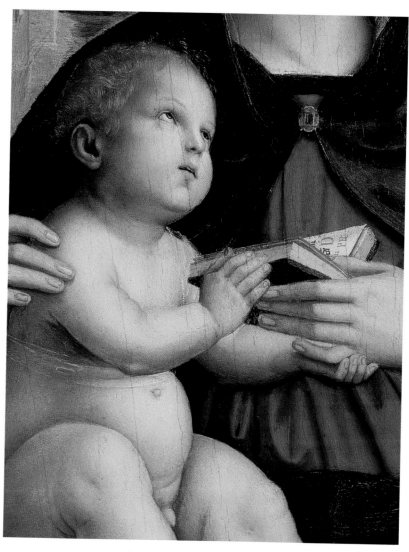

92 *Raphael, Christ Child with a Book* (detail of 87)

volume. It has been rightly pointed out that this may be a borrowing from Leonardo's *Benois Madonna*, of which the artist may have seen copies, or even the original, during an earlier short visit to Florence (**103**).[111]

The *Madonna and Child with a Book* illustrates clearly Raphael's continuing affinity with Perugino, which is equally noticeable in his later Umbrian altarpieces. Yet Raphael is determined to move beyond Perugino's style, and to give his composition a solid – one could almost say monumental – form, together with greater profundity. His aim is therefore to make a carefully and lucidly composed group, organized along a narrative subtext and incorporating both Peruginesque and Florentine elements.

The *Small Cowper Madonna* (**93**; National Gallery, Washington, named after the third Earl Cowper, British minister to Florence in the late eighteenth century, where he acquired this painting and also the *Niccolini–Cowper Madonna*) is generally dated to the artist's first Florentine period, with opinions varying between 1504 and 1506. The main issue under debate is its dating relative to that of the *Madonna del Granduca* (**98**). Recent cleaning of the picture, undertaken in 1983 in connection with the Raphael quincentenary, has allowed a new and more precise reading. The Virgin is shown on a wooden bench in front of a green wall, which divides foreground and background, but which in coloration mediates between the two areas. Mary wears a blue cloak with green lining over a red dress and supports the Child with her left hand. The Child puts his left foot on his mother's resting hand and embraces her round the neck; the two heads slightly incline in opposite directions. Both figures gaze thoughtfully at some point beyond the picture space, linking them together and providing a contemplative accent to the animated movements of the Child. The background consists of a broad, hilly landscape with minute figures, a lake on the left and monastic buildings on a hill on the right. The background architecture, typical of the time, has traditionally been thought to represent the church of S. Bernardino outside Urbino, but modern opinion regards it as a very free rendition.[112]

On comparing the two paintings, **87** and **93**, it becomes apparent that although Raphael still tended towards Perugino's coloration, he had otherwise dispensed with all Peruginesque traits – the group appears more at ease, more alive and spatially less restricted. This progress may be explained by the influence on Raphael of a type of half-length Madonna composition very common in Florence. The type is particularly well represented by terracotta sculpture from the workshop of Luca and Andrea della Robbia. The motif of the standing Child, held by his mother and embracing her neck, is known in several versions, although none is close enough to have been the direct model.[113] Our reference is a related type, a *Madonna and Child* by Luca della Robbia (**94**; Bargello, Florence), which also amplifies the subsequent discussion of the *Madonna del Granduca*. Luca's works, produced from the middle of the fifteenth century, made use of a rich vocabulary of forms to intensify the spiritual relationship between mother and child; they far surpassed anything Perugino achieved in this respect. It is a testimony to Raphael's quick perception of the qualities of earlier Florentine sculpture that he exploited their potential at the very beginning of his period in that city, and from this basis developed a completely new sense of spatial freedom for the two figures in the *Small Cowper Madonna*. In effect, he translated a fifteenth-century type into the language of the early High Renaissance.

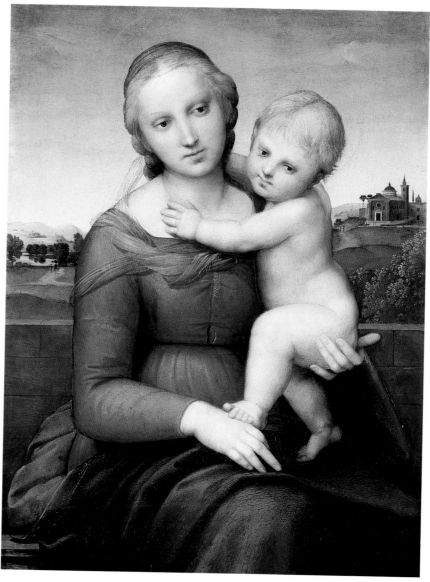

93 Raphael, *Small Cowper Madonna*. Oil on panel. National Gallery of Art, Washington.

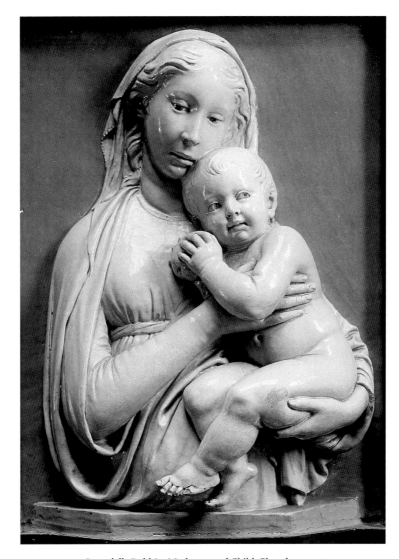

94 Luca della Robbia, *Madonna and Child*. Glazed terracotta.
Museo Nazionale del Bargello, Florence.

Such positive features, showing Raphael's independent approach to his models, are marred by some infelicities. In the foreground, the space defined by the bench and wall is not large enough to accommodate the ample figure of the Virgin, and the lively outlines of the Child find no response in the severe and somewhat dry representation of Mary's right arm. Most importantly, the weight of the Child's robust figure is not made palpable: Mary's right hand rests rather limply on her thigh and lends as little support to the Child's left foot as does her left hand to his body. These details alone suggest that the *Small Cowper Madonna* should be dated to the very beginning of Raphael's period in Florence.

No preliminary studies for the painting have come down to us. Differentiated underdrawing is revealed by infrared reflectogram, which penetrates thin layers of paint (**95**). This technique makes visible the drawing of the upper part of the bodies, executed with black chalk on a white ground. The areas of the blue cloak, where the paint was more thickly laid on, show no underdrawing, however, and neither does the sketchily painted landscape with its religious architecture. Presumably the artist prepared the landscape only in rough outline as he did for other paintings.[114] Finally, charcoal dots along the outlines indicate that Raphael first transferred the complete composition, of which he must have prepared a cartoon, by pricking out the contours. Then he seems to have corrected these lines with a few strokes, and sketched the interior modelling for further clarification before the final execution. The reflectogram (the analysis of which in some ways acts as a substitute for a preparatory drawing or a cartoon) gives us the means to examine the corrections the artist drew at the last moment. Here, they consist only of slight *pentimenti* and a harmonization of the contours.

The *Madonna del Granduca* (**98**) has likewise been reassessed after its most recent restoration and scientific examination. At first sight, the conception appears much more simple than that of the *Small Cowper Madonna*. The almost half-length figure of Mary is shown standing, her left hand supporting the Infant and her right lightly holding him. Both heads are slightly inclined and are linked by the shared direction of their gazes. Against the strong blue-and-red contrasts of Mary's dress the flesh tones of the figures, seemingly touched by sunlight, acquire delicately shaded nuances. Today, the figures stand out against a dark background; originally they were not so tonally isolated from the background.

An x-ray photograph taken during restoration work shows the painting to be in generally good condition with few losses, and that the background was conceived as a piece of architecture in two parts (**97**). On the right, a round arch opens into an indistinct landscape where a bright strip presumably indicates the horizon. Sill, pilaster, capital, transom and the beginning of the archivolt may indicate a window or an arcade. There was a corresponding construction on the left, but its details cannot be identified with any certainty. The x-ray failed to provide any clues about possible alterations made while painting was in progress. The arcade or double-windowed architecture may have been derived from early productions of Leonardo's circle; it reappears in the later *Aldobrandini Madonna* (National Gallery, London). According to experts entrusted with the restoration, these architectural elements were overpainted by Raphael himself. This would mean that the artist removed the views into the landscape in order to give more weight to the figures.[115]

The one surviving preparatory sketch for the *Madonna del Granduca* shows that Raphael decided fairly late on the architectural elements and used them at first to steady the figure

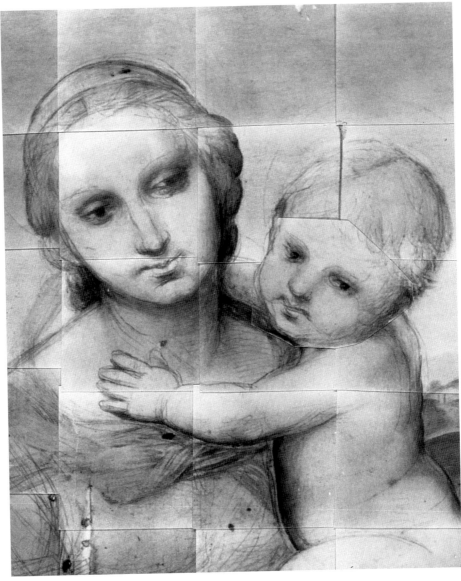

95 Raphael, *Small Cowper Madonna*. Infrared reflectogram (see **93**)

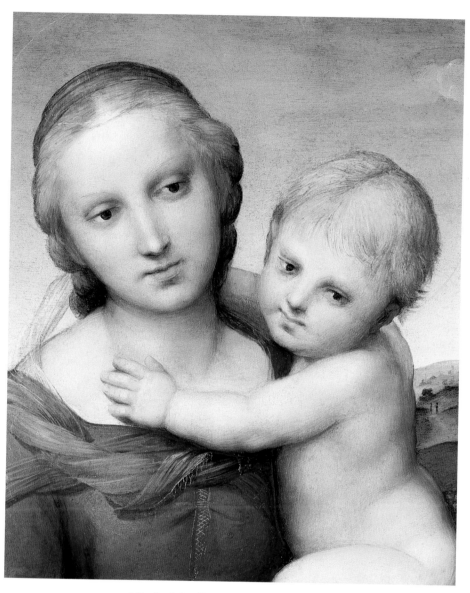

96 Raphael, *Small Cowper Madonna* (detail of **93**)

97 Raphael, *Madonna del Granduca.* X-ray photograph (see **98**)

composition (**99**). The chalk drawing illustrates the first conception for the painting, and also shows that several stages were needed to reach the final format. Still undecided, Raphael explored the tondo form, as well as a wide and a very narrow upright format. For the background he probably intended a landscape with hills. The Child's lively posture recalls that in the *Small Cowper Madonna.* The slender Virgin's head shows a more pronounced inclination, and she uses her right hand not to support the Child but only to catch his raised foot. While Raphael has altered the motif by making Mary hold up the Child, the whole composition is still indebted to the *Small Cowper Madonna,* which presumably provided the basic imagery for the *Madonna del Granduca.* Infrared photographs show that the cartoon, which has not survived, was transferred by pricking.

In the finished painting, the group has been clarified and has acquired much greater plasticity. Raphael renders the Child stouter and expresses the combined movement of closeness and detachment more persuasively. Mary's head is only slightly inclined and she both holds and supports the Child. Both figures are given broader movement, the corporeality of the Child corresponding to the plasticity of the Virgin, and the right arm with the enfolding cloth acting as a counterbalance to the Child. In the preparatory sketch, this last motif is only partly developed, the garment tightly fitted to the still slender figure. All this would imply that between the sketch and the painting Raphael had intensely studied the most recent Florentine

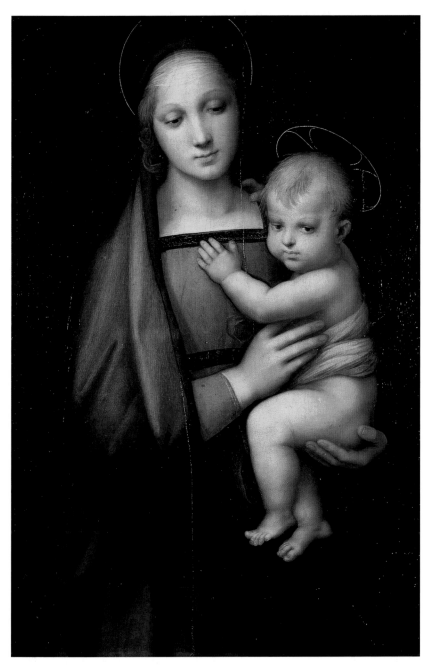

98 Raphael, *Madonna del Granduca*. Oil on panel. Palazzo Pitti, Florence.

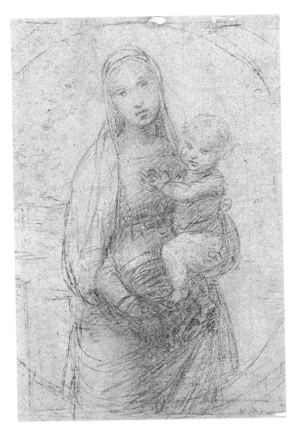

99 Raphael, *Sketch for the Madonna del Granduca.*
Chalk over stylus. Galleria degli Uffizi, Florence.

works of art. The greater maturity of the formal language tempts one to suggest the influence of Fra Bartolommeo and Albertinelli. The latter's *Visitation* of 1503 not only has the motif of the cloth across the arm, but could also have suggested the broad sweeps of the drapery (**25**).

With the *Madonna del Granduca*, Raphael again created a popular type expressed in the formal language of the early High Renaissance. Another look at Luca della Robbia's *Madonna and Child* clarifies Raphael's position further. Two central motifs explored in the *Madonna del Granduca* – the Virgin both holding and supporting the Child – are already present in Luca's work. Comparing the two, we realize that some fifty years earlier della Robbia had already shown these motifs as real actions, with his convincing visualization of the volume and weight of the Child. Raphael borrowed the hand gestures, but they remain mere motifs, giving no indication of the weight of the little body. These aspects are sufficient to suggest a date for the *Madonna del Granduca* some time at the beginning of Raphael's Florentine period, when modes of representation he had learned in Umbria were still in evidence.

The *Madonna with a Carnation* (**101**; Alnwick Castle, Northumberland) shows considerable progress compared to the earlier works. The painting, long thought to have been lost, was probably a great success at the time of its production, for many copies of the composition have come down to us. It has long been recognized that Raphael invented the motif and that the arrangement of the figures is strongly Leonardesque; its direct links with Leonardo's

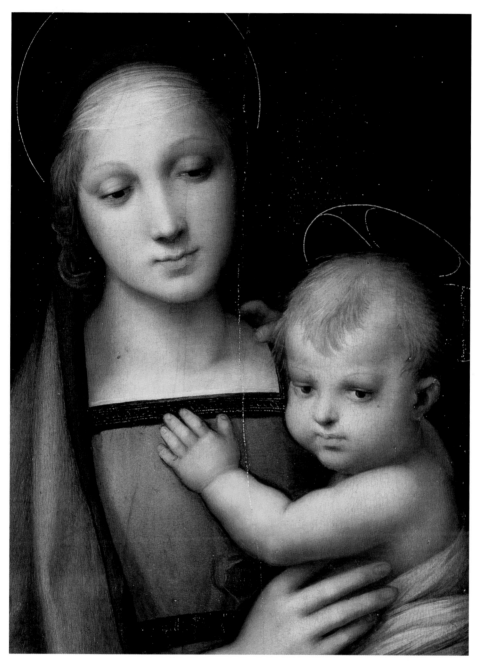

100 Raphael, *Madonna del Granduca* (detail of **98**)

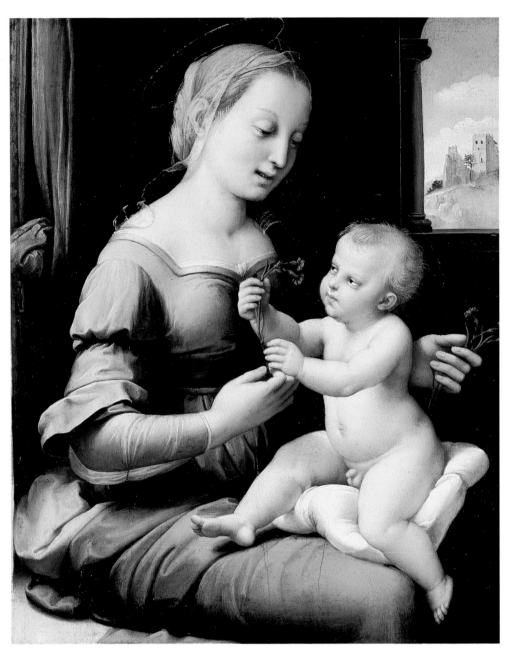

101 Raphael, *Madonna with a Carnation*. Oil on panel.
Collection of the Duke of Northumberland, Alnwick Castle.

Benois Madonna (**103**) were also noticed early. The long but fruitless search for the original cast doubt on whether Raphael had in fact ever produced a painting based on the design. Recently, however, it has been interestingly argued that the painting at Alnwick Castle, long regarded as a copy, is one autograph. It remains difficult to establish its exact position within the artist's oeuvre since no direct preparatory studies have survived, although infrared photographs show underdrawing similar to that of the *Small Cowper Madonna*.[116]

A clear light falls on Mary sitting on a bench, dressed in rich and fashionable clothes and turning slightly away from the picture plane. Her cape has slipped and now covers her thighs, while a delicate veil over her head lightly floats down to her shoulders. With her right hand she offers a long-stemmed carnation to the Child who, seated on a cushion, reaches eagerly for it. The window on the right gives a view into a landscape, while on the left a curtain accentuates the dark background. The gazes and gestures of mother and child constitute a network of relationships centred on the carnation, emphasizing its symbolic significance. All attributes in such Madonna-and-Child groups carry messages, but the carnation is especially rich in meaning. It is a symbol not only of the Virgin but also of love and fertility, and is believed to have the power to ward off evil. A bunch of carnations often appears in sixteenth-century paintings to symbolize a betrothal, and the motif here of Mary offering the Child with her right hand a stem from the bunch she holds in her left would be very appropriate for a betrothal painting. Such a reading explains both the motif and, perhaps, the specific purpose of the painting.[117]

Important for a proper assessment of the painting are its connections with Leonardo's work. His *Benois Madonna* (**103**; Hermitage, St Petersburg) dates from the late 1470s; the existence of numerous copies and variants suggests that the original remained in Florence until the early sixteenth century, giving Raphael a chance to study it.[118] Leonardo's painting has the floral motif Raphael borrowed and a similar disposition of the figures, but is invested with a completely different spirit. The Child is placed closer to his mother, and the depiction of his stout body with its baby fat is obviously the result of very close studies from nature. At the centre of the composition, the interplay of the offer and acceptance of the flower is charged with supreme intensity. With his left hand touching his mother's right hand, the Child holds the flower – a specimen of the genus *Cruciferae* – and inspects it with the greatest attention.[119] Mary's gaze and gestures are concentrated on her child's reaction, and she supports him with her right hand, in which she holds the bunch of flowers. This is an early example of Leonardo's search for immediate, life-like representations, a quest documented by a large number of drawings. One is reminded of the *Madonna with a Dish of Fruit* (**102**; Louvre, Paris), a sketch made at about the same time. This drawing, long thought to be by Raphael, shows a somewhat similar situation: the mother offers a bowl of fruit to the Child sitting on her lap, who in turn is fully occupied with playfully 'feeding' his mother. Although the motif is different, the artistic intention is the same as in the *Benois Madonna*. From drawings Raphael made later in his Florentine period, it is obvious that as a result of his studies after Leonardo he handled the pen with greater confidence and freedom (see, for instance, **106** and **109**). But whereas Leonardo's sketch shows his power to present a spontaneous, fully articulated and coordinated human interaction with supreme lucidity, Raphael's priorities were of a different kind.

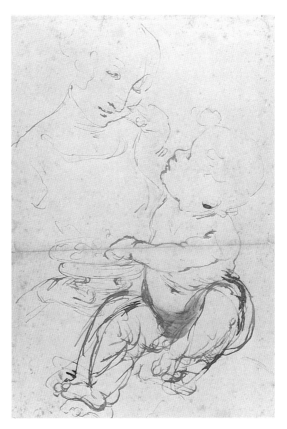

102 Leonardo da Vinci, *Madonna with a Dish of Fruit.*
Pen over chalk. Musée du Louvre, Paris.

The *Madonna with a Carnation* makes clear the principles according to which Raphael modified the lessons of the great master. First, he opens up the tightly linked group and creates a narrative across the picture plane. The gestures of mother and child are no longer interwoven and fused into a single whole, but are arranged sequentially. Mary's right hand offers the carnation, Christ puts one hand on his mother's and with the other takes the flower. These gestures lead the observer's eye towards the heads of the mother and child, and to Mary's left hand with the bunch of flowers. The idealization of the figures is particularly evident in the much slimmer body of the Child, but Raphael adds animation by giving the legs of the seated Child a movement as if he were walking. This happy invention was also used in later drawings and borrowed by other artists.[120]

The delicately nuanced application of colour is rather typical for a work of this size; at 29×23 centimetres, it is one of Raphael's smallest paintings. The overall handling, the rich tactile values of the dress and the fine sheerness of the veil, together with the carefully studied carnations, are the result of the artist's studies of Leonardo.[121] His debt may even extend to the strange, cool colours and Mary's remarkably pale flesh tones, unusual in Raphael's work but not uncommon in Leonardo's early productions. Following Leonardo so closely resulted in some obvious weaknesses in the composition, a fact that would point to a date during the middle of Raphael's Florentine period rather than its end, as has been recently suggested. The

166

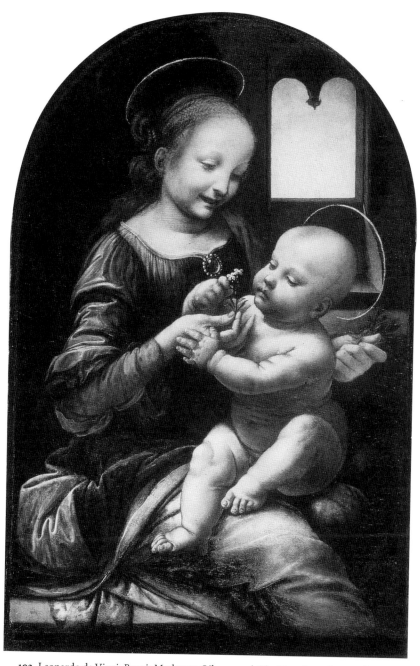

103 Leonardo da Vinci, *Benois Madonna*. Oil on panel. The Hermitage, St Petersburg.

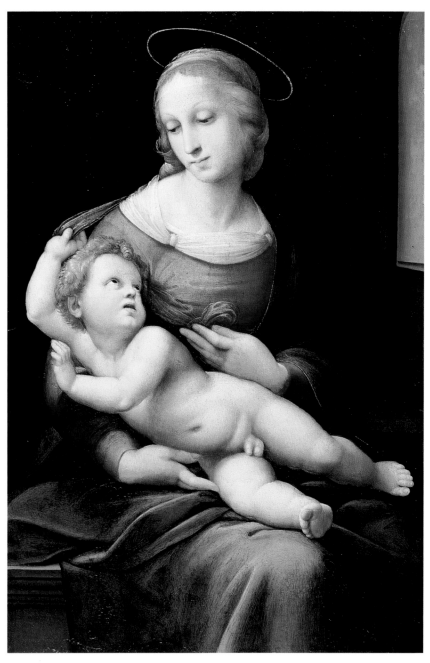

104 Raphael, *Bridgewater Madonna*. Oil on panel transferred to canvas.
Collection of the Duke of Sutherland, on loan to the National Gallery of Scotland, Edinburgh.

unresolved points are due mainly to the younger artist's tendency to turn a complex composition into one constructed as a narrative sequence. In the *Madonna with a Carnation* this results in the Virgin's thigh being much too long and her left hand – although part of the central cluster of movements – looking strangely detached from the body. The hand gestures seem to indicate rather than perform real actions. In Leonardo's *Benois Madonna* the hands have a sure and firm grasp, whereas Raphael simply combines hands and objects, for example, placing the carnations in the hand without indicating how they are held. Such handling may be a last echo of his Umbrian training; by the end of his Florentine period, he has freed himself of all traditional manners of representation. Compared with his first Florentine paintings, the *Madonna with a Carnation* documents a definite advance, yet it seems sensible to date it not later than 1506.

Raphael's dialogue with his great models is still much in evidence in the *Bridgewater Madonna* (**104**), but has obviously entered a new stage. The evolution of this painting is recorded by several drawings, which provide much insight into the arrival at the final conception. At first sight the composition strikes one as out of the ordinary, even slightly strange. Mary is shown in an interior setting, sitting at a slight angle to the picture plane. The Child on her lap is placed in a strange diagonal pose, only lightly supported by his mother's right hand. His outspread legs lie on her thighs, while his whole body performs a very pronounced torsion which culminates in the turned-back head and the right hand touching the veil.[122] The Child's movements receive a calming response from the Virgin, whose own body is slightly inclined.

The most recent restoration of the picture has recovered its painterly qualities to an unexpected degree, and allows a more discriminating assessment. An examination of the layers of colour suggests that Raphael originally showed Mary in a landscape setting similar to that in the *Small Cowper Madonna*; this landscape was later painted over with an interior, of which the main features have survived. A view through a window with a rounded arch on Mary's right, however, was later painted out by Raphael himself. In its present state, the window jamb has acquired a niche-like appearance, while the shutter – its proportions somewhat askew – has lost its purpose. Beneath the shutter one can just make out the suggestion of a deeper niche and the profile of a wooden seat further left. The wall to the left of Mary is covered by a curtain whose dark blue colour is barely recognizable. Such a disposition is not completely unknown; it relates in some ways to that of the *Madonna with a Carnation*, but here the arrangement is more complicated and not at all successfully resolved. It may well be that Raphael repeats here what he had done in the *Madonna del Granduca* – namely, close off the outside view to emphasize the figure composition, and keep the now superfluous window shutters as a colourful counterpoint to the profile of the brown seat.

The central motif of the painting is a conventional one, which Raphael had used before both for the *Small Cowper Madonna* and the *Madonna del Granduca*: the intimate relationship between mother and child, without any intervening or explicatory elements. Compared with the two previous paintings, however, the *Bridgewater Madonna*, especially the disposition of the Child, sounds a completely new note. The explanation can be found in Raphael's dialogue with Michelangelo and Leonardo, to which there is now explicit reference. We know nothing about the original location, or about the client who commissioned the painting, and

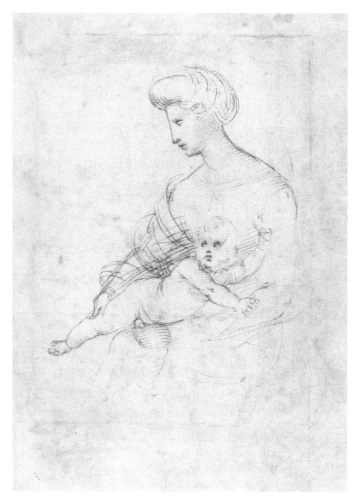

105 Raphael, *Study for the Bridgewater Madonna* (detail).
Pen over stylus. Musée du Louvre, Paris.

who may conceivably have been interested in the artistic competition Raphael had entered
into with his two great contemporaries. Yet there is some indication that aesthetic considera-
tions were more important than usual, an impression strengthened by a discussion of the
preparatory drawings.[123]

An early stage is probably illustrated by a drawing (**105**; Louvre, Paris) in which Raphael
repeats the basic features of Michelangelo's *Taddei Tondo* (**36**). It may by called a 'creative
copy', even if the rephrasing is quite considerable in that Raphael's sketch focuses on the cru-
cial elements of the mother-and-child group and omits the young St John and the goldfinch.
In Michelangelo's relief, however, it is the offering of the goldfinch, a symbol of Christ's
Passion, that provides the crucial motif, being the cause both of the frightened withdrawal of
Christ and the contemplative gaze of his mother. Without that motif, Mary's gaze loses its
object and the Child's movements their motivation. Raphael attempts to unify them by for-
mal means, giving Mary's arm in full length, placing the Child higher and giving his left arm
an upward twist. This last alteration is particularly interesting because it reappears in the final

composition. The sketch is significant for showing that, rather than copying Michelangelo's tondo, Raphael treats it as an inspiration, a possible starting-point for his own composition.

The next step is illustrated by one of the most famous sheets of compositional sketches by Raphael (**106**; British Museum, London). It includes various designs for a mother-and-child group, the largest being a preparation for the *Bridgewater Madonna*. Raphael was to use this new type of sketch, called a '*pentimento*' or sometimes, more aptly, a '*pensiero*' drawing, increasingly during his Florentine years.[124] Rapid strokes of the pen fix the main elements and modify them with numerous *pentimenti*, a technique Raphael took from Leonardo. What is new is that the artist does not explore a single conception, but instead jots down a host of ideas, all presumably produced within a short time. Raphael no longer makes several drawings from the model to prepare the composition but uses circular and oval elements to explore new relations between the figures. By this time he was able to call on a great number of patterns which he had acquired through figure studies and the copying and rephrasing of his chief Florentine models. The two large drawings give the Madonna in almost identical positions, whereas the Child's pose is different. The main sketch records an important step in clarifying the composition. The Child is now angled in the opposite direction to that in **105**, and holds Mary's right hand with both of his. Only the main motifs have been defined, but the many *pentimenti* graphically illustrate how Raphael was still concerned with harmonizing the arrangement and expressing the intimate relationship between the two. The sheet shows particularly well how much more accomplished the artist had become by the end of his Florentine period and to what splendid use he put his *pensiero* sketches.

Another drawing (**107**; Albertina, Vienna) retains the seated position, but the exact configuration of the Child on Mary's lap is still unresolved. The left arm of the Child is again stretched out, and his right forearm raised. With one hand Mary supports the Child, the other she rests on his hip. The composition again recalls elements from Michelangelo's *Taddei Tondo* (**36**), but the disposition of the Child is reminiscent of Leonardo's *Madonna with the Yarnwinder* as well as *St Anne with the Madonna and Child and the Infant John the Baptist* (**29, 31**). The drawings illustrate Raphael's creative approach to his masters' works and his skill at modifying a given conception. Much was still to change between the Vienna drawing and the finished painting, because Raphael was intensifying his study of Leonardo and Michelangelo while at the same time beginning to regard himself as their equal.

In the *Bridgewater Madonna*, the Child no longer sits on Mary's lap but is placed in an oblique position, with a very pronounced torsion to his body. Both his gesture and gaze seem to express apprehension, which needs to be explained. It has recently been suggested that the Child has woken from a dream of the Passion. The idea of a frightened awakening would make sense of the Child's position, and leads one to examine the iconographical background to the motif of the sleeping Child. This is less common in Florence than elsewhere in northern and central Italy, and is usually understood as a foreshadowing of the Pietà: the Child asleep in his mother's lap anticipates Christ's body lying in her arms after the Deposition. This interpretation finds support from the narrative motif implied in the position of the legs, which appears neither in the relevant works by Michelangelo and Leonardo, nor in the artist's own preliminary sketches. An almost identical motif does occur, however, in one of the most famous central Italian paintings of the early Renaissance, Piero della Francesca's *Montefeltro*

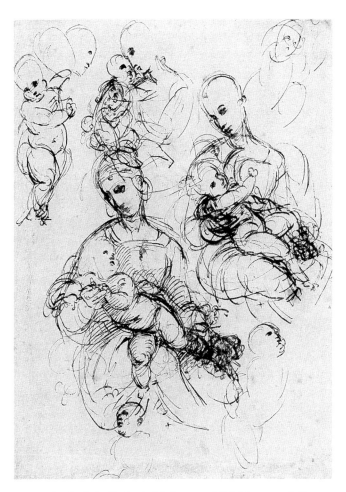

106 Raphael, *Studies for the Madonna and Child*. Pen over chalk.
British Museum, London.

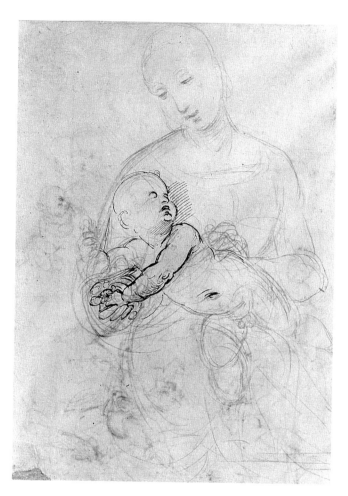

107 Raphael, *Compositional Study for the Bridgewater Madonna.*
Pen over silverpoint. Albertina, Vienna.

Altarpiece (**3**). There, the Child is shown asleep in an allusion, among other things, to his own future Passion, and his legs are arranged in exactly the same position as in Raphael's painting.[125] Raphael probably knew this painting (see page 19); in borrowing the very prominent motif, he presumably meant to invoke its significance as well.

Once this connection is established, the meaning of the *Bridgewater Madonna* becomes clear, and we realize that the surviving drawings provide no documentation about the last stages of the conception. Based on his intense dialogue with Michelangelo and Leonardo and including a pointed reference to Piero della Francesca, Raphael creates a highly complex composition of almost narrative character. In certain respects he applies to the devotional picture what Alberti demanded of history paintings – 'a *historia* will move spectators when the men painted in the picture outwardly demonstrate their own feelings as clearly as possible …. Yet these feelings are known from movements of the body' – translated into the language of the High Renaissance.[126] The aesthetics of the painting reflect contemporary artistic developments, while in content it is a very free interpretation of the traditional imagery of the small devotional painting. We may assume that this was totally in keeping with the general outlook of the time, recalling how Pietro da Novellara interpreted Leonardo's cartoon for *St Anne with the Madonna and Child* in symbolic terms and explained the figures and their relationships by means of a narrative (**30**; see page 68).

Raphael's *Bridgewater Madonna* is characterized by an acutely felt challenge from Leonardo and Michelangelo; the strain of the competition shows up in the complexity of the composition. In form and content much superior to his earlier works, the *Bridgewater Madonna* is still not the culmination of Raphael's Florentine years. The last word, so to speak, about his development in the field of half-length portraits of the Virgin is the *Niccolini–Cowper Madonna* (**108**, also known as the *Large Cowper Madonna*; National Gallery, Washington). The painting is dated and signed on the border of Mary's dress MDVIII R[aphael] PIN[xit] and was thus unquestionably finished during the artist's last year in Florence. All sense of strain and effort has vanished and is replaced by joyful ease. The Child, again placed on a cushion, sits on his mother's lap completely relaxed. Looking cheerfully at the observer, he playfully grasps the border of his mother's dress. The mother gazes pensively at the Infant, protects her dress with her left hand and with her right places a veil around his body. The cool colours of Mary's dress and the light flesh tones of both figures combined with the blue hue of the sky invest the small group with a cheerful air.

The starting-point for the composition was the *Madonna with a Carnation* (**101**), which supplied in particular the posture of the Child. A preparatory design (**109**) is found on the back of the compositional sketch for the *Bridgewater Madonna* (**107**). The sheet shows further examples of *pensiero* sketches, in this case again of widely differing mother-and-child groups; the pertinent drawing is found left of centre. The position of the Child in the *Madonna with a Carnation* is further elaborated, and the new motif of the grasping gesture introduced. In its final state, the body has lost its emphatic torsion, and the Child, sitting relaxed and comfortable, is given a striking immediacy.

Raphael's *Niccolini–Cowper Madonna* stands at the end of his Florentine years. Despite its references to the *Madonna with a Carnation*, the later work is fully autonomous and no longer directly indebted to studies of his contemporaries' achievements. The last traces of

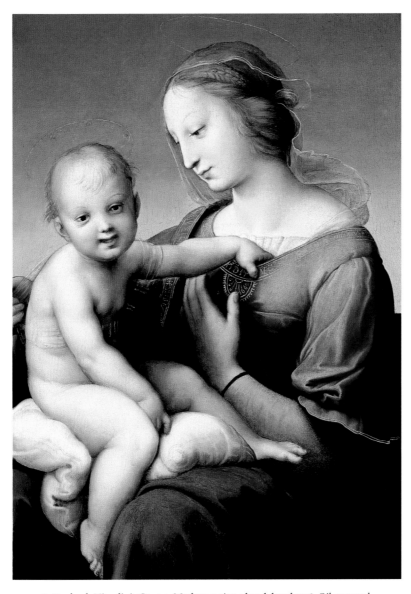

108 Raphael, *Niccolini–Cowper Madonna*, signed and dated 1508. Oil on panel.
National Gallery of Art, Washington.

artificiality – still noticeable in the *Bridgewater Madonna* – have now disappeared, and the complex stabilizing interaction seems entirely natural and self-explanatory. The painting impresses one with the sense that the artist's 'Florentine apprenticeship' has come to an end: he is now ready for new and greater challenges.

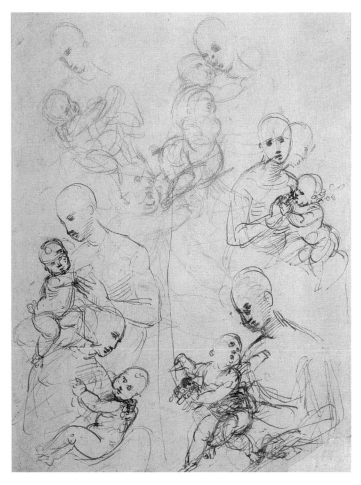

109 Raphael, *Studies for the Niccolini–Cowper Madonna.*
Pen and chalk. Albertina, Vienna.

Paintings with more than two figures in full length

So far our discussion of Raphael's artistic development has concentrated on paintings depicting half-length mother-and-child groups. The restricted repertoire of figures makes for easy comparison, and the paintings selected illustrate considerable advances. The following discussion of large-format paintings with more than two full-length figures will concentrate on the problems inherent in their greater complexity, but will refer back to the half-length works. Invaluable ongoing attempts by scholars to establish a chronological sequence date back to Vasari and his concept of a rational and continuous progress of the arts towards perfection. In Raphael's case he discerned two distinct stylistic phases, one characterized by Perugino's influence, the other reflecting inspiration from Leonardo and Michelangelo: 'and abandoning little by little, although with great difficulty, the manner of Pietro [Perugino], he sought to the best of his power and knowledge to imitate that of Leonardo in time he found himself very much hindered and impeded by the manner that he had adopted from Pietro when he was quite young . . . His being unable to forget it was the reason that he had great difficulty in learning the beauties of the nude and the methods of difficult foreshortenings from the cartoon that Michelagnolo Buonarroti made for the Council Hall in Florence'. Observations of style confirm this claim in many respects, but today we no longer adhere to a rigid sequential argument – assuming, for instance, that only after one work was finished was the next one begun.[127] Of course, there are overlaps in the evolution of the paintings, and conception and execution may not necessarily follow each other closely. Furthermore, where a painting includes a signature and date, these cannot always be taken at face value: *The Holy Family (Canigiani)* is dated yet unfinished, and the *Ansidei Madonna* was conceived long before it was finished and dated. This should not, however, lead us to abandon all attempts at chronological clarification, or to reject stylistic analysis to make up for the absence of textual evidence. We saw in the previous chapter that one of the crucial factors of Raphael's artistic development during his Florentine years was his dialogue with Leonardo, and that during this period that dialogue changed very much in character. It is both fascinating and instructive to examine the artistic development behind this change.

Raphael's *Madonna di Terranuova* (**111**; from the collection of the Genoese family of the Duca di Terranuova, now in the Gemäldegalerie, Berlin) appears at present too dark, its colour values differing from those of the other paintings discussed so far. The difference is probably deceptive because, like all Raphael's paintings in the Gemäldegalerie, it has not been cleaned in recent times. Except for the opaque layers of varnish, the painting seems in good condition and very likely would show the same luminous coloration as Raphael's other works of the period. The tondo is easy to read. Mary is seated in front of a wall which separates the main scene from the background. The Christ Child lying across her lap takes from the infant St John a scroll with the inscription ECCE AGNUS DEI (misspelled 'AGNIUS'). The matching figure of the child on the right-hand side has sometimes been identified as James the Less, but the argument is not persuasive. He advances on the group, but is stopped by Mary's soothing gesture. The light of the setting sun permeates the scene and illuminates the top of the town's church-tower on the left and the rock formations on the right.

There is a compositional sketch which is generally regarded as a preliminary study for the

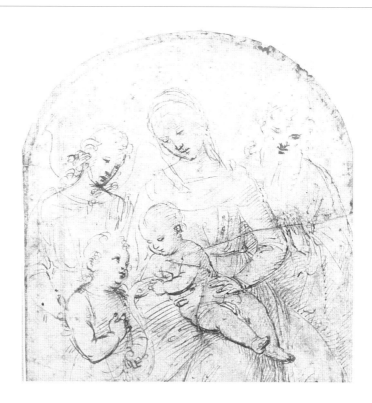

110 Raphael, *The Holy Family with the Infant John the Baptist and an Angel.*
Pen over chalk. Musée des Beaux-Arts, Lille.

Madonna di Terranuova (**110**; Musée des Beaux-Arts, Lille). The top of the sheet has been cut into a semi-circular shape and on the lower right a lost section has been repaired and redrawn. It was noticed long ago that the overall disposition is based on a concept Raphael had already used for the *Madonna with St Jerome and St Francis*, also in the Gemäldegalerie, a work from his Umbrian period usually dated about 1501/2.[128] The rectangular drawing fills the whole sheet and shows slender figures, still reminiscent of Perugino, but with greater presence than in the earlier painting, yet the composition appears crowded and with too little sense of volume. It seems therefore justified to dissociate the Lille sketch from the *Madonna di Terranuova* and to date it to the late Umbrian period. We may reasonably assume that he made the drawing in Umbria, took it with him to Florence, and then used it for the tondo.

With a diameter of 87 centimetres, the *Madonna di Terranuova* is rather large and was therefore presumably a commissioned work. The tondo format suggests a Florentine client; although not completely unknown in Umbria, the format was mainly associated with Florence, and appears in Raphael's oeuvre only after his arrival in that city.[129] A close look at the painting shows that Raphael had problems mastering a format which was probably new to him, and the adaptation of the Umbrian design is not completely successful. The crowdedness of the drawing (**110**) has disappeared, but so has its solid construction. In the triangular arrangement, the children now determine all the action: they give too much weight to the lower part of the painting, do not link as a group and, furthermore, are cut off rather badly by the picture border. For comparison, it may be unfair to cite the exemplary solutions

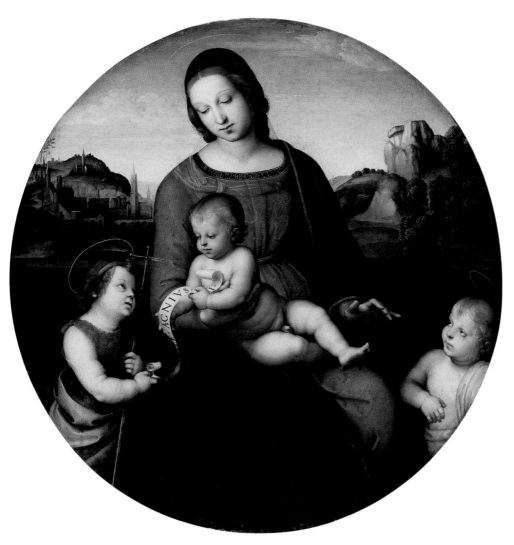

111 Raphael, *Madonna di Terranuova*. Oil on panel. Gemäldegalerie, Berlin Dahlem.

Michelangelo produced at the time with his Taddei and Pitti tondi (**36, 37**), but even a glance at Piero di Cosimo's tondo *Madonna and Child with the Infant John the Baptist* (**28**) is sufficient to prove the point. Piero follows a strict triangular scheme with the main motif of the embracing children at the centre, and views into the landscape as framing devices. Such concentration was still beyond Raphael at the time of the *Madonna di Terranuova*, when he was obviously not yet fully alert to the particular problems posed by the tondo format.

Of special interest are the painting's first indications of the influence of Leonardo. While the *Madonna with the Yarnwinder* (**29**) may have suggested certain features of the Child's pose, there can be no doubt that it did provide the model for the extremely foreshortened hand which Leonardo depicted raised as if for protection (**112**). Recently, infrared photography has shown that Raphael included the slightly simplified motif at the very last moment (**113**). The underdrawing shows a completely different position of Mary's left hand: resting on her thigh and lightly supporting the Child's foot.[130] This brief quotation from Leonardo, which plays a significant part in the painting, marks the beginning of Raphael's dialogue right at the start of his Florentine period. Taking into account the Umbrian mode of the Virgin's head, the absence of Florentine influences in the drapery and the last-minute alteration of the gesture, it seems likely that the painting dates from about 1504/5.

The full-length *Holy Family with the Lamb* (**115**) long presented special problems of dating, and is even today sometimes erroneously assigned to 1507 on the basis of a later version in the Prado with an apocryphal and misspelt date. The original painting (formerly in the collection of Viscount Lee of Fareham), was identified only much later and at first not sufficiently appreciated.[131] It is dated and signed on the border of Mary's dress, RAPHAEL.URBINAS AD.MDIV. By a happy coincidence, the corresponding cartoon has survived (it is kept in the Ashmolean Museum, Oxford). The upper part is damaged, but the figure composition is largely legible (**114**). The outer and interior contour lines were transferred from the cartoon by pouncing – like tracing, a common technique which Raphael used more frequently during his early years in Florence. For this procedure, a sheet is placed behind the cartoon and the contours are pricked at short intervals to produce a dotted line of tiny holes. The sheet is then laid on the picture ground and dusted with powdered charcoal, reproducing the position of the holes as small dots. As the Oxford cartoon shows pricking marks corresponding to the dots in the painting, there can be no doubt that the two works belong together.[132]

Compared with the *Madonna di Terranuova*, the composition of *The Holy Family* at first seems a model of consistency. The Christ Child astride the lamb is held by the kneeling Mary while Joseph, supporting himself on a staff, bends down to the two figures. The group is placed in a meadow, and the background landscape shows on the left a settlement in the northern style similar to that of the *Madonna di Terranuova*. A closer look, however, reveals several inconsistencies in the disposition of the figures. Mary's seated pose remains obscure, her right leg seems slightly raised, and the position of her left leg is undefined. Similar infelicities occur in Joseph's posture: he bends forward, gripping the staff with both hands, in such a position that the right leg should act as support, but the artist has failed to indicate this. Such weaknesses are sufficient to suggest an early date, and also that Raphael borrowed the composition from someone else.

The figure composition of *The Holy Family with the Lamb* in fact corresponds closely to

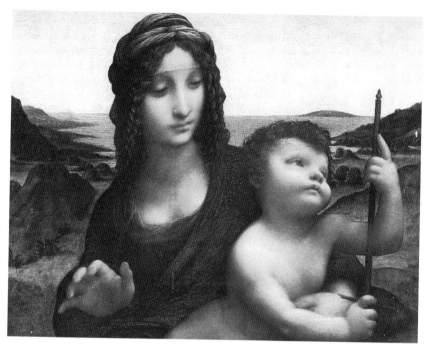

112 Leonardo da Vinci, *Madonna with the Yarnwinder* (detail of **29**)

113 Infrared photograph of *Madonna di Terranuova* (detail of **111**)

181

114 Raphael, *Cartoon for The Holy Family with the Lamb.*
Pen, brush and wash and white highlights. Ashmolean Museum, Oxford.

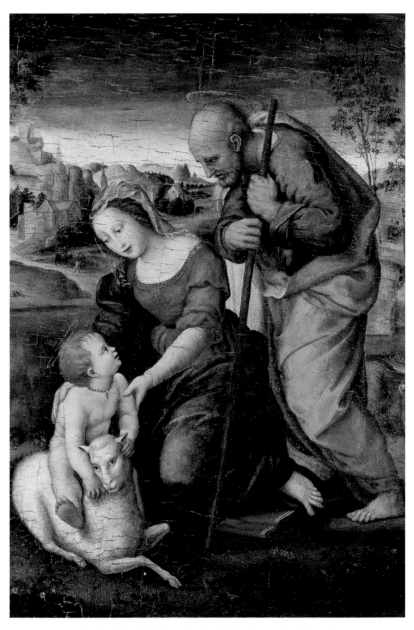

115 Raphael, *The Holy Family with the Lamb*, signed and dated 1504.
Oil on panel. Private Collection.

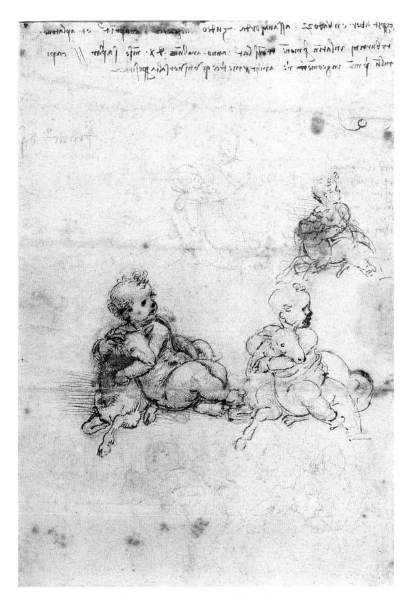

116 Leonardo da Vinci, *Three Sketches of a Child with a Lamb*. Pen on chalk.
J. Paul Getty Museum, Los Angeles.

Leonardo's cartoon for *St Anne with the Madonna and Child* of 1501 described by Pietro da Novellara and known from a later copy (**30**; see pages 68–9). This drawing shows Mary in the act of rising from Anne's lap, while the latter tries to hold her back. Mary bends down and attempts to reach her child, who is embracing a lamb. Raphael borrows this motif but does not quite succeed in coordinating the seated position with the downward movement. And, instead of showing the Child embracing the lamb, Raphael simply places him astride it. Thus he not only simplifies the action shown by Leonardo but also breaks up the compact group, making the paratactic arrangement of the figures more pronounced. The result is a regular rhythm of movements which provides the composition with a certain unity and solidity. In this typical example of Raphael's rephrasing of Leonardo during his early Florentine days, we notice the same tendency towards simplification that was already apparent in his early drawings. This applies equally to the painting's content. In connection with the Infant, the lamb symbolizes his Passion. While Leonardo illustrates the subject with differentiated activities by all participants and expresses Mary's apprehension, Raphael reduces the action to Mary's and Joseph's loving attention, and so produces an image more symbolic than narrative.

Raphael not only oriented himself on Leonardo's composition but presumably also on his other drawings, which he was probably able to examine soon after his arrival in Florence. A sheet of drawings of the Child and lamb (**116**, the so-called 'TL-sheet'; Getty Museum) shows Leonardo experimenting with various configurations. In the present context, three well-defined sketches of the Child placed next to the lamb are particularly interesting.[133] The pose of the animal, especially of its head and forelegs, was copied by Raphael in reverse. The fact that the verso shows the motif of 'riding on the lamb' makes it even more likely that Raphael studied Leonardo's drawings on this subject. There is an element in the painting which dates it with some poignancy to the transitional period at the beginning of Raphael's sojourn in Florence: the flowers in the meadow are depicted in a very fine, miniature-like manner conforming exactly to Perugino's modelling and handling.[134] We have already noticed in the *Madonna with a Carnation* that Raphael occasionally employed a special mode for his small paintings, using a manner and technique recalling miniatures.

These two paintings retain Umbrian features and at the same time include characteristic aspects of Raphael's earliest explorations of Leonardo's work, although on very different levels. The *Madonna di Terranuova* contains some first timid borrowings for the posture of the Child and the direct copy of a single motif (the raised hand), a guarded experiment within an otherwise rather conventional, axial, symmetrical composition. *The Holy Family*, on the other hand, is conceived totally in response to Leonardo, for it is based on his famous and much-discussed pyramidal composition, which it refashions into a new conception. In this adaptation the tendency towards simplification is still evident, and the intention is obviously to present a narrative along the picture plane in easily understandable terms. The different levels of Raphael's interaction with Leonardo are also reflected in the painting's format. The large *Madonna di Terranuova* was a commission and as such hardly suitable for artistic experiments, while the *Holy Family with the Lamb*, with its measurements of *circa* 32 × 22 centimetres, may well have been something of an experiment, a testing ground for new ideas. Small and relatively less exacting works were the most suitable candidates for non-commissioned productions, and presumably presented no financial risks.

The *Madonna del Prato* (**117**; Kunsthistorisches Museum, Vienna) must have been commissioned, on account of its size. It may be one of the two paintings Raphael produced for his friend Taddeo Taddei. We already know from Vasari of their cordial relationship and of two paintings, 'which incline to his first manner, derived from Pietro [Perugino]', which in Vasari's time still belonged to Taddeo's heirs.[135] Perhaps Vasari was reminded of Perugino by the wide landscape stretching into the misty distance and the settlement on the left, but even at first sight the great progress Raphael had made since his arrival in Florence is obvious. Especially skilful is the way the compact triangular composition takes account of the large painting surface, while the severity of the conception is somewhat relieved by the clouds on both sides. The group of figures develops across the entire breadth of the picture space, culminating in Mary's head. The subject is related to *The Holy Family*; the core group is extended to include the figure of the infant St John who, kneeling, offers the cross-staff, a symbol of the Passion, to Christ who grasps it with one hand. Mary lightly supports her child with both hands and looks pensively at St John. Some of the plants in the foreground, such as the dandelion, are traditionally associated with the Passion.

The surviving preliminary studies for the *Madonna del Prato* afford interesting insights into its evolution. Scholars have paid particular attention to a folded sheet with drawings on both sides that illustrate the genesis of the figure composition (**119** and **120**; Albertina, Vienna).[136] We shall limit our discussion to those that refer directly to the *Madonna del Prato*. The drawings follow no particular order. It is common practice to talk first of the recto, which shows the larger figures, on the implicit assumption that Raphael then re-used the paper by folding it into two smaller oblong formats for further sketches; however, the sheet may have been folded from the start and the sequence reversed, which is the reading chosen here. On the left half of the verso (**119**) we see, on the left side, Mary with the two children. Raphael pursues this conception, which will be important for the *Madonna del Cardellino* (**126**), for some time. Supported by his mother, Christ undertakes some awkward attempts at walking, and reaches for the cross-staff held by St John who is shown in almost frontal view. On the right are three full-length studies of children, the last two certainly variations on the main theme: John is now turned sideways and the Infant bends over further to grasp the cross-staff. The right half of the verso again shows a design of the complete disposition. Mary's posture has completely changed, and comes close to that in the painting. The Child is again supported by his mother, and holds her right arm while John approaches from a distance. The next two full-length sketches deal with St John. The first is a variation on his walking pose; the second combines walking and standing positions with a slight bow.

The crucial breakthrough solution is found on the recto (**120**), where the problem of the central configuration – the seated Madonna supporting the Child on his unsteady legs – has been resolved. Here, the logical development of the pictorial conception emerges clearly if one reads the four large studies from left to right. The brief sketch on the left illustrates Raphael's preoccupation with the central motif, where he seems to concentrate only on the Child's attempts to walk and his mother's supporting gestures. The next sketch is more elaborate: Mary's seated position is lightly indicated, and the Child now turns to his mother for support while she casts her eyes sideways. This motif finds its explanation only in the third drawing, which gives the whole scene. On the left the infant St John kneels and Mary turns to

186

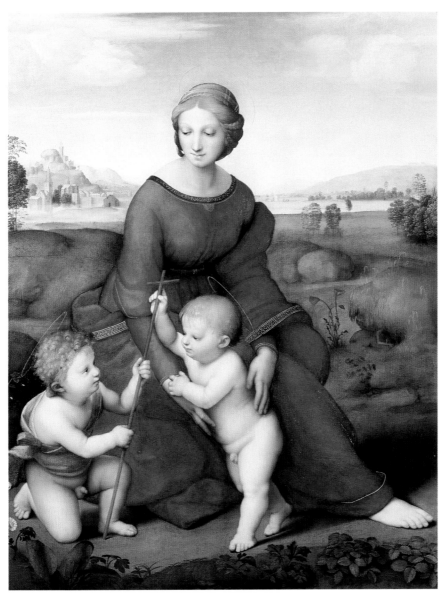

117 Raphael, *Madonna del Prato*, dated 1505/6. Oil on panel. Kunsthistorisches Museum, Vienna.

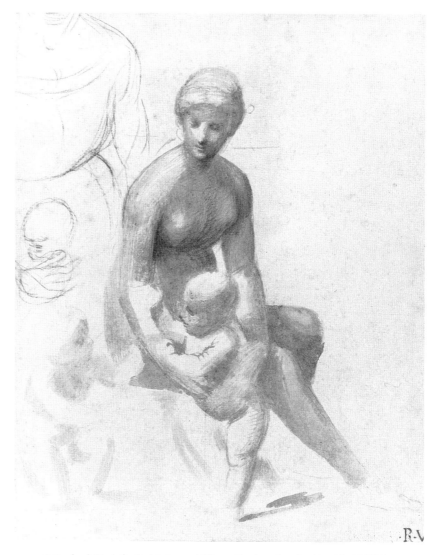

118 Raphael, *Study for the Madonna del Prato*. Brush and wash with white highlights.
Ashmolean Museum, Oxford.

him with a twist of the torso and a downward gaze. Her seated position, with one leg stretched out and the other tucked in, is given parallel to the picture plane, and the Child holds fast to her arm and looks at the observer. Only in the last design, again more briefly sketched, does the Child turn towards John, who is not shown. These drawings are akin to *pensiero* sketches, but show more clearly the progressive build-up of ideas towards a solution. They constitute explorations of an image whose final form has yet to be found.

A provisional solution is represented by a very free wash drawing giving the main pictorial concept and heavily accentuating the plasticity of the bodies (**118**; Ashmolean Museum, Oxford). This sheet shows one of Raphael's rare brush drawings; although he has not indicated Mary's dress, she can hardly be called nude. The technique allows him to study the corporeal relationships and the incidence of light. Compared with the previous drawings, the disposition of the seated and standing main figures is much clearer. The infant St John is indicated only very lightly, yet his significance as the narrative and structural focus of the overall composition is easily recognizable.

There is a further reason why these preliminary studies deserve our attention, in particular **120**. More clearly than the painting itself, they document Raphael's intense study of Leonardo, in this case his *St Anne with the Madonna and Child* (**32**). The evolution of Leonardo's painting is still a matter of debate, but the general idea must have been formulated by the time Raphael used it for his own conception. He was especially interested in the pivotal motif of Mary bending down to embrace the Child. Here again, Raphael's noted tendency to simplify motifs of great formal and spiritual complexity is much in evidence. Leonardo's characteristic interlacing of figures is tempered in particular by Raphael's decision to place the infant Christ in front of the Madonna, whose seat is left undefined. He is also at pains to play down the drama of the emphatic downward-bending movement of the Virgin, and to make her the stabilizing mainstay of the composition. This idea, with all its consequences, was already anticipated in the wash drawing and is fully elaborated in the painting: the pronounced uplift of the upper part of the body and the more upright positioning of her head finally accord Mary the position expected of her in a devotional painting with such a theme. However, two crucial elements – the simplification of Leonardo's motif and the monumental characterization of the Virgin – are responsible for a major incongruity of the composition: Mary's seated position with her legs arranged sideways does not easily accommodate her upright and only slightly inclined torso. This awkward passage is largely covered by the voluminous blue dress, contrasting harmoniously with the red undergarment and providing an apparently solid base for the superstructure. Despite the much-vaunted harmony of the *Madonna del Prato*, the painting still reflects a rather early and ambiguous phase of Raphael's dialogue with Leonardo, suggesting a date of late 1505 or early 1506. Therefore the spelling of the year M.D.V.☉.I. on the seam of Mary's dress presents no problem. The separation of the Roman numerals V and I by a double circle – interpreted by some as a zero, and by others as a mere ornament – has led to a rather fruitless debate about whether Raphael meant 1505 or 1506. If one dates the painting on stylistic grounds to this period, it makes little difference how the date is read.

There are several good reasons, seldom discussed, for supposing that the final conception for *The Holy Family (Canigiani)* (**121**; Alte Pinakothek, Munich) was arrived at soon after the

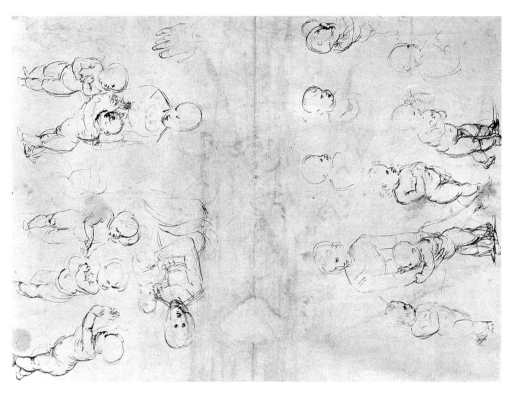

119 Raphael, *Studies of the Madonna and Child.* Pen over stylus. Albertina, Vienna: verso.

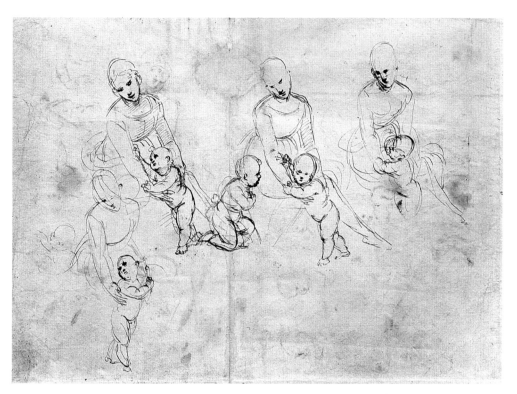

120 Raphael, *Studies of the Madonna and Child.* Pen over stylus. Albertina, Vienna: recto.

Madonna del Prato. Containing five figures, the painting's composition was much more difficult than those for the other works discussed so far, yet only a few details betray the artist's efforts to achieve such a harmoniously balanced work. Raphael places the Infant and St John at the centre of the group, a further development of the motif he used for the *Madonna del Prato*. There the children were playfully engaged with a cross-staff, here it is a scroll. This too refers to the Passion and thus emphasizes the seriousness of the scene. St John, who is partly supported by the kneeling St Elizabeth, bends forward to offer the Child the scroll. Elizabeth looks up at St Joseph, who stands behind the group supporting himself on a staff; the twist of his body leads the observer's eye to Mary, who is seated on a low wall. In her left hand she holds an open book, and with her right she catches the infant Jesus who is half-sliding from her lap. Christ looks at John with a lively expression and holds the scroll in such a way that the word DEI is prominently displayed. The figures, arranged in pyramidal form, are firmly bound together through repeated cross-references. Recent restoration has removed opaque overpainting and layers of varnish to reveal the clouds with *putti*, who soften the severity of the composition; they derive from a further elaboration of the cloud motif in the *Madonna del Prato*. The townscape in the background recalls Raphael's studies of Northern artists.[137]

The genesis of the composition of *The Holy Family (Canigiani)* is documented by only a few authentic drawings, three of which can be used to illustrate the main steps. The first sheet is sometimes regarded as an independent design, but nevertheless reflects a preliminary stage of the conception for the painting.[138] A wash drawing in rather poor condition (**122**; Museé du Louvre, Paris), it must originally have been of a similar quality to the sketch for the *Madonna del Prato* (**118**). Raphael started out with only four figures, confronting Mary and the Child with St Elizabeth and St John. The sketch already includes a narrative element: John, held by his crouching mother, offers a goldfinch to the Infant, symbolizing the Passion. Mary, sitting on an elevation and holding the Infant who withdraws in fright, is the culmination of the pyramidal composition; her pose is taken from the earlier *Holy Family with the Lamb* (**115**), but now her seated position is entirely plausible.

The next evolutionary stage is represented by a drawing conceived slightly more broadly and placing the same four figures in front of a wide landscape (**123**; Windsor Castle). The drawing style, with its strong cross-hatching, is very similar to preliminary studies for *The Entombment* (see **140**, **141**) and therefore cannot conceivably be earlier than 1506. The infant St John, with the attributes of a loosely tied garment, a hand-cross and the chalice of the Passion, takes the right arm of Christ, who shrinks back. This seemingly playful gesture again alludes to the Passion, specifically to John's future role as Baptist. The two playfully engaged children are a preparation for one of the central motifs of the painting as well as for the interlocking of the figures, a concept Raphael derived from his dialogue with Leonardo.

The next stage is known only through a copy, but it is an instructive one which combines the two concepts just mentioned with that of *The Holy Family (Canigiani)* (**124**). The figures are shown naked to clarify anatomical aspects, but it hardly seems to be a life-study. Again, the main action involves four figures, with the two protagonists now confronting each other almost antithetically. The children, as before protected by the adults from behind, are now linked by a scroll. The group forms an almost closed circle, but the sketch of a fifth figure prepares for the future development. Drawn above St Elizabeth is a man supporting himself on a

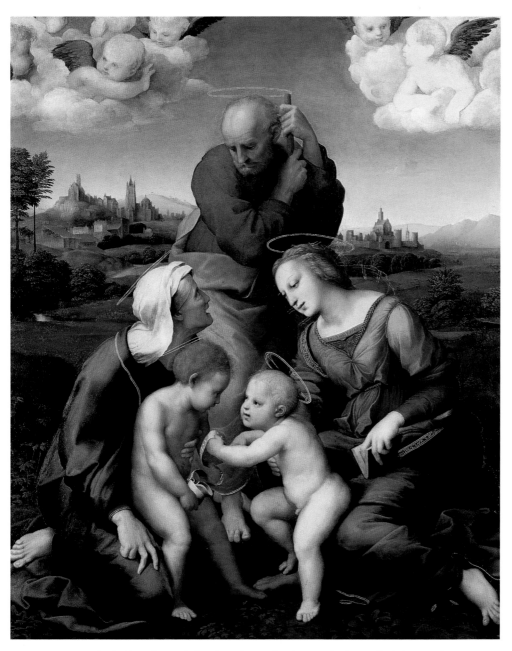

121 Raphael, *The Holy Family (Canigiani)*, signed. Oil on panel. Alte Pinakothek, Munich.

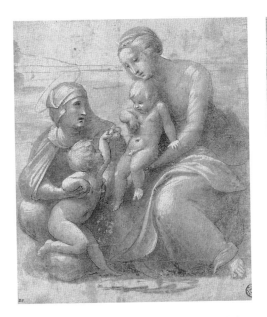

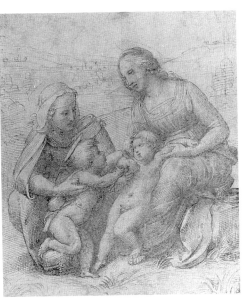

122 Raphael (copy after?), *Compositional Study for*
The Holy Family (Canigiani).
Brush, wash and white highlights. Musée du Louvre, Paris.

123 Raphael, *Compositional Study for*
The Holy Family (Canigiani).
Pen. Windsor Castle.

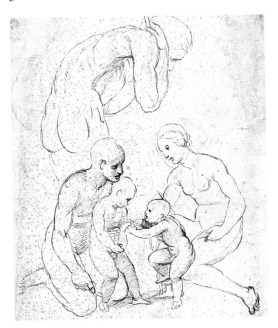

124 Raphael (copy), *Compositional Study for*
The Holy Family (Canigiani).
Pen. Musée Condé, Chantilly.

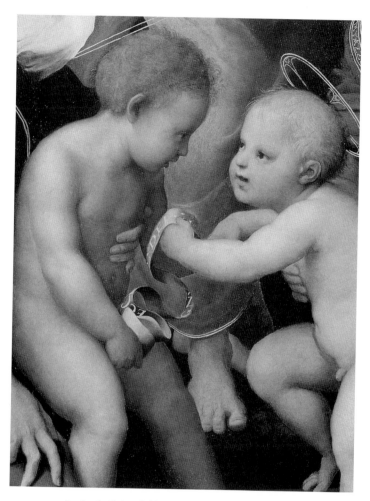

125 Raphael, *Christ Child and St John the Baptist* (detail of **121**)

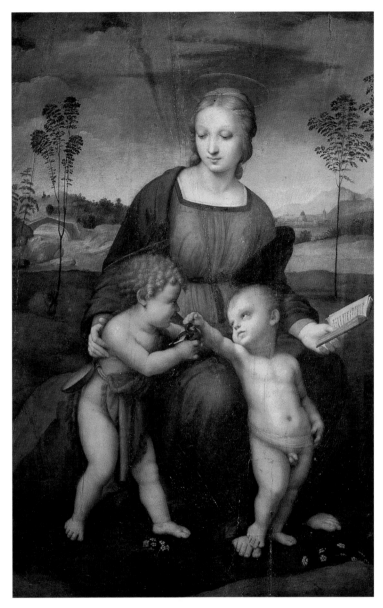

126 Raphael, *Madonna del Cardellino*. Oil on panel. Galleria degli Uffizi, Florence.

staff, a motif that recalls St Joseph in the *Holy Family with the Lamb* (**115**). Although the figure is neither proportionally nor compositionally linked to the group below, the final disposition of *The Holy Family (Canigiani)* is already faintly suggested: Raphael will turn the figure to give a frontal view and place it along the central axis behind the group.[139]

This sequence of preliminary drawings, briefly sketched, holds special interest because of its evidence about Raphael's much more differentiated dialogue with Leonardo. While the *Madonna di Terranuova* (**111**) or *The Holy Family with the Lamb* are relatively straightforward adaptations, *The Holy Family (Canigiani)* shows a more reflective approach. On the basis of a strict triangular composition guaranteeing compactness, Raphael seeks to give each figure an active part and to link them through gestures and gazes. The description of the painting makes this plain, but a closer look at the composition reveals the interlocking as only partly successful. The figures or pairs of figures do not quite connect; rather, they are carefully arranged on different planes so that the group is built from front to back. In the lower part, too many limbs intersect, and in the children's hands the motif of giving and receiving is not logically developed (**125**).[140] Finally, the angels' unfinished haloes show up an imbalance between the two sides of the figure composition.

The Holy Family (Canigiani) is a remarkable advance over the *Holy Family with the Lamb*, but its noticeable weaknesses caution against dating it much later. The concept was presumably finalized in 1506, and belongs to the same stage in Raphael's development as the *Madonna with a Carnation* (**101**). This suggested date agrees with documentary evidence, according to which the painting was said to have been commissioned to celebrate the marriage of Domenico Canigiani and Lucrezia di Girolamo Frescobaldi in 1507. Since weddings were usually planned long ahead, the order was probably placed well before the event. The date the client took possession of the unfinished painting will presumably never be known.

Although it seems appropriate for the last-mentioned work, this method of using documentary evidence to date a painting becomes problematic in the case of the *Madonna del Cardellino* (**126**). The historical facts have often persuaded scholars to date the picture as early as 1505/6 (see pages 42–3): Vasari states that the painting was kept in the house of the late Lorenzo Nasi, 'who had taken a wife about that time', suggesting that it was a wedding picture. Recent research has established that Lorenzo married Sandra di Matteo Canigiani before 23 February 1506, a fact that is occasionally used for dating purposes.[141] The inference is not supported by direct evidence: neither the commissioning of the painting nor its completion is recorded. The date of the wedding can therefore provide only a rough indication of the date of the picture; its completion, for example, may have been delayed. Once again, it is necessary to use stylistic criteria to date the *Madonna del Cardellino* more precisely.

The painting was seriously damaged during the collapse of Lorenzo Nasi's house on 17 November 1548, and subsequently heavily repaired and partly painted over. Its present state is so precarious that no thorough restoration, which would include the removal of the old opaque layers of varnish, has yet been attempted. The main composition has survived, as have details testifying to the high painterly qualities of the central areas. The solid construction of the figures, again forming a pyramid, is handled with greater freedom than in earlier paintings. The Madonna is shown seated on a rock in an almost frontal position along the main axis, and appears relaxed and natural. She puts her right arm around the young St John,

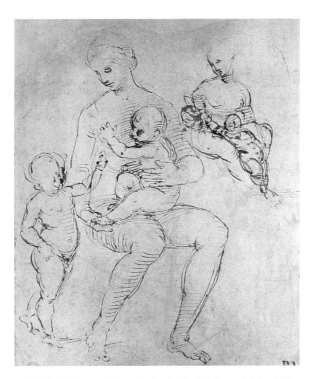

127 Raphael, *Compositional Studies for the Madonna del Cardellino.*
Pen. Ashmolean Museum, Oxford.

whose bowl and loosely tied hide identify him as a young hermit and baptist; in her left hand Mary holds a book. Christ stands between her knees, caressing the goldfinch John holds out. The side views are dominated by landscape elements, the familiar town motif placed in the far distance on the right. Carefully graded, the figures define the depth of the foreground, and their postures and gestures appear natural and persuade by precise foreshortening.

Two preparatory studies are particularly helpful for tracing the evolution of the *Madonna del Cardellino*. The earlier (**127**; Ashmolean Museum, Oxford) includes two sketches, the posture of the Virgin in the larger drawing being directly related to the *Madonna del Prato*: Mary, seated upright and almost frontally, turns her head towards John on the left. With both arms she holds the snuggling child. Although the composition differs from that of the finished painting, her pose seems to have provided a starting point. The smaller drawing on the same sheet, highly reminiscent of Leonardo's use of *pensiero* sketches, shows a new idea: Mary reads a breviary and the Infant, between her legs in a position more recumbent than standing, tries to reach it. Both motifs reappear in modified form in the painting. The decisive breakthrough seems to have come after another look at an early sketch for the *Madonna del Prato* (**117**), which shows both children standing. This provided the basis for a second drawing (**128**; Ashmolean Museum, Oxford) with a new configuration combining elements of the earlier design – the breviary and the Child positioned between his mother's knees. Mary is now placed along the main axis and the Child turns to the book his mother shows him, while St John is a purely assistant figure. But still the conclusive idea for the painting escapes the artist, who must have made further sketches, none of which has survived.

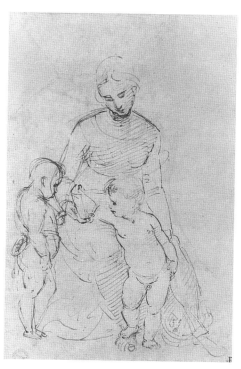

128 Raphael, *Compositional Study for the Madonna del Cardellino.*
Pen over leadpoint. Ashmolean Museum, Oxford.

In the finished painting, the symbol of the goldfinch provides the narrative focus of the composition. The same motif plays a major role in Michelangelo's *Taddei Tondo* (**36**), which Raphael is known to have studied. All attention is now directed towards this symbol: St John holds out the bird and the Child touches it thoughtfully, thereby expressing his acceptance of the Passion. Mary's contemplative figure gathers the group together; the breviary, held sideways and no longer interposed between the children, contributes a further narrative element – looking up from her devotional reading, she watches the children's meaningful play. Greater clarity is achieved both in form and content. The figure of Mary has gained in plasticity, and her upright position allows the group to develop freely. The slightly awkward oblique position of the legs in the drawing (**127**) has now been resolved by placing the Child between his mother's knees, a pose presumably derived from Michelangelo's Bruges *Madonna and Child* (**34**); more generally, it seems that the plasticity and spatial configuration of the group owes much to a close study of Michelangelo's works. Looking again at the two preliminary designs, it seems likely that the final inspiration occurred only while work was already in progress.

In terms of balance and plasticity, the *Madonna del Cardellino* is so much more accomplished than the *Madonna del Prato* that it must be of later date. The obvious affinities between the preliminary studies and the *Madonna del Prato* make it likely, however, that the interval was not considerable; indeed, work on both paintings may have overlapped. This may also apply to *The Holy Family (Canigiani)*, clearly structured yet with certain weaknesses in detail, but then again this was a more demanding work because of its multi-figure

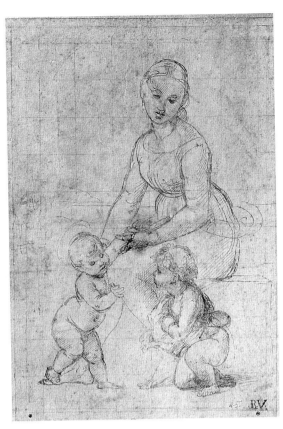

129 Raphael, *Compositional Study for La Belle Jardinière.*
Pen over stylus. Musée du Louvre, Paris.

subject. A characteristic feature of Raphael's work methods during his formative years in Florence was the concurrence of numerous pictorial concepts at various stages of elaboration, together with the determined exploration of stylistic idoms. With the final conception and the execution of the *Madonna del Cardellino* we have reached 1506, a year both highly productive and highly critical during which Raphael was working intently to absorb both Leonardo's and Michelangelo's modes of representation. Our suggested date for the *Madonna del Cardellino* shows that the documentary evidence mentioned earlier provides only a rough timescale; stylistic analysis is necessary to achieve greater precision.

At first sight, the disposition of *La Belle Jardinière* (**130**) appears to be a mirror-image of the *Madonna del Prato* (**117**), because most of the motifs are similar. The standing Child looks up to his mother seated on a rock and reaches out for the breviary resting against her arm, while the kneeling St John regards him in adoration. The group is placed on a meadow full of plants and flowers; the hilly landscape of the background includes again a Northern-style townscape. The similarities between the two paintings are deceptive, however, for the evolution of the mature and differentiated later composition begins with a different starting-point. For *La Belle Jardinière*, two compositional full-length studies, besides the cartoon, survive. The squared sheet (**129**; Louvre, Paris), generally regarded as the earlier sketch, already includes the main elements of the painting. The drawing takes up the figure disposition of the

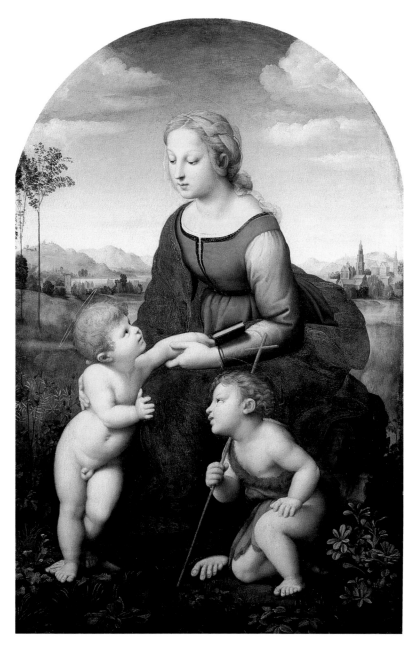

130 Raphael, *Madonna and Child (La Belle Jardinière)*, signed and dated 1508[?].
Oil on panel. Musée du Louvre, Paris.

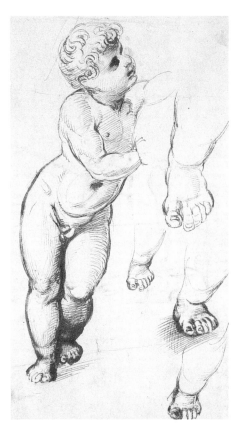

131 Raphael, *Christ Child and Other Studies.*
Pen over leadpoint. Ashmolean Museum, Oxford.

Madonna del Prato and adopts the idea of a dialogue between the two children, but places them more successfully in front of the Madonna, who has slightly changed her seat. With his right hand, the wreathed St John embraces the lamb leaping up at him – only in later studies does Raphael revert to the motif of the cross-staff. The twisted body of the Child derives from the figure of St John in a preliminary study for *The Holy Family (Canigiani)* (**122**), but its nervous contour fails to round off the group harmoniously. It was presumably this figure that caused Raphael to revise his conception; once again Michelangelo's sculpted *Madonna and Child* (**34**) provided the decisive inspiration. A sketch of the standing Christ paraphrases Michelangelo's figure and prepares the final resolution (**131**). The drawing defines not only the pronounced *contrapposto* of the Child (explained in the painting where the Child puts his left foot on his mother's), but also shows more graceful outlines and greater plasticity. It is interesting that Raphael did not borrow this motif from his own *Madonna del Prato*, but found it only after renewed consultation with Michelangelo's work. This tells us something about the artist's complex creative processes and the intense search for the final formulation, and also hints at a prolonged gestation period for the painting.

La Belle Jardinière represents the sum of Raphael's achievements in the field of monumental paintings of the Madonna, Child and infant St John. Basing himself on a triangular framework originally derived from Leonardo, the artist during his later Florentine years developed

132 Raphael, *Christ Child* (detail of 130)

a language of images of great persuasive power, which culminates in this picture. The easily legible form – a large triangle, inscribed with a smaller one defined by the two children – is now enriched by a confident exploration of space and volume. Although the original appearance has been seriously affected by the lost brilliance of Mary's blue mantle, the children as well as the upper part of the Virgin's body provide free movements within the picture space. These movements are harmonious, lively and fully modelled in the round; they represent a major advance over the two earlier paintings, the *Madonna del Prato* and the *Madonna del Cardellino*. The same new-found confidence is apparent in the treatment of the foreground. The plants, too, are now conceived spatially and no longer as a narrow strip laid out in front of the figure composition, as was still the case in the *Madonna del Prato*. Such progress certainly speaks for a rather late date, far into 1507. The controversy about the date inscribed on the hem of Mary's garment, therefore, need not bother us too much: MDVII or MDVIII in this case does not mean a difference of a full year but possibly only a few weeks.[142]

Its size alone would suggest that the painting was produced on commission, but so far no likely client has emerged. Two passages in Vasari's *Vite* are thought to refer to *La Belle Jardinière*. In Raphael's biography, the author mentions an unfinished painting of the Madonna, adding that Ridolfo del Ghirlandaio (1483–1561) completed the Virgin's mantle and various other small patches, and then sent it to 'several gentlemen from Siena'; this fact is

repeated in Ghirlandaio's biography. As a possible candidate for a Sienese client, the name of Filippo Sergardi, secretary to Pope Leo x, has been put forward, but without sufficient proof. This circumstantial material, however, would fit the dating of the painting to Raphael's late Florentine period.[143]

Finally, the *Esterházy Madonna* (133) presents an opportunity to recapitulate some fundamental aspects of Raphael's development during his Florentine sojourn. The unfinished painting certainly dates from the end of his Florentine period, and affords valuable insights into Raphael's painting technique. While work on the landscape and the draperies had progressed quite far, the flesh tones show as yet almost no modelling. The paint has been applied evenly almost throughout, however, and creates such a uniform overall impression that the balanced composition can be fully appreciated. The small picture is painted on a very thin, and now heavily warped, panel which was discovered only in 1812 in the Esterházy collection, with a note stating that it was presented to the Empress Elizabeth by Pope Clement xi. It was kept in a small wooden box and is in generally very good condition.[144]

The only surviving preparatory drawing is of almost identical size and gives the complete composition (134). The close correspondence between the drawing and the painting, and the fact that the drawing shows pricking marks, seems proof enough that it served as a cartoon and was used for direct transfer of the composition to the panel. Evidently, the original conception was for a slightly narrower format, so that Raphael made adjustments for the broader panel, mainly to the landscape. The townscape on the right disappeared and was replaced by a classical ruin on the left, and the rocky outcrops in the foreground were more broadly laid out.

Long ago it was noticed that for this composition Raphael was guided by pictorial concepts from Leonardo. Unlike previous examples, the immediate source for this painting can no longer be identified with certainty, but a sketch by Leonardo among some early studies gives his basic idea (135). It also shows a kneeling Madonna as part of a distinctly asymmetrical pyramidal composition: she nurses the Child on her left thigh and turns her head towards the approaching young John. The sketch, dated to the end of the 1470s, provides many crucial motifs and elaborates the pronounced, volume-enhancing torsion of the Madonna. This invention was borrowed by various artists at the time, and Leonardo himself produced several sketches with variations of Mary's pose right up to the *Madonna with the Yarnwinder*, where it appears in a new context (29).[145] It is highly instructive to see what Raphael does with Leonardo's example. He retains defining elements, but changes the emphasis and makes both form and content more clearly legible by making all three figures parts of a continuous, undulating motion. The kneeling St John indicates the central theme simply by what he is reading, the words of his text – ECCE AGNUS DEI – to be supplied by the observer. In a free and easy manner the narrative continues with Mary behind St John, likewise kneeling, bending down to him and with a twist of her torso lending support to the Child perched on a rock. The Child concludes the sequence of movements by emphatically leaning forward and pointing at the scroll.

Compared with paintings from the early Florentine years, such as *The Holy Family with the Lamb* (115), it is obvious that Raphael's approach to Leonardo has become much more reflective and mature. The principles of torsion and interlocking figures demonstrated by Leonardo at the beginning of the century in the highly complex versions of *St Anne with the Madonna and Child* (31, 32) now meet with an independent and well-considered response.

133 Raphael, *Esterházy Madonna*. Oil on panel. Szepmüvészeti Múzeum, Budapest.

134 Raphael, *Compositional Sketch for the Esterházy Madonna*.
Pen over chalk. Galleria degli Uffizi, Florence.

Raphael accepts them and, basing himself on one of Leonardo's figure drawings, produces a composition that is tightly interlocked and at the same time easy to read. This goal, recognizable time and again in Raphael's sketches from the early Florentine period, was reached only shortly before his move to Rome, and is realized in a painting that combines, in a deceptively casual manner, everything the artist had learned during his Florentine years.

The depiction of a classical ruin in the background is a novelty in Raphael's paintings of this period; it has led to the suggestion that the picture was either completed after the move to Rome or was directly connected with an earlier visit to the Holy City. But this decorative, rather free, rendition of classical ruins was not based on personal observation: the view, identified as the Forum Nervae with the campanile of S. Basilio in the background, is derived from one of two prints in the *Codex Escurialensis*. This practice recalls Raphael's use of Northern prints and drawings during his earlier Florentine period. The fact that this late painting shows a Roman view may simply be a coincidence; there is no compelling reason to associate it with his immediate departure for the city.[146]

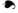

Surveying Raphael's development during his years in Florence from the heights of such mature Madonna paintings as the *Niccolini–Cowper Madonna* or the *Esterházy Madonna* (**108, 133**), we may recall Vasari's words: 'he changed and improved his manner so much, from having seen many works by the hands of excellent masters, that it had nothing to do

135 Leonardo da Vinci, *Sheet of Sketches.*
Pen. Windsor Castle.

with his earlier manner'.[147] What happened between the production of the Madonna paintings of his early years, still redolent of Perugino's art, and those from his later Florentine period is indeed remarkable. Vasari's theory of the evolution of Raphael's art and his patterns of analysis are very much of their time, but nevertheless his point of view is often confirmed by our own observations based on modern criteria. Vasari's claim that Perugino's training was the greatest obstacle to Raphael's career, however, is certainly unjustified. On the contrary, what he learned from Perugino gave Raphael a solid framework for his Florentine studies and, during his most intense dialogue with Leonardo and Michelangelo, saved him from becoming a mere follower of their art. It was not only his much-vaunted 'inbred grace' that caused Raphael to remain wary of Leonardo's and Michelangelo's complexity, but also his deep understanding of Perugino's simply constructed, lyrical compositions, which helped him to develop his own style. In such mature statements about art as the *Niccolini–Cowper Madonna*, Raphael recaptures a lightness and grace that have their roots in Perugino's Umbrian idiom, but are now expressed in the more differentiated language of the Florentine High Renaissance.

V. SUMMARY

Three altarpieces

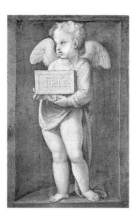

The foregoing observations have brought out the major characteristics of Raphael's early artistic development. During relatively modest beginnings in Florence, the artist devoted himself to studying Leonardo and later also Michelangelo, the range of his reflections expressed in everything from a straightforward quotation to a paraphrase with variations. His drawings illustrate his manner of 'creative copying'; the Madonna paintings clearly record the various stages in a continuous progress. First – and up to now little considered – reflections of Leonardo's works like the *Madonna di Terranuova* or *The Holy Family with the Lamb* probably date from about 1504/5 (**111, 115**). A more differentiated approach becomes noticeable by about 1506, when compositions based on Leonardo show greater freedom, although the problems Raphael has to contend with are still plain to see. Typical examples of this phase are *The Holy Family (Canigiani)* and the *Madonna del Cardellino* (**121, 126**). Shortly afterwards, Raphael's much greater assurance finds expression in *The Bridgewater Madonna* and *La Belle Jardinière* (**104, 130**). Full of confidence, Raphael now begins to place himself on an equal footing with his great masters and, in paintings either executed or conceived before his departure for Rome, finally achieves complete artistic independence. Of this last phase, the *Niccolini–Cowper Madonna* and the *Esterházy Madonna* provide instructive examples (**108, 133**).

Against this background, we shall look at three altarpieces, each of which belongs to one of the evolutionary stages and adds to the insights already gained. The altarpiece differs from the devotional painting in certain respects. Devotional pictures were primarily designed for private use; they were in great demand, and their production was presumably highly organized. An altarpiece, on the other hand, was executed solely on commission and could involve a number of different specialists (painters, sculptors and architects). Furthermore, because of its size and its often large number of figures, the altarpiece was a much more demanding piece of work. A special feature of the situation in Florence was that altarpieces, being generally acces-

sible, came under close public scrutiny. For quite some time after his arrival in Florence, the only commissions Raphael received for altarpieces came from Umbria, where he had already executed a number of them. It was only near the end of his Florentine period that he received an order for a large altarpiece, from the Dei family – an indication that he had finally established his reputation in that city.

Raphael's *Colonna Altarpiece* (**136**) today survives in an incomplete state and, like most of the extant altarpieces from this period, removed from its original context. The predellas are dispersed in various collections, one, with the main panel and lunette, being kept at the Metropolitan Museum, New York. The two latter panels are fitted in an old frame; although it is not the original, it helps us to imagine what they must once have looked like, and to appreciate their unity. The disposition of the figures of the main image is severely symmetrical and clearly accentuated. Mary is seated on a stepped throne under a *baldacchino*, holding the Child who faces the approaching infant John with a gesture of benediction. Standing in the foreground are the large figures of St Peter and St Paul, which largely obscure those of St Catherine and St Cecilia behind them. The female saints, placed on a platform, counterbalance the strict pyramidal construction of the central group and partly block out the views into the landscape on either side. The crowded disposition of figures in the lunette links awkwardly with the main picture, even though the figure of God the Father, flanked by two angels, is placed along the central axis.

The altarpiece was produced for the convent of S. Antonio in Perugia, where it remained for almost two hundred years before entering the Colonna Collection in Rome in the late seventeenth century, from which it takes its present title. Vasari mentions the altar in connection with a visit by Raphael to Perugia, to which he also assigns the *Ansidei Madonna* and the S. Severo *Trinity* (**14, 15**). In dating these pictures to 1505 we have to assume that the artist, arriving in Florence in October 1504, stayed for only a few months before returning to Perugia to finish the paintings, which had probably been ordered and partly begun some time before. No specific evidence of this sojourn in Perugia survives.[148] Vasari gives an extensive description of the *Colonna Altarpiece*; he mentions all the main figures and the clothed Christ, praises the beauty of the female saints with their unusual hairstyles and finally singles out from among the predellas the movement of figures in the Deposition scene. There can be no doubt that Vasari himself closely inspected the altarpiece, which was famous in its time and much venerated by the nuns.[149] And it is probably due to his connecting the *Colonna Altarpiece* with Raphael's stay in Perugia that modern scholarship tends to date it to about 1504/5. Doubts have been raised about this date, which we shall attempt to justify here.[150]

The debate starts with the obvious stylistic contradictions of the whole arrangement. The main panel was inspired directly by Perugino's *Decemviri Altarpiece* of the 1480s (**24**). In Raphael's modernized version, the steps lead up realistically to the throne which is covered by a *baldacchino*; the pyramidal figure composition has been rationally resolved and the scene supplied with a landscape background. The success of this conception, which may incorporate further borrowings from Perugino, is indicated not only in Vasari's words of praise but also in several later Umbrian versions.[151] The compact central group of the Madonna, the Child and St John – a subject more commonly associated with devotional pictures – is constructed with a clear sequence of movements. Raphael translates a group from a composition by Pinturicchio,

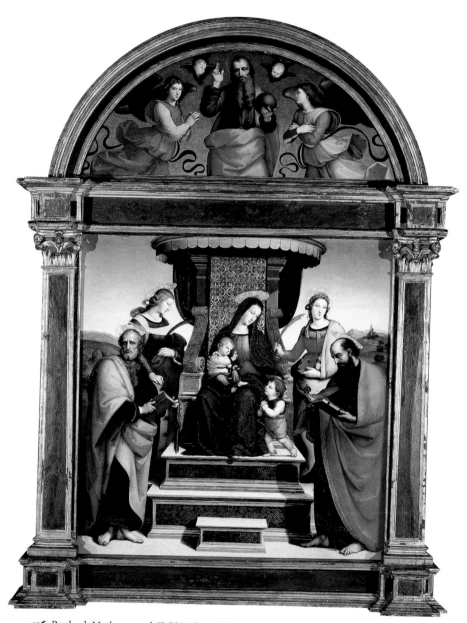

136 Raphael, *Madonna and Child Enthroned with Saints (Colonna Altarpiece)*. Oil on panel.
The Metropolitan Museum of Art, New York.

137 Fra Bartolommeo, *Study for a Prophet*. Chalk.
Museum Boymans-van Beuningen, Rotterdam.

which served as an inspiration, into the formal language of his late Umbrian period, the style of the Pasadena *Madonna and Child with a Book* (**87**).[152] The flanking figures, however, hardly correspond to the main group and they include stylistic discrepancies. While the garments, hairstyle and type of the female saints are still Peruginesque, the male figures anticipate an imagery that has nothing to do with Perugino or the Umbrian style. This element has quite correctly been attributed to the direct influence of Fra Bartolommeo who, according to Vasari, was a close friend of Raphael.[153]

The *Last Judgement* of 1501 was Fra Bartolommeo's most ambitious early work and highly influential (**26**). Contemporary drawings of the fresco, which is difficult to read today, document the artist's manner of figure painting and allow us to draw certain conclusions; one study for a prophet provides a good example (**137**; Boymans–van Beuningen, Rotterdam). Here the figure is monumentally conceived, its vigorous, bold drapery both voluminous and expressive. This type of draped figure with a strong, space-defining presence represents one of Fra Bartolommeo's major contributions to Florentine art of the High Renaissance; it must have made a strong impression on the young Raphael. The two male saints of the *Colonna Altarpiece* derive their pronounced plasticity from Fra Bartolommeo, although Raphael does not adopt the latter's style of drapery. His approach shows up very clearly in the massive and solidly constructed figure of St Peter on the left: two great swathes of folded drapery invest the figure with a sense of space in a crucial passage of the composition. The drapery, however, is still indebted

138 Raphael, *The Agony in the Garden.* Oil on panel. Metropolitan Museum of Art, New York.

to an idiom derived from Perugino and is also found on later altarpieces from Raphael's Umbrian period, such as *The Betrothal* or the *Ansidei Madonna* (**13, 14**).

In this way, the two male figures in particular represent a transitional phase, perhaps best described as one of ambivalence. This is evident not only in the contrast between the monumental figures of the Apostles on the one hand and the very Umbrian group with the Madonna on the other, but also in the figures themselves. Whereas St Peter's pose is basically convincing, the firm stance of St Paul is inconsistent with the broad sweep of his garment: the feet and upper part of the body appear somehow unconnected. Even more obvious are the discrepancies between the panel and the lunette, the latter being severely, almost rigidly constructed, with the traditionally conceived figures crowding together because of insufficient space. It is very different from the predella showing the Agony in the Garden (**138**).[154] In this small space Raphael was able to develop his painting manner more freely; both the plasticity of the figures and their spatial disposition are much less problematic, and the whole picture appears more compact and, within the Florentine context, more modern than the main panel.

These inconsistencies between its traditional and more progressive elements date the *Colonna Altarpiece* clearly to Raphael's early Florentine period. It is hardly conceivable that such a creation could be followed by altarpieces so thoroughly Peruginesque as the *Crucifixion* of 1503 (**10**) or *The Betrothal* of 1504 (**13**). The direct and very pointed dialogue with Fra Bartolommeo jars with the harmonious Peruginesque visual idiom of Raphael's Umbrian

213

phase. It is instructive to look again at two large works from this period. The fresco of *The Trinity* in S. Severo, dated 1505, presents very similar problems (15). The overall disposition is still a rather simple paraphrase of Fra Bartolommeo's *The Last Judgement* (26), comparable to the way in which Raphael adapted Leonardo for his *Holy Family with the Lamb* (115) of 1504. In the S. Severo fresco, the conflict between the monumentally conceived draped figures of Christ and the seated saints and the totally Peruginesque depiction of the angels typifies this transitional stage. The painting suggests that Fra Bartolommeo's art must have had such an overwhelming effect on Raphael that he was rendered incapable of immediately formulating a new and homogenous visual language. So it is all the more surprising to find in the *Ansidei Madonna* (14) of the same year a coherence based on Perugino's characteristic uniformity of figure types, with no indication of a fundamentally new departure, although it does exhibit greater plasticity. The apparent contradiction is explained by the fact that the inscribed date of 1505 refers only to the painting's completion: its conception had been decided before Raphael's departure for Florence. For the *Colonna Altarpiece*, on the other hand, Raphael may have prepared only preliminary studies, so that he could incorporate his reactions to Fra Bartolommeo, resulting in the disparities we have noted. The *Colonna Altarpiece* exemplifies Raphael's situation during his early years in Florence. As a whole it poignantly expresses the insecurity he must have experienced during the early stage of his dialogue with the great Florentine masters, which made him unable to formulate a coherent pictorial style for such a demanding genre as the altarpiece.

The Entombment or *Baglioni Altarpiece*, signed and dated RAPHAEL URBINAS M.D. VII, was also produced for a Peruginese client (139). According to Vasari the commission came from Atalanta Baglioni (see page 24); once Raphael had received it he returned to Florence to design the cartoon, finishing the work only during a later stay at Perugia. Vasari gives a detailed description of this altarpiece: 'In this most divine picture there is a Dead Christ being borne to the Sepulchre, executed with such freshness and such loving care, that it seems to the eye to have been only just painted. In the composition of this work, Raffaello imagined to himself the sorrow that the nearest and most affectionate relatives of the dead one feel in laying to rest the body of him who has been their best beloved, and on whom, in truth, the happiness, honour, and welfare of a whole family have depended. Our Lady is seen in a swoon; and the heads of all the figures are very gracious in their weeping, particularly that of S. John, who, with his hands clasped, bows his head in such a manner as to move the hardest heart in pity. And in truth, whoever considers the diligence, love, art, and grace shown by this picture, has great reason to marvel, for it amazes all who behold it, what with the air of the figures, the beauty of the draperies, and, in short, the supreme excellence that it reveals in every part.'[155]

Vasari understood *The Entombment* as a narrative painting, and emphasized in particular the expressive quality of the figures and their pure harmony. He thus touched upon the specific qualities of the *historia* already recommended by Alberti. Vasari, Raphael's junior by a generation, saw no fundamental difference between a narrative painting and an altarpiece, and it was exactly at this period that the principles of the *historia* were consistently applied to both devotional pictures and altarpieces. With this in mind, a look at two of the numerous preliminary studies for *The Entombment* reveals two different conceptions, one of which superseded the other.[156] The early sketches culminated in a drawing of a Lamentation which has all the charac-

teristics of a *modello* (**140**; Louvre, Paris). The composition is generally based on patterns Raphael had learned from Perugino.[157] But he goes much further than Perugino in the modelling, the differentiated expression of the figures, and the compact construction of the groups. Although narrative elements are emphasized, the conception retains the traditional character of the multi-figure altarpiece and fulfils its purpose by making it possible to address the central image for both meditation and worship. In a Pietà the dead body of Christ is the main subject, and the grief of the mourning mother is echoed by that of St John. It is interesting to note that in the unfinished *modello* the figure of the mourning St John remains incomplete and, of his companions, only the profile of one standing figure has been sketched.[158] Such a state would suggest that Raphael rejected the whole conception of this *modello*, which had been preceded by a number of earlier studies, because he was no longer satisfied with it.

A new beginning is illustrated by a drawing that introduces important elements of the final composition (**141**; British Museum, London). Various sources contributed to the solution, but the crucial factor was the change of subject from a Lamentation to an Entombment.[159] This decision altered the whole character of the painting – it was no longer an iconic image of the Pietà but a narrative representation, a *historia*. By choosing to paint a narrative scene, Raphael took up the challenge posed in particular by the grand designs of Leonardo and Michelangelo for the Council Chamber.[160] The drawing suffers, however, from the same conflict that remained unresolved even in the final painting: the dead body of Christ is the dominant image, while his mourning mother and her companions are relegated to the sidelines.

Modern scholars have frequently criticized *The Entombment* for this imbalance. The disposition of the figures carrying and lamenting over Christ's body is an artistic *tour de force* which illustrates how Raphael had developed a new visual idiom within a short time. The same applies to the group of the three Marys surrounding the fainting mother of Christ. Yet, even though the figure of the kneeling woman, in a direct paraphrase of Michelangelo's Mary in the *Doni Tondo* (**38**), links the two groups, the imbalance remains: the dead body of Christ is the main subject, his mother's mourning a lesser event. Nevertheless we may presume that, even before Vasari's time, the reputation of *The Entombment* and its new elements had reached such a degree that the absence of unity in form and content mattered little.

Interest in a new visual language was shared by the educated public and open-minded clients. Although no details concerning the client for *The Entombment* are known, Vasari's identification of her as Atalanta Baglioni is generally accepted; the altarpiece was certainly displayed in S. Francesco al Prato in Perugia with an inscription, lost but recorded, identifying Atalanta as the donor.[161] She was the mother of Grifonetto Baglioni, who murdered his family rivals and was then himself assassinated, and is likely to have commissioned the altarpiece on the occasion of his death. The date is unrecorded, but the preliminary drawings were executed within a short span of time so we may assume that Raphael received the order in 1505 during a visit to Perugia and that most of the drawings date from 1506. The Lamentation was appropriate subject matter both for the immediate context and for the general purpose of the painting, and it therefore seems unlikely that the donor was responsible for the change, although it seems reasonable to assume that she was receptive to progressive ideas in the arts.

The retable survives only in parts; its general appearance can be reconstructed, but not its architectural details. Vasari's description deals only with the main panel; no other sections

were mentioned until the late eighteenth century, long after the main panel had been removed to Rome by order of Cardinal Scipione Borghese and a copy substituted in the original setting. The eighteenth-century description and the surviving fragments indicate that the altar was of a composite type quite common in Central Italy during the later fifteenth century, and different from altars like Raphael's *Coronation of the Virgin* for the same church (11). The Baglioni altar consisted of an almost square main panel, a smaller panel above it with God the Father giving his blessing, and three predella panels. The architrave of the central framework was presumably decorated with a frieze of gryphons.[162] It seems that Raphael worked in cooperation with other painters; the gryphon frieze has always been attributed to his workshop, while the upper panel showing God the Father is not by his hand.[163] An unusual feature is the decoration of the predellas with the triad of theological virtues – normally one would expect illustrations of subjects connected typologically with the main theme in the central image. The original sequence of the panels showing Faith, Charity and Hope is implied by the disposition of the figures and confirmed by a surviving copy.[164] The grisaille predellas imitate sculpture in that each figure, symbolizing a virtue, is depicted within a tondo and flanked by two putti placed in niches. In the case of Faith the angels bear tablets inscribed CPX and IHS, allusions to Christ as an object of faith. The attributes of the angels flanking Charity are also significant: the putto on the left carries on its shoulders the flaming chalice associated with Charity; the chalice emptied by the angel on the right presumably refers to generosity. The subjects of the predellas relate symbolically to the main panel: Charity in the centre emphasizes the theme of motherhood, while Hope and Faith refer to the principal motif, Christ's martyrdom. Raphael's conception, new in iconographic terms, is appropriate in two ways: it refers to the theme of the altarpiece, and also alludes to the private circumstances of the donor. It is a remarkably sophisticated realization of a new concept within the genre: the central image, although translated into the language of a *historia*, still relates to the rather static predellas which – executed in grisaille imitating sculpture – provide a calm counterpoint.

The Entombment is an example of Raphael's art at an advanced stage of his Florentine period. At first reverting to Perugino's style, under the influence of current movements in art Raphael gave his preparatory sketches the dramatic character of a narrative painting. His dialogue with Michelangelo becomes highly significant, discernible in the drawing techniques, the quotation from the *Doni Tondo* and the group of figures in the Charity design. The latter's sculptural character closely relates to Michelangelo's art, in particular to his Florentine tondi (37, 38).[165] The large number of preparatory studies reveal Raphael's efforts to create a new formal language based on Florentine inspirations. Other paintings of the period share *The Entombment*'s complexity, for example *The Holy Family (Canigiani)* (121). As yet, however, the problems revealed have not been completely solved. Nevertheless, *The Entombment* as a whole, with its unity of main panel and predellas, represents a remarkable new work, unlike almost anything produced in Florence at that time.

The *Madonna of the Baldacchino* (142), Raphael's last and most distinguished commission before his departure to Rome, is evidence that the artist had finally won the highest approval. Although no date for the commission is known, it is usually connected with the testament of Bernardo Dei of 1506. Measuring 276 × 224 centimetres, and thus much larger than *The Entombment*, the altarpiece has had a chequered history. When Raphael left Florence in 1508 it

139 Raphael, *The Entombment (Baglioni Altarpiece)*. Oil on panel. Galleria Borghese, Rome.
Predella panels, *Faith, Charity, Hope*. Oil on panel. Pinacoteca Vaticana, Rome.

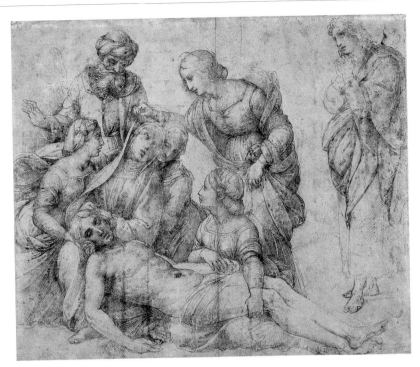

140 Raphael, *Lamentation over the Dead Christ*. Pen over chalk. Musée du Louvre, Paris.

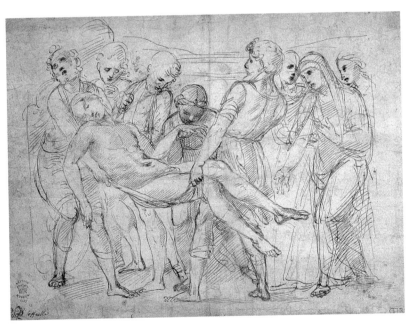

141 Raphael, *The Entombment*. Pen over chalk. British Museum, London.

was unfinished, although the main parts had been prepared – Vasari calls it an almost completed design (*bozza*).[166] The Dei had intended it for their family chapel in S. Spirito, but soon after 1508 it was acquired by the papal datary Baldassare Turini who placed it in his chapel in the cathedral at Pescia in about 1540. In the late seventeenth century, it was acquired by the Medici who had its upper part slightly enlarged and installed it in their gallery in the Palazzo Pitti. In place of their commission to Raphael, in 1522 the Dei placed a painting by Rosso Fiorentino on the altar of their family chapel.

The *Madonna of the Baldacchino* has been very harshly treated by critics. Left unfinished by Raphael, it was later moved to various locations, and for a long time it was unclear how far later interventions might have altered its original appearance – all facts that have caused arguments about how much of it could safely be assigned to Raphael.[167] Awkward hanging in the Palazzo Pitti did the rest. Only after a thorough restoration, completed in 1991, has it become possible to give a more confident appraisal. Careful technical examination has confirmed Vasari's report: the execution of the painting was far advanced, and all important areas were painted by Raphael himself. Although there are no completely finished sections and the degree of preparation varies, the painting as a whole appears homogeneous and gives a good idea of the intended colour scheme. In this regard it resembles the *Esterházy Madonna* (**133**), likewise unfinished and revealing similar working methods. Fortunately we know its destination (which we do not in the case of the *Colonna Altarpiece* and *The Entombment*): the Capella Dei in S. Spirito allows us to see for ourselves how Raphael took the intended location into account.

The overall disposition of the *Madonna of the Baldacchino* is clear and easy to read.[168] At the centre, Mary and the Child are seated on a stepped throne crowned with a *baldacchino*, the curtain of which is drawn back by two angels. The space in front of the throne is defined by two *putti* singing from a sheet of music (**143**) – they, as well as Mary and the Child, accentuate the main axis, which, with the two angels hovering above on either side, assumes the shape of a cross. Two saints are shown on each side, Peter and Bernard on the left, James and Augustine on the right. The background is provided by a classical niche framed by slender composite columns. The treatment of the figures already illustrates the great artistic freedom Raphael had achieved by the end of his Florentine sojourn. This is particularly obvious in the depiction of Peter and Bernard, conceived as monumental draped figures who relate to each other in a variety of ways. This harmonious interplay is not yet achieved quite so well in the pair opposite, where Augustine's gesture especially appears over-theatrical. The mother-and-child group represents a variation on a motif developed successfully in the *Niccolini–Cowper Madonna* at about the same time (**108**). So again the group is characterized by Raphael's effort to connect the hieratic pose of the enthroned Virgin with the lively and playful movements of the Child. But it is principally the angels who invest the painting with a new spirit: rendered with bold foreshortening and dressed in gaily fluttering draperies, they no longer have anything in common with their Peruginesque predecessors, such as those that appear in the *Crucifixion* of 1503 (**10**).

The *Madonna of the Baldacchino* belongs to the type of *sacra conversazione* Raphael had already explored in drawings of his Umbrian period and of which the *Ansidei Madonna* and the *Colonna Altarpiece* are examples (**14, 136**). Now Raphael achieves a synthesis of his earlier efforts and the contemporary Central Italian style. The construction of the throne is a direct

borrowing from the *Colonna Altarpiece*, in turn inspired by a Perugino design, and here Raphael emphasizes Mary's seated pose by giving the throne itself a more monumental appearance and elaborating the *baldacchino* motif by the addition of the airborne angels. This feature, a curtain drawn back by angels, is an old one, which had made a recent appearance in Florentine paintings such as Botticelli's *S. Barnaba Altarpiece* of 1490. A comparison of the flanking pairs of saints with those in the earlier *Colonna Altarpiece* makes obvious Raphael's artistic development during his Florentine years. Here, the stances of the figures and their spatial relationships are fully resolved, each figure playing its part in the composition with natural ease. On the left, Peter in conversation with Bernard invites the observer to enter the picture; both figures act as visual reference points for the architectural setting and its pictorial depth. The bent figure of James continues this movement, and then Augustine, gazing straight at the observer, leads the eye with an emphatic gesture to the central group. By this time Raphael has succeeded in turning a well-established pattern into a vibrant High Renaissance work of art, and the reading he offers is that of a *historia*.

The dignified framework for the 'action' in the foreground is supplied by the architecture, which is now much more than simply a backdrop. Large composite columns flank an apse accentuated by pilasters and carry an entablature supporting a coffered half-dome. This arrangement was also well-established; it appears, for example, in Piero della Francesca's *Montefeltro Altarpiece*, probably familiar to Raphael since his childhood days in Urbino (3). No doubt Raphael went back to such exemplars, but on the basis of a complete reformulation of his aesthetic idiom he now invests them with a classical spirit which is perfectly appropriate for the architecture of S. Spirito, the altarpiece's intended destination. This building, by Brunelleschi, is characterized by elegant chapels with semi-circular niches. In the fifteenth century, these chapels were decorated in the traditional manner with altarpieces that were almost square or slightly oblong, a format used by Filippino Lippi and Raphaellino del Garbo (see **21, 22**). The *Madonna of the Baldacchino* was presumably designed for the same format, and a conjectural reconstruction exists of the altar and its immediate context.[169] Raphael's contribution to architectural representations consists in the monumental semi-circular niche that defines the background space. It provides an emphatic accent and the necessary depth for the figures to move freely. Although it refers directly to the architecture of the chapel, its classical features present a stark contrast to the delicate, austere style of Brunelleschi. Other inspirations from classical architecture, in particular the interior of the Pantheon, can also be discerned.[170] In such a way, the architecture supports and encloses the disposition of the figures and produces an overall impression of monumental and organic forms.

Only since the recent restoration can we appreciate the full meaning of the *Madonna of the Baldacchino* and dispose of some earlier misconceptions. One of these concerned Raphael's relationship with Fra Bartolommeo. There is no doubt of the friar's great influence on the young artist – clearly demonstrated, for example, in the S. Severo *Trinity* and the *Colonna Altarpiece* (**15, 136**). It has often been suggested that this relationship extended to the *Madonna of the Baldacchino*. However, at the end of Raphael's Florentine period the influence was working the other way: Fra Bartolommeo was basing himself on Raphael for his multi-figure altarpieces, and thereby contributing greatly to the character of Florentine painting of the High Renaissance.[171]

220

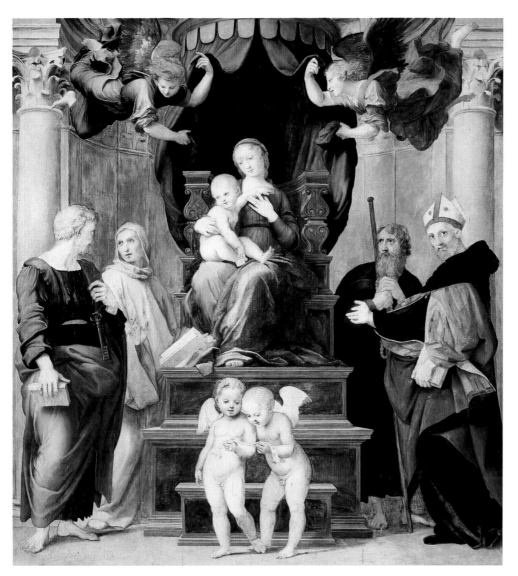

142 Raphael, *Madonna of the Baldacchino*. Oil on panel. Palazzo Pitti, Florence.

In comparison to the fifteenth-century manner of the *Ansidei Madonna* (**14**), we can see that in the *Madonna of the Baldacchino* Raphael found compositional and stylistic solutions that allowed him finally to abandon any remaining Quattrocento influence and prove his mastery of a language of images typifying the High Renaissance. With its enhanced sense of volume, more expressive and complex treatment of the mother-and-child group, greater freedom of gesture and of movement in drapery, and classical borrowings, the *Madonna of the Baldacchino* represents the sum of Raphael's Florentine experience and serves as a prelude to his work in Rome.

In a letter of 24 October 1542, Michelangelo found occasion to make a bilious remark about Raphael, dead and buried well over twenty years before: 'All the disagreements between Pope Julius and me were caused by the jealousy of Bramante and Raphael of Urbino; it was because of this that he did not proceed with his tomb in his lifetime, much to my disadvantage. And Raphael had good reason, for all he knew about art he learnt from me.'[172] Michelangelo, who was well known for his sharp tongue in matters concerning his fellow artists, was presumably not only recalling his strained relations with the papal court caused by his rivalry with the two men from Urbino. The pointed remark that Raphael had learned everything from him certainly referred to his period in Florence – and Michelangelo's pride probably kept him from mentioning other important influences, such as Leonardo. Michelangelo's opinion of Raphael mentioned by the older artist's biographer, Ascanio Condivi – that 'this art did not come to him naturally, but by long study'[173] – confirms, albeit obliquely, Raphael's consistent and systematic method of appropriation, his determination to exploit the works of great masters in order to create his own language. For all their bitterness, Michelangelo's words still seem to betray surprise that this young man, trained by such an old-fashioned character as Perugino, could, by studying his works (among others), achieve a rank equal to his own within such a short time. It is precisely this artistic development that it has been possible to reconstruct here, from a group of works which have a documentary value almost unique in the history of art.

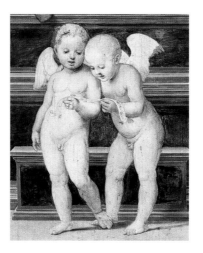

143 Raphael, *Two Putti* (detail of **142**)

222

Notes

1. See Barolsky 1995.

2. The dukedom remained in the hands of the della Rovere family until the seventeenth century. On the culture of the Montefeltro court at Urbino, see Clough 1981; Ciardi Duprè and Dal Poggetto 1983; Cerboni Baiardi, Chittolini, and Floriani 1986; Dal Poggetto 1992; on Francesco di Giorgio's work in Urbino, see Fiore and Tafuri 1993.

3. On the ideal cityscape, see the summary by Kemp in Levenson 1991, nos 147f.; Morolli in Dal Poggetto 1992, p.215; both Krautheimer and Damisch in Millon and Lampugnani 1994, pp.233, 539. An early depiction of the ducal palace at Urbino from the circle of Raphael has survived in the so-called *Libretto Veneziano* in the Accademia, Venice; see Ferino Pagden 1982, p.201; Ferino Pagden 1984, p.109.

4. On S. Bernardino, see Burns in Fiore and Tafuri 1993, p.230.

5. On Berruguete and Justus of Ghent, see Zeri 1987, pp.583, 651; Montevecchi in Dal Poggetto 1992, p.338.

6. See Schmarsow 1887, p.91, quoting Giovanni Santi's comparison of Leonardo and Perugino, the latter being praised as a 'divine painter': 'Dui giovin per detate e per damori / Leonardo da Vinci el Perusin / Pier dalle Pieve che un divin pictore.'

7. See Joannides in Sambucco Hamoud and Strocchi 1987, p.55.

8. For *The Courtier*, see Castiglione 1982; on the author himself, see Hanning and Rosand 1983.

9. On Girolamo Genga and Timoteo Viti, see Arcangeli in Briganti 1988, pp.724, 864.

10. See, for instance, the examples given by De Vecchi 1966, nos 40ff., 45, the arguments by Brown 1983 [1], p.115, the contributions in Gregori et al. 1984, p.58, nos 2–4, and Bellosi in Sambucco Hamoud and Strocchi 1987, p.401; and the conjectures by Shearman 1970, p.72.

11. See Canuti 1931, p.93; Scarpellini 1984, p.38 n.163.

12. On Raphael's Umbrian period and his clients, see Bombe 1911, p.296; Wittkower 1963, p.150; Oberhuber 1977, p.55; Luchs 1983, p.29; De Vecchi in Cotteri 1985, p.43; Ettlinger in Beck 1986, p.85; Mancini 1987.

13. On the contracts, see Golzio 1971, p.7, and Mercanti 1994, p.19, who also throws light on Andrea Baronci; on the theory that the commission was primarily addressed to the workshop and not to Raphael, see Ettlinger in Beck 1986, p.85; on the price of altarpieces, see Bombe 1912, Lehmkuhl-Lerner 1936.

14. See Béguin and Viatte in Béguin 1983 [1], pp.69, 163.

15. For positive arguments about an extended period in Perugino's workshop see, for instance, Béguin in Beck 1986, p.26; for an early negative opinion, see Bombe 1911, p.301.

16. Vasari 1981, v, p.318 (Vasari 1979, II, p.879): '[Raphael] se n'andò con alcuni amici suoi a Città di Castello; dove fece una tavola in Santo Agostino, di quella maniera; e similmente in San

Domenico una d'un Crucifisso; la quale, se non vi fusse il suo nome scritto, nessuno la crederebbe opera di Raffaello, ma sì bene di Pietro.'

17. For details, see Luchs 1983, p.29; Burckhardt 1929–34, V, p.20. According to Blanshei 1979, p.597, the Baglioni were by far the richest and most influential family in Perugia at the time; see also the article by R. Abbondanza in the *Dizionario Biografico degli Italiani*, V, p.207.

18. There is no need to repeat the classic point-by-point comparison. Even though the exact date of completion of Perugino's painting is unknown, it is today almost unanimously agreed that his design was earlier than Raphael's; on Perugino's painting, see Scarpellini 1984, no.129. There is the question, however, of whether the Albizzini could have asked Raphael to base himself on Perugino's painting (for this argument, see Bertelli in Pirovano 1984, p.28), since it is not clear how far work had progressed at the time Raphael received the commission. In general, such practice was not unusual in Umbria; see Bombe 1912, p.244.

19. The recorded visit to Umbria was in connection with the *Monteluce Altarpiece* which Raphael himself never executed; see Golzio 1971, p.11, and Mancinelli in Shearman and Hall 1990, p.153. Raphael's esteem in Perugia is all the more remarkable, for Peruginese patrons were mainly interested in fostering native artists; see Blanshei 1979, p.617.

20. The roman letters MDV appear within a series of ornamental signs purely decorative in intent, a not uncommon feature in Raphael's work. The fact that the date is followed by two vertical strokes has occasionally led to speculation that they form part of it, but this is unlikely since the numeric letters themselves are prominently displayed. The significance of dates with ornamental embellishments in Raphael's work has so far received little attention; see the remarks in Gould 1975, p.216. Vasari mentions the painting as one of Raphael's early works and dates it to the artist's brief return to Perugia; see Vasari 1981, IV, p.323 (Vasari 1979, II, p.883): 'Dopo queste opere ed avere accomodate le cose sue, ritornò Raffaello a Perugia, dove fece nella chiesa de' frati de' Servi, in una tavola alla cappella degli Ansidei, una Nostra Donna, San Giovanni Battista e San Nicola.' For attempts to identify the client, see Manzoni 1899, p.627; for a comprehensive discussion of the Ansidei, see Mancini 1987, p.57.

21. For preparatory studies, see Knab, Mitsch, and Oberhuber 1983, nos 26, 77; Joannides 1983, nos 20r., 37; Cordellier and Py 1992 [1], p.29. More

closely related than the *Decemviri Altarpiece* is Perugino's *Family of the Virgin*, today generally dated to about 1502; see Scarpellini 1984, no.125. Raphael may have been directly influenced by this painting.

22. See Ettlinger in Beck 1986, p.87, suggesting that the clients may have asked specifically for paintings after Perugino.

23. For problems about the signature and a possible later date, see Fischel 1913, p.213; Fischel 1962, p.49; Gere and Turner 1983, p.90; Dussler 1971, p.68. The 1505 date is also accepted by Oberhuber 1982, p.38, and Mancini 1987, p.57.

24. For details, see Mancini 1987, p.53.

25. See Golzio 1971, p.9: 'Sarà lo esebitore di questa Raffaele pittore da Urbino, il quale avendo buono ingegno nel suo esercizio, ha deliberato stare qualche tempo in Fiorenza per imparare. E perchè il padre fo molto virtuoso e mio affezionato, e così il figlio discreto, e gentile giovane; per ogni rispetto io lo amo sommamente, e desidero che egli venga a buona perfezione; però lo raccomando ala Signoria Vostra strettamente … Urbini, prima Octobris 1504. Joanna Feltria de Ruvere. Ducissa Sorae et Urbis Praefectissa.'

26. For a study of Pier Soderini's cultural policies, see Cooper 1978 with further suggested reading.

27. Vasari 1981, IV, p.321 (Vasari 1979, II, p.881): 'fu nella città molto onorato; e particolarmente da Taddeo Taddei, il quale lo volle sempre in casa sua ed alla sua tavola, come quegli che amò sempre tutti gli uomini inclinati alla virtù. E Raffaello, che era la gentilezza stessa, per non esser vinto di cortesia, gli fece due quadri, che tengono della maniera prima di Pietro, e dell' altra che poi studiando apprese, molto migliore, come si dirà: i quali quadri sono ancora in casa degli eredi del detto Taddeo.'

28. See Golzio 1971, p.18; for Taddeo Taddei and his family, see Gregori et al. 1984, p.39.

29. On the inspiration of Leonardo, see pages 116–20; see also the remarks by Cecchi in Sambucco Hamoud and Strocchi 1987, p.437, about Maddalena Doni's advanced pregnancy in 1507 in connection with his suggestion of dating the painting before 1507. On Florentine portraits in general see, for instance, Alazard 1951.

30. Vasari 1981, IV, p.325 (Vasari 1979, II, p.884): 'Dimorando adunque in Fiorenza, Agnolo Doni, il quale quanto era assegnato nell' altre cose, tanto spendeva volentieri, ma con più risparmio che poteva, nelle cose di pittura e di scultura, delle quali si dilettava molto, gli fece fare il ritratto di sè e della sua donna in quella maniera che si veggiono

appresso Giovanbatista suo figliuolo nella casa che detto Agnolo edificò bella e comodissima in Firenze nel Corso de' Tintori, appresso al canto degli Alberti.' In his *Vita* of Michelangelo, Vasari makes another sarcastic remark about Agnolo's meanness in connection with the purchase of the *Doni Tondo*; see ibid. 1981, VI, p.158.

31. Vasari 1981, IV, pp.321–2 (Vasari 1979, II, pp.881–2): 'Ebbe anco Raffaello amicizia grandissima con Lorenzo Nasi; al quale, avendo preso donna in que' giorni, dipinse un quadro, nel quale fece fra le gambe alla Nostra Donna un putto, al quale un San Giovannino tutto lieto porge un uccello, con molta festa e piacere dell' uno e dell' altro. È nell' attitudine d'ambidue una certa simplicità puerile e tutta amorevole, oltre che sono tanto ben coloriti e con tanta diligenza condotti, che piuttosto paiono di carne viva che lavorati di colori e di disegno; parimenti la Nostra Donna ha un' aria veramente piena di grazia e di divinità; ed insomma il piano, i paesi, e tutto il resto dell' opera è bellissimo. Il quale quadro fu da Lorenzo Nasi tenuto con grandissima venerazione mentre che visse, così per memoria di Raffaello statogli amicissimo, come per la dignità ed eccellenza dell' opera. Ma capitò poi male quest' opera l'anno 1548 a dì 17 novembre, quando la casa di Lorenzo, insieme con quelle ornatissime e belle degli eredi di Marco del Nero, per uno smottamento del monte di San Giorgio, rovinarono insieme con altre case vicine: nondimeno ritrovati i pezzi di essa fra i calcinacci della rovina, furono da Batista figliuolo d'esso Lorenzo, amorevolissimo dell' arte, fatti rimettere insieme in quel miglior modo che si potette.' For Lorenzo Nasi, see Gregori et al. 1984, p.77.

32. For Domenico Canigiani, see Gregori et al. 1984, p.43; Troncarelli describes Domenico Canigiani as a typical *cortegiano*, who was also a friend of Michelangelo, but nothing is known about his patronage or collecting interests (*Dizionario Biografico degli Italiani*, 18: p.89). Vasari mentions him only as the client of *The Holy Family*, of which he gives a long description; see Vasari 1981, IV, p.325 (Vasari 1979, II, p.884).

33. On the Dei family, see Gregori et al. 1984, p.43, and the article by Guidotti in the *Dizionario Biografico degli Italiani*, XXXVI, p.243.

34. For the pertinent remark in Raphael's letter to his uncle, see Golzio 1971, p.8; on the altarpiece, see also Vasari 1981, IV, pp.328–9 (Vasari 1979, II, p.885): 'Finito questo lavoro [*The Entombment*] e tornato a Fiorenza, gli fu dai Dei, cittadini fiorentini, allogata una tavola che andava alla cappella

dell' altar loro in Santo Spirito; ed egli la cominciò, e la bozza a bonissimo termine condusse…. per che, lasciate l'opere di Fiorenza e la tavola dei Dei non finita, ma in quel modo che poi la fece porre messer Baldassarre da Pescia nella pieve della sua patria dopo la morte di Raffaello.'

35. On altar paintings, see Burckhardt 1929–34, XII, p.1; Humfrey and Kemp 1990; Humfrey 1993; Borsook and Superbi Gioffredi 1994; with special reference to Florence, see Locher 1993, p.487.

36. The dating of the painting is controversial (between 1488 and 1494); see Berti and Baldini 1991, pp.63, 193, and the not very persuasive argument by Bridgeman 1988, p.668. On the decoration of S. Spirito, see Markowsky 1973, p.105, and Locher 1993, p.487.

37. See Aronberg Lavin 1955, p.85; Aronberg Lavin 1961, p.319.

38. Vasari 1981, III, p.585 (Vasari 1979, I, p.740): 'Aveva Pietro tanto lavorato, e tanto gli abondava sempre da lavorare, che e'metteva in opera bene spesso le medesime cose; ed era talmente la dottrina dell' arte sua ridotta a maniera, ch' e'faceva a tutte le figure un' aria medesima. Perchè essendo venuto già Michelagnolo Buonarroti al suo tempo, desiderava grandemente Pietro vedere le figure di quello, per lo grido che gli davano gli artefici. E vedendosi occultare la grandezza di quel nome, che con sì gran principio per tutto aveva acquistato, cercava molto con mordaci parole offendere quelli che operavano. E per questo meritò, oltre alcune brutture fattegli dagli artefici, che Michelagnolo in publico gli dicesse, ch' egli era goffo nell' arte. Ma non potendo Pietro comportare tanta infamia, ne furono al magistrato degli Otto tutti due; dove ne rimase Pietro con assai poco onore.'

39. In his *Libro*, Antonio Billi criticized Perugino's altarpiece for the Annunziata ('finì la parte di dietro P. Perugino molto male [the back by P. Perugino is very badly done]') before 1530; see Billi 1891, p.329, and Billi 1991, p.94. For Vasari's lengthy disapproval, see Vasari 1981, III, p.585 (Vasari 1979, I, p.740). The discussion by Chastel 1984, p.120, is biased and uses the sources in cavalier fashion.

40. For mention of Fra Bartolommeo's destruction of his own works, see Vasari 1981, IV, p.178; on Signorelli, see Riess 1995.

41. Vasari 1981, IV, p.326 (Vasari 1979, II, p.884): 'Ebbe, oltre gli altri, mentre stette Raffaello in Fiorenza, stretta dimestichezza con Fra Bartolomeo di San Marco, piacendogli molto e cercando assai d'imitare il suo colorire: ed, all'

incontro, insegnò a quel buon Padre i modi della prospettiva, alla quale non aveva il Frate atteso insino a quel tempo.' The *quid pro quo* – Raphael imitating Fra Bartolommeo's coloration and in return teaching him the rules of perspective – is presumably Vasari's artistic licence. There is some truth in it, however: Raphael learned from the friar, who was later to profit from the younger artist's pictorial ideas, particularly from the *Madonna of the Baldacchino* (**142**).

42. On the tondo, see Hauptmann 1936; on the historical evidence, Olson 1993; numerous examples are also in Kecks 1988.

43. See Vasari 1981, III, p.689.

44. For details, see Kemp 1981, p.213.

45. See Crowe in Kemp 1992, p.25.

46. For a transcription of the letter see Pedretti 1982, no.44: 'El Quadretino che fa e una Madona che sede come se volesse inaspare fusi, el Bambine posto el piede nel Canestrino dei fusi e ha preso laspo e mira atentamēte que quattro raggi che sono in forma di Croce. E Como desideroso dessa Croce ride et tienla salda nōla volendo ceder a la Mama che pare gela volia torre.'

47. See Vezzosi in Pedretti 1982, no.27/8: 'Altro nō ha facto senō che dui suoi garzoni fano retrati et lui ale volte ī al cuno mette mano. Da opra forte ad la geometria Impiacēti simo al pannello.'

48. Vasari 1981, IV, pp.38–9 (Vasari 1979, II, p.788): 'ed i frati perchè Lionardo la dipingnesse, se lo tolsero in casa, facendo le spese a lui ed a tutta la sua famiglia: e così li tenne in pratica lungo tempo, nè mai cominciò nulla. Finalmente fece un cartone dentrovi una Nostra Donna ed una Sant' Anna con un Cristo, la quale non pure fece maravigliare tutti gli artefici, ma finita ch' ella fu, nella stanza durarono due giorni d'andare a vederla gli uomini e le donne, i giovani ed i vecchi, come si va alle feste solenni; per veder le maraviglie di Lionardo, che fecero stupire tutto quel popolo; perchè si vedeva nel viso di quella Nostra Donna tutto quello che di semplice e di bello può con semplicità e bellezza dare grazia a una madre di Cristo, volendo mostrare quella modestia e quella umiltà, ch'è in una vergine, contentissima d'allegrezza nel vedere la bellezza del suo figliuolo che con tenerezza sosteneva in grembo, e mentre che ella con onestissima guardatura a basso scorgeva un San Giovanni piccol fanciullo, che si andava trastullando con un pecorino, non senza un ghigno d'una Sant' Anna, che colma di letizia vedeva la sua progenie terrena esser divenuta celeste: considerazioni veramente dallo intelletto ed ingegno di Lionardo. Questo cartone, come di sotto si dirà,

andò poi in Francia.' On the preparatory drawings, see the less than convincing attempt by Wasserman 1970, p.201, to establish a correspondence between Vasari's description and the British Museum drawing 1875-6-12-17 recto; see Budny 1983, p.34, and Nepi-Scirè 1992, p.244. Kemp 1981, p.223, also treats Vasari's text with caution; he further dissociates the St Anne complex from the commission for the altarpiece for SS Annunziata, perceptively arguing that Leonardo chose the St Anne motif himself because it was popular in Florence on account of its nationalist appeal (Florentines still vividly recalled the memory of the liberation of the city from the Duke of Athens on St Anne's Day, 1343).

49. Pedretti 1982, no.2718: 'La vita di Leonardo e varia et indeterminata forte sicħ pare vivere a gornata. A facto solo dopoi cħ e ad firenci uno schizo in uno Car tone. Finge uno christo bambino de eta cerca una anno che usiendo quasi de bracci ad la māma piglia uno agnello et pare che lo stringa. La māma qī [quasi] levandose de grembo ad S.ta Anna piglia il bambino per spicarlo dalo agnel lino (animale immolatile che significa la passiōe). S.ta Anna alquanto levandose da sedere pare cħ voglia retenere la figliola cħ nō spica el bambino da lo agnello. Cħ forsi vole figurare la chiesa cħ ñ vorebbe fussi impedita la passione di Christo. Et sono q̄ste figure grāde al naturale ma stano in picolo cartone perche Tutte o sedeno o stano curve et una stae alq̄to dinanti ad laltra verso la man sinistra. Et q̄sto schizo ancora nō e finito.' See also Kemp 1992, no.9.

50. Suida 1929, p.131, connected Brescianino's composition with Leonardo's cartoon of 1501 and pointed out that this early design was unknown in Milanese circles. The drawing (**30**) has rarely been exhibited and it will be possible only after close examination to decide whether it is autograph or a copy after Leonardo.

51. Seventeenth-century sources connected the picture with a commission by King Louis XII of France in 1499; although the commission is not documented, experts at first tended to date the cartoon to 1498–1500. Later, a date of 1505 was favoured and there were even suggestions of dating it to 1508–10, assuming a royal commission of about 1508.

52. The occasional attempt to identify the figure in the London cartoon as St Elizabeth instead of St Anne is unconvincing (see particularly Schug 1968, p.446; Schug 1969, p.24, following a suggestion by Suida 1929, p.131; the case against was made by Wasserman 1971, p.325 n.60). The motif of

Mary sitting on her mother's lap, which Leonardo here modifies, is part of the standard iconography of the St Anne triad and does not appear in depictions of the Holy Family that include St Elizabeth.

53. The best-known copy is by Barnardino Luini (Ambrosiana, Milan); see also Suida 1929, pp.130, 235. On the transfer technique, see page 180.

54. On the Chatsworth drawing, see comprehensively Nepi-Scirè 1992, no.22, p.244. The whole discussion about the evolution of the St Anne compositions often seems somewhat futile in view of the fact that almost certainly only a small number of Leonardo's sketches of the subject have survived. This makes even conscientious readings like those by Wasserman 1970, p.194, Wasserman 1971, p.312, and Budny 1983, p.43, appear problematic from the outset.

55. See Béguin 1983 [2], p.79.

56. Vasari 1981, IV, pp.39–40 (Vasari 1979, II, p.789): 'Prese Lionardo a fare per Francesco del Giocondo il ritratto di mona Lisa sua moglie; e quattro anni penatovi, lo lasciò imperfetto; la quale opera oggi è appresso il re Francesco di Francia in Fontanableo: nella qual testa chi voleva vedere quanto l'arte potesse imitar la natura, agevolmente si poteva comprendere; perchè quivi erano contraffatte tutte le minuzie che si possono con sottigliezza dipignere. Avvengachè gli occhi avevano que' lustri e quelle acquitrine che di continuo si veggono nel vivo, ed intorno a essi erano tutti que' rossigni lividi e i peli, che non senza grandissima sottigliezza si possono fare. La ciglia, per avervi fatto il modo del nascere i peli nela carne, dove più folti, e dove più radi, e girare secondo i pori della carne, non potevano essere più naturali. Il naso, con tutte quelle belle aperture rossette e tenere, si vedeva essere vivo. La bocca, con quella sua sfenditura, con le sue fini unite dal rosso della bocca, con l'incarnazione del viso, che non colori, ma carne pareva veramente. Nella fontanella della gola chi intentissimamente la guardava, vedeva battere i polsi; e nel vero si può dire che questa fussi dipinta d'una maniera da far tremare e temere ogni gagliardo artefice, e sia qual si vuole. Usovvi ancora questa arte; che essendo madonna Lisa bellissima, teneva, mentre che la ritreava, chi sonasse e cantasse, e di continuo buffoni che la facessino stare allegra, per levar via quel malinconico che suol dar spesso la pittura a' ritratti che si fanno: ed in questo di Leonardo vi era un ghigno tanto piacevole, che era cosa più divina che umana a vederlo, ed era tenuta cosa maravigliosa, per non essere il vivo altrimenti.'

57. The quotation from Antonio de Beatis's *Relazione* is in Marani 1989, p.106: 'una certa donna fiorentina facta di naturale ad istantia del quondam magnifico Juliano de Medici.'

58. See Wallace in Hager 1992, p.55, who also points out that Michelangelo invested in property and real estate around Florence.

59. Barocchi and Ristori 1965–83, I, p.12: 'l'altra è quella Nostra Donna di marmo: vorrei la faciessi portare chostì in casa e non lasiassi vedere a persona.'

60. Seymour 1967, p.140: 'non sta bene che la donna uccida lhomo, et maxime essendo stata posta chon chattiva chonstellatione, perchè da poi in qua siate de male in peggio: perdessi poi Pusa.'

61. See Landucci 1912/13, p.119.

62. Vasari 1981, VII, pp.156–7 (Vasari 1979, III, p.1846): 'e veramente che questa opera ha tolto il grido a tutte le statue moderne et antiche, o greche o latine che elle si fussero ... E certo chi vede questa, non dee curarsi di vedere altra opera di scultura fatta nei nostri tempi o negli altri da qualsivoglia artefice.'

63. See Tolnay 1943–60, I, p.162; Vasari 1981, VII, p.157.

64. Vasari 1981, VII, pp.158–9 (Vasari 1979, III, p.1846): 'Venne volontà ad Agnolo Doni, cittadino fiorentino, amico suo, sì come quello che molto si dilettava aver cose belle, così d'antichi come di moderni artefici, d'avere alcuna cosa di Michelagnolo: perchè gli cominciò un tondo di pittura, dentrovi una Nostra Donna, la quale, inginocchiata con amendua le gambe, ha in sulle braccia un putto e porgelo a Giuseppo, che lo riceve; dove Michelagnolo fa conoscere, nello svoltare della testa della madre di Cristo, e nel tenere gli occhi fissi nella somma bellezza del Figliuolo, la maravigliosa sua contentezza e lo affetto del farne parte a quel santissimo vecchio; il quale con pari amore, tenerezza e reverenza lo piglia, come benissimo si scorge nel volto suo, senza molto considerarlo. Nè bastando questo a Michelagnolo, per mostrare maggiormente l'arte sua essere grandissima, fece nel campo di questa opera molti ignudi appoggiati, ritti, ed a sedere, e con tanta diligenza e pulitezza lavorò questa opera, che certamente delle sue pitture in tavola, ancora che poche sieno, è tenuta la più finita e la più bella opera si truovi.' See Condivi 1928, p.79.

65. Vasari 1981, IV, p.47 (Vasari 1979, II, p.792): 'Era sdegno grandissimo fra Michelagnolo Buonarroti e lui: per il che partì di Fiorenza Michelagnolo per la concorrenza, con la scusa del duca Giuliano, essendo chiamato dal papa per la facciata di San Lorenzo. Lionardo intendendo ciò, partì ed andò in Francia, dove il re avendo avuto opere sue, gli era molto affezionato, e desiderava

che colorisse il cartone della Sant' Anna …' The second quotation is taken from the *Anonimo Magliabechiano* (1892, p.115) written in about 1540: 'Et passando ditto Lionardo insieme con Giovanni da Gavine da Santa Trinita dalla pancaccia delli Spini, dove era una ragunata d'huomini da bene, et dove si disputava un passo di Dante, chiamero detto Lionardo, dicendogli, che dichiarassi loro quel passo. Et a caso apunto passo di qui Michel Agnolo, et chiamato da un di loro, rispose Lionardo: "Michele Agnolo ve lo dichiarera egli." Di che parendo a Michelangelo, l'havessi detto per sbeffarlo, con ira gli rispose: "Dichiaralo pur tu, che facesti un disegno di uno cavallo per gittarlo di bronzo et non lo potesti gittare et per vergogna lo lasciasti stare." Et detto questo, volto loro le rene et ando via; dove rimase Lionardo, che per le dette parole divieto rosso.' See the somewhat exaggerated account of the rivalry between Leonardo and Michelangelo in Chastel 1984, p.142.

66. The commonly used reconstruction of the council chamber is by Wilde, of which Isermeyer produced a revised and controversial scheme. Because so little is known about its original appearance, all attempts at reconstruction are problematic. The present Salone dei Cinquecento is much higher due to Vasari's building additions, but one can still follow the former decorative scheme. For a detailed summary of the reconstruction of the council chamber in republican times, see Kemp 1981, p.234; from among the considerable literature about the chamber with special regard to its painted decoration by Leonardo and Michelangelo, see particularly Köhler 1907, p.115; Tolnay 1943–60, I, p.209; Neufeld 1949, p.170; Wilde 1953, p.65; Gould 1954, p.117; Isermeyer 1964, p.83; Gould 1966; Chastel 1984, p.149; Joannides 1988, p.76; Zöllner 1991, p.177; Farago 1994, p.301.

67. This may be implied by a crucial passage in Vasari 1981, IV, p.41: 'la quale [the Grand Council Chamber] finita con grande prestezza, fu per decreto publico ordinato che a Lionardo fussi dato a dipignere qualche opera bella.' A surviving document of 4 April 1504 about this commission suggests that both payments and preliminary work had begun by that date: work on a cartoon had begun, forty gold florins had been paid, and Leonardo was obliged to complete a cartoon for the whole painting by February 1505, otherwise he would have to pay back the advance; once transfer of the painting to the wall had started, he was to receive monthly wages. For details see Isermeyer 1963, p.116.

68. In a letter of 1523 Michelangelo explains the situation (Barocchi and Ristori 1965–83, III, p.7): 'io avevo tolto a fare la metà della Sala del Consiglio di Firenze, cioè a dipingere. [I had begun to paint half of the council chamber in Florence.]' There is an ambiguity about whether 'half of the chamber' refers only to the eastern part of the wall – this is the current, generally held view – or to separate walls, as suggested in Isermeyer 1963.

69. Leonardo's work methods were described by Matteo Bandello who, when a young monk at S. Maria della Grazie, had watched progress on *The Last Supper* (Bandello 1910, p.283; Clark 1989, p.146): 'ed io più volte l'ho [Leonardo] veduto e considerato, andar la matina a buon'ora e montar sul ponte, perchè il cenacolo è alquanto da terra alto; soleva, dico, dal nascente sole sino a l'imbrunita sera non levarsi mai il penello di mano, ma scordatosi il mangiare e il bere, di continovo dipingere. Ne sarebbe poi stato dui, tre e quatto dì che non v'averebbe messa mano, e tuttavia dimorava talora una e due ore del giorno e solamente contemplava, considerava ed essaminando tra sè, le sue figure giudicava. L'ho anco veduto secondo che il capriccio o ghiribizzo lo toccava, partirsi da mezzo giorno, quando il sole è in lione, da Corte vecchia ove quel stupendo cavallo di terra componeva, e venirsene dritto a le Grazie ed asceso sul ponte pigliar il pennello ed una o due pennellate dar ad una di quelle figure, e di subito partirsi e andar altrove. [Many a time I have seen Leonardo go early in the morning to work on the platform before the Last Supper; and there he would stay from sunrise till darkness, never laying down the brush, but continuing to paint without eating or drinking. Then three or four days would pass without his touching the work, yet each day he would spend several hours examining it and criticizing the figures to himself. I have also seen him, when the fancy took him, leave the Corte Vecchia when he was at work on the stupendous horse of clay, and go straight to the Grazie. There, climbing on the platform, he would take a brush and give a few touches to one of the figures: and then suddenly he would leave and go elsewhere.]' See Heydenreich 1974, p.15.

70. For a comprehensive account of these events with a fresh look at Leonardo's writings, see Farago 1994, pp.301, 310 (on the problem of Leonardo's painting materials).

71. Isermeyer 1963, p.123: 'Anchora ciscusa la V.S. in concordar un di Leonardo da Vinci, il quale non si è portato come doveva con questa republica; perchè ha preso buona soma di denaro e dato un

piccolo principio a un opera grande doveva fare.'

72. Vasari 1981, IV, pp.41–3 (Vasari 1979, II, p.790): 'fu per decreto publico ordinato che a Lionardo fussi dato a dipignere qualche opera bella ... Per il che, volendola condurre, Lionardo cominciò un cartone alla sala del papa ... dentrovi la storia di Niccolò Piccinino capitano del duca Filippo di Milano, nel quale disegnò un groppo di cavalli che combattevano una bandiera: cosa che eccellentissima e di gran magisterio fu tenuta, per le mirabilissime considerazioni che egli ebbe nel far quella fuga ... che due lo difendono con una mano per uno, e l'altra in aria con le spade tentano di tagliar l'aste, mentre che un soldato vecchio, con un berretton rosso, gridando tiene una mano nell' asta, e con l'altra inalberato una storta, mena con stizza un colpo per tagliar tutte a due le mani a coloro, che con forza digrignando i denti tentano con fierissima attitudine di difendere la loro bandiera ... Dicesi che per disegnare il detto cartone fece uno edifizio artificiosissimo, che stringendolo s'alzava, ed allargandolo s'abbassava. Ed imaginandosi di volere a olio colorire in muro, fece una composizione d'una mistura sì grossa per lo incollato del muro, che continuando a dipignere in detta sala, cominciò a colare di maniera, che in breve tempo abbandonò quella, vendendola guastare.'

73. Leonardo da Vinci 1970, no.601: 'E se farai cavalli corrēti fori della turba, fa li nuboletti di polvere distati l'uno dall' altro, quato può essere lo ītervallo de' salti fatti dal cavallo e quello nu volo'. Ibid., no.602: 'farai alcuno cavallo strascinare morto il suo signore e dirieto a quello lasciare per la polvere e fãgo il segno dello strascinato corpo; farai i vīti e battuti pallidi colle ciglia alte nella lor cōgiūtione e la carne che resta sopra loro sia abbondāte di dolēti crespe; Le faccie del naso sieno con alquāte grīze partite in arco dalle narici e terminate nel prīcipio dell' occhio; Le narici alte, cagiō di dette pieghe, le labra arcate scoprano i dēti di sopra, dēti spartiti in modo di gridare cō lamēto.... Altri farai gridāti colla bocca sbarrata e fugiēti: farai molto sorte d'arme īfra i piedi de' cōbattitori, come scudi rotti, lancie, spade rotte e altre simili cose, farai omini morti alcuni ricoperti mezzi dalla povere, altri tutti.'

74. For a discussion of the preparatory studies for *The Battle of Anghiari*, see most recently Nepi-Scirè 1992, p.256.

75. All the more so in view of the well-known fact that Leonardo inevitably made major revisions while work was in progress. For what is probably the most sensible, comprehensive account of the reconstruction of the whole intended composition, see Gould 1954, p.118; also Pedretti 1973, p.82; for a more recent overview, see Joannides 1988, p.76.

76. For an attempt to reconstruct Michelangelo's early painting oeuvre, see Hirst and Dunkerton 1994.

77. Isermeyer 1963, p.124: 'Significando alla S.V. che ha principiato una storia per il publico che sarà cosa admiranda ...'

78. Vasari 1981, VII, pp.159–61 (Vasari 1979, III, p.1847): 'Avvenne che, dipignendo Lionardo da Vinci, pittore rarissimo, nella sala grande del Consiglio ... Piero Soderini, allora gonfaloniere, per la gran virtù che egli vidde in Michelagnolo, gli fece allogagione d'una parte di quella sala; onde fu cagione che egli facesse a concorrenza di Lionardo l'altra facciata, nella quale egli prese per subietto la guerra di Pisa.... e quivi cominciò un grandissimo cartone, nè però volse mai che altri lo vedesse: e lo empiè di ignudi, che bagnandosi per lo caldo nel fiume d'Arno, in quello stante si dava a l'arme nel campo, fingendo che gli inimici li assalissero ... si vedeva ... molti mettersi altre arme in dosso, ed infiniti combattendo a cavallo cominciare la zuffa. Eravi, fra l'altre figure, un vecchio che aveva in testa per farsi ombra una grillanda di ellera; il quale, postosi a sedere per mettersi le calze, e non potevano entrargli per aver le gambe umide dell' acqua V'erano ancora molte figure aggruppate ed in varie maniere abbozzate, chi contornato di carbone, chi disegnato di tratti, e chi sfumato, e con biacca lumeggiati, volendo egli mostrare quanto sapesse in tale professione perciochè da poi che fu finito e portato alla sala del Papa ... tutti coloro che su quel cartone studiarono, e tal cosa disegnarono ... diventarono persone in tale arte eccelenti, come vedemo.'

79. Cellini 1954, I-12, p.31 (Cellini 1956, p.31): 'Stetteno questi dua cartoni, uno in nel palazzo dei Medici, e uno alla sala del papa. In mentre che gli stetteno in piè, furno la scuola del mondo.'

80. See the convincing reconstruction in Gould 1966.

81. Vasari 1981, IV, pp.325–6 (Vasari 1979, II, pp.883–4): 'Nè tacerò che si conobbe, poi che fu stato a Firenze, che egli variò ed abellì tanto la maniera, mediante l'aver vedute molte cose di mano di maestri eccellenti, che ella non aveva che fare alcuna cosa con quella prima, se non come fussino di mano di diversi e più e meno eccellenti nella pittura.... Studiò questo eccellentissimo pittore nella città di Firenze le cose vecchie di Masaccio; e quelle che vide nei lavori di Lionardo e di Michelagnolo lo feciono attendere maggior-

mente agli studi, e per conseguenza acquistarne miglioramente straordinario all' arte e alla sua maniera.'

82. Ghiberti 1912, v: 'lo scultore e'l pictore, el disegno è il fondamento et teorica di queste due arti.' For a basic introduction to the subject, see Ames-Lewis 1981; also important are Ames-Lewis and Wright 1983, and Ragghianti and Dalli Regoli 1975; on Florentine drawing of the late fifteenth century. see Petrioli Tofani 1992.

83. Leonardo 1970, no.484: 'Ritrai prima disegni di buono maestro fatto sul' arte e sul naturale e nõ di pratica, poi di rilievo in cõpagnia del disegnio tratto da esso rilievo, poi di buono naturale, il quale debbi mettere ī uso.'

84. On the subject of 'creative copies', see Haverkamp-Begemann and Logan 1988 with extensive bibliography; on Michelangelo, see Hirst 1988, p.59; on 'imitatio' in Raphael's work, see Quedneau 1984.

85. On Raphael's drawings, see the fundamental studies by Fischel 1913–41; Knab, Mitsch and Oberhuber 1983; Joannides 1983; Ames-Lewis 1986; Cocke 1969; Forlani Tempesti in Becherucci 1968, II, p.307; Forlani Tempesti 1983.

86. There are heads by Leonardo more closely corresponding to Raphael's profile, for instance two from a group of classical profiles (see Nepi-Scirè 1992, nos 39, 40). On the subject of grotesque character heads, see Gombrich 1976, p.57; Caroli 1991; Nepi-Scirè 1992, p.308.

87. See Ames-Lewis 1986, p.13.

88. There are three principal studies of the Leda, the dating of which is controversial. One version shows a kneeling Leda and is documented by Leonardo drawings and a few copies. For the figure of a standing Leda, Müller-Walde and later Clark have suggested two versions. The first one shows an emphatic torsion of the body, an elaborate coiffure of coiled tresses, and the swan's wing embracing her thigh reaching only as far as the hollow of her knee. The second and later version repeats the basic figure composition, but the twist of the body is reduced, the coiled tresses have disappeared and the swan's wing-feathers reach further down. This version is usually dated to Leonardo's stay in Milan in 1507/8 when he may have executed a cartoon or a painting. The painting acquired by the King of France was lost in the eighteenth century, but we have Cassiano da Pozzo's description of 1625 in which he mentions the naked Leda, the swan, the infants hatched from eggs and the meticulous representation of the plants; see Clark 1989, p.181. The drawings of

plants, of children emerging from eggshells and the very female shape of the Leda all relate to Leonardo's interest in the mysteries of natural organisms and the larger subject of man's relationship with nature. For details, see Müller-Walde 1897, p.137; Pedretti 1973, p.97; Kemp 1980, p.182; Pedretti and Clark 1980, p.34; Kemp 1981, p.270; Pedretti and Vezzosi 1983, p.79; Clark 1989, p.180; Marani 1989, p.142; Dalli Regoli 1990, p.5. The greatest numbers of copies are illustrated in Pedretti and Vezzosi 1983; from this material it is evident that the Raphael drawing and the Louvre drawing discussed below represent the first type of the standing Leda as well as some other paintings (see nos 167, 170ff.); the second type is best represented by a painting in the former Spiridon collection (ibid., no.166), and of this version there also exist numerous repetitions and variations.

89. Leonardo da Vinci 1970, no.596: 'Non usar mai fare la testa volta dove il petto, nè 'l braccio andare come la gãba, e se la testa si volta alla spalla destra. Fa le sue parti piu basse dal lato sinistro che dal destro, e se fai il petto infori fa che, voltandosi la testa sul lato sinistro, che le parti del lato destro sieno piu alte che le sinistre.' A similar rapid advance after relatively simple beginnings is noticeable in the evolution of the St Anne compositions.

90. An almost identical pose is documented in another sketch by Baldassare Peruzzi, which seems to relate to a Leda figure by Leonardo, presumably to a drawing. Here again we do not know the exemplar but it may well be that Peruzzi's sketch records a stage immediately prior to the one Raphael saw: the rhythm of the figure is slightly livelier and the head more strongly inclined; see Wurm 1984, p.423 (Uffizi 528 A. recto). We have not included in our discussion a small sketch by Leonardo which occurs on a sheet with geometric drawings in the Codice Atlantico; see Müller-Walde 1897, p.137; Pedretti and Vezzosi 1983, no.142. The sketch in the Codice Atlantico obviously relates to Leda's posture, but what seems to be a later redaction has changed it so much that it is uncertain whether it still refers to the Leda motif.

91. The plant appears on a study by Leonardo, where it has been identified as a Star of Bethlehem (Ornithogalum umbellatum; Windsor castle, no.1242); see also Clark and Pedretti 1968, p.67; Pedretti and Clark 1984, p.34; Kemp in Levenson 1991, no.184; on plants in Leonardo's work in general, see Emboden 1987.

92. Leonardo da Vinci 1970, no.389: 'Nota il moto del livello dell' acqua, il quale fa a uso de' capelli,

che ànno due moti, de' quali l'uno attēde al peso del vello, l'altro al linia mento delle volte; così l'acqua à le sue volte revertigino se, delle quali una parte attende al inpeto del corso principale, l'al tro attēde al moto incidēte e reflesso.'

93. The drawing is generally dated about 1505, although there are disagreements; see Joannides 1983, pl. 15, no.175, as against, for instance, Viatte in Bèguin 1983 [1], p.216; see also Cordellier and Py 1992 [1], p.60. Its relation to the *Lady with a Unicorn*, which can only partly be ascribed to Raphael, cannot be discussed here; see also Cordellier and Py 1992 [2], p.92.

94. See also references in the catalogue entry for the *Mona Lisa* (**33**); the most recent discussion is Shell and Sironi in Fiorio and Marani 1991, p.148.

95. We refer only to the *Portrait of a Young Woman* (Musée des Beaux-Arts, Lille, inv. no.469), where Raphael again bases himself firmly on Leonardo, giving one of the latter's characteristic facial types. The resemblance to Leonardo's drawing technique is particularly noticeable in the differentiated modelling achieved by delicate hatching; see Knab, Mitsch, and Oberhuber 1983, no.103; Brejon de Lavergnée 1990, no.28.

96. Leonardo da Vinci 1971, p.475: 'Imperò che 'l pittore con grand' aggio siede dinanzi alla sua opera ben vestito, e move il levissimo penello con li vaghi colori, et ornato di vestimenti come a lui piace, e l'abitazione sua piena di vaghe pitture e pulita, et accompagnata spesse volte di musiche o lettori di varie e belle opere, le quale senza strepito di martelli o d'altri rumori misto, sono con gran piacere udite.'

97. See, for instance, Forlani-Tempesti 1984, p.17; the number of relevant studies could certainly be extended to include, for instance, no.523 verso in the Ashmolean, Oxford; see Knab, Mitsch, and Oberhuber 1983, no.173.

98. On the subject of principal viewpoints, see Larsson 1974. It is well-known that Renaissance sculptors provided for only a few viewpoints. In the case of the *David* Michelangelo's choice was restricted by the fact that he was working with a pre-cut block.

99. See Vasari 1981, IV, p.326; but we do know a Michelangelo drawing after Masaccio, which would suggest that the earlier Florentine master was regarded as a suitable model; see note 84.

100. The figure of the standing armoured man was used at least three times by Perugino in about 1500: for the St Michael in the altarpiece for the Certosa di Pavia, for the Julius Sicinius in the Collegio del Cambio at Perugia, and again for the St Michael in

the *Assunta* dated 1500, now in the Accademia, Florence; see Scarpellini 1984, nos 94, 101, 104, 112.

101. The sketches on the verso of the sheet also relate directly to the *David*, giving variations of the position of the arms; see Knab, Mitsch, and Oberhuber 1983, no.173.

102. The figure on the right side is a much modified copy of the decoration of an antique clay relief; see Fischel 1919, no.87.

103. See Fischel 1919, nos 87, 90; Parker 1956, no.523. It remains doubtful, however, whether surviving drawings like that in the British Museum (1895-9-15-628) are connected with this composition and whether the sheet deals with the decoration for a palace façade.

104. A well-reasoned explanation offered for these modifications is that Raphael intended to use the motif of the *St Matthew* for one of the figures carrying the dead body of Christ in *The Entombment*, on which he was working in 1506/7 and for which there is a compositional study on the verso of this same sheet. Although no similar figure later appears in the preliminary studies for *The Entombment*, the reasoning nevertheless sounds plausible; see Fischel 1923, no.172; Ferrara, Staccioli, and Tantillo 1972/3, p.26.

105. On the development of the *historia* during Raphael's years in Florence, see Ferino Pagden in Hager 1992, p.95.

106. The expression *quadri da spose* is found in Vasari in the *Vita* of Liberale da Verona; see Vasari 1981, V, p.279. See also Armenini 1988 (English trans. Olszewski 1977), p.214: 'Laonde, per tal conto, è ottimo certo il costume di Toscana e di Roma, conciosiach' essi non maritani citelle, che con i doni loro, oltre la dote, non vi sia quello d'un bel quadro e ben dipinto, attesoché i Toscani sono acutissimi nel conoscere la forza e l'eccellenza di quest' arte.' On the evolution of the devotional painting, see Burckhardt 1929-34, XII, pp.297, 405; Wackernagel 1938, p.182; Os 1994. On Madonna paintings, see particularly Kecks 1988; on Madonna paintings displayed at home, see, for instance, examples given in Hollingsworth 1994, p.17; on the iconography of half-length Madonna paintings in Giovanni Bellini's oeuvre, see Goffen 1975, p.487.

107. On the Antwerp art market, see Floerke 1905; Campbell 1976, p.188. On the situation in Italy, see Burckhardt 1929-34, XII, p.296; with special reference to Florence, Wackernagel 1981, and Lehmkuhl-Lerner 1936. The latter two authors do not discuss the 'open art market' which possibly was evolving at the time, but as Kecks 1988, p.149,

also points out, the production of devotional pictures for stock would suggest the existence of an extensive art market. On Giovanni Battista della Palla, see Wackernagel 1938, p.289, and the collection of source material and documentary evidence in Gilbert 1980. On aspects of the organization of workshops and serial production, see Bernacchioni and Venturini in Gregori et al. 1992, pp.23, 147, although the question of art markets is not specifically addressed.

108. We lack details about the financial situation of the young Raphael, but it seems reasonable to assume that he did not possess great means. No large sums were involved in matters of inheritance among Raphael's close relatives, and remuneration for his first altarpiece was equally modest; for documentary evidence, see Golzio 1971, p.4.

109. The motif of a child looking into an open book, however, appears repeatedly in Raphael's work.

110. On *garzone* drawings, see Ames-Lewis 1981, p.91; with special reference to Raphael, see Ames-Lewis 1986, pp.14, 24.

111. A direct dialogue with Leonardo's *Benois Madonna* is especially evident in early devotional pictures by Lorenzo di Credi, for instance, that in the Dresden Gemäldegalerie, where Lorenzo adopts not only central elements of the figure disposition but also the motif of the window; see Dalli Regoli 1966, no.9. On early Florentine repetitions, see Gronau 1912, p.253; see the same phenomenon in connection with the *Madonna with a Carnation* (**101**).

112. See most recently Burns in Fiore and Tafuri 1993, p.230.

113. On the type of standing child, see Pope-Hennessy 1980, no.40; Brown 1983 [1], p.128. Further comparative examples are in Gentilini 1993, pp.40, 50, 98, 232.

114. See, for instance, Sonnenburg 1983, ill. 65, on *The Holy Family (Canigiani)*, and Meyer zur Capellen 1994, p.347, on the *Madonna di Terranuova*.

115. On x-ray photographs and scientific examinations, see Gregori et al. 1984, p.247; Chiarini in Beck 1990, p.79; Chiarini 1995, p.37; Chiarini in Curti and Gallone Galassi 1986, p.21. Early examples of pictorial architecture with a view on either side of the Virgin occasionally occur in works by Leonardo or artists from his circle, for example in the Munich *Madonna with the Carnation*, the *Litta Madonna* in the Hermitage, St Petersburg, and the Washington *Dreyfus Madonna*; see Marani 1989, p.20, nos 1, 3; Fiorio and Marani 1991, p.206. For an

example in Lorenzo Credi's work, see Kecks 1988, ill. 141; on the *Madonna and Child with the Infant Baptist* or *Aldobrandini Madonna*, see Gould 1975, p.215. Raphael seems also to have planned an architectural setting for the *Portrait of Maddalena Strozzi Doni* and only later confined himself to a view into the landscape; see Gregori et al. 1984, p.254. A radical change of setting also occurs in other works of his Florentine period, for example in the *Bridgewater Madonna* (**104**).

116. We owe the discovery of this painting in an English private collection to Nicholas Penny; see Penny 1992, p.67. Its date is a matter of debate, Penny suggesting about 1507/8 at the end of Raphael's Florentine period, whereas Rosenberg and Gronau 1919, no.201, had proposed a date of about 1506; others, like Dussler 1971, p.63, have refrained from committing themselves with any precision.

117. On plant symbolism, see Wolffhardt 1954, p.184.

118. Kustodieva has drawn attention to a description in Francesco Bocchi's *Bellezze della città di Firenze* of 1591, which may refer to this painting; see Alpatov, Kustodieva, and Pedretti 1984, p.16. Gronau had already suggested that the painting remained in Florence for a considerable time, pointing out that whereas there were numerous Florentine copies and variations of the composition, he was not aware of any Milanese ones; see Gronau 1912, p.253.

119. See Emboden 1987, p.120. Here again the representation of a specific identifiable plant contributes significantly to the painting's meaning: by showing great interest in the plant, the Child is also contemplating his own Passion.

120. It is likely that Raphael was inspired by related studies of Leonardo (e.g. Windsor Castle, nos 12564ff.), and it is not entirely impossible that the very motif came from a lost Leonardo drawing. Leonardo's great interest in a naturalist depiction of the Child is recorded not only through numerous drawings but also through the theme of 'children at play'; see Moro in Fiorio and Marani 1991, p.120.

121. This may also apply to the cut of the garment, which is very similar to that in the *Benois Madonna*; another very similar depiction, however, is found in Raphael's *Holy Family under a Palm-Tree* in the National Gallery of Scotland; see Weston-Lewis in Clifford 1994, p.52, and no.5.

122. The thin veil the Child is grasping is certainly one of the narrow bands originally used for swaddling infants, for which see also the infant figures

with which Andrea della Robbia decorated the Florence orphanage; Alexandre-Bidon 1989. It seems that during the fifteenth century these bands developed into a distinctive decorative feature of baby wear, to which artists gave various functions and which Raphael also depicted in *The Holy Family under a Palm-Tree* (see Weston-Lewis in Clifford 1994, p.36) and the *Niccolini-Cowper Madonna* (**108**). Its function being eminently practical, it would seem that a religious connotation – as a reference to Christ's shroud – can be assumed only in exceptional cases; see Goffen 1975, n.82.

123. On Raphael's approach to Michelangelo's *Doni Tondo*, see also Gronau 1902, p.38; Forlani Tempesti 1984, p.44.

124. For details, see Ames-Lewis 1986, p.61; for a thorough discussion of the sheet, see Pouncey and Gere 1962, no.19, and Joannides 1983, pl. 19. Ames-Lewis calls this type of drawing a '*pensiero* sketch', and Joannides a '*pentimento* study'.

125. The motif of awakening is referred to in Jones and Penny 1983, p.36. The discussion about the complex meaning of the *Montefeltro Altarpiece* has concentrated mainly on the relation between the sleeping Christ and the donor, neglecting this more general aspect. Certainly Piero's depiction of the recumbent Child also alludes to the Pietà, all the more so since the overall conception explicitly refers to the Resurrection, as Lightbown 1992, p.245, has shown. Related representations of the subject occur in numerous devotional paintings from north and central Italy, but also on altarpieces like those Alvise Vivarini produced for Montefiorentini in 1476 and Bartolommeo della Gatta for Castiglion Fiorentino (Arezzo) in 1486; see, for instance, Zeri 1987, II, pp.400, 572. On the relation between the sleeping Christ and the Pietà, see Schiller 1971, p.83; Goffen 1975, p.503.

126. Alberti 1877, p.120 (repr. 1970, p.81): 'Poi movera l'historia l'animo quando li huomini ivi dipinti molto porgeranno suo proprio movimento d'animo … Ma questi movimenti d'animo si conosconodai movimenti del corpo.' On emotional aspects of mother-and-child groups of the Quattrocento, see Kecks 1988, p.51.

127. Vasari 1981, IV, p.373 (Vasari 1979, II, pp.908–9): 'e lasciando, sebbene con gran fatica, a poco a poco la maniera di Pietro, cercò quanto seppe e potè il più d'imintare la maniera di esso Lionardo … gli fu col tempo di grandissimo disaiuto e fatica quella maniera che egli prese di Pietro quando era giovanetto … perciocchè non potendosela dimenticare, fu cagione che con

molta difficultà imparò la bellezza degl' ignudi ed il modo degli scorti difficili dal cartone che fece Michelangelo Buonaroti per la sala del Consiglio di Fiorenza'. On establishing a chronology for the Madonna paintings, see the partly justified arguments of Pope-Hennessy 1970, p.186.

128. See Schleier in Bock 1975, p.334, no.145; Dussler 1971, p.4.

129. On the tondo, see note 42. Tondi were something of a Florentine speciality; Umbrian artists seem to have produced them in large numbers only from the late fifteenth century, apparently while working in the region of Florence; see Todini 1989, p.195. Raphael's second tondo, the *Connestabile Madonna*, produced presumably at about the same time, shows the same awkward handling of this format; see Dussler 1971, p.6.

130. I am very grateful to Erich Schleier for arranging for the infra-red photography. The fact that the cartoon originally showed a completely different position for the hand throws new light on the compositional drawing in the Berlin Kupferstichkabinett (inv. no.KdZ 2358) which, since Fischel 1913, no.54, has generally been regarded as a copy of the Lille drawing, which is still intact. It now appears more likely, however, that the drawing represents a variation by another artist who perhaps knew Raphael's design and the finished version. This would still not explain the very clumsy rendering of Mary's raised left hand in the Berlin drawing; for details, see Meyer zur Capellen 1994, p.347.

131. Questions about the signature and date were first raised by Schug 1967, p.470. Infrared photographs of the Prado version show what may be an autograph preparatory drawing by Raphael which, because of poor legibility, is difficult to interpret; see Meyer zur Capellen 1989, p.98, and Lehmann 1996. In this connection, one may usefully consider the question of how much sense it makes to try and identify *the* original in Raphael's early works and whether in some instances we may be dealing rather with partial or complete autograph repetitions.

132. Paintings from Raphael's early period with tracing dots include the *Vision of a Knight* in the National Gallery, London, which also holds the cartoon (Dussler 1971, p.6); the *Madonna del Granduca* (**98**); and the *Esterházy Madonna* (**133**). Traces of transfer by pouncing are especially common on small-sized works from the Florentine period, but they also appear, for instance, on the *Madonna del Prato* (**117**); Shearman 1983, p.15, points out that from 1503 onwards Raphael used

pen drawings for cartoons. On transfer techniques, see in particular Sonnenburg 1983, p.48.

133. Drawings were produced with pen and ink, but also with metalpoint, and these are sometimes difficult to read; this is especially the case with the large drawing on the verso of the sheet. On the 'TL-Sheet' see Pedretti 1988, pp.145, 151. The *Studies for the Infant with the Lamb* at Windsor (no.12563), however, which Clark and Pedretti assign to Cesare da Sesto, are more likely to depend on Raphael's exemplar; see Clark and Pedretti 1968, p.70.

134. One thinks of the flowers depicted, for instance, in Perugino's small panel painting of *Apollo and Marsyas*; see Scarpellini 1984, no.49. Their botanical identification, however, presents difficulties: on the left is shown a composite, in the centre a dandelion and on the right a plant resembling a plantain. A similar vagueness in Raphael's early works should not surprise us; and indeed among the flowers in his *St George* (National Gallery of Art, Washington), rendered as carefully as in the present painting, appears a long-stemmed plant which combines the most diverse botanical features; see Dussler 1971, p.13; Brown 1983 [1], p.135. For professional advice I am grateful to Professor Dr D. Podlech of the Institute for Systematic Botany, University of Munich.

135. See Vasari 1981, IV, p.321; see also page 38.

136. See Mitsch 1983, no.3. Mitsch pointed out the problems associated with the handling of this sheet, since its actual measurements are seldom taken into account in reproductions, and the indications of verso and recto differ; for our discussion we have relied on the catalogue by Birke and Kertész 1992.

137. The townscape on the left, derived from Northern art, in some respects seems to build upon that of the *Madonna di Terranuova*; for the latter's underdrawing, see Meyer zur Capellen 1994, p.347.

138. In particular the wash drawing (**122**) is generally connected with a composition sometimes called the *Drottningholm Madonna* after a surviving copy; see Gere and Turner 1983, no.58; Brown 1983 [1], fig.19, nn.123ff.; for further copies, see Ruland 1985. Paintings and engravings after the Louvre wash drawing include stylistic features which do not accord with Raphael's formal language during his Florentine years; see comprehensively Cordellier and Py 1992 [1], p.78; Cordellier and Py 1992 [2], no.35. Since no autograph painting has so far turned up, we must consider the possibility that Raphael's early composition may

have supplied the basis for a painting executed in his Roman workshop, or even that we are dealing with a posthumous production.

139. On the sequence of the drawings, see Sonnenburg 1983, p.48.

140. Sonnenburg 1983, p.32, concentrates on this feature and compares the original with several copies that attempt to resolve these difficulties. He turns the argument on its head, however, by proclaiming the superiority of the original. Although all the 'improvements' remain unsatisfactory, they at least document the copyists' uneasiness with this problematic passage, an infelicity which, needless to say, would be unthinkable in Raphael's mature works.

141. See Gregori et al. 1984, p.77.

142. See, for instance, Béguin 1983 [1], no.6; Cordellier and Py 1992 [2], p.96.

143. See details in Béguin 1983 [1], p.81; the relevant quotation from the *Vita* of Raphael is in Vasari 1981, IV, p.328: 'ed intanto fece un quadro, che si mandò in Siena, il quale nella partita di Raffaello rimase a Ridolfo del Ghirlandaio, perch' egli finisse un panno azzuro che vi mancava', and from the *Vita* of Ridolfo del Ghirlandaio in Vasari 1981, VI, p.534: 'che dovendo Raffaello andare a Roma, chiamato da papa Giulio secondo, gli lasciò a finire il panno azzurro, ed altre poche cose che mancavano al quadro d'una Madonna che egli avea fatta per alcuni gentiluomini sanesi, il quale quadro finito che ebbe Rifolfo con molto diligenza, lo mandò a Siena.'

144. On the painting manner, see in detail Sonnenburg 1983, p.69; for a careful consideration of the crucial problems, see Garas 1983, p.41.

145. For the further history of the pictorial idea, see Suida 1929, p.53, who reproduces a Madonna painting by Andrea da Salerno (fig.39) which borrows the motif of the kneeling Virgin. In view of the fact that its influence was by no means as great as Suida suggests, one need not go along with him and hypothesize a fully finished painting ('*durchgeführte Form*') from the sketch. There might have existed further variations in Leonardo's hand, however, one of which may have been Raphael's starting point. On Leonardo's drawing, see also Kemp 1992, no.7.

146. See Shearman 1977, who posits a visit to Rome in about 1506. On the depiction of ancient ruins in the *Esterházy Madonna*, see also the summary account in Garas 1983, who unfortunately chooses the large-scale view from the *Codex Escurialensis* for comparison. In this case the small background view of fol.29 verso is relevant: some parts of it are

confused and were corrected by Raphael to produce a cogent architectural feature – although these 'corrections' naturally do not correspond to other depictions of the Forum Nervae. See Egger 1906, fols 29 verso, 57 verso, and pp.92, 142.

147. Vasari 1981, IV, p.325 (Vasari 1979, II, p.883): 'che egli variò ed abbellì tanto la maniera, mediante l'aver vedute molte cose e di mano di maestri eccellenti, che ella non aveva che fare alcuna cosa con quella prima'.

148. Neither the length of the visit nor its approximate date is known. Contractual documents concerning the nuns of Monteluce that record Raphael's presence between 12 and 23 December 1505 are suggestive, but cannot be regarded as firm evidence for a sojourn at Perugia.

149. See the detailed description in Vasari 1981, IV, p.324: 'Gli fu anco fatto dipignere nella medesima città, dalle donne di Santo Antonio da Padoa, in una tavola la Nostra Donna, ed in grembo a quella, sì come piacque a quelle semplici e venerande donne, Gesù Cristo vestito, e dai lati di essa Madonna San Piero, San Paulo, Santa Cecilia e Santa Caterina, alle quali due sante vergini fece le più belle e dolci arie di teste e le più varie acconciature da capo (il che fu cosa rara in que' tempi) che si possino vedere: e sopra questa tavola, in un mezzo tondo, dipinse un Dio Padre bellissimo, e nella predella dell' altare tre storie di figure piccole: Cristo quando fa orazione nell' orto; quando porta la croce, dove sono bellissime movenze di soldati che lo strascinano; e quando è morto in grembo alla madre: opera certo mirabile, devota, e tenuta da quelle donne in gran venerazione, e da tutti i pittori molto lodata.'

150. See Oberhuber 1977, an opinion that has found a certain following.

151. Oberhuber's reasoning (Oberhuber 1977, p.68) is not necessarily conclusive. The existence of a related altarpiece from Perugino's circle (now in the Baltimore Art Museum; see Scarpellini 1984, no.139) does not necessarily imply the existence of a Perugino exemplar. The rephrasing of the *Decemviri Altarpiece* may well have been Raphael's own contribution, incorporating elements possibly derived from Venetian painting; for a distantly related early formulation, namely Francesco Melanzio's altarpiece at Montefalco of 1498, see Todini 1989, no.1012. The derivative Umbrian altarpieces seem to have taken their lead not from Perugino, however, but from Raphael; for examples, see Todini 1989, nos 1346, 1359, 1370, 1377, 1449, 1454.

152. Oberhuber 1977, p.69, mentions

Pinturicchio's devotional picture in the Fitzwilliam Museum, Cambridge. The two compositions do indeed correspond very closely, suggesting that Raphael was aware at least of the basic design, all the more so as Pinturicchio's picture is generally dated earlier; see Goodison and Robertson 1967, p.133, no.119. The clothed Christ had already been noticed by Vasari; in the references quoted below it is suggested that the commissioning nuns insisted on some clothing for the Child. Although we lack explicit evidence the suggestion is convincing, particularly because of the Child's remarkable dress, a small, tightly fitting garment with long sleeves. In artistic representations the unclothed Christ Child became the rule during the fifteenth century, but light little frocks or more or less tightly draped bands (*fasciae*) are not infrequent and appear also in Florentine paintings; see Kecks 1988 with numerous examples, an exception being no.66 by Luca della Robbia which shows a very similar dress. In Umbria, on the other hand, it is remarkable how often one finds – and not only in Pintoricchio's works – depictions of Christ in garments that cover the body almost completely. This is perhaps a traditional feature and characteristic of the attitude of commissioning monasteries. For very similar repetitions by Pintoricchio, see Todini 1989, nos 1222, 1224, 1230; for different kinds of clothing also with long sleeves by various Umbrian painters, see, for instance, Todini 1989, nos 1019, 1047f., 1054, 1326, 1416, 1427.

153. See Vasari 1981, IV, pp.326–7 (given in note 41, above). The artistic rapport between the two painters has been confirmed by subsequent research; see, for instance, Padovani in Chiarini, Ciatti and Padovani 1991, p.21.

154. For details including the stiff figure of the hovering angel, probably by a later hand, see Brown 1983 [1], p.119.

155. Vasari 1981, IV, pp.327–8 (Vasari 1979, II, pp.884–5): 'E in questa divinissima pittura un Cristo morto portato a sotterrare, condotto con tanta freschezza e sì fatto amore, che a vederlo pare fatto pur ora. Immaginossi Raffaello nel componimento di questa opera il dolore che hanno i più stretti ed amorevoli parenti nel riporre il corpo d'alcuna più cara persona, nella quale veramente consista il bene, l'onore e l'utile di tutta una famiglia. Vi si vede la Nostra Donna venuta meno, e le teste di tutte le figure molto graziose nel pianto, e quella particolarmente di San Giovanni; il quale, incrocicchiate le mani, china la testa con una maniera da far commuovere qual è più duro

animo a pietà. E di vero, che considera la diligenza, l'amore, l'arte e la grazia di quest' opera, ha gran ragione di maravigliarsi; perchè ella fa stupire chiunque la mira, per l'aria delle figure, per la belleza de' panni, ed insomma per una estrema bontà ch' ell'ha in tutte le parti.'

156. See Ferrara, Staccioli and Tantillo 1972/3; Gere and Turner 1983, nos 72ff.; the convincing reading of the sequence by Ames-Lewis 1986, p.50; for a summary, see also Ferino Pagden 1986, p.19; the series is illustrated in Knab, Mitsch, and Oberhuber 1983, nos 187ff., and in Joannides 1983, nos 124ff.

157. Reference has often been made with good reason to Perugino's *Lamentation* in the Palazzo Pitti, Florence; see Scarpellini 1984, no.63.

158. One conception for this group appears on a sheet in the Ashmolean Museum, Oxford (P11530); see Gere and Turner 1983, no.74.

159. Raphael has in fact chosen not to paint one of the more conventional types of Entombment but rather to show the dead body of Christ being carried to the tomb. Inspirations may have come from his own design for the *Death of Meleager* and from Luca Signorelli's *Lamentation* fresco in Orvieto which includes a funerary cortège; see Gilbert in Beck 1986, p.118. It is generally agreed that Mantegna's engraved *Entombment* also played a part, giving a closely related rendering of the way the dead body is carried and of the group of mourners on the right; see Levenson, Oberhuber, and Sheehan 1973, no.70; Martineau 1992, nos 38ff. The transition from the first to the second concept is recorded by several sheets in the Ashmolean Museum, Oxford, and the British Museum, London; see Knab, Mitsch, and Oberhuber 1983, nos 195ff.; Ames-Lewis 1986, p.53; Ferino Pagden 1986, p.21.

160. See Rosenberg in Beck 1986, p.175.

161. See Ferino Pagden in Frommel and Winner 1986, p.19; the inscription reads: 'Atalante Baliona hoc divo Salvatori/domum donat et sacrum dedicat/Raphael Urbinas 1507'; for a summary, see also della Pergola 1959, p.117; Locher 1994, p.26; on the Oddi and Baglioni as Raphael's clients, see also Luchs 1983, p.29; on Perugia at this time, see Burckhardt 1929–34, v, p.20; see also the chronicle by Francesco Matarazzo 1910, especially 112ff., and the genealogy of the Baglioni after p.xxxii.

162. For the history of the altar, see Ferrara, Staccioli, and Tantillo 1972/3; Locher 1994, p.25.

163. For *God the Father in Benediction*, a *garzone* drawing has survived; see Knab, Mitsch, and Oberhuber 1983, no.198. The painting, which is now in the Galleria Nazionale, Perugia, has been tentatively identified as a copy (Santi 1985, no.104), although Raphael may have entrusted an assistant with the execution; another sixteenth-century version is illustrated in De Vecchi 1966, no.70. A detailed study of how the superstructure fits the overall conception is still lacking.

164. For a summary of the predellas, see Mancinelli in Pietrangeli et al. 1982, no.79; for a copy of these, see Locher 1994, p.25, n.28, ill.11.

165. On the preliminary drawing, which also includes Leonardesque elements, see Knab, Mitsch, and Oberhuber 1983, no.218; for suggestions about the iconography, see Wind 1937/8, p.322, who incidentally gives a wrong dating.

166. For the relevant quotation, see note 34.

167. See Riedl 1957/59 for a sensitive and in many respects still essential interpretation, albeit almost inevitably coming to the wrong conclusions. On the painting's genesis, see Ames-Lewis 1986, p.65; Petrioli Tofani in Gregori et al. 1984, p.334.

168. Our discussion ignores the seventeenth-century addition which impairs the original composition. The addition consists of a strip 32cm long showing an upward continuation of the half-dome above the niche; it is usually illustrated as part of the whole painting.

169. See Riedl 1957/59, p.223.

170. The correspondence between Brunelleschi's columns and those depicted in the painting is obvious, and the coffer of the half-dome is probably related to the Pantheon which Raphael saw either on an earlier visit to Rome or – more likely – in the *Codex Escurialensis*; see Frommel, Ray, and Tafuri 1984, pp.17, 26. On the debate about Raphael's drawing of the Pantheon, see Petrioli Tofani in Gregori et al. 1984, p.323, and Shearman 1977, p.107.

171. See Padovani in Chiarini, Ciatti, and Padovani 1991, p.21, for a succinct discussion of the iconographic evolution of the *Madonna del Baldacchino* and its immediate widespread impact.

172. Barocchi and Ristori 1965–83, IV, p.155: 'Tutte le discordie che naqquono tra papa Iulio e me fu la invidia di Bramante et di Raffaello da Urbino; et questa fu causa che non e' seguitò la sua sepultura in vita sua, per rovinarmi. Et avevane bene cagione Raffaello, ché ciò che haveva dell' arte, l'aveva da me.'

173. Condivi 1928, p.196: 'Raffaello non ebbe quest' arte da natura, ma per lungo studio.' See also Dalli Regoli in Sambucco Hamoud and Strocchi 1987, p.419.

Catalogue

I. EARLY WORKS, CLIENTS AND THE HISTORICAL CONTEXT

The court at Urbino, Raphael's Umbrian
commissions and his relationship with Perugino

1
Anonymous
Ideal Cityscape
circa 1500. Oil on panel, 60 × 200 cm.
Palazzo Ducale, Urbino.

Salmi 1979, pp.191ff.; Kemp 1991, pp.95ff., no.147f.;
Morolli and Salvi in Dal Poggetto 1992, pp.215ff.,
nos 42, 42bis.

2
Anonymous
Ideal Cityscape (detail of central building).

3
Piero della Francesca
Montefeltro Altarpiece
Oil on panel, 251 × 172 cm.
Pinacoteca di Brera, Milan, no.510.

Meiss 1972; Bertelli in Pirovano 1984, no.10;
Lightbown 1992, pp.245–55; Castelli in Dal
Poggetto 1992, pp.175f., nos 32, 32bis.

4
Giovanni Santi
Oliva Altarpiece
dated 1489. Oil on panel, 225 × 215 cm.
Convento di Montefiorentino, Frontino.

Passavant 1839, I, pp.1ff.; Schmarsow 1887; Dubos
1971, pp.95f., 113; Curzi in Zeri 1987, p.751.

5
Raphael
Compositional Study for the
S. Nicola da Tolentino Altarpiece
Chalk over stylus, 40 × 26.3 cm.
Musée des Beaux-Arts, Lille, no.474.

Fischel 1913, pp.40ff. nos 5, 6; Knab et al. 1983,
no.12; Joannides 1983, p.38, no.14 recto; Brejon de
Lavergnée 1990, pp.88f.

6–9
Raphael
Fragments from the S. Nicola da Tolentino
Altarpiece
painted 1500–01. Oil on panel, overall size
probably 390 × 230 cm.

Madonna
Oil on panel, 51 × 41 cm. Museo Nazionale,
Capodimonte, Naples, no.50.

God the Father Holding a Diadem
Oil on panel, 112 × 75 cm.
Museo Nazionale, Capodimonte, Naples.

Angel with a Scroll
Oil on panel, 58 × 36 cm. Musée du Louvre,
Paris, no.RF 198135.

Head of an Angel
Oil on panel transferred to canvas, 31 × 27 cm.
Pinacoteca Tosio Martinengo, Brescia, no.149.

Passavant 1839, II, pp.10f.; Passavant 1858, p.82;
Fischel 1912, pp.105–21; Schöne 1950, pp.113–36;
Dussler 1971, pp.1ff.; Béguin 1982, no.2, pp.99–115;
Béguin 1983 [1], pp.69ff., 163ff.; Marabottini 1983,
pp.48ff., 191ff.; Padoa Rizzo 1983, pp.3–7; Béguin in
Beck 1986, pp.15ff.; Passamani 1986, pp.15ff., 39ff.,
51ff.; Béguin, Hall and Uhr 1987, pp.467–9; Mercati
1994.

10
Raphael
Crucifixion
signed and dated 1503. Oil on panel, 280.7 × 165 cm.
National Gallery, London, no.3943.

Predella panels:
The Miracle of St Cyril
Oil on panel, 23 × 41 cm.
National Museum, Lisbon.

St Jerome Castigates the Heretic Sabinianus
Oil on panel, 23 × 41 cm. North Carolina Museum
of Art, Raleigh, North Carolina.

Vasari 1981, IV, p.318; Passavant 1839, II, pp.12f.;
Dussler 1971, pp.8f.; Gould 1975, pp.222f; Marabottini
1983, pp.65ff., 194f.; Dunkerton et al. 1991, p.366.

11
Raphael
Coronation of the Virgin
Oil on panel, 267 × 163 cm.
Pinacoteca Vaticana, Rome, no.334.

Predella panels:
Annunciation, Adoration, Circumcision
Oil on panel, each 39 × 190 cm.
Pinacoteca Vaticana, Rome, no.335.

Vasari 1981, IV, pp.317f.; Passavant 1839, II,
pp.20ff.; Passavant 1858, pp.85ff.; Redig De
Campos 1958, pp.343–8; Dussler 1971, p.10; Zentai
1978, no.1–4, pp.195–9; Zentai 1979, pp.69–79;
Mancinelli in Pietrangeli 1982, no.78; Luchs 1983,
pp.29ff.; Marabottini 1983, pp.69ff.; Mancinelli in
Beck 1986, pp.127ff.; De Vecchi in Beck 1986,
pp.73ff.; Ferino Pagden in Frommel and Winner
1986, pp.13ff.; Krems 1995.

12
Pietro Perugino
The Betrothal
Oil on panel, 236 × 186 cm.
Musée de Caen

Scarpellini 1948, no.129, pp.107f.

13
Raphael
The Betrothal
signed and dated 1504. Oil on panel, 170 × 118 cm.
Pinacoteca di Brera, Milan, no.472.

Vasari 1981, IV, pp.318ff.; Passavant 1839, II,
pp.28ff.; Passavant 1858, p.87; Dussler 1971, pp.10f.;
De Vecchi 1973; Marabottini 1983, pp.79ff., 93ff.,
197f.; Bertelli in Pirovano 1984, no.1; Acidini
Luchinat in Sambucco Hamoud and Strocchi
1987, pp.229ff.

14
Raphael
Ansidei Madonna
signed and dated 1505. Oil on panel, 209 × 148 cm.
National Gallery, London, no.1171

Predella:
St John the Baptist Preaching
Oil on panel, 26 × 53 cm. National Gallery,
London, no.6480.

Vasari 1981, IV, p.323; Passavant 1839, II, pp.43ff.;
Manzoni 1899, pp.627–45; Dussler 1971, pp.13f.;
Gould 1975, pp.216ff.; Dalli Regoli 1983, pp.8–19;
Braham and Wyld 1984, pp.15–23; Mancini 1987,
pp.57ff.; Dunkerton et al. 1991, p.376.

15
Raphael
The Trinity (detail)
Fresco, wall measurement 470 × 390 cm.
S. Severo, Perugia.

Vasari 1981, IV, pp.323f.; Passavant 1839, II, pp.46ff.; Passavant 1858, pp.90f.; Dussler 1971, pp.68f.; Santi 1979, pp.57–64; Francesca Floccis in Marabottini 1983, pp.214ff.; Mancini 1987, pp.53ff.

16
Raphael
St George
Oil on panel, 31×27 cm.
Musée du Louvre, Paris, no.609.

Lomazzo 1974, pp.50f.; Passavant 1839, II, pp.33f.; Schmarsow 1882, pp.254ff.; Gruyer 1889, pp.383–402; Lynch 1962, pp.151ff.; Dussler 1971, p.5; Ettlinger 1983, pp.25–9; Shearman 1983, pp.15–25; Béguin 1983 [1], no.4, pp.75ff.; Brown in Beck 1986, pp.37ff.; Clough in Sambucco Hamou andStrocchi 1987, pp.275ff.; Zancan in Sambucco Hamoud and Strocchi 1987, pp.291ff.; Béguin in Sambucco Hamoud and Strocchi 1987, pp.455ff.

17
Raphael
St Michael
Oil on panel, 30.9×26.5 cm.
Musée du Louvre, Paris, no.608.

Passavant 1839, II, p.34; Dussler 1971, pp.5f.; Béguin 1983 [1], pp.78ff.; and see **16**.

Florence and the Florentine patrons of the early Cinquecento

18
attributed to Francesco Granacci
Portrait of a Man (detail showing the Palazzo Vecchio and Michelangelo's *David*)
Oil on panel, 70.5×51.4 cm.
National Gallery, London, no.895.

Alazard 1951, pp.93f.; Davies 1961, pp.424f.; Dunkerton et al. 1991, p.98.

19
Raphael
Portrait of Agnolo Doni
Oil on panel, 65×45.7 cm.
Palazzo Pitti, Florence, Inv. 1912, no.61.

For literature, see **20**.

20
Raphael
Portrait of Maddalena Strozzi Doni
Oil on panel, 65×45.8 cm.
Palazzo Pitti, Florence, Inv. 1912 no.59.

Vasari 1981, IV, p.325; Passavant 1839, II, pp.52ff.; Davidsohn 1900, pp.211–16; Burckhalter 1932, pp.5ff.; Beenken 1935, pp.145ff.; Dussler 1971, p.17; Gregori 1984, pp.105ff.; Steingräber 1986, pp.77–88; Cecchi in Sambucco Hamoud and Strocchi 1987, pp.429ff.

II. THE ARTISTIC CONTEXT

Art in Florence around 1500

21
Filippino Lippi
Nerli Altarpiece
Oil on panel, 160×180 cm.
S. Spirito, Florence.

Neilson 1938/1972, pp.70ff.; Scharf 1950, pp.21, 54; Bridgeman 1988, pp.668–71; Baldini 1988, pp.24–31; Berti and Baldini 1991, pp.63f., 193f.; Nelson in Gregori, Paolucci and Acidini Luchinat 1992, pp.121ff.

22
Raffaellino del Garbo
Madonna and Child with Saints
signed and dated 1505. Oil on panel, 285×283.5 cm.

S. Spirito, Florence.

Filippini in Dal Prà 1990, p.152; Buschmann 1993, pp.80ff., 133ff.

23
Pietro Perugino
The Pazzi Crucifixion
circa 1494–6. Fresco, 480×812 cm.
S. Maria Maddalena dei Pazzi, Florence.

Bombe 1914, XVIII; Canuti 1931, pp.86ff.; Luchs 1977, pp.109f.; Scarpellini 1984, no.68.

24
Pietro Perugino
Decemviri Altarpiece

Oil on panel, 193 × 165 cm.
Pinacoteca Vaticana, Rome.

Bombe 1914, pp.239f.; Canuti 1931, pp.99ff.;
Scarpellini 1984, no.65; Chastel 1984, pp.120ff.

25
Mariotto Albertinelli
The Visitation
dated 1503. Oil on panel, semi-circular
at the top, 232.5 × 146.5 cm.
Galleria degli Uffizi, Florence, Nos 1587, 1596.
Predella panels:
The Annunciation, The Adoration,
The Circumcision

Holst 1974, pp.273ff.; Borgo 1976, pp.276ff.;
Pagnotta in Zeri 1987, p.619; Fischer 1994,
pp.60ff.; Natali and Cabras 1995.

26
Fra Bartolommeo
The Last Judgement
Fresco, 350 × 380 cm.
Museo di San Marco, Florence.

Gabelentz 1922, pp.21ff.; Holst 1974, pp.273ff.;
Borgo 1976, pp.51ff.; Fischer 1990, pp.43ff.;
Fischer 1994, pp.29ff.

27
Luca Signorelli
Madonna and Child
Oil on panel, 170 × 115 cm.
Galleria degli Uffizi, Florence, no.502.

Levi d'Ancona 1973, pp.321–46.

28
Piero di Cosimo
Madonna and Child with the
Infant John the Baptist
Oil on panel, 93 cm diameter.
Musée des Beaux-Arts, Strasbourg.

Bacci 1966, no.20; Fermor 1993, pp.153ff.

Leonardo in Florence 1499–1506

29
Leonardo da Vinci
Madonna with the Yarnwinder
Oil on panel, 48.3 × 36.9 cm.
Collection of the Duke of Buccleuch.

Pedretti 1982; Kemp 1992; Kemp in Fiorio and
Marani 1991, pp.35–48; Pedretti 1992, pp.169–75;
Gould 1992, pp.12–16.

30
[After?] Leonardo da Vinci
St Anne with the Madonna and Child
Black chalk over leadpoint, 21.2 × 16.2 cm.
Private collection, Switzerland.

Pedretti 1982, no.21; Kemp 1992, no.9.

31
Leonardo da Vinci
St Anne with the Madonna and Child
and the Infant John the Baptist
Chalk and white lead, 141.5 × 104 cm.
National Gallery, London, no.6337.

Heydenreich 1933, pp.205–19; Gould 1963, pp.49ff.;
Schug 1968, pp.446–55; Schug 1969, pp.24–35;
Pedretti 1968, pp.22–8; Wasserman 1970, pp.194–204;
Wasserman 1971, pp.312–25; Kemp 1981, pp.220ff.;
Budny 1983, pp.34–50; Braham, Wyld, Harding
and Burnstock 1989, pp.5–27; Marani 1989,
pp.103ff.; Dunkerton et al. 1991, p.378; Marani in
Hager 1992, pp.1ff.; Nepi-Scirè 1992, pp.242–9.

32
Leonardo da Vinci
St Anne with the Madonna and Child
Oil on panel, 168 × 130 cm.
Musée du Louvre, Paris, no.776

Béguin 1983 [2], pp.77f.; Marani 1989, pp.112f.;
Marani in Hager 1992, pp.1ff.; see also **31**.

33
Leonardo da Vinci
Mona Lisa
Oil on panel, 77 × 53 cm.
Musée du Louvre, Paris, no.779.

Béguin 1983 [2], pp.74ff.; Marani 1989, pp.106ff.;
Shell and Sironi 1991, pp.95ff.; Shell and Sironi in
Fiorio and Marani 1991, pp.148ff.

Michelangelo in Florence 1501–1506

34
Michelangelo
Madonna and Child
Marble, height inc. base 128 cm.
Notre Dame, Bruges.

Tolnay 1943–60, I, pp.156ff.; Weinberger 1967, pp.98ff.; Mancusi-Ungaro 1971; Ewing 1978, pp.77–105; Poeschke 1992, pp.80f.

35
Michelangelo (copy)
David
Marble, height 410 cm. Piazza della Signoria, Florence. (The original is in the Galleria dell'Accademia, Florence.)

Tolnay 1943–60, I, pp.150ff.; Seymour 1967; Weinberger 1967, pp.77ff.; Chastel 1984, pp.142ff.; Hartt 1987; Poeschke 1992, pp.85ff.

36
Michelangelo
Taddei Tondo
Marble, 109 cm diameter.
Royal Academy of Arts, London.

Tolnay 1943–60, I, pp.162f.; Weinberger 1967, pp.98ff.; Smart 1967, pp.835–62; Lightbown 1969, pp.22–31; Poeschke 1992, pp.81f.

37
Michelangelo
Pitti Tondo
Marble, 85.5/82 cm diameter.
Museo Nazionale del Bargello, Florence.

Tolnay 1943–60, I, pp.160f.; Weinberger 1967, pp.98ff.; Poeschke 1992, pp.83ff.

38
Michelangelo
Doni Tondo
Oil on panel, 80/91 cm diameter (120 cm with frame). Galleria degli Uffizi, Florence, no.1456.

Tolnay 1943–60, I, pp.163ff.; Lisner 1965, pp.167–78; Weinberger 1967, pp.98ff.; Hayum 1981–2, pp.209–51; Forlani Tempesti 1984, pp.144ff.; Berti 1985.

39
Michelangelo
St Anne with the Madonna and Child
Pen, 25.7×17.5 cm. Ashmolean Museum, Oxford, no.PII291 recto.

Parker 1956, no.291; Wasserman 1969, pp.122ff.; Tolnay 1975–80, I, no.17 recto; Whistler 1990, p.16; Marani in Hager 1992, pp.14f.

The rivalry between Leonardo and Michelangelo

40
Anonymous copy after Leonardo da Vinci
The Battle of Anghiari
Pen, 29.4×43 cm. Ruccellai Collection, Florence.

Neufeld 1949, pp.170–83; Gould 1954, pp.117ff.; Kemp 1981, pp.236ff.; Chastel 1984, pp.149ff.; Joannides 1988, pp.76–86; Zöllner 1991, pp.177–92; Farago 1994, pp.301ff.

41
Leonardo da Vinci
Horsemen in Combat, Study of Battling Figures
Pen, 10.1×14.2 cm. Galleria dell'Accademia, Venice, no.216 recto.

Nepi-Scirè 1992, no.30.

42
Leonardo da Vinci
Cavalcade
Chalk, 16×19.7 cm.
Windsor Castle, no.12339 recto.

Clark and Pedretti 1968, p.34; Nepi-Scirè 1992, no.33.

43
Leonardo da Vinci
Battling Figures
Pen over chalk, 25×19.5 cm.
Biblioteca Reale, Turin, no.15577 D.C. recto.

Clark and Pedretti 1968, pp.131f.; Nepi-Scirè 1992, no.37.

44
Aristotele da Sangallo after Michelangelo
The Battle of Cascina
Grisaille on panel, 78.7×129 cm.
Holkham Hall, Norfolk.

Köhler 1907, pp.115–72; Gould 1966; Chastel 1984, pp.149ff.; Kemp 1991, pp.95ff., no.167.

45
Michelangelo
Sketch for the Battle of Cascina
Silverpoint, 23.9×35.6 cm.
Galleria degli Uffizi, Florence, Gabinetto disegni e stampe no.613 E recto.

Tolnay 1975–80, I, no.45 recto.

46
Michelangelo
Horsemen in Combat, Sketch for St Matthew
Pen, 18.6 × 18.3 cm. British Museum, London,
no.1895–9–15–496 verso.

Tolnay 1975–80, I, no.36 verso.

47
Reconstruction of the decorative scheme for the
new council chambers in the Palazzo della
Signoria (after Wilde, Pedretti and Kemp).

Wilde 1953, pp.65ff.; Isermeyer 1963, pp.83ff.;
Pedretti 1973, pp.95ff.; Kemp 1981, pp.234ff.

III. FLORENTINE STUDIES

48
Raphael
Studies of Heads and Hands
Silverpoint with white highlights, 21.2 × 27.4 cm.
Ashmolean Museum, Oxford, no.PII535.

Fischel 1923, p.210; Knab et al. 1983, p.112;
Joannides 1983, no.99; Gere and Turner 1983, p.69;
Whistler 1990, p.9;

49
Raphael
Head (detail of **48**)

50
Leonardo da Vinci
*Head, Compositional Sketch for St Anne with the
Madonna and Child and the Infant John the Baptist*
Chalk and pen, 26 × 19.5 cm. British Museum,
London, no.1875–6–12–17 verso.

Popham and Pouncey 1950, no.108;
Nepi-Scirè 1992, no.23a.

51
Anonymous copy after Leonardo da Vinci
The Battle of Anghiari (see **40**)

Nepi-Scirè 1992, no.30.

52
Leonardo da Vinci
Cavalcade (detail of **42**)

53
Raphael
Sketch of a Battle Scene (detail of **48**)

54
Raphael
Leda and the Swan

Pen over leadpoint and black chalk, 30.8 × 19.2 cm.
Windsor Castle, no.12759.

Popham and Wilde 1949, no.789; Knab et al. 1983,
no.114; Joannides 1983, no.98.

55
Anonymous copy after Leonardo da Vinci
Leda and the Swan
Chalk, 28 × 17.5 cm. Musée du Louvre, Paris,
Cabinet des Dessins no.2563.

Béguin 1983 [2], p.91.

56
Leonardo da Vinci
Figure Study (detail of **43**)

Nepi-Scirè 1992, no.32

57, 58
Leonardo da Vinci
*Two Figure Studies for Leda on a Sheet
with Diagrams and Notes on the Digestive Organs*
Pen and ink, 26.8 × 19.5 cm.
Windsor Castle, no.12642 recto and verso.

Clark and Pedretti 1968, pp.137f.

59
Leonardo da Vinci
Studies for the Head of Leda.
Pen over chalk, 20 × 16.2 cm.
Windsor Castle, no.12516.

Clark and Pedretti 1968, p.92f.; Kemp 1991, no.172.

60
Raphael
Head of Leda (detail of **54**)

61
Raphael
Portrait of a Woman
Pen over chalk and wash, 22.3 × 15.8 cm.
Musée du Louvre, Paris, Cabinet des Dessins no.3882.

Fischel 1919, no.80; Knab et al. 1983, no.125;
Joannides 1983, no.175; Viatte in Béguin 1983 [1],
pp.216ff., no.50; Cordellier and Py 1992 [1], p.60.

62
Raphael
Portrait of a Young Woman
Chalk, 25.9 × 18.3 cm. British Museum, London,
no.1895–9–15–613.

Fischel 1919, no.33; Pouncey and Gere 1962, no.13;
Knab et al. 1983, no.73; Joannides 1983, no.79.

63
Raphael
Portrait of Maddalena Strozzi Doni (see **20**)

64
Leonardo da Vinci
Mona Lisa (detail of **33**)

65
Raphael
Portrait of a Woman (detail of **61**)

66
Raphael after Michelangelo
David
Pen over chalk, 39.3 × 21.9 cm.
British Museum, London, no.Pp1–68.

Gronau 1902, pp.32f.; Fischel 1923, no.187; Pouncey
and Gere 1962, no.15; Knab et al. 1983, no.226;
Joannides 1983, no.97; Ames-Lewis 1986, pp.41f.

67
Michelangelo (copy)
David (see **35**)

68
Leonardo da Vinci
Standing Figure
Pen and wash, 27 × 20.1 cm.
Windsor Castle, no.12591 recto (detail).

Clark and Pedretti 1968, pp.117f.

69
Raphael
Figure of a Youth
Pen, 27.9 × 16.9 cm.
British Museum, London, no.Pp.1–65 recto.

Gronau 1902, pp.32f.; Fischel 1919, no.85; Pouncey
and Gere 1962, no.14; Knab et al. 1983, no.169;
Joannides 1983, no.85 verso; Ames-Lewis 1986, pp.41f.

70
Leonardo da Vinci
Standing Figure (detail of **43**)

71
Michelangelo
Male Nude (detail)
Pen over chalk, 37.9 × 18.7 cm.
Albertina, Vienna, no.118 recto.

Tolnay 1975–80, I, no.22 recto; Birke and Kertész
1992, no.118.

72
Raphael after Michelangelo
David (detail of **66**)

73
Raphael
Four Soldiers
Pen, 27.1 × 21.6 cm.
Ashmolean Museum, Oxford, no.P11523 recto.

Fischel 1919, no.87; Parker 1956, no.523; Forlani
Tempesti 1970, no.XXII; Gere and Turner 1983,
no.46; Knab et al. 1983, no.165; Joannides 1983,
no.88 recto.

74
Donatello
St George
Marble, 209 × 67 cm.
Museo del Bargello, Florence.
Janson 1963, pp.23ff.; Rosenauer 1993, pp.19ff., 56ff.

75
Pietro Perugino
Study of a Soldier
Metalpoint with white highlights, 24.9 × 18.5 cm.
Windsor Castle, no.12801.

Popham and Wilde 1949, no.21; Forlani Tempesti
1970, no.XVI; Ragghianti and Dalli Regoli 1975,
pp.80ff.; Scarpellini 1984, no.104.

76
Raphael
Study for a St Paul
Pen, 26.5×18.7 cm. Ashmolean Museum,
Oxford, no.PII522 recto.

Fischel 1919, no.83; Parker 1956, no.522; Knab et al.
1983, no.168; Joannides 1983, no.87 recto; Gere and
Turner 1983, no.37.

77
Raphael
Four Soldiers (detail of **73**)

78
Raphael after Michelangelo
St Matthew
Pen, 23×31.9 cm. British Museum, London,
no.1855–2–14–1, verso.

Gronau 1902, pp.33ff.; Fischel 1923, no.172;
Pouncey and Gere 1962, no.12; Ferrara, Staccioli
and Tantillo 1972, p.26; Knab et al. 1983, no.206;
Joannides 1983, no.133 verso; Gere and Turner
1983, no.78; Forlani Tempesti 1984, no.44; Ames-
Lewis 1986, pp.56f.

79
Michelangelo
St Matthew
Marble, height 216 cm.
Galleria dell' Accademia, Florence.

Tolnay 1943–60, I, pp.168ff.; Poeschke 1992, pp.87ff.

80
Raphael
Figure Study (detail)
Pen over leadpoint, 23.4×17.1 cm.
Albertina, Vienna, no.260.

Gronau 1902, p.36; Fischel 1923, no.218; Knab et al.
1983, no.215; Joannides 1983, no.262; Mitsch 1983,
no.23; Birke and Kertész 1992, no.260.

81
Raphael
Study of a Head (detail)
Pen, 27.1×18.6 cm.
Windsor Castle, no.12760 verso.

Gronau 1902, p.36; Knab et al. 1983, no.369;
Joannides 1983, no.241 verso; Gere and Turner
1983, no.106.

82
Raphael after Michelangelo
St Matthew (detail of **78**)

83
Raphael
Battle Scene with Captives
Pen over chalk, 26.8×41.7 cm.
Ashmolean Museum, Oxford, no.PII538 recto.

Gronau 1902, pp.42ff.; Fischel 1923, no.194; Parker
1956, no.538; Knab et al. 1983, no.234; Joannides
no.186 recto; Gere and Turner 1983, no.51.

84
Aristotele da Sangallo after Michelangelo
The Battle of Cascina (detail of **44**)

85
Leonardo da Vinci
Head of a Warrior
Chalk, 22.7×18.6 cm. Szépmüveszéti Múzeum,
Budapest, no.1774 recto.

Nepi-Scirè 1992, no.35.

IV. THE FLORENTINE PAINTINGS

The half-length Madonna paintings

86
Raphael
Christ Child
(detail of **126**)

87
Raphael
Madonna and Child with a Book
Oil on panel, 55.2×40 cm. Norton Simon

Foundation, Pasadena, California.

Dussler 1971, p.7; Van Buren 1975, pp.41–52, 466;
Quednau 1983, pp.130ff.

88
Pietro Perugino
Madonna and Child
Oil on panel, 70×51 cm.

National Gallery of Art, Washington, DC,
no.326/1939.i.215 (Samuel H. Kress Collection).

Scarpellini 1984, no.123.

89
Raphael
Figure Study for the Madonna
Silverpoint, 25.1 × 18 cm.
Musée des Beaux-Arts, Lille, no.442 recto.

Fischel 1923, no.50; Knab et al. 1983, p.68;
Joannides 1983, no.34 recto; Brejon de Lavergnée
1990, no.27.

90
Raphael
Madonna and Child
Pen over stylus, 11.4 × 13 cm.
Ashmolean Museum, Oxford, no.P.II508a recto.

Fischel 1923, no.46; Parker 1956, no.508; Ferino
Pagden 1981, pp.236ff.; Knab et al. 1983, p.64;
Joannides 1983, no.32 recto.

91
Raphael
Study for the Christ Child
Pen over stylus, 11.4 × 13 cm. Ashmolean Museum,
Oxford, no.P.II508a verso.

Fischel 1923, no.47; Parker 1956, no.508; Knab et al.
1983, p.65; Joannides 1983, no.32 verso.

92
Raphael
Christ Child with a Book (detail of **87**)

93
Raphael
Small Cowper Madonna
Oil on panel, 59.5 × 44 cm.
National Gallery of Art, Washington,
no.653 (Widener Coll.).

Passavant 1839, II, pp.37f.; Passavant 1858, pp.89f.;
Dussler 1971, pp.19f.; Brown 1983 [1], pp.124ff.;
Brown 1983 [2], pp.9ff.; Merrill in Beck 1986
pp.139ff.; Brown in Sambucco Hamoud and
Strocchi 1987, pp.465ff.

94
Luca della Robbia
Madonna and Child

Glazed terracotta, 70 × 52 cm.
Museo Nazionale del Bargello, Florence.

Pope-Hennessy 1980, no.37; Gentilini 1993, pp.39ff.

95
Raphael
Small Cowper Madonna
Infrared reflectogram

96
Raphael
Small Cowper Madonna (detail of **93**)

97
Raphael
Madonna del Granduca
X-ray photograph (see **98**)

98
Raphael
Madonna del Granduca
Oil on panel, 84 × 55 cm. Palazzo Pitti, Florence.

Passavant 1839, II, pp.35f.; Passavant 1858, pp.88f.;
Dussler 1971, pp.18f.; Bertocci 1974, pp.27–33;
Gregori 1984, pp.88ff.; Chiarini in Curti and
Gallone Galassi 1986, pp.21ff.; Chiarini 1995, p.37.

99
Raphael
Sketch for the Madonna del Granduca
Chalk over stylus, 21.3 × 18.4 cm.
Galleria degli Uffizi, Florence, Gabinetto
delle disegni e stampe no.505E.

Fischel 1922, no.105; Knab et al. 1983, p.117;
Joannides 1983, no.105; Ferino Pagden in
Gregori 1984, pp.352f.

100
Raphael
Madonna del Granduca (detail of **98**)

101
Raphael
Madonna with a Carnation
Oil on panel, 29 × 23 cm.
Collection of the Duke of Northumberland,
Alnwick Castle.

Passavant 1839, II, pp.79f.; Passavant 1858, p.99;
Dussler 1971, p.63; Penny 1992, pp.67ff; Dunkerton
and Penny 1993, pp.7–21; Weston-Lewis in

Clifford 1994, no.16; De Vecchi 1995, p.246.

102
Leonardo da Vinci
Madonna with a Dish of Fruit
Pen over chalk, 28.4 × 21.4 cm.
Musée du Louvre, Paris, Cabinet des Dessins
no.R.F.1978.

Béguin 1983 [2], p.83.

103
Leonardo da Vinci
Benois Madonna
Oil on panel, 48 × 31 cm.
The Hermitage, St Petersburg.

Alpatov, Kustodieva and Pedretti 1984;
Marani 1989, p.53.

104
Raphael
Bridgewater Madonna
Oil on panel transferred to canvas, 81 × 56 cm.
Collection of the Duke of Sutherland, on loan to the
National Gallery of Scotland, Edinburgh.

Passavant 1839, II, pp.144ff.; Dussler 1971, p.23;
Brigstocke 1994, pp.129ff.; Weston-Lewis in
Clifford 1994, no.18.

105
Raphael
Study for the Bridgewater Madonna (detail)
Pen over stylus, 26.6 × 40.6 cm. Musée du Louvre,
Paris, Cabinet des Dessins no.3856 verso.

Gronau 1902, pp.38ff.; Fischel 1919, no.96; Knab et
al. 1983, p.133; Joannides 1983, no.93 verso;
Cordellier and Py 1992 [1], no.36; Weston-Lewis
in Clifford 1994, no.19.

106
Raphael
Studies for the Madonna and Child
Pen over chalk, 25.4 × 18.4 cm.
British Museum, London, no.Ff.1–36.

Gronau 1902, pp.38ff.; Fischel 1922, no.109; Knab
et al. 1983, p.161; Joannides 1983, no.180; Gere and
Turner 1983, no.84; Gere 1987, no.12; Weston-
Lewis in Clifford 1994, no.20.

107
Raphael
*Compositional Study for
the Bridgewater Madonna*
Pen over silverpoint, 25.5 × 18.8 cm.
Albertina, Vienna, no.209 recto.

Fischel 1922, no.111; Knab et al. 1983, no.162;
Mitsch 1983, no.11; Joannides 1983, no.181 verso;
Birke and Kertész 1992, no.209; Weston-Lewis in
Clifford 1994, no.21.

108
Raphael
Niccolini–Cowper Madonna
signed and dated 1508. Oil on panel, 80.7 × 57.5 cm.
National Gallery of Art, Washington, no.25
(Andrew W. Mellon Collection).

Passavant 1839, II, pp.83f.; Passavant 1858, p.100;
Dussler 1971, p.26; Brown 1983 [1], pp.157ff.;
Christensen in Beck 1986, pp.50ff.

109
Raphael
Studies for the Niccolini–Cowper Madonna
Pen and chalk, 25.5 × 18.8 cm.
Albertina, Vienna, no.209 verso.

Fischel 1922, no.110; Knab et al. 1983, no.163;
Mitsch 1983, no.12; Joannides 1983, no.181 recto;
Birke and Kertész 1992, no.209 verso.

Paintings with more than two figures in full length

110
Raphael
*The Holy Family with the Infant John the Baptist
and an Angel*
Pen over chalk, 17.9 × 15.7 cm.
Musée des Beaux-Arts, Lille, no.431.

Fischel 1918, no.54; Knab et al. 1983, no.98;
Joannides 1983, no.69.

111
Raphael
Madonna di Terranuova
Oil on panel, 87 cm diameter.
Gemäldegalerie, Berlin-Dahlem, no.247A.

Passavant 1839, II, pp.36f.; Passavant 1858, p.89;
Lippmann 1881, pp.62–6; Grimm 1882, pp.154–70;
Fischel 1922, pp.13–15; Dussler 1971, pp.16f.;

Schleier in Bock 1985, pp.308f.; Meyer zur
Capellen 1994, pp.347ff.

112
Leonardo da Vinci
Madonna with the Yarnwinder (detail of **29**)

113
Infrared photograph of *Madonna di Terranuova*
(detail of **111**)

114
Raphael
Cartoon for The Holy Family with the Lamb
Pen, brush and wash and white highlights,
squaring up in stylus, pricked, 27.5 × 22.7 cm.
Ashmolean Museum, Oxford, no.PII520.

Parker 1952, no.520; Knab et al. 1983, no.242;
Joannides 1983, no.154; Lehmann 1995, no.6.

115
Raphael
The Holy Family with the Lamb
signed and dated 1504. Oil on panel, 32.2 × 22 cm.
Formerly in the Collection of Viscount Lee of
Fareham, now in a private collection.

Passavant 1839, II, pp.91f.; Passavant 1858, pp.104f.;
Lee of Fareham 1934, pp.2–19; Schug 1967, pp.470–82;
Dussler 1971, pp.11ff.; Meyer zur Capellen 1989,
pp.98ff.; De Vecchi 1995, p.31, no.19; Lehmann 1996.

116
Leonardo da Vinci
Three Sketches of a Child with a Lamb
Pen on chalk, 20.3 × 13.8 cm.
J. Paul Getty Museum, Los Angeles,
California, no.86.GG.725 recto.

Pedretti, 1988, pp.145, 151.

117
Raphael
Madonna del Prato
dated 1505/6. Oil on panel, 113 × 88 cm.
Kunsthistorisches Museum, Vienna, no.628.

Vasari 1981, IV, p.321; Passavant 1839, II, pp.49ff.;
Passavant 1858, p.91; Swoboda 1969, pp.180–95;
Dussler 1971, p.20; Rosenauer1983; Brown 1983 [2],
pp.9ff.; Prohaska 1984, pp.76–93; Rosenauer in
Cotteri 1985, pp.73ff.; Prohaska in Shearman and
Hall 1990, pp.57ff.

118
Raphael
Study for the Madonna del Prato
Brush and wash with white highlights, 21.8 × 18 cm.
Ashmolean Museum, Oxford, no.PII518.

Fischel 1922, p.118; Parker 1956, no.518; Knab et al.
1983, no.123; Joannides 1983, p.66, no.112; Gere
1987, no.7; Whistler 1990, no.11.

119
Raphael
Studies of the Madonna and Child
Pen over stylus, 24.6 × 36.3 cm.
Albertina, Vienna, no.207 verso.

Fischel 1922, pp.115f.; Knab et al. 1983, no.122;
Mitsch 1983, no.3; Joannides 1983, no.110 recto;
Ames-Lewis 1986, p.60; Birke and Kertész 1992,
no.207 verso.

120
Raphael
Studies of the Madonna and Child
Pen over stylus, 24.6 × 36.3 cm.
Albertina, Vienna, no.207 recto.

Fischel 1922, pp.115f.; Knab et al. 1983, no.119;
Mitsch 1983, no.3; Joannides 1983, no.110 verso;
Ames-Lewis 1986, p.60; Birke and Kertész 1992,
no.207.

121
Raphael
The Holy Family (Canigiani)
Oil on panel, 131 × 107 cm.
Alte Pinakothek, Munich, no.476.

Vasari 1981, IV, pp.325f.; Passavant 1839, II,
pp.68ff.; Passavant 1858, p.97; Dussler 1971, p.19;
Sonnenburg 1983; Sonnenburg in Shearman
and Hall 1990, pp.65ff.

122
Raphael (copy after?)
*Compositionial Study for
The Holy Family (Canigiani)*
Brush, wash and white highlights, 22 × 18.2 cm.
Musée du Louvre, Paris, Cabinet des Dessins
no.3949.

Fischel 1922, no.131; Knab et al. 1983, no.246;
Joannides 1983, no.152; Viatte in Béguin 1983 [1],
pp.317f., no.132; Cordellier and Py 1992 [1], pp.78f.,

no.70; Cordellier and Py 1992 [2], no.35.

123
Raphael
Compositional Study for
The Holy Family (Canigiani)
Pen, 23.4 × 18 cm. Windsor Castle, no.12738.

Fischel 1922, no.130; Popham and Wilde 1949,
no.790; Knab et al. 1983, no.244; Joannides 1983,
no.151; Gere and Turner 1983, no.58; Gere 1987, no.9.

124
Raphael (copy)
Compositional Study for
The Holy Family (Canigiani)
Pen, 37 × 24.5 cm.
Musée Condé, Chantilly, no.FRvIII, 43.

Fischel 1922, no.132; Knab et al. 1983, no.245;
Mitsch 1983, no.49; Joannides 1983, no.148 recto;
Lefébure 1983, no.9.

125
Raphael
Infant Christ and St John the Baptist (detail of **121**)

126
Raphael
Madonna del Cardellino
Oil on panel, 107 × 77 cm.
Galleria degli Uffizi, Florence, no.1447.

Vasari 1981, IV, pp.321f.; Passavant 1839, II, pp.48f.;
Passavant 1858, p.91; Dussler 1971, pp.20f.; Gregori
1984, no.5, pp.77–87; Baldini 1984, pp.60–5; Baldini
in Sambucco Hamoud and Strocchi 1987, pp.473ff.

127
Raphael
Compositional Studies for the
Madonna del Cardellino
Pen, 24.8 × 20.4 cm.
Ashmolean Museum, Oxford, no.PII516 recto.

Fischel 1922, no.112; Parker 1956, no.516; Gere
and Turner 1983, no.56; Knab et al. 1983, no.149;
Joannides 1983, no.115 recto; Whistler 1990, no.12.

128
Raphael
Compositional Study for the
Madonna del Cardellino

Pen over leadpoint, 22.9 × 16.3 cm.
Ashmolean Museum, Oxford,
no.PII517 recto.

Fischel 1922, no.113; Parker 1956, no.517; Gere
and Turner 1983, no.57; Knab et al. 1983, no.148;
Joannides 1983, no.116 recto.

129
Raphael
Compositional Study for La Belle Jardinière
Pen over stylus, 30.2 × 20.8 cm. Musée du Louvre,
Paris, Cabinet des Dessins no.RF 1006.

Fischel 1922, no.120; Knab et al. 1983, no.182;
Joannides 1983, no.120; Cordellier and Py 1992 [1],
pp.61f.; Cordellier and Py 1992 [2], pp.96ff.

130
Raphael
Madonna and Child (La Belle Jardinière)
signed and dated 1508[?]. Oil on panel, 122 × 80 cm.
Musée du Louvre, Paris, no.602.

Vasari 1981, IV, p.328; Passavant 1839, II, pp.86ff.;
Passavant 1858, pp.100f.; Nicodemi 1956, pp.11–17;
Dussler 1971, p.22; Béguin 1983 [1], pp.81ff, no.6.

131
Raphael
Christ Child and Other Studies
Pen over leadpoint, 28.3 × 16.1 cm.
Ashmolean Museum, Oxford, no.PII521 recto.

Fischel 1922, no.121; Parker 1956, no.521; Knab et al.
1983, no.184; Joannides 1983, no.122 recto; Gere
and Turner 1983, no.61.

132
Raphael
Christ Child (detail of **130**)

133
Raphael
Esterházy Madonna
Oil on panel, 29 × 21.5 cm.
Szepmüvészeti Múzeum, Budapest, no.71.

Passavant 1839, II, pp.92f.; Passavant 1858,
p.105; Dussler 1971, p.21; Shearman 1977, pp.128,
134; Sonnenburg 1983, pp.69f.; Garas 1983,
pp.41ff., 183ff.

134
Raphael
Compositional Sketch for the Esterházy Madonna
Pen over chalk, squared up, pricked, 24.8×19.1 cm.
Galleria degli Uffizi, Florence, Gabinetto disegni e
stampe no.539E.

Fischel 1922, no.126; Knab et al. 1983, no.241;
Joannides 1983, no.169; Petrioli Tofani in Gregori
1984, no.44, pp.356ff.

135
Leonardo da Vinci
Sheet of Sketches
Pen, 40.5×29 cm.
Windsor Castle, no.12276 recto.

Clark and Pedretti 1968, pp.3f; Kemp 1992, no.7.

V. SUMMARY

Three altarpieces

136
Raphael
*Madonna and Child Enthroned with Saints
(Colonna Altarpiece)*
Oil on panel, main panel 172.4×172.4 cm,
lunette 180×74.9 cm.
The Metropolitan Museum of Art, New York
(Gift of J. Pierpont Morgan, 1916 [16.30ab]).

Predella panels:
The Deposition
Oil on panel, 24.1×85.1 cm.
National Gallery, London, no.2919.

The Agony in the Garden
Oil on panel, 24.1×28.9 cm.
Metropolitan Museum of Art, New York
(Funds from various donors, 1932 [32.130.1]).

Pietà
Oil on panel, 24×28 cm. Isabella Stewart Gardner
Museum, Boston, Massachusetts.

St Francis
Oil on panel, 25.8×16.8 cm.
Dulwich College Picture Gallery, London, no.241.

St Antony of Padua
Oil on panel, 26.6×16.4 cm.
Dulwich College Picture Gallery, London, no.243.

Vasari 1981, IV, p.324; Passavant 1839, II, pp.39ff.;
Passavant 1858, p.90; Dussler 1971, pp.14f.;
Oberhuber 1977, pp.55ff.; Murray 1980, p.99;
Zeri 1980, pp.72ff.; Brown 1983 [1], pp.119ff.

137
Fra Bartolommeo
Study for a Prophet

Chalk, 29.4×21.8 cm. Museum Boymans-van
Beuningen, Rotterdam, vol.M 61.

Fischer 1990, pp.66f., no.14.

138
Raphael
The Agony in the Garden (see **136**)

139
Raphael
The Entombment (Baglioni Altarpiece)
signed and dated 1507. Oil on panel, 184×176 cm.
Galleria Borghese, Rome, no.369.

Top panel:
God the Father in Benediction (copy after Raphael?)
Oil on panel, 81.5×88.5 cm.
Galleria Nazionale dell' Umbria, Perugia, no.288.

Frieze:
Putti and Gryphons (Raphael's workshop)
Oil on four panels, 12×36 cm; 12×54 cm;
12×54 cm; 12×37 cm.
Galleria Nazionale dell' Umbria, Perugia, no.281.

Predella panels:
Faith, Charity, Hope
Oil on panel, each 18×44 cm.
Pinacoteca Vaticana, Rome, no.320–22.

Vasari 1981, IV, pp.324, 327f.; Passavant 1839, II,
pp.72ff.; Passavant 1858, pp.98f.; Della Pergola 1959,
no.170; Dussler 1971, pp.23ff.; Ferrara, Staccioli and
Tantillo 1972, p.3; Ragghianti 1978, pp.143–61;
Mancinelli in Pietrangeli 1982, no.79; Ferino
Pagden in Calvesi 1984, no.5; Santi 1985, nos 102,
103; Gilbert in Beck 1986, pp.118ff.; Rosenberg in
Beck 1986, pp.175ff.; Ferino Pagden in Frommel

and Winner 1986, pp.19ff.; Rosci 1991; Locher 1994.

140
Raphael
Lamentation over the Dead Christ
Pen over chalk, 33.5 × 39.7 cm.
Musée du Louvre, Paris, Cabinet des Dessins
no.3865.

Fischel 1923, no.168; Knab et al. 1983, no.193;
Joannides 1983, no.125; Ames-Lewis 1986, pp.50ff.;
Cordellier and Py 1992 [1], pp.69f., no.57;
Cordellier and Py 1992 [2], pp.104ff., no.32.

141
Raphael
Study for The Entombment
Pen over chalk, 23 × 31.9 cm.
British Museum, London,
no.1855–2–14–1, recto.

Fischel 1923, no.171; Pouncey and Gere 1962, no.12;
Knab et al. 1983, no.199; Joannides 1983, no.133
recto; Gere and Turner 1983, no.78; Ames-Lewis
1986, pp.50ff.

142
Raphael
Madonna of the Baldacchino
Oil on panel, 279 × 217 cm.
Palazzo Pitti, Florence, no.165.

Vasari 1981, IV, pp.328f.; Passavant 1839, II, pp.89f.;
Passavant 1858, pp.102f.; Riedl 1957/9, pp.59,
223ff.; Dussler 1971, p.26; Gregori 1984, pp.119ff.;
Ames-Lewis 1986, pp.65ff.; Chiarini, Ciatti and
Padovani 1991.

143
Raphael
Two Putti (detail of **142**)

Select bibliography

Alazard, Jean. *Le Portrait florentin de Botticelli à Bronzino*. Paris, 1951.

Alberti, Leone Battista. *Kleinere kunsttheoretische Schriften*. Edited by Hubert Janitschek. Volume 11 of *Quellenschriften für Kunstgeschichte*. 1877. Reprint Osnabrück, 1970.

—. *On Painting and Sculpture*. Translated and edited by Cecil Grayson. London, 1972.

Alexandre-Bidon, Danièle. 'Du drapeau à la cotte: vêtir l'enfant au Moyen Age (XIIIè–XVè s.)', *Le Vêtement: Histoire, archéologie et symbolique vestimentaires au Moyen Age*. Volume 1 of *Cahiers du Léopard d'Or*. Paris, 1989, pp.123–68.

Alpatov, Michele, Tatiana Kustodieva and Carlo Pedretti. *La Madonna Benois di Leonardo da Vinci a Firenze. Il capolavoro dell' Ermitage in mostra agli Uffizi*. Florence, 1984.

Ames-Lewis, Francis. *Drawing in Early Renaissance Italy*. New Haven and London, 1981.

—. *The Draftsman Raphael*. New Haven and London, 1986.

—. and Joanne Wright. *Drawing in the Italian Renaissance Workshop*. London, 1983.

Anonimo Magliabechiano. See Magliabechiano.

Armenini, Giovanni Battista. *De' veri precetti della pittura*. Edited by Marina Gorreri. Turin, 1988. *On the True Precepts of the Art of Painting*. Translated and edited by Edward J. Olszewski. N.p., 1977.

Aronberg Lavin, Marilyn. 'Giovannino Battista: A Study in Renaissance Religious Symbolism', *Art Bulletin*, 37, no.2 (1955), pp.85–101.

—. 'Giovannino Battista: A Supplement', *Art Bulletin*, 43, no.4 (1961), pp.319–26.

Bacci, Mina. *Piero di Cosimo*. Milan, 1966.

Baldini, Umberto. 'Restauro e scienza', *Critica d'arte*, 49, no.3 (1984), pp.60–65.

—. 'La pala di Santo Spirito di Filippino Lippi', *Critica d'arte*, 53, no.17 (1988), pp.24–31.

Bandello, Matteo. *Le novelle*. Edited by Gioachino Brognoligo. Bari, 1910.

Barocchi, Paola, and Renzo Ristori, eds. *Il carteggio di Michelangelo*. 5 volumes. Florence, 1965–83.

Barolsky, Paul. *Why Mona Lisa Smiles and Other Tales by Vasari*. Philadelphia, 1991.

Becherucci, Luisa, et al. *Raffaello: L'opera, le fonti, la fortuna*. 2 volumes. Novara, 1968.

Beck, James H., ed. *Raphael before Rome*. Volume

17 of *Studies in the History of Art*. Washington, 1986.

Beenken, Hermann. 'Zu Raffaels frühesten Bildnisschöpfungen', *Zeitschrift für Kunstgeschichte*, 4 (1935), p.145.

Béguin, Sylvie. 'Un nouveau Raphaël au Louvre: un ange du retable de Saint Nicolas de Tolentino', *Revue du Louvre et des Musées de France*, 2 (April 1982), pp.99–115.

—. *Léonard de Vinci au Louvre*. Paris, 1983. (Quoted as Béguin 1983 [2].)

—. *Les peintures de Raphaël au Louvre*. Paris, 1984.

—. et al. *Raphaël dans les collections françaises*. Paris, 1983. (Quoted as Béguin 1983 [1].)

—, Edwin Hall and Horst Uhr. 'Concerning Raphael's St Nicholas of Tolentino Altarpiece', *Art Bulletin*, 69, no.3 (1987), pp.467–9.

Bernini, Dante, Sara Staccioli and Giulia Barberini. *Raffaello nelle raccolte Borghese*. Rome, 1984.

Bernini Pezzini, Grazia, et al. *Raphael invenit: Stampe da Raffaello nelle collezioni dell' Istituto nazionale per la grafica*. Rome, 1985.

Berti, Luciano, ed. *Il Tondo Doni di Michelangelo e il suo restauro*. Volume 2 of *Gli Uffizi: Studi e ricerche*. Florence, 1985.

Bertocci, Silvio. 'Ipotesi sull' autenticità di un mito: La Madonna del Granduca di Raffaello', *Arti*, 24, nos 11–12 (1974), pp.27–33.

Billi, Antonio. *Il Libro di Antonio Billi*. Edited by Cornelius von Fabriczy. Florence, 1891. Edited by Fabio Benedettucci. Anzio, 1991.

Birke, Veronika and Janine Kertész. *Die italienischen Zeichnungen der Albertina. Generalverzeichnis 1*. Vienna, 1992.

Blanshei, Sarah Rubin. 'Population, Wealth and Patronage in Medieval and Renaissance Perugia', *Journal of Interdisciplinary History*, 9 (1979), pp.597–619.

Bock, Henning, ed. *Gemäldegalerie Berlin*. Berlin, 1975, 1985.

Boissard, Elisabeth de. Chantilly. *Musée Condé. Peintures de l'école italienne*. Paris, 1988.

Bombe, Walter. 'Raffaels Peruginer Jahre', *Monatshefte für Kunstwissenschaft*, 4, no.1 (1911), pp.296–308.

—. *Geschichte der Peruginer Malerei bis zu Perugino und Pinturicchio*. Volume 5 of *Italienische Forschungen*, edited by the Kunsthistorisches Institut at Florence. Berlin, 1912.

—. *Perugino: Des Meisters Gemälde*. Stuttgart and Berlin, 1914.

Borgo, Ludovico. *The Works of Mariotto Albertinelli*. New York and London, 1976.

Borsook, Eve and Fiorella Superbi Gioffredi, eds. *Italian Altarpieces 1250–1550: Function and Design*. Oxford, 1994.

Braham, Allan and Martin Wyld. 'Raphael's St John the Baptist Preaching', *National Gallery Technical Bulletin*, 8 (London, 1984), pp.15–23.

Braham, Allan, Martin Wyld, Eric Harding and Aviva Burnstock. 'The Restoration of the Leonardo Cartoon', *National Gallery Technical Bulletin*, 12 (London, 1989), pp.5–27.

Brejon de Lavergnée, Barbara, et al. *Raffael und die Zeichenkunst der italienischen Renaissance*. Cologne, 1990.

Bridgeman, Jane. 'Filippino Lippi's Nerli Altarpiece – A New Date', *Burlington Magazine*, 130 (1988), pp.668–71.

Briganti, Giuliano, ed. *La pittura in Italia: Il cinquecento*. 2 volumes. Milan, 1988.

Brigstocke, Hugh. *Italian and Spanish Paintings in the National Gallery of Scotland*. 2nd edition, Edinburgh, 1994.

Brown, David Alan. *Raphael and America*. Washington, 1983. (Quoted as Brown 1983 [1].)

—. 'Raphael's Small Cowper Madonna and Madonna of the Meadow: Their Technique and Leonardo Sources', *Artibus et historiae*, 4, no.8 (1983), pp.9–26. (Quoted as Brown 1983 [2].)

Budny, Virginia. 'The Sequence of Leonardo's Sketches for "The Virgin and Child with Saint Anne and Saint John the Baptist"', *Art Bulletin*, 65 (1983), pp.34–50.

Burckhalter, Margarethe. *Die Bildnisse Raffaels.*
Laupen and Berne, 1932.

Burckhardt, Jacob. *Gesamtausgabe.* Edited by
Hans Trog, Emil Dürr, Werner Kaegi et al.
Berlin and Leipzig, 1929–34.

Buschmann, Hildegard. 'Raffaellino del Garbo:
Werkmonographie und Katalog', Ph.D. disser-
tation, University of Freiburg, 1993.

Calvesi, Maurizio, et al. *Raffaello in Vaticano.*
Milan, 1984.

Camesasca, Ettore. *Raffaello scritti: Lettere, firme,
sonetti, saggi tecnici.* Milan, 1993.

Campbell, Lorne. 'The Art Market in the Southern
Netherlands in the Fifteenth Century',
Burlington Magazine, 118 (1976), pp.188–98.

Canuti, Fiorenzo. *Il Perugino.* 2 volumes. 1931.
Reprint Perugia, 1983.

Caroli, Flavio. *Leonardo: Studi di fisionomia.*
Milan, 1991.

Castiglione, Baldassare. *Il libro del cortegiano.*
Edited by Ettore Bonora and Paolo Zoccola.
Milan, 1982. *The Book of the Courtier.*
Translated by George Bull. London and New
York, 1967.

Cellini, Benvenuto. *Vita.* Edited by Ettore
Camesasca. Milan, 1954. *The Autobiography of
Benvenuto Cellini.* Translated by George Bull.
Harmondsworth, 1956.

Cerboni Baiardi, Giorgio, Giorgio Chittolini and
Piero Floriani. *Federico di Montefeltro: Lo Stato.
Le Arti. La Cultura.* Volume 30 of *Biblioteca del
Cinquecento.* 3 volumes. Rome, 1986.

Chambers, David S. *Patrons and Artists in the
Italian Renaissance.* London, 1970.

Chastel, André. *Chronique de la peinture italienne
à la Renaissance, 1280–1580 [Chronik der ital-
ienischen Renaissancemalerei 1280–1580].*
Fribourg, 1984. Trans. Linda and Peter Murray,
Art of the Italian Renaissance, Arch Cape Press,
New York, 1988.

Chiarini, Marco, Marco Ciatti and Serena
Padovani. *Raffaello a Pitti: La Madonna del
Baldacchino, storia e restauro.* Florence, 1991.

Chiarini, Marco, '"La Madonna del Granduca" di
Raffaello', *Critica d'Arte,* 68 (1995), 1, pp.37–46.

Ciardi Duprè, Maria Grazia and Paolo dal
Poggeto, eds. *Urbino e le Marche prima e dopo
Raffaello.* Florence, 1983.

Clark, Kenneth. *Leonardo da Vinci.* With an
introduction by Martin Kemp. London, 1989.

— and Carlo Pedretti. *The Drawings of Leonardo
da Vinci in the Collection of Her Majesty the
Queen at Windsor Castle.* 2nd edition,
2 volumes. London, 1968.

Clifford, Timothy, et al. *Raphael: The Pursuit of
Perfection.* Edinburgh, 1994.

Clough, Cecil H. *The Duchy of Urbino in the
Renaissance.* London, 1981.

Cocke, Richard. *The Drawings of Raphael.*
London, 1969.

Condivi, Ascanio. *Michelangelo: La vita raccolta
dal suo discepolo Ascanio Condivi.* Edited by
Paolo d'Ancona. Milan, 1928. *The Life of
Michelangelo by Ascanio Condivi.* Edited by
Hellmut Wohl. Oxford, 1976.

Cordellier, Dominique and Bernadette Py.
*Raphaël: Son atelier, ses copistes. Musée du
Louvre. Inventaire général des dessins italiens.*
Paris, 1992. (Quoted as Cordellier and Py [1].)

—, et al. *Raffaello e i suoi.* Rome, 1992. (Quoted as
Cordellier and Py [2].)

Cotteri, Luigi. *Raffaello Sanzio 1493–1520.* Volume
5 of *Studi Italo-Tedeschi, Deutsch-Italienische
Studien.* Merano, 1985.

Crowe, Joseph Archer and Giovanni B.
Cavalcaselle. *Raphael: His Life and Works.*
2 volumes. London, 1882.

Curti, Orazio and Antonietta Gallone Galassi.
Raffaello: Recenti indagini scientifiche. Milan,
1986.

Cuzin, Jean-Pierre. *Raphael: His Life and Works.*
Secaucus, N.J., n.d.

Dal Poggetto, Paolo, ed. *Piero e Urbino: Piero e le
corti rinascimentali.* Venice, 1992.

Dal Prà, Laura. *Bernardo di Chiaravalle nell' arte
italiana dal XIV al XVII secolo.* Milan, 1990.

Dalli Regoli, Gigetta. *Lorenzo di Credi*. Cremona, 1966.

—. 'Raffaello "angelica farfalla": Note sulla struttura e sulle fonti della pala Ansidei', *Paragone (Arte)*, 399 (1983), pp.8–19.

—. 'Mito e scienza nella "Leda" di Leonardo', *Letteratura Vinciana*, 30 (1990), pp.5–23.

Davidsohn, Robert. 'Das Ehepaar Doni und seine von Raffael gemalten Porträts', *Repertorium für Kunstwissenschaft*, 23 (1900), pp.211–16.

Davies, Martin. *National Gallery Catalogues: The Earlier Italian Schools*. London, 1961.

De Vecchi, Pierluigi. *L'opera completa di Raffaello*. Milan, 1966.

—. *Lo Sposalizio della Vergine di Raffaello*. Volume 2 of *Quaderni di Brera*. Milan, 1973.

—. *Raffaello: La pittura*. Florence, 1981.

—. *Raffaello: La mimesi, l'armonia e l'invenzione*. Florence, 1995.

Della Pergola, Paola. *Galleria Borghese: I dipinti*. 2 volumes. Rome, 1955–1959.

Dizionario Biografico degli Italiani. Edited by the Istituto della Enciclopedia Italiana. Rome, 1960–.

Dubos, Renée. *Giovanni Santi, peintre et chroniqueur à Urbin, au XV siècle*. Bordeaux, 1971.

Dunkerton, Jill, Susan Foister, Dillian Gordon and Nicholas Penny. *Giotto to Dürer: Early Renaissance Painting in the National Gallery*. London, 1991.

Dunkerton, Jill and Nicholas Penny. 'The Infrared Examination of Raphael's "Gavargh Madonna"', *National Gallery Technical Bulletin*, 14 (London, 1993), pp.7–21.

Dussler, Luitpold. *Raphael: A Critical Catalogue of His Pictures, Wall-Paintings and Tapestries*. Translated by Sebastian Cruft. London and New York, 1971.

Egger, Hermann. *Codex Escurialensis: Ein Skizzenbuch aus der Werkstatt Domenico Ghirlandaios*. Vienna, 1906.

Emboden, William A. *Leonardo da Vinci on Plants and Gardens*. London, 1987.

Ettlinger, Helen S. 'The Question of St George's Garter', *Burlington Magazine*, 135 (1983), pp.25–29.

Ettlinger, Leopold D. and Helen S. Ettlinger. *Raphael*. Oxford, 1987.

Ewing, Dan. 'The Influence of Michelangelo's Bruges Madonna', *Revue belge d'archéologie et d'histoire de l'art*, 47 (1978), pp.77–105.

Farago, Claire J. 'Leonardo's "Battle of Anghiari": A Study in Exchange between Theory and Practice', *Art Bulletin*, 76, no.2 (1994), pp.301–30.

Ferino Pagden, Sylvia. 'Raphael's Activity in Perugia as Reflected in a Drawing in the Ashmolean Museum, Oxford', *Mitteilungen des Kunsthistorischen Institutes in Florenz*, 25 (1981), pp.231–52.

—. *Disegni umbri del rinascimento da Perugino a Raffaello*. Volume 58 of *Gabinetto disegni e stampe degli Uffizi*. Florence, 1982.

—. *Gallerie dell' Accademia: Disegni umbri*. Milan, 1984.

— and M. Antonietta Zancan. *Raffaello: Catalogo completo*. Florence, 1989.

Fermor, Sharon. *Piero di Cosimo: Fiction, Invention and Fantasìa*. London, 1993.

Ferrara, Luciana, Sara Staccioli and Anna Maria Tantillo. *Storia e restauro della Deposizione di Raffaello*. Rome, 1972/3.

Fiore, Francesco Paolo and Manfredo Tafuri. *Francesco di Giorgio architetto*. Milan, 1993.

Fiorio, Maria Teresa and Piero Marani. *I leonardeschi a Milano: Fortuna e collezionismo. Atti del convegno internazionale*. Milan, 1991.

Fischel, Oskar. 'Raffaels erstes Altarbild, die Krönung des Hl. Nikolaus von Tolentino', *Jahrbuch der preussischen Kunstsammlungen*, 33 (1912), pp.105–21.

—. *Raffaels Zeichnungen*. 8 volumes. Berlin 1913–41 (for Volume 9 see Oberhuber).

—. 'Ein Kartonfragment von Raphael: Zur Madonna del Duca di Terranuova', *Amtliche*

Berichte der Berliner Museen, 1922, part 1/2, pp.13–15.

—. *Raphael.* Berlin, 1962.

Fischer, Chris. *Fra Bartolommeo: Master Draughtsman of the High Renaissance.* Rotterdam, 1990.

—. *Fra Bartolommeo et son atelier: Dessins et peintures des collections françaises.* Paris, 1994.

Floerke, Hans. *Studien zur niederländischen Kunst- und Kulturgeschichte: Die Formen des Kunstmarktes, des Ateliers und des Sammlers in den Niederlanden vom 15.–18. Jahrhundert.* Munich and Leipzig, 1905.

Forlani Tempesti, Anna. *Capolavori del rinascimento: Il primo cinquecento toscano.* Milan, 1970.

—. 'Raffaello e il Tondo Doni', *Prospettiva*, 32–36 (1983/84), pp.144–9.

—, ed. *Raffaello e Michelangelo.* Florence, 1984.

Förster, Ernst. *Raphael.* Leipzig, 1867.

Frommel, Christoph Luitpold, Stefano Ray and Manfredo Tafuri. *Raffaello architetto.* Milan, 1984.

Frommel, Christoph Luitpold, Matthias Winner, et al. *Raffaello a Roma: Il convegno del 1983.* Rome, 1986.

Gabelentz, Hans von der. *Fra Bartolommeo und die Florentiner Renaissance.* 2 volumes. Leipzig, 1922.

Garas, Klára. 'Bildnisse der Renaissance III: Der junge Raffael und der alte Tizian', *Acta historiae artium*, 21, nos 1–2 (1975), pp.53–74.

—. 'Sammlungsgeschichtliche Beiträge zu Raffael: Raffael-Werke in Budapest', *Bulletin du Musée Hongrois des Beaux–Arts*, 60–61 (1983), pp.41–81, 183–201.

Gentilini, Giancarlo. *I Della Robbia: La scultura invetriata nel rinascimento.* 2 volumes. Florence, 1993.

Gere, John A. *Drawings by Raphael and His Circle.* New York, 1987.

— and Nicholas Turner. *Drawings by Raphael from the Royal Library, the Ashmolean, the British Museum, Chatsworth and Other English Collections.* London, 1983.

Ghiberti, Lorenzo. *Lorenzo Ghibertis Denkwürdigkeiten (I commentari).* Edited with commentary by Julius von Schlosser. Berlin, 1912.

Gilbert, Creighton E. *Sources and Documents in the History of Art Series: Italian Art 1400–1500.* Englewood Cliffs, N.J., 1980.

Glasser, Hannelore. *Artist's Contracts of the Early Renaissance.* New York and London, 1977.

Goffen, Rona. 'Icon and Vision: Giovanni Bellini's Half-Length Madonna', *Art Bulletin*, 57, no.1 (1975), pp.487–518.

Golzio, Vicenzo. *Raffaello nei documenti, nelle testimonianze dei contemporanei e nella letteratura del suo secolo*, 1936. Corrected edition, London, 1971.

Gombrich, Ernst H. 'Leonardo da Vinci's Method of Analysis and Permutation: The Grotesque Heads', in *The Heritage of Apelles: Studies in the Art of the Renaissance.* Oxford, 1976, pp.57–75.

Goodison, J.W. and G.H. Robertson. *Italian Schools.* Volume 2 of *Fitzwilliam Museum Cambridge: Catalogue of Paintings.* Cambridge, 1967.

Gould, Cecil. 'Leonardo's Great Battle Piece: A Conjectural Reconstruction', *Art Bulletin*, 36 (1954), pp.117–29.

—. 'Cartoon: The Virgin and Child with St Anne and St John the Baptist', in *National Gallery Catalogues: Acquisitions 1953–1962*, edited by Philip Hendy. London, 1963, pp.49–58.

—. *Michelangelo: Battle of Cascina.* Newcastle-upon-Tyne, 1966.

—. *National Gallery Catalogues: The Sixteenth Century Italian Schools.* London, 1975.

—. 'Leonardo's Madonna of the Yarnwinder: Revelations of Reflectogram Photography', *Apollo*, 136, no.365 (1992), pp.12–16.

Gregori, Mina, et al. *Raffaello a Firenze: Dipinti e disegni delle collezioni fiorentine.* Florence, 1984.

Gregori, Mina, Antonio Paolucci and Cristina

Acidini Luchinat, eds. *Maestri e botteghe: Pittura a Firenze alla fine del quattrocento.* Florence, 1992.

Grimm, Herman. 'Raphael's Madonna di Terranuova auf dem Berliner Museum', In *Fünfzehn Essays*, 3rd series. Berlin, 1882, pp.154–70.

Gronau, Georg. *Aus Raphaels Florentiner Tagen.* Berlin, 1902.

—. 'Ein Jugendwerk des Leonardo da Vinci', *Zeitschrift für Bildende Kunst*, 47 (1912), pp.253–59.

—. *Raffael: Des Meisters Gemälde.* 5th rev. edn., Stuttgart, 1923.

Gruyer, François-Anatole. *Les Vierges de Raphaël et l'iconographie de la Vierge.* 3 volumes. Paris, 1869.

—. 'Le saint Georges et les deux saints Michel', *Gazette des Beaux-Arts*, 3rd series, 1 (1889), pp.383–402.

Hager, Serafina, ed. *Leonardo, Michelangelo and Raphael in Renaissance Florence from 1500 to 1508.* Washington, 1992.

Hanning, Robert W. and David Rosand. *Castiglione: The Ideal and the Real in Renaissance Culture.* New Haven and London, 1983.

Hartt, Frederick. *David by the Hand of Michelangelo: The Original Model Discovered.* New York, 1987.

Hauptmann, Moritz. *Der Tondo.* Frankfurt am Main, 1936.

Haverkamp-Begemann, Egbert and Caroly Logan. *Creative Copies: Interpretative Drawings from Michelangelo to Picasso.* London and Amsterdam, 1988.

Hayum Andrée. 'Michelangelo's Doni Tondo: Holy Family and a Family Myth', *Studies in Iconography*, 7–8 (1981–2), pp.209–51.

Heydenreich, Ludwig H. 'La sainte Anne de Léonard de Vinci', *Gazette des Beaux-Arts*, 6th series, 10 (1933), pp.205–19.

—. *Leonardo: The Last Supper. Art in Context.* London, 1974.

Hirst, Michael. *Michelangelo and His Drawings.* New Haven and London, 1988.

— and Jill Dunkerton. *The Young Michelangelo: The Artist in Rome 1496–1501.* London, 1994.

Hollingsworth, Mary. *Patronage in Renaissance Italy: From 1400 to the Early Sixteenth Century.* London, 1994.

Holst, Christian von. 'Fra Bartolomeo und Albertinelli: Beobachtungen zu ihrer Zusammenarbeit am Jüngsten Gericht aus Santa Maria Nuova und in der Werkstatt von San Marco', *Mitteilungen des Kunsthistorischen Instituts in Florenz*, 18 (1974), pp.273–318.

Humfrey, Peter. *The Altarpiece in Renaissance Venice.* New Haven and London, 1993.

— and Martin Kemp, eds. *The Altarpiece in the Renaissance.* Cambridge, 1990.

Isermeyer, Christian Adolf. 'Die Arbeiten Leonardos und Michelangelos für den Großen Ratssaal von Florenz: Eine Revision der Bild- und Schriftquellen für ihre Rekonstruktion und Geschichte', *Studien zur toskanischen Kunst. Festschrift für Ludwig Heinrich Heydenreich.* Munich, 1963, pp.83–110.

Janson, Horst Woldemar. *The Sculpture of Donatello.* Princeton, 1963.

Joannides, Paul. *The Drawings of Raphael, With a Complete Catalogue.* Berkeley and Oxford, 1983.

—. 'Leonardo da Vinci, Peter Paul Rubens, Piere-Nolasque Bergeret and the "Fight for the Standard"', *Achademia Leonardi Vinci*, 1 (1988), pp.76–86.

Jones, Roger and Nicholas Penny. *Raphael.* New Haven and London, 1983.

Kecks, Ronald G. *Madonna und Kind: Das häusliche Andachtsbild im Florenz des 15. Jahrhunderts.* Berlin, 1988.

Kemp, Martin. 'Leonardo's Leda and the Belvedere River Gods: Roman Sources and a New Chronology', *Art History*, 3, no.2 (1980), pp.182–93.

—. *Leonardo da Vinci: The Marvellous Works of Nature and Man*. London and Toronto, 1981.

—. 'The Mean and Measure of All Things', *Circa 1492: Art in the Age of Exploration*, edited by Jay A. Levenson. New Haven and London, 1991, pp.95–111.

—. *Leonardo da Vinci: The Mystery of the Yarnwinder*. Edinburgh, 1992.

Knab, Eckhart, Erwin Mitsch and Konrad Oberhuber. *Raphael: Die Zeichnungen*. Stuttgart, 1983.

Köhler, Wilhelm. 'Michelangelos Schlachtenkarton', *Kunstgeschichtliches Jahrbuch d. k.k. Zentralkommission*, 1 (1907), pp.115–72.

Krems, Eva-Bettina. *Raffaels 'Marienkrönung' im Vatikan*. Frankfurt am Main, 1995.

Kristeller, Paul. *Early Florentine Woodcuts*. London, 1968.

Landucci, Luca. *Ein Florentinisches Tagebuch 1516–1542*. Edited by Maria Herzfeld. Jena, 1912/13.

Larsson, Olof. *Von allen Seiten gleich schön: Studien zum Begriff der Vielansichtigkeit in der europäischen Plastik von der Renaissance bis zum Klassizismus*. Stockholm, 1974.

Lee of Fareham, Viscount. 'A New Version of Raphael's "Holy Family With the Lamb"', *Burlington Magazine*, 64 (1934), pp.2–19.

Lefébure, Amélie. *Hommage à Raphaël: Raphaël au Musée Condé*. Chantilly, 1983.

Lehmann, Jürgen M. *Raphael: 'The Holy Family with the Lamb' of 1504. The Original and Its Versions*. Translated by Susanna Swoboda with David Britt. Studio exhibition, Museum Fridericianum, Landshut, 1996.

Lehmkuhl-Lerner, Hanna. 'Zur Struktur und Geschichte des Florentinischen Kunstmarktes im 15. Jahrhundert', Ph.D. dissertation, University of Münster, 1936.

Leonardo da Vinci. *The Notebooks of Leonardo da Vinci*. Compiled and edited by Jean Paul Richter. 2 volumes. 1883. Reprint New York, 1970.

—. *Trattato della pittura*. Excerpts in Volume 1 of *Scritti d'arte del cinquecento*, edited by Paola Barocchi. Naples, 1971, pp.235–50, 475–88.

—. *Sämtliche Gemälde und die Schriften zur Malerei*. Edited by André Chastel. Munich, 1990.

Levenson, Jay A., Konrad Oberhuber and Jacqueline L. Sheehan. *Early Italian Engravings from the National Gallery of Art*. Washington, 1973.

Levi d'Ancona, Mirella. 'The Medici Madonna by Signorelli', in *Studi offerti a R. Ridolfi*. Florence, 1973, pp.321–46.

Lightbown, Ronald. 'Michelangelo's Great Tondo: Its Origin and Setting', *Apollo*, 89 (1969), pp.22–31.

—. *Sandro Botticelli: Life and Work*. London, 1978.

—. *Piero della Francesca*. New York, 1992.

Lippmann, Friedrich. 'Raffaels Entwurf zur Madonna del Duca di Terranuova und zur Madonna Staffa–Connestabile', *Jahrbuch der preussischen Kunstsammlungen*, 2 (1881), pp.62–6.

Lisner, Margrit. 'Zum Rahmen von Michelangelos Madonna Doni', *Studien zur Geschichte der europäischen Plastik. Festschrift Theodor Müller*. Munich, 1965, pp.167–78.

Locher, Hubert. 'Das gerahmte Altarbild im Umkreis Brunelleschis: Zum Realitätscharakter des Renaissanceretabels', *Zeitschrift für Kunstgeschichte*, 56, no.4 (1993), pp.487–508.

—. *Raffael und das Altarbild der Renaissance: Die 'Pala Baglione' als Kunstwerk im sakralen Kontext*. Berlin, 1994.

Lomazzo, Gian Paolo. 'Trattato dell' arte della pittura, scoltura et archittetura', *Scritti sulle arti*. Edited by Roberto Paolo Ciardi. Florence, 1974, volume 2, pp.5–589.

Luchs, Alison. *Cestello: A Cistercian Church of the Florentine Renaissance*. New York and London, 1977.

—. 'A Note on Raphael's Perugian Patrons', *Burlington Magazine*, 125 (1983), pp.29–31.

Lynch, James B. 'The History of Raphael's Saint George in the Louvre', *Gazette des Beaux-Arts*, 6th series, 59 (1962), pp.203–12.

Magherini, G. and E. Giovagnoli. *La prima giovinezza di Raffaello*. Città di Castello, 1927.

Magliabechiano, Anonimo. *Il codice Magliabechiano, contenente notizie sopra l'arte degli antichi e quella de' Fiorentini da Cimabue a Michelangelo Buonarotti, scritti da anonimo Fiorentino*. Edited by Carl Frey. Berlin, 1982.

Mancinelli, Fabrizio, et al. *Musei Vaticani*. Florence, 1981.

Mancini, Federico. *Raffaello in Umbria: Cronologia e committenza. Nuovi studi e documenti*. Perugia, 1987.

Mancusi-Ungaro, Harold R. *Michelangelo: The Bruges Madonna and the Piccolomini Altar*. New Haven and London, 1971.

Manzoni, L. 'Notizie d'arte: La Madonna degli Ansidei', *Bollettino della R. Deputazione di Storia Patria per l'Umbria*, 5 (1899), pp.627–41.

Marabottini, Alessandro, et al. *Raffaello giovane e Città di Castello*. Rome, 1983.

Marani, Pietro C. *Leonardo e i leonardeschi a Brera*. Milan, 1987.

—. *Leonardo: Catalogo completo*. Florence, 1989.

Markowsky, Barbara. 'Eine Gruppe bemalter Paliotti in Florenz und der Toskana und ihre textilen Vorbilder', *Mitteilungen des Kunsthistorischen Instituts in Florenz*, 17 (1973), pp.105–40.

Martineau, Jane, ed. *Andrea Mantegna*. London, 1992.

Matarazzo, Francesco. *Chronik von Perugia 1492–1503*. Edited by Marie Herzfeld. Jena, 1910.

Meiss, Millard. *La Sacra Conversazione di Piero della Francesca*. Volume 1 of *Quaderni di Brera*. Milan, 1972.

Mena Marqués, Manuela, et al. *Rafael en España*. Madrid, 1985.

Mercati, Enrico. *Andrea Baronci e gli altri committenti tifernati di Raffaello. Con documento inediti*. Città di Castello, 1994.

Meyer zur Capellen, Jürg. 'Raffaels "Hl. Familie mit dem Lamm"', *Pantheon*, 47 (1989), pp.98–111.

—. 'Randbemerkungen zu Raffaels "Madonna di Terranuova"', *Zeitschrift für Kunstgeschichte*, 57 (1994), pp.347–56.

Middeldorf, Ulrich. *Raphael's Drawings*. New York, 1945.

Millon, Henry and Vittorio Magnago Lampugnani, eds. *Rinascimento da Brunelleschi a Michelangelo: La rappresentazione dell' architettura*. Milan, 1994.

Mitsch, Erwin. *Raphael in der Albertina aus Anlaß des 500. Geburtstages des Künstlers*. Vienna, 1983.

Müller-Walde, Paul. 'Eine Skizze Leonardo's zur stehenden Leda', *Jahrbuch der königlich preussischen Kunstsammlungen*, 18 (1897), pp.137–42.

Müntz, Eugène. *Raphaël: Sa vie, son oeuvre et son temps*. 2nd edition, Paris, 1900.

Murray, Peter. *The Dulwich Picture Gallery: A Catalogue*. London, 1980.

Natali, Antonio and Giovanni Cabras. *Gli Uffizi: La 'Visitazione' di Mariotto Albertinelli restaurata*. Florence, 1995.

Neilson, Katharine B. *Filippino Lippi: A Critical Study*. 1938. Reprint Westport, Connecticut, 1972.

Nepi-Scirè, Giovanna, et al. *Leonardo e Venezia*. Venice, 1992.

Neufeld, Günther. 'Leonardo da Vinci's "Battle of Anghiari": A Genetic Reconstruction', *Art Bulletin*, 31, no.3 (1949), pp.170–83.

Nicodemi, Giorgio. 'Discorso su due originali della "Bella Giardiniera" da Raffaello Sanzio', *L'arte*, 55 (1956), pp.11–17.

Oberhuber, Konrad. *Raphaels Zeichnungen*. Berlin, 1972. Volume 9 of Oskar Fischel, *Raffaels Zeichnungen*.

—. 'The Colonna Altarpiece in the Metropolitan Museum and Problems of the Early Style of Raphael', *Metropolitan Museum Journal*, 12

(1977), pp.55–92.

—. *Raffaello.* Milan, 1982.

Olson, Roberta J.M. 'Lost and Partially Found: The Tondo, a Significant Florentine Art Form, in Documents of the Renaissance', *Artibus et historiae*, 27, XIV (1993), pp.31–65.

Oppé, A. Paul. *Raphael.* 1909. Edited by Charles Mitchell. London, 1970.

Os, Henk van, et al. *The Art of Devotion in the Late Middle Ages in Europe 1300–1500.* Princeton, 1994.

Padoa Rizzo, Anna. 'Appunti raffaelleschi: L'Incoronazione di San Nicola da Tolentino per Città di Castello', *Paragone (Arte)*, 399 (1983), pp.3–7.

Parker, K.T. *Italian Schools.* Volume 2 of *Catalogue of the Collection of Drawings in the Ashmolean Museum.* Oxford, 1956.

Passamani, Bruno, et al. *Raffaello e Brescia: Echi e presenze.* Brescia, 1986.

Passavant, Johann David. *Rafael von Urbino und sein Vater Giovanni Santi.* Volumes 1, 2, Leipzig, 1839; volume 3, Leipzig, 1858.

Pedretti, Carlo. 'The Burlington House Cartoon', *Burlington Magazine*, 110 (1968), pp.22–8.

—. *Leonardo: A Study in Chronology and Style.* London, 1973.

—. *Leonardo da Vinci nature studies from the Royal Library at Windsor Castle.* Exhibition catalogue, Museum of Fine Arts, Houston, 7 February–4 April 1982. Introduction by Kenneth Clark. Royal Academy of Arts, London, 1981, and Johnson Reprint, New York, n.d. Trans. *Leonardo da Vinci: Natur und Landschaft. Naturstudien aus der Königlichen Bibliothek in Windsor Castle.* Hamburg, 1984.

—. 'The Getty "TL-Sheet"', *Achademia Leonardi Vinci*, 1 (1988), p.145.

—. *Raphael: His Life and Works.* Florence, 1989.

—. 'The Mysteries of a Leonardo Madonna, Mostly Unsolved', *Achademia Leonardi Vinci*, 5 (1992), pp.169–71.

—, et al. *Leonardo dopo Milano: La Madonna dei fusi* (1501). Florence, 1982.

—, Alessandro Vezzosi, et al. *Leonardo e il leonardismo a Napoli e a Roma.* Florence, 1983.

Penny, Nicholas. 'Raphael's "Madonna dei garofani" Rediscovered', *Burlington Magazine*, 134 (1992), pp.67–81.

Pesman Cooper, Roslyn. 'Pier Soderini: Aspiring Prince or Civic Leader?' *Studies in Medieval and Renaissance History*, 11 (1978), pp.71–126.

Petrioli Tofani, Annamaria. *Il disegno fiorentino del tempo di Lorenzo il Magnifico.* Florence, 1992.

Pietrangeli, Carlo, et al. *The Vatican Collections: The Papacy and Art.* New York, 1982.

Pirovano, Carlo, ed. *Raffaello e Brera.* Milan, 1984.

Plemmons, Barbara Mathilde. 'Raphael, 1504–1508', Ph.D. dissertation, University of California, Los Angeles, 1978.

Poeschke, Joachim. *Michelangelo und seine Zeit.* Munich, 1992.

Pope-Hennessy, John. *Raphael.* New York, 1970.

—. *Luca della Robbia.* Oxford, 1980.

Popham, Arthur E. and Johannes Wilde. *The Drawings of the XV and XVI Centuries at Windsor Castle.* London 1949.

Popham, Arthur E. and Philip Pouncey. *Italian Drawings in the Department of Prints and Drawings in the British Museum: The Fourteenth and Fifteenth Centuries.* London, 1950.

Pouncey, Philip and John A. Gere. *Italian Drawings in the Department of Prints and Drawings in the British Museum: Raphael and His Circle.* London, 1962.

Prohaska, Wolfgang, et al. 'Zu Raphaels "Madonna im Grünen"', *Wiener Berichte über Naturwissenschaft in der Kunst*, 1 (1984), pp.76–93.

Quatremère de Quincy, Antoine Chrysostôme. *Histoire de la vie et des ouvrages de Raphaël.* 1824; 2nd edition, Paris, 1833. *History of the Life and Works of Raphael.* New York, 1979.

Quednau, Rolf. 'Raphael und "alcune stampe di

maniera tedesca"', *Zeitschrift für Kunstgeschichte*, 46 (1983), pp.129–75.

—. ' "Imitazione d'altrui": Anmerkungen zu Raphaels Verarbeitung entlehnter Motive', in *De arte et libris. Festschrift Erasmus 1945–1984*. Amsterdam, 1984, pp.349–67.

Ragghianti, Carlo Lodovico. 'Raffaello, nota postuma. Raffaello a Firenze (1977). La Deposizione Borghesiana di Raffaello (1947)', *Critica d'arte*, nos 157–59 (1978), pp.143–61.

— and Gigetta Dalli Regoli. *Firenze 1470–1480: Disegni dal modello*. Pisa, 1975.

Redig de Campos, Deoclecio. *Raffaello e Michelangelo: Studi di storia e d'arte*. Rome, 1946.

—. 'L'incoronazione della Madonna di Raffaello', *Fede e arte*, 6 (1958), pp.343–48.

Riedl, Peter Anselm. 'Raffaels "Madonna del Baldacchino"', *Mitteilungen des Kunsthistorischen Instituts in Florenz*, 8 (1957/59), pp.223–45.

Riess, Jonathan B. *The Renaissance Antichrist: Luca Signorelli's Orvieto Frescoes*. Princeton, 1995.

Rosci, Marco. *Raffaello Deposizione*. Turin, 1991.

Rosenauer, Artur. *Raffael: Die Madonna im Grünen*. Volume 2 of *Kunsthistorisches Museum Wien. Das Meisterwerk: Einführungen und Betrachtungen zu ausgewählten Werken des Kunsthistorischen Museums*. Vienna, 1983.

—. *Donatello*. Milan, 1993.

Rosenberg, Adolf and Georg Gronau. *Raffael*. 4th edition, Stuttgart and Leipzig, 1909.

Ruland, Carl. *The Works of Raphael Santi da Urbino as Represented in the Raphael Collection in the Royal Library at Windsor Castle, Formed by H.R.H. the Prince Consort, 1853–1861 and Completed by Her Majesty Queen Victoria*. 1876. Warburg Institute Microfiche. London, 1985.

Salmi, Mario. *La pittura di Piero della Francesca*. Novara, 1979.

Sambucco Hamoud, Micaela and Maria Letizia Strocchi, eds. *Studi su Raffaello: Atti del congresso internazionale di studi, Urbino–Firenze, 6–14 aprile 1984*. 2 volumes. Urbino, 1987.

Santi, Francesco. 'Il restauro dell' affresco di Raffaello e del Perugino in San Severo di Perugia', *Bollettino d'arte*, 64, no.1 (1979), pp.57–64.

—. *Galleria Nazionale dell' Umbria: Dipinti, sculture e oggetti dei secoli XV–XVI*. Rome, 1985.

Scarpellini, Pietro. *Perugino*. Milan, 1984.

Scharf, Alfred. *Filippino Lippi*. Vienna, 1950.

Schiller, Gertrud. *Iconography of Christian Art*. London, 1971–.

Schmarsow, August. 'Raphaels Heiliger Georg in St Petersburg', *Jahrbuch der preussischen Kunstsammlungen*, 2 (1882), pp.256–7.

—. *Giovanni Santi, der Vater Raphaels*. Berlin, 1887.

Schmidt, Werner, ed. *Raffael zu Ehren*. Dresden, 1983.

Schöne, Wolfgang. 'Raphaels Krönung des Hl. Nikolaus von Tolentino', in *Eine Gabe der Freunde für Carl Georg Heise zum 28.VI.1950*. Berlin, 1950, pp.113–36.

—. *Raphael*. Berlin and Darmstadt, 1958.

Schug, Albert. 'Zur Chronologie von Raffaels Werken der vorrömischen Zeit: Überlegungen im Anschluß an das Kritische Verzeichnis der Gemälde, Wandbilder und Bildteppiche Raffaels von L. Dussler', *Pantheon*, 25 (1967), pp.470–82.

—. 'Zur Ikonographie von Leonardos Londoner Karton', *Pantheon*, 26 (1968), pp.446–55; 27 (1969), pp.24–35.

Seymour, Charles, Jnr. *Michelangelo's 'David': A Search for Identity*. Pittsburgh, 1967.

Shearman, John. 'Raphael at the Court of Urbino', *Burlington Magazine*, 112 (1970), pp.72–8.

—. 'Raphael, Rome and the Codex Escurialensis', *Master Drawings*, 15, no.2 (1977), pp.107–46.

—. 'A Drawing for Raphael's "St George"', *Burlington Magazine*, 125 (1983), pp.15–25.

Shearman, John and Marcia B. Hall. *The Princeton Raphael Symposium – Science in the Service of*

Art History. Princeton and New York, 1990.

Shell, Janice and Grazioso Sironi. 'Salaì and Leonardo's Legacy', *Burlington Magazine*, 133 (1991), pp.95–108.

Smart, Alistair. 'Michelangelo: The Taddeo Taddei "Madonna" and the National Gallery "Entombment"', *Journal of the Royal Society of Arts*, 115 (1967), pp.835–62.

Sonnenburg, Hubertus von. *Raphael in der Alten Pinakothek: Geschichte und Wiederherstellung des ersten Raphael-Gemäldes in Deutschland und der von König Ludwig I. erworbenen Madonnenbilder*. Munich, 1983.

Steingräber, Erich. 'Anmerkungen zu Raffaels Bildnissen des Ehepaars Doni', in *Forma et subtilitas. Festschrift für Wolfgang Schöne*. New York, 1986, pp.77–88.

Suida, Wilhelm. *Leonardo und sein Kreis*. Munich, 1929.

—. *Raphael*. New York, 1941.

Swoboda, Karl M. 'Raffaels Madonna im Grünen in der Wiener Gemäldegalerie', in *Kunst und Geschichte. Vorträge und Ansätze*. Supp. volume 22 of *Mitteilungen des Instituts für österreichische Geschichtsforschung*. Vienna, 1969, pp.180–95.

Thuillier, Jacques, Martine Vasselin and Jean Pierre Cuzin. *Raphaël et l'art français*. Paris, 1983.

Todini, Filippo. *La pittura Umbra*. 2 volumes. Milan, 1989.

Tolnay, Charles de. *Michelangelo*. 5 volumes. Princeton, 1943–60.

—. *Corpus dei disegni di Michelangelo*. 4 volumes. Novara, 1975–80.

Ullmann, Ernst. *Raphael*. Leipzig, 1983.

Van Buren, Anne H. 'The Canonical Office in Renaissance Painting: Raphael's Madonna at Nones', *Art Bulletin*, 57, no.1 (1975), pp.41–52.

—. 'Raphael's Madonna at Nones', letter to *Art Bulletin*, 57, no.3 (1975), p.466.

Vasari, Giorgio. *Le Vite de' più eccellenti architetti, pittori e scultori italiani, Le opere di Giorgio Vasari*. Edited by Gaetano Milanesi. 8 volumes. 1906. Reprint Florence, 1981. (Quoted as Vasari 1981.) *Lives of the Most Eminent Painters, Sculptors and Architects*. Translated by Gaston du C. de Vere, London, 1912–14. Repr. with introduction by Kenneth Clark. 3 volumes. New York, 1979. (Quoted as Vasari 1979.)

Vöge, Wilhelm. *Raffael und Donatello: Ein Beitrag zur Entwicklungsgeschichte der italienischen Kunst*. Strasbourg, 1896.

Wackernagel, Martin. *The World of the Florentine Renaissance Artist*. Translated by Alison Luchs. Princeton, 1981.

Wasserman, Jack. 'Michelangelo's Virgin and Child with St Anne at Oxford', *Burlington Magazine*, 111 (1969), pp.122–31.

—. 'A Re-discovered Cartoon by Leonardo da Vinci', *Burlington Magazine*, 112 (1970), pp.194–204.

—. 'The Dating and Patronage of Leonardo's Burlington House Cartoon', *Art Bulletin*, 53, no.3 (1971), pp.312–25.

Weinberger, Martin. *Michelangelo the Sculptor*. London and New York, 1967.

Whistler, Catherine. *Drawings by Michelangelo and Raphael*. Oxford, 1990.

Wilde, Johannes. 'Michelangelo and Leonardo', *Burlington Magazine*, 95 (1953), pp.65–77.

Wind, Edgar. 'Charity: The Case History of a Pattern', *Journal of the Warburg Institute*, 1 (1937/8), pp.322–30.

Wittkower, Rudolf. 'The Young Raphael', *Allen Memorial Art Museum Bulletin*, 20 (Oberlin, 1963), pp.150–68.

Wolffhardt, Elisabeth. 'Beiträge zur Pflanzensymbolik', *Zeitschrift für Kunstwissenschaft*, 8 (1954), pp.177–96.

Wurm, Heinrich. *Baldassare Peruzzi: Architekturzeichnungen*. Tübingen, 1984.

Zentai, Roland. 'Considerations on Raphael's Compositions of the Coronation of the Virgin', *Actae historiae artium*, 24, nos 1–4 (1978), pp.195–99.

—. 'Contribution à la période ombrienne de Raphaël', *Bulletin du Musée Hongrois des Beaux-Arts*, 53 (1979), pp.69–79.

Zeri, Federico. *Italian Paintings: Sienese and Central Italian Schools. The Metropolitan Museum of Art.* New York, 1980.

—, ed. *La pittura in Italia: Il quattrocento.* 2 volumes. Milan, 1987.

Zöllner, Frank. 'Rubens Reworks Leonardo: "The Fight for the Standard"', *Achademia Leonardi Vinci*, 4 (1991), pp.177–92.

Photographic acknowledgements

Azimuth Editions, the picture researcher, and the author wish to thank the institutions and individuals who have kindly provided photographic material or artwork for use in this book. Museums and galleries are given in the captions; any additional credits, along with other sources, are listed below.

AKG, London: **103**; Jörg P. Anders, Berlin: **111**; Archive Alinari, Florence: **3, 21, 24, 26, 27, 35, 37, 45, 79, 94, 134**; Artothek, Peissenberg: **121**; Bildarchiv Österreichische Nationalbibliothek: **71, 80, 107, 119, 120**; Bridgeman Art Library, London: **133**; By permission of the Duke of Buccleuch and Queensberry, KT: **29**; Bulloz, Paris: **12**; Geoffrey Clements (photograph): **136**; Cliché des Musées Nationaux, Paris: **16, 17, 32, 55, 61, 102, 105, 122, 130, 140**; Galleria degli Uffizi, Florence, Sopritendente per i beni artistici e storica

Gabinetto fotografico: **63**; Giraudon, Paris: **33, 124, 129**; Graphische Sammlung Albertina, Vienna: **109**; Hirmer Fotoarchiv, Munich: **34**; Laboratoire de recherche des musées de France: **6–9**; Musée de la Ville Strasbourg: **28**; National Gallery of Art, Washington © 1995 Board of Trustees: **93, 96, 108**; Royal Academy of Arts, London: **36**; The Royal Collection © Her Majesty Queen Elizabeth II: **42, 54, 57, 58, 68, 75, 81, 123, 133**; Scala, Florence: **1, 2, 11, 13, 15, 23, 38, 98, 126, 139** (also for frontispiece and chapter decorations), **142, 143**; Staatliche Museen zu Berlin – Preussischer Kulturbesitz Gemaldegalerie: **111, 113**; University of Oxford, Ashmolean Museum: **48, 49, 53, 83**